Red Grooms
The Graphic Work

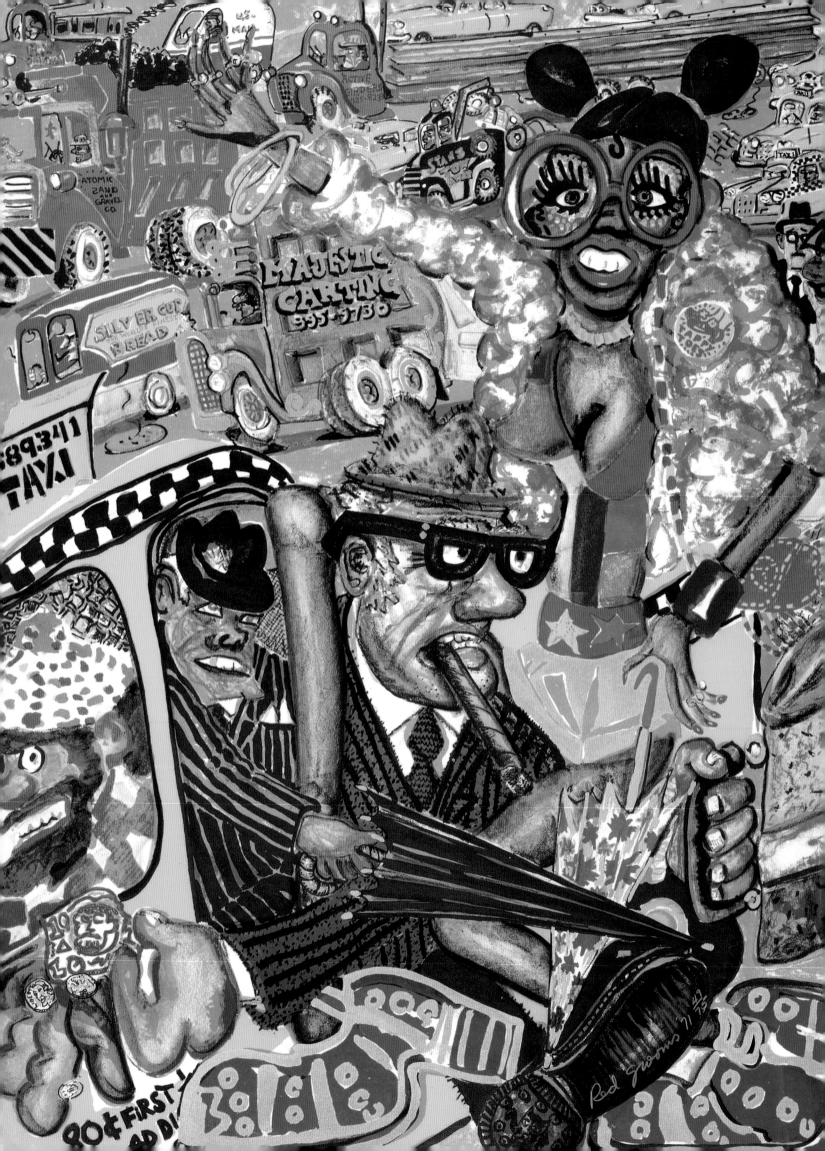

Red Grooms
The Graphic Work

Introduction and Catalogue
by Walter G. Knestrick

Essay by Vincent Katz

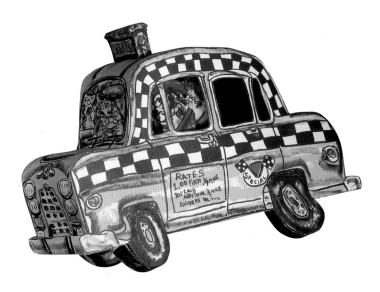

Harry N. Abrams, Inc., Publishers

Library of Congress Cataloging-in-Publication Data
Knestrick, Walter.
Red Grooms: the graphic work / introduction and catalogue by Walter Knestrick; essay by Vincent Katz
 p. cm.
 Includes index.
 ISBN 0–8109–6733–2 ISBN 0–8109–6734–0 (Museum pbk.)
 1. Grooms, Red—Catalogs. I. Grooms, Red. II. Katz, Vincent, 1960– III. Title.
NE539.G74 A4 2001
769.92—dc21 00–56555

Photography by Bill Lafevor, unless otherwise noted.

All prints and posters are in the collection of Walter G. Knestrick, with the exception of the following:
Courtesy of Red Grooms: *Comic*, catalogue number 8; *Organize the Sea*, catalogue number 20; *The Nashville Artist Guild Presents Charles "Red" Grooms*, catalogue number 199. Courtesy of Mimi Gross; *Arthur and Elizabeth*, catalogue number 24 (Photo by Eric Pollitzer); *Drawings*, catalogue number 197; *Shoot the Moon*, catalogue number 200; *Tibor de Nagy*, catalogue number 201; *Lurk*, catalogue number 202; *Intolerance*, catalogue number 203; *This Way to the Marvel*, catalogue number 206; *A Charlie for Saskia*, catalogue number 235 (All photos by D. James Dee). Courtesy of Benni and Anne Korzen: *Camal*, catalogue number 16 (photo by Benni Korzen). Courtesy of Rusty Morgan: *Saskia*, catalogue number 209 (Photo by Gary Kable). Courtesy of Wilhelmina Grooms: *Paper Bag Players*, catalogue number 204; *Doughnut Girl*, catalogue number 208.

Front cover: *Self-Portrait with Litho Pencil*. 1999. Woodcut on Japanese Paper. © Red Grooms. Photo by Bill Lafevor.
Back cover: *The Collector*. 1999. Woodcut on Japanese Paper. © Red Grooms. Photo by Bill Lafevor.

Printed and bound in Hong Kong

ABRAMS
Harry N. Abrams, Inc.
100 Fifth Avenue
New York, N.Y. 10011
www.abramsbooks.com

Executive Director's Note

By his own account, Red Grooms liked growing up in Nashville, Tennessee. He believed it to be a good place to live—full of ghosts, and heroes, and shooting stars. It was a civilized and languid city, full of boulevards, green trees, orange night skies, and all of the eccentric characters one might find in a Faulkner novel. There was a concrete conglomerate replica of the Parthenon in Athens, great universities, and isolated ghettos that bordered the city.

Georgia O'Keeffe visited Nashville in 1949 to present the Alfred Stieglitz collection to Fisk University. That collection, along with the Cowan Collection held at the Parthenon, the Kresge teaching collection at George Peabody College, and Watkins Art Institute comprised the art venues available in Nashville to Red during his formative years.

When Red burst onto the New York scene in the 1950s by way of Chicago, his mind was in many ways a tabula rasa, ready to be filled with the sights and sounds of big city life—the oceans, the fish markets, the subways, the skyscrapers, the Bowery. He was, in essence, a social historian with a hot glue gun. Red's work, *Picasso Goes to Heaven* (1976), was as meaningful to his interpretation of life as *Saskia Doing Homework* (1976) or *The Cedar Bar* (1987). Red managed to be a performance artist, a filmmaker, a draftsman, a cartoonist, and a master of construction architecture. The iconography of life was the catalyst for the 40-year body of Red's work. He loved life, his family and friends; he loved the grotesque, the vulgar, and the satirical; he loved to startle and amuse, and he absorbed each thing he saw. Then, through an artist's eye, he documented it with a giant exclamation point.

When the Pennsylvania Academy of Fine Arts toured the exhibit, *Red Grooms, A Retrospective* (1954–1984) in 1986, the Tennessee State Museum was a pivotal stop. Red was already a citizen of New York then, a rising star in the art firmament. So that Tennesseans might fully appreciate one of their own, the museum produced a film, a documentary short created by film producer Tom Neff and Tennessee curator and art critic, Louise LeQuire. The film was entitled, *A Sunflower in a Hothouse,* the title taken from a quote by *The New York Times* critic, John Canaday, who in reviewing the early works of Red Grooms, had likened Red to a sunflower in a hothouse. The film, which was nominated for an Academy Award, interviewed all those people who had been a part of Red's early life, his parents, his best friends, including the author of this book, Walter Knestrick, and re-created the panoply of visual experiences that had become Red Grooms from art to life. The film was premiered in Lysiane and Red's movie theater, "Tut Fever," which is now housed at the Museum of the Moving Image in Astoria, New York.

Today, Red Grooms is part of the fabric of Tennessee life, a Tennessean shared with the world, like Elvis and Davy Crockett; Alex Haley and Robert Ryman; W. C. Handy or Dolly Parton. Red is a shooting star—prolific, burning bright, always changing, yet

always the same. How lucky we have been to have him! In 100 years, art historians and perhaps even anthropologists will look back at his work as a commentary on the twentieth century, a look at the ghosts of artists past, at daily life, at high society, the low, the twisted, and the irreverent. They will marvel at what he was, and how little we might have known about ourselves without him.

It is with great pleasure that the Tennessee State Museum has assembled this exhibition, *Red Grooms: The Graphic Work.*

Lois Riggins-Ezzell
Executive Director
Tennessee State Museum

Exhibition Venues

NATIONAL ACADEMY MUSEUM
 & SCHOOL OF FINE ARTS
New York, New York
July to November 2001

CHICAGO CULTURAL CENTER
Chicago, Illinois
January to March 2002

MONTGOMERY MUSEUM OF FINE ARTS
Montgomery, Alabama
May to September 2002

MUSEUM OF FINE ARTS
St. Petersburg, Florida
September 2002 to January 2003

PLAINS ARTS MUSEUM
Fargo, North Dakota
February to April 2003

CAPE MUSEUM OF FINE ARTS
Dennis, Massachusetts
June to October 2003

LOWE ART MUSEUM, UNIVERSITY OF MIAMI
Coral Gables, Florida
November 2003 to January 2004

HECKSCHER MUSEUM OF ART
Huntington, New York
February to April 2004

FRIST CENTER FOR THE VISUAL ARTS
Nashville, Tennessee
June to September 2004

Contents

Acknowledgments

There is no way one person could have completed this book (especially a contractor/ engineer authoring his first work) without an enormous amount of assistance from so many people. The accuracy and completeness of the information is due in large part, of course, to Red and Lysiane for the considerable amount of time they have both spent helping me document the prints and move the book forward. I am deeply indebted to Red for his insights, encouragement, attention to detail, and dedication to this project. It was his idea to include personal comments on the prints, as well as those of the master printers, which I know the reader will find interesting, enlightening, and often delightfully humorous. Red has been personally involved every step of the way—editing, reviewing, and finally producing a splendid self-portrait woodcut for the front cover, and one of me for the back.

Red's mother, Wilhelmina Grooms, deserves a special thank-you. Mrs. Grooms has always had an open door for me—when Red and I were young, as well as recently when we reviewed old photographs and newspaper articles she has stored away in many drawers and boxes at her home in Nashville. Her incredible memory of our early years has added much to my Introduction. It is with love and admiration that I dedicate this book to her.

Mimi Gross spent hours helping me locate and document the prints of the 1960s and finding old friends such as Julie Martin and Billy Klüver, Anne and Bennie Korzen, Rusty Morgan and Yvonne Andersen, all of whom contributed much information about his work and their friendship with Red in the 1960s when there was very little documentation of his prints. Thanks also to Joshua Mack, who took the time to search his grandmother's closet for the print "Fall of Jericho," which she had commissioned for his Bar Mitzvah. Mack graciously sent the print to me for my collection. A special thanks to Bruce Shelton of the Shelton Gallery in Nashville, Tennessee, who uncovered many lost prints, which somehow seemed to appear in his gallery at exactly the right time.

Red's longtime assistant, Tom Burckhardt, was always helpful and patient when deadlines were short and questions still remained unanswered. Among others who were especially generous with their time and who provided invaluable records and recollections were the master printers: Bud Shark of Shark's, Inc., and his assistant, Roseanne Colochis; Steve Andersen of Akasha Studio; Jennifer Melby; Mauro Giuffrida of Dragonfly Press (who was very concerned that I should spell his name correctly); Maurice Sanchez of D'Erriere L'Etoile Studios; Carol Weaver; and Felix Harlan of Harlan and Weaver Studio.

Publishers, too, have been an indispensable source of information. I am indebted to Brooke Alexander, Brooke Alexander Editions; Pierre Levai and Tara Reddi, Marlborough Graphics; and Richard Solomann of Pace Prints.

It was a pleasure to work with photographer Bill Lafevor, whose talents are obvious

throughout the book, and with framer William Parker, Ambiance by Parker, who along with James Rutherford and Susan Knowles, worked tirelessly through the tedious process during which each print had to be removed from its frame, carefully photographed, and then replaced. Many thanks to Lois Riggins-Ezzell, Executive Director of the Tennessee State Museum, who graciously agreed to organize the traveling exhibition of Red's prints.

Heartfelt thanks to Louise LeQuire, a second cousin of Red's and a wonderful writer, who as art editor for the *Nashville Banner* reviewed Red's and my two-man show in Nashville in 1955. Louise helped me find just the right words for my Introduction and jogged my memory concerning the facts surrounding our early years. A "special heroic award" goes to Kathy Cagle, administrative assistant to my son Bill (who now runs the construction and real estate companies) who—in addition to her full work load—did all the typing and re-typing of my many notes and manuscripts, which were in a state of constant flux for a number of years.

I appreciate the confidence of Harry N. Abrams, Inc., for selecting Vincent Katz to produce the critical essay. What a perfect choice! Vincent is a wonderful writer whom Red has known from an early age, and whose father, Alex Katz, remains Red's longtime friend. This relationship made the many hours of interviews a pleasurable undertaking. I am indebted to Paul Gottlieb of Abrams for believing in this work. Many thanks to Morgan Entrekin for introducing me to Paul Gottlieb, who had the courage to sign on for this book, and also to Adele Westbrook and Dena Bunge, as well as Dana Sloan, who have helped enormously in making this book a fitting tribute to the work of Red Grooms.

Introduction
by Walter G. Knestrick

WOW! It doesn't seem possible that more than fifty years have passed since I first met Charles Grooms in 1947, on the day that I transferred from Clement School to Burton School in Nashville, Tennessee. We were both ten years old and in the fifth grade.

I say Charles, because we never knew him as Red until 1959. I have a pencil drawing that Charles made for a history class in the fifth grade. (After finding it in his attic, Charles's teacher gave it to me twenty years later.) It is signed "Chas. Grooms, 1947," and is one of the highlights of the many Red Grooms pieces in my collection.

In 1948, Charles and I were enrolled at the Nashville Children's Museum for art lessons that took place every Saturday morning. Mrs. Grooms would take Charles via a streetcar on Eighth Avenue to the museum on Second Avenue South. Charles's mother went with him

the first day, where she met Emily Colvet, who was both an artist and the class instructor. Mrs. Grooms remembers Ms. Colvet telling her after the first session: "This child has rhythm." He had just finished a watercolor of a tree on the grounds of the Children's Museum.

The Grooms family did not have a car until Charles was fourteen years old, and so on many occasions my mother would pick him up and take both of us to the museum. The museum was located in an old school building that had just been renovated. I particularly remember the dioramas of ancient wildlife that filled the great halls we had to pass through to reach the art class. Unfortunately, after about a year, the museum encountered financial problems and had to eliminate the Saturday morning classes, but we both still appreciate the special introduction to drawing and painting we received from Ms. Colvet. Our next joint venture was to sign up for art lessons with Juanita Williams, who was also an instructor at the Watkins Art Institute in Nashville. I took one class and never went back.

She was too much of a taskmaster for me. Charles enjoyed her instruction and studied with her for a number of years.

There were art contests for different age groups at the Tennessee State Fair held in Nashville each fall. When Charles and I heard about them, we entered our work. We still laugh today, remembering that I won a blue ribbon and Charles took second place.

Since there were no art classes at the Burton Elementary School, we were delighted when we enrolled at Hillsboro High School in 1951 and found that we could study art there. We had a wonderful full-time art teacher, Helene Connell, who was the sister of the playwright William Inge. She took a very special interest in both of us, and her wide-ranging interests and enthusiasm for our work had a strong influence upon us while we were in high school. We enrolled in every one of her classes that we could fit into our schedules. Printmaking was not a part of our curriculum in high school, so neither of us did any prints during our high school years.

During those years we would spend many hours drawing after school and on week-ends. Charles's mother was wonderful. She would roll up the carpet in the downstairs dining room so that we could work on the hardwood floor. Some of my fondest childhood memories are of the two of us sitting on the floor happily engrossed in our favorite pastime. We constantly encouraged one another to draw and paint from life, and shared sketching trips to interesting places, while drawing people and buildings from observations made mostly around Nashville.

During our high school years, Charles collected the Dell books on famous artists such as Degas, Cézanne, Picasso, and others, which you could purchase then for only twenty-five cents. On many occasions Charles would carry these around with him in his back pocket. I remember very clearly his boast at that time that "If I had to cut off my ear to be a famous artist like Van Gogh, I would do it!" He felt very certain that he could be an artist like those he read about in the Dell books.

In high school Charles was voted the wittiest in his class. His wit and sense of humor have stayed with him throughout the years and are reflected in his work. We were seldom scheduled for the same art class, but most week-ends he and I would go into the city to draw and paint watercolors. Charles would always be inclined to sketch people, either from life or from his imagination, while I invariably drew and painted buildings that interested me. Perhaps our natural interests were even then pointing the way toward our very different careers.

In 1952, when we were sophomores in high school, we began taking art lessons from Joseph van Sickle, in his English Tudor house on Bowling Avenue, across the street from West End High School in Nashville. Van Sickle soon rented a studio on Nashville's "Music Row," and we would go

there once a week. Our class lasted from about seven until nine o'clock in the evening—although the three of us often stayed much later. We continued our art lessons with this artist for two years. He painted recognizable architecture and figures, but with an intense interest in abstract design, and he particularly loved to do cubist Grand Ole Opry paintings. Neither of us was interested in copying his style, but we learned a great deal about composition from him, and we grew in confidence and skill.

We were both invited to become members of the Nashville Artist's Guild and the Tennessee Art League in 1954—the first teenagers to be accepted for membership. We exhibited in several shows with both these groups of adult artists. One "All-State Competition" we entered was held at the Parthenon, Nashville's magnificent replica of the original in Athens, Greece. The rules for this competition restricted the size of the painting and required that all entries be framed. Charles submitted one work that was larger than the rules allowed, and he painted a line around it to make a frame, but the authorities refused to accept his entry.

We may not have been too proud of these entries, because neither Charles nor I returned to pick up our works until a year later, when someone called from the Parthenon to see if we still wanted them! Actually, we were notorious for abandoning paintings that were on exhibit. We have been surprised several times over the years when some of these early works have shown up in public places around Nashville.

Myron King, a local art dealer and framer, as well as the owner of Lyzon's gallery in Nashville, was wonderful to both of us. We would spend a week-end drawing and painting, and then we would take our work over to his shop. We would give him one of the paintings we had done, and he would let us go into the back of his shop and make our own frames, at no cost. During the summer months, he encouraged Charles to come and

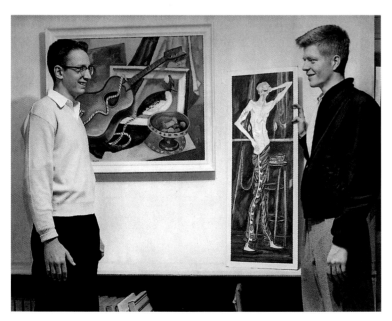

Walter Knestrick and Charles Grooms at Hillsboro High School, Nashville, Tennessee, 1955. Photo by D. S. McCormac for the Nashville Banner Publishing Co.

paint in the upstairs rooms in a building behind his shop, giving him a weekly fixed salary and supplying him with paints, brushes, and paper, then selling his works. Nashvillians were delighted with these early, sensitive drawings and watercolors, and King was able to sell some to collectors. Charles began to feel increasingly secure in his talent as a producing artist with an audience.

In our senior year of high school, King asked us to put together a two-man show, which was exhibited in the upstairs gallery at Lyzon's. My mother, Dora, remembers that she and my father, Bern, along with Red's parents, Wilhelmina and Jerry, prepared punch and cookies and sent out

the invitations for the opening reception on Sunday, February 13, 1955. The exhibit ran through the 28th of February. Charles did a drawing of little "Gremlins" for the invitations, and I did the lettering. Louise LeQuire, art critic for the newspaper, did a review of our show that included a picture of Charles and me with two of our paintings. I remember that all of Charles's works were of people and mine were mainly of buildings. Charles's works were all on paper, and he priced them from $10.00 to $15.00, while I showed both oil on canvas and works on paper, priced from $15.00 to $20.00. We didn't sell very many, even at those prices, but it was a great experience.

During our senior year in high school, Mrs. Joseph Fenn, the Art Director for all the city schools, approached us with a plan for the design of a mural for the new Metropolitan School Board Building in Nashville. The idea was that we would work on a huge scale, probably twelve feet by thirty feet in the main entrance hall. Charles and I were excited about the project and spent six months doing sketches and presentation drawings for Mrs. Fenn to submit to the Superintendent. (The sketches are documented in Carter Ratcliffe's monograph on Red Grooms.) But, ultimately, the Superintendent turned down our proposal, and the mural was never painted. Years later, when Charles made his acceptance speech for the Arts Club Gold Medal award in New York in 1989, he referred to "the mural that was never painted!" Looking back, I think the Superintendent's decision was an opportunity missed for Nashville.

During my senior year, I won a scholarship to attend the Art Institute

Charles Grooms and Walter Knestrick, Proposal for a School Board Mural, *1954. Watercolor on paper and tracing paper 20 × 26¼" (50.8 × 66.7 cm). Collection of the Artist. Photo by Bill Lafevor.*

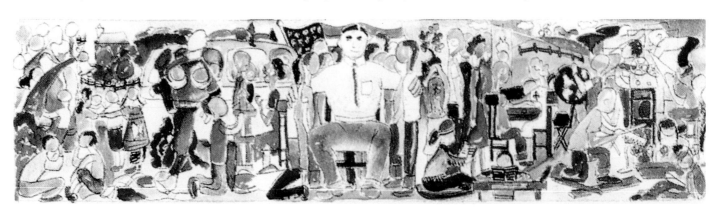

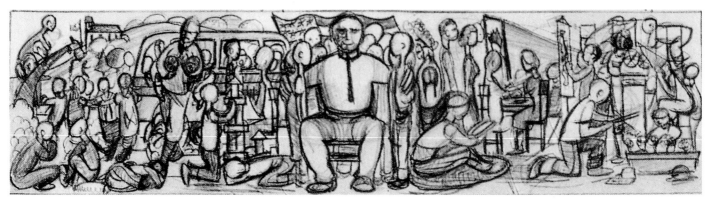

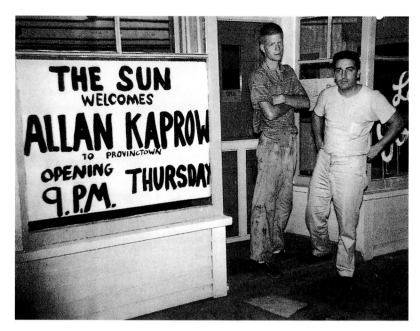

Red Grooms and Dominic Falcone in front of the Sun Gallery, Provincetown, Massachusetts, 1959. Photo by Yvonne Andersen.

Red Grooms, *1965 by Sterling Strausser, oil on board, 17 × 12″ (43.2 × 30.5 cm). Collection of Walter G. Knestrick. Photo by Bill Lafevor*

of Chicago. However, I chose to attend Vanderbilt University and study engineering, which was what my father hoped I would do. Charles decided that he would go to the Art Institute of Chicago, so he did, without a scholarship, and lived in the downtown YMCA. He didn't quite make it through the first semester. His parents drove to Chicago and brought him back to Nashville. Charles stayed with his family over the Christmas–New Year Holiday, and then he left by Greyhound bus for New York City, where he checked in at a YMCA there. This time, he made it through the semester at the New School for Social Research. Upon his return to Nashville he enrolled in Peabody College, where he made his very first print during the spring term in 1956. Charles made only one of these prints, and he gave it to me on my sixtieth birthday. Since our birthdays are only a few days apart, we have often exchanged gifts, but among all the other gifts, this print is a very special one to me.

While I continued to study engineering at Vanderbilt, Charles left Nashville for the North again in 1957 to study with Hans Hofmann in Provincetown, Massachusetts. Working as a dishwasher that summer, Charles adopted Red as his professional name. His fellow worker, Dominic "Val" Falcone, would shout, "Hey, Red," and it stuck. Val, a budding poet, and Red became good friends. After a summer in Massachusetts, Red moved permanently to New York City, along with Val and his wife, Yvonne Andersen, a painter. I went on to graduate from Vanderbilt where I had done very little painting. I married and was living with my wife, Anne, in a two-room apartment in Nashville when Charles (now Red) first came to visit in 1961, which was about the time I entered the construction business. We were surprised because he was wearing strange sunglasses and his hair was hardly regulation length. His orange, yellow, and chartreuse clothes clashed with his red hair, and he spoke about things like the moon and the stars and other strange topics for a Nashville conversation. Red's world seemed so foreign to us that we thought he had gone "over the edge." My collection includes a portrait of Red with a goatee, which was done around this time by a New York artist, Sterling Strausser. A photograph taken at about the same time proves that he looked exactly as the portrait depicts him.

Between 1965 and 1971, Red and I saw each other on occasional visits whenever he would return to visit his parents. I had started my own construction business, Walter Knestrick Contractor, Inc., in 1969, and so had become considerably more interested in constructing buildings than in

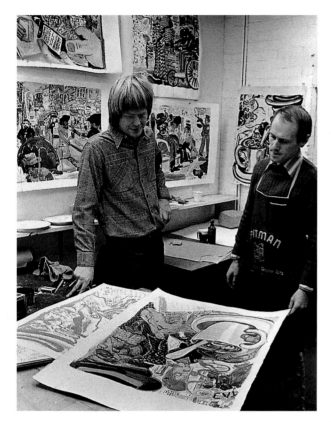

Red Grooms and Jean-Pierre Remond looking over proofs of No Gas Café, *1971. Photo by Bolotsky.*

doing watercolors of them. It was in 1971, when Red had completed his first print series called *No Gas,* that I felt the first spark of interest in collecting his prints. I went to New York and attended the opening at Abrams Fine Art Editions. Before I knew it, I had purchased the complete *No Gas* portfolio, and that was the beginning of my collection of Red Grooms prints. I determined then that I would try to purchase every print he made during the 1970s.

In 1975, Red had a joint show with Robert Indiana in Purchase, New York, at the Neuberger Museum. A big opening was planned. Invitations were sent out and Red was told he could invite two couples to the event. He called me and said, "The only two people I know to invite are you and Minnie Pearl." (Minnie Pearl, a star of "The Grand Ole Opry" in Nashville, and her husband, Henry Cannon, lived next door to Red's mother and father.) I still have the note Minnie Pearl wrote to me to say that she was sorry she would not be able to join us for the occasion. Red's message to me when he called to invite me had been, "I may have to shoot my way out, and I want you there with me!" Anne and I flew to New York, and then traveled by limousine to attend the opening. I had a memorable evening, seated next to the artist Louise Nevelson, who was dressed in her inimitable black and sporting huge artificial eyelashes. It was there that I heard Red make his first public speech. The Governor of New York and the Mayor of

Red Grooms with Jerry and Wilhelmina, 1978, Nashville, Tennessee. Photo by Nancy Warnec.

New York City were both there. In Red's words, "It was a really big deal!"

I collected Red's prints throughout the 1970s. After 1980, I did not collect another print until about 1983, when my good friend Ervin Entrekin told me that collecting Red's prints was important—that I should not stop with the prints of the 1970s but should continue purchasing his prints during the entire span of his career. I had already missed three years of editions, so I called Brooke Alexander, Red's publisher at the time, and asked him to find examples of those prints issued during 1980–1983. Alexander promptly located the prints for me, completing my collection to that date.

In 1981, during my tenure as president of Cheekwood's Fine Arts Department, we applied for a grant from the Southern Federation of Arts to fund a traveling exhibition of Red's prints, with an accompanying catalogue. I wanted the venues to be college and university galleries because of my interest in exposing Red's work to younger audiences, who might eventually become collectors of his work. The Southern Federation of Arts funded the grant and approximately fifty prints traveled to ten colleges and universities through 1985, after which we reworked the catalogue and added additional three-dimensional works to the traveling exhibition. This extended exhibition was circulated through 1992 by the Trust for Museum Exhibitions, Washington, D.C., to over twenty-five museums throughout America.

By 1983, my print collection numbered close to 100 prints, and I began to realize that my collection was a valuable documentation of Red's growth as an artist. Throughout the 1980s and 1990s, I have expanded my collection to include more than 300 prints and posters, and I have added many of Red's original works. Although I have been involved in numerous arts initiatives in Nashville and throughout the state of Tennessee, my overriding passion has always been that of collecting Red's prints and making them available to a wider audience.

I no longer consider myself a serious artist, but I still love to dabble in watercolors—when I'm not out trying to locate and research every print Red has ever produced. During my research for this book, I had a wonderful conversation with Billy Klüver, who initiated the "New York Collection for Stockholm," in which Red was included. He told me that one of the most important things in recording history is accuracy. I think my background in engineering has helped me in this regard and, after twelve years of research, I hope this book not only reflects the story of my longtime friendship with Red Grooms, but also provides an accurate account of the richness and variety of Red's prints and his development as one of the most original, as well as accessible, artists of our time.

Red Grooms and Walter Knestrick at Shark's studio, Boulder, Colorado, 1995 with three-dimensional lithograph Times Square *in progress. Photo by Bud Shark.*

The Prints

1. Beginnings

Red Grooms's first print, the linoleum cut *Minstrel* (1956), already suggests the exuberant theatricality that would come to define his mature work. Although he made it while enrolled in Peabody College in Nashville, pursuing a degree in teaching, it represents more than an academic exercise. Grooms had gained experience during brief stints at the School of The Art Institute of Chicago and the New School for Social Research in New York, and he put it to good use in this punchy, clear image exhibiting an energetic line and Grooms's native subject matter. "Both in Chicago and New York," he explains, "I had done a lot of drawings, pencil and ink. I didn't do any paintings at all. I didn't even do watercolors. I just did black-and-white drawings. I was developing some peculiar imagery."[1]

Informing the *Minstrel* image is Grooms's love of the theater and movies, both of which were to play

of Red Grooms
by Vincent Katz

seminal roles in the conception and the actual production of his mature art. The minstrel in this print is wearing a top hat, an important early symbol for Grooms of a crazed stage persona, a mad professor gone vaudevillian. One of the first artists to make an impact on him, while he was still a teenager, had been Jacob Lawrence, and in *Minstrel,* Grooms attempted to combine the enthusiasm of his personal stage experiences with the formal and social sophistication he had observed in Lawrence's depictions of African-Americans. Access to reproductions of art was important to Grooms's development, and received images were soon to make themselves evident as subject matter in his work.

In the summer of 1957 Grooms went to Provincetown, where he studied for two weeks with Hans Hofmann and met Yvonne Andersen and Dominic Falcone. Their Sun Gallery was showing post-abstract art that

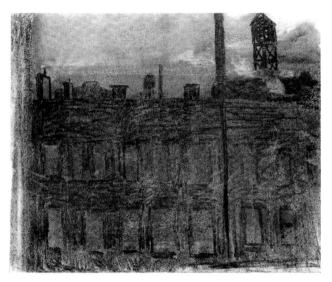

Lester Johnson, rooftop image from City *portfolio, 1958, metal plate printed in one color on a letterpress, 4½ × 5⅝″, designed by Yvonne Andersen, with prints by Grooms and Johnson and poems by Dominic Falcone. Collection of Walter G. Knestrick.*

would prove to be a catalyst Grooms needed to arrive at his own vision. From his reading and observation, Grooms was attracted to the improvisatory bravura of the Abstract Expressionists, but he was also drawn irresistibly toward the human figure and various characters he wished to depict. After the summer, Grooms moved to New York with Andersen and Falcone, and in 1958 they produced a portfolio called *City,* designed by Andersen with prints by Grooms and Lester Johnson and poems by Falcone. Grooms's four prints—drawings that Andersen reproduced on a small letterpress—are in black-and-white and reveal the facility he had by then developed in line drawing, as well as an interest in the macabre in one of the images, *The Operation.* At this stage, though, Grooms's treatment of a body being operated on still relies on the fantasy appeal of the movies. In particular, it brings to mind *Frankenstein,* the monster Grooms would later play in Rudy Burckhardt's film *Lurk* (1964). Also in 1958, Grooms made *Five Futurists,* a linocut based on a famous photograph, which is the first example in Grooms's work of art-historical figures as subject matter.

In 1959, back in Provincetown, Andersen and Falcone's Sun Gallery was thriving, with shows by Johnson, Alex Katz, and Anthony Vevers. Allan Kaprow came up at the end of the summer, and there was much discussion about a new kind of art that, taking its cue from Jackson Pollock's "Action Painting" (as critic Harold Rosenberg had called it), would make action itself the art. That September, up in Provincetown, Grooms staged his first Happening, *Walking Man.*

Back in New York, Kaprow and others began doing Happenings—brief events with elaborate sets performed in front of an audience—and they began to attract attention. Grooms had an alternative space then, which he called the Delancey Street Museum, and it was there in December of 1959 that he staged *The Burning Building*, perhaps his most famous Happening, and one upon whose imagery he would draw in the future. Grooms's Happenings were never as free-form as those by many other figures; they were more like mini-plays. He made a woodcut to advertise *The Burning Building*, posting copies downtown. Although it was his first woodcut, it shows a maturity not evident in his previous graphic work. The interaction of the strongly outlined figures with each other and the urban backdrop behind them is deftly effected. The elegant lettering has the perfect blend of clarity and irregularity needed to render it intensely alive. Lettering would continue to be an important part of Grooms's graphic output, as would the aggressive use of poster advertising.

During this same period, Grooms put out a mimeographed *Comic*

(1959), at the request of Claes Oldenburg, who was having his Ray Gun Show at the Judson Church. Grooms's comic book, printed in black on pink paper, folded and stapled to mimic the appearance of a real comic book, revisited the big-city danger theme of firemen that so intrigued him. *Comic* provides tangible evidence of key elements in Grooms's repertoire that would distinguish him throughout his career: the humor and silly outrageousness inherent in comics or funny papers. With their serial frames, bright, eye-grabbing colors, improbable plots, and light conclusions, comics furnished Grooms with ingredients perfectly suited to his natural talent for rapid, unedited drawing. Grooms would combine the high-art aestheticism of French modernist artists, the spontaneous, aggressive draughtsmanship of the Abstract Expressionist painters, and the low-art spectacle, humor, and plain zaniness of comedic movies and comic books.

In 1962, Grooms teamed up with filmmaker and photographer Rudy Burckhardt to make *Shoot the Moon*, a 16-millimeter film inspired by Georges Méliès's pioneering 1902 film, *Voyage À La Lune (A Trip to the Moon)*. The film's preposterously self-important Mayor, played by poet and dance critic Edwin Denby, and two officials, played by Burckhardt and Katz, develop figures that, along with the fireman, and later on the policeman, represent iconic urban images for Grooms. His city is one in which people and buildings are in perpetual motion, all in a constant shuffle of energy. As in Pollock's paintings or the Baroque compositions of Rubens, the eye is led on a ceaseless chase around the image, with one detail, then another, clamoring for attention. This can be true even when there is a predominant image.

Grooms made two prints which enlarge upon the exalted whimsy of *Shoot the Moon's* top-hatted eminences. *Self-Portrait in a Crowd* (1962, published in 1964) was Grooms's first etching and his first print commission. It depicts a man wearing a stove-pipe hat, hurrying through a crowded street scene, with activity everywhere within the frame, from the ghoulish countenance at the top left to a little dog scurrying along the pavement. A drypoint from 1963, *Parade in Top Hat City*, pulls back for a view that encompasses brick buildings near and far, all peopled by men in top hats, with a parade of more top-hatted men marching into the distance under a darkly-etched helium balloon. Leaning in from the right is the star of the show, a young man with spiky hair, doffing a prominent, dark, top hat. He could be the same figure rushing through *Self-Portrait in a Crowd*. These are early examples of Grooms's predilection for inserting images of himself into scenes, whether they be imaginary ones such as these or even, anachronistically, historical or art-historical scenes.

In time, Grooms would come to look upon prints as a way of reaching a wide audience. For the present, he concentrated on his three-dimensional

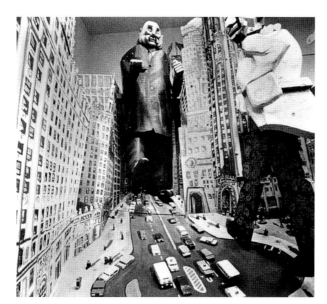

Red Grooms, City of Chicago *(detail), 1968, mixed-media installation, approximately 8 × 6 × 4′. Photo by Jonas Davadenas.*

work, which kept getting bigger and more environmental until his *City of Chicago* installation of 1968 finally established him as a major artist some ten years after his arrival on the art scene. He made prints sporadically, developing a reduced graphic sensibility, with simplified color and blunt outlines, as in *Mayan Self-Portrait* (1966), *Mayan with Cigarette* (1966), and *The Philosopher* (1966). Perhaps his most significant graphic productions of the 1960s were the posters and flyers he ran off as announcements for his exhibitions at the Tibor de Nagy Gallery. Large for their time, modeled on movie posters, they were gaudy and ambitious statements, often mixing media. As in the films he continued to make (where Grooms would frequently combine live footage with animation) so in these lively posters he would interweave photographic and drawn imagery.

Expressionism of the German and American varieties was also influential on Grooms's graphic style. The variable perspectives of his cityscapes recall German Expressionist films, but it is in fact closer to home that we find more apt graphic parallels—in the prints of John Marin, for one. In 1913, Alfred Stieglitz published a Marin suite entitled *Six New York Etchings.* Marin's *Brooklyn Bridge* and *Woolworth Building No. 2* take as subjects architectural monuments Grooms would tackle in his defining *Ruckus Manhattan* installation of 1975. Marin's treatment presages Grooms's in its skewed angles that evoke the city's tumult.

Observation and categorization of urban types in public spaces has a long history within fine art, at first marginalized, then gradually accepted. William Hogarth in the 18th century made engravings of fanciful theatrical scenes, as well as his more famous moralistic sequences. In the 19th century,

Right: John Marin, Brooklyn Bridge, *1913, etching, 11¼ × 8¾″. Philadelphia Museum of Art, The Alfred Stieglitz Collection.*

Far right: John Marin, Woolworth Building, New York, *No. 2, 1913, etching, 13 × 10½″. Philadelphia Museum of Art, The Alfred Stieglitz Collection.*

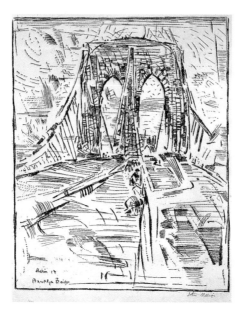

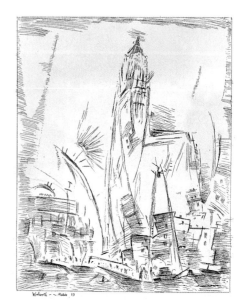

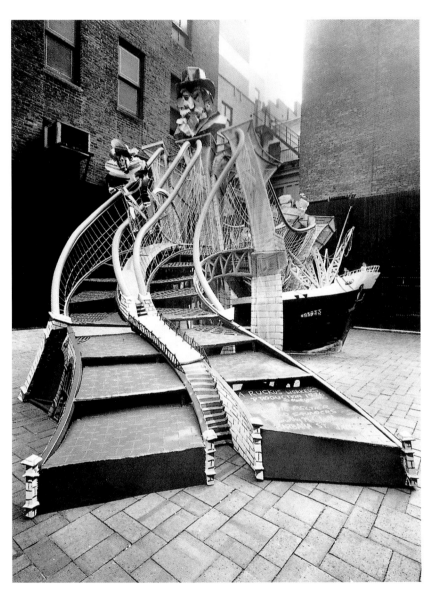

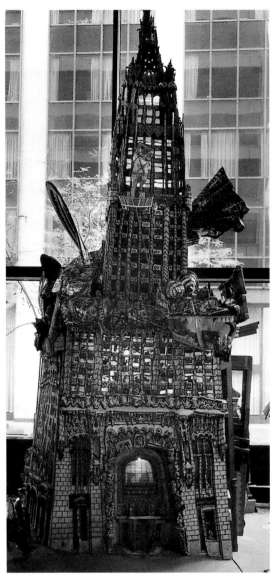

Red Grooms, Brooklyn Bridge from
Ruckus Manhattan, *1975, mixed-
media installation, 16 × 12 × 31'. Photo
courtesy Marlborough, New York.*

Red Grooms, Woolworth Building from
Ruckus Manhattan, *1975, mixed-media
installation, 17 × 14 × 15'. Photo courtesy
Marlborough, New York.*

Honoré Daumier used the recently invented lithography technique as a means of mass communication. His political caricatures were published in popular magazines, but he also made paintings and watercolors based on observation of Parisian types. Baudelaire considered him on a par with Ingres and Delacroix as a draughtsman.

Both Hogarth and Daumier, like Grooms, had limited formal education and worked professionally as artists from an early age. The same could be said of another graphic precursor to Grooms, Reginald Marsh. Although he studied at Yale, Marsh got his real education after moving to New York, working as an illustrator for *Vanity Fair, Harper's Bazaar, The Daily News,* and *The New Yorker.* He drew people on the subway, making prints like the linocut *Subway Car* (1921) and the etching *Third Avenue El* (1931). Daumier, too, in his *Types Parisiens* series, had done an interior of a bus which featured a pretty girl wedged between a drunk and a butcher.

In his book on Marsh's prints, Norman Sasowsky points out that, while he always carried a pocket sketchbook and also made watercolors and took photographs of subjects that interested him, Marsh did not normally use these studies as actual material for his prints, preferring instead to rely on his imagination to mold his observed material into a new reality.[2] Red Grooms also tends to have a sketchbook near at hand and is wont to take down several versions of a scene in rapid succession. When he comes to make a print or painting, however, he too prefers not to be limited to his sketched observations. Grooms goes much farther than Marsh, creating fantastic scenes wholly free from naturalistic constraints such as perspective and the laws of gravity.

Below, left: William Hogarth, Southwark Fair, *1733, engraving, 13½ × 17¹³⁄₁₆″. Print Collection, Miriam and Ira D. Wallach Division of Art, Prints and Photographs, The New York Public Library, Astor, Lenox, and Tilden Foundations.*

Below, right: William Hogarth, Strolling Actresses Dressing in a Barn, *1738, engraving, 16¾ × 21¼″. Print Collection, Miriam and Ira D. Wallach Division of Art, Prints and Photographs, The New York Public Library, Astor, Lenox, and Tilden Foundations.*

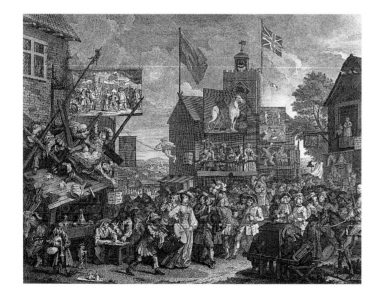

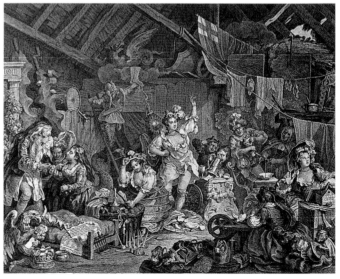

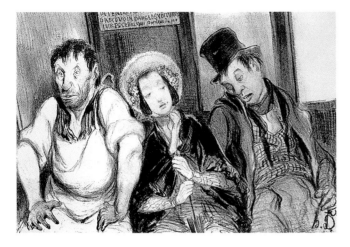

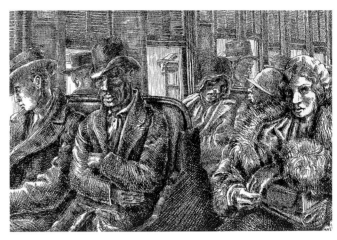

Above, left: Honoré Daumier, Intérieur d'un Omnibus Entre un Homme Ivre et un Charcutier, 1839, lithograph, 6½ × 9¾". Print Collection, Ira D. Wallach Division of Art, Prints and Photographs, The New York Public Library, Astor, Lenox, and Tilden Foundations.

Above, right: Reginald Marsh, Third Avenue El, 1931, etching, 6 × 9". Print Collection, Ira D. Wallach Division of Art, Prints and Photographs, The New York Public Library, Astor, Lenox, and Tilden Foundations.

By the late 1960s, Grooms had developed graphic mastery and was moving rapidly toward his mature style. To achieve it, he needed to plunge headfirst into the actual chaos of the city, to move beyond the polite but somewhat adolescent fantasies of early images such as *Parade in Top Hat City*. The first clear step in the direction that would ultimately lead to a masterpiece such as *Ruckus Manhattan* was *Patriot's Parade*, the artist's first lithograph, which he published himself in an edition of 25 in 1967. Quite unlike the storybook air of his earlier parade, which floated gaily into the distance, this parade makes a full frontal attack on the viewer. To complement its savage subject matter—the violent fervor of pro-war demonstrators—Grooms created an apocalyptic, shifting scene, in which scale is rudely abused. Larger heads lie frighteningly behind smaller ones, a tiny baby disappears beneath the sole of an enormous shoe, and a relentless filling-in of space adds up to a suffocating feeling that there is no escape. A grimacing, jut-jawed policeman raises a billy club, about to bring it down on an already vanquished peace protester, and in the upper right corner of the print, under a sign reading "NAPALM EM ALL," a group of paraders marches toward us in stars-and-stripes top hats, and we realize with a sigh that our innocence has ended, that those funny, top-hatted loonies of our youth have retreated to the realm of childhood memories, to be replaced by a reality which, although repellent, can also be energizing.

2. Nervous City

"We want a poem to be beautiful," wrote W. H. Auden, "that is to say, a verbal earthly paradise, a timeless world of pure play. At the same time, we want a poem to be true, to provide us with some kind of revelation about our life, and a poet cannot bring us any truth without introducing the problematic, the painful, the disorderly, the ugly." Grooms mastered early on Auden's "timeless world of pure play." Before he could move beyond the realm of the merely titillating and become a major artist, he needed to add layers of

complexity to his pictures. This he accomplished by introducing the disorderly and ugly. If his subject was to be the city and its denizens, its characterization had to be as complete as possible.

Grooms studied first in Chicago, then in New York. His first major installation was *City of Chicago* (1968); later, he made *Ruckus Manhattan* (1975). Perhaps by coincidence—or perhaps by instinct—he always tackled the Second City before going to the capital. The same is true of his mature print work. In 1970, he was asked to take part in a portfolio of Chicago artists entitled *76 artists—78 prints*. Grooms's participation was his first silkscreen, printed on glossy poster paper. Its official title is *Manic Pal Co. Mix,* but a close look at the print reveals the heading actually reads "MANICIPAL CO-MIX," a Groomsian verbal transformation of "Municipal Comics." Language in Grooms's prints often functions as a tongue-in-cheek commentary, while at the same time allowing the potential for confusion, as in this case. Both phrases have relevance, as the image is definitely a mix, an all-over stew of Chicago images, and also humorous, as Grooms, again affirming his appreciation of comic books, gives disaster an approachable spin.

Manic Pal Co. Mix is a direct precursor to Grooms's first major prints, *Nervous City* (1971) and the *No Gas* portfolio (1971), which move to New York for their settings. The Chicago print includes in its margin a wailing firetruck with the comic-book style sound effect "AHRRR," an image which would reappear in *No Gas*. It also settles on certain urban types (the fashionable young lady, the crude cop, the hippie, the porn shop habitués) which would become staples in Grooms's work. The setting too—a public place complete with garbage and sewer systems—would soon become a constant.

Nervous City, a color lithograph printed by Mauro Giuffrida at Bank Street Atelier in New York, was Grooms's first chance to work in a professional print studio. The difference is unmistakable, not only in the wonderfully enhanced richness of tones that lithography allows, but also in the controlled composition, in which each figure stands out vividly while simultaneously adding to a powerfully chaotic compositional whole. While it contains many of the elements from *Manic Pal Co. Mix,* and it continues scalar distortions like those in *Patriot's Parade, Nervous City* clarifies such details as the rats scurrying along the sidewalk, a man's bloodied face, and a leering man injecting a hypodermic needle into the central figure. This female figure is shocking both in the graphic evidence of the abuse she has suffered and also in her current violation, which is the central image of the print. While *Nervous City* has greater buoyancy in its actual execution than *Manic Pal Co. Mix,* its picture of humanity is more explicit and grimmer.

Grooms's particular achievement during this period was that of taking a hard look at urban life and showing what he saw there, while not sinking into cynicism or indulging in facile social commentary. In his

Red Grooms, Subway Car
(detail) from Ruckus Manhattan,
1975, mixed-media installation,
5 × 12 × 4'. Photo courtesy
Marlborough, New York.

graphic work, he was developing the vision that would enable him to conceive of *Ruckus Manhattan's* various elements and connect them. In his *No Gas* portfolio of lithographs, while maintaining graphic interest in every part of an image, Grooms moved away from the visual cacophony of *Nervous City* toward dominant, central, images. The fire truck which appeared in *Manic Pal Co. Mix's* margin is now the main subject of the print *Aarrrrrhh.* The rat which skirted the bottom of *Nervous City* looms large in *Rat.* A haggard, unshaven figure hovers over a huge coffee cup in *No Gas Café,* while an outrageous floozy gets center stage in *Taxi Pretzel.* The image that looks forward most directly to *Ruckus Manhattan,* while winking backward at Marsh and Daumier, is *Local,* a subway interior with a gaggle of extreme characters who will be developed three dimensionally in the life-size subway car of *Ruckus Manhattan.*

Nervous City marked the first time Grooms allowed sexually explicit subject matter into his work in any medium. It may have had to do with his belief that printmaking could provide an avenue to a wider audience where filmmaking had not. As Grooms describes it, "I don't know where my raunch comes from exactly. We were like the anti-raunch, when we did *Shoot the Moon.* We were like these Boy Scouts, doing this movie that had zero sex appeal. I think that raunch was part of my equation to some sort of modernism. I suppose I thought that if I could be out there on the raunch level I could get to some kind of edge."

In the early 1970s, Grooms began working with professional printmakers in a variety of techniques. 1976 was a watershed year for Grooms's printmaking; he produced 22 editions, including the two versions of *Picasso Goes to Heaven.* This image had started as a 15 × 16 foot painting on paper in response to the news of Picasso's death in 1973. With the onslaught of the *Ruckus Manhattan* project, Grooms had to leave the Picasso painting unfinished. He made two marvelous prints of the image upon resurfacing from *Ruckus Manhattan* in 1976. After completing that 6,400-square-foot installation, Grooms relished the opportunity to work alone, and prints provided that opportunity. One of the first he did was the lithograph *Matisse,* a detailed and faithful rendering of a famous Brassai photograph of Matisse drawing a nude.

The most significant body of prints Grooms made during the 1970s were the etchings printed by Jennifer Melby. The majority of them continue the sexual undercurrent that first surfaced in *Nervous City.* Two prints of 1976, *Manet/Romance* and *Heads Up D.H.,* extend a complexity of grounds first encountered in *Manic Pal Co. Mix.* In these images, vastly

different scales and worlds overlap with a gyrating intensity that prevents the eye or mind from stopping until it has left the image. Included in the mix in both cases are images of a sexual nature. In *Heads Up D.H.,* in particular, one notices, next to the pensive figure of Lawrence himself, a dominatrix with studded collar and whip. The artists named in the titles figure in both images, and the effect is that of a psychosexual whirl, reflecting someone's inner fears and desires, accentuated by the fact that there is no realistic ground for the eye to settle on.

For the suite *Nineteenth-Century Artists,* Grooms's first and most extensive set of etchings, he was able to delight in the pure power of black line on paper. The prints vary in technique from the openness of *Baudelaire,* with its expanses of untouched paper, to the dense aquatints in *Guys* and *Degas.* In all the prints, an air of erotic play parallels Grooms's carefree speed and wit with line. In terms of subject matter, these prints are different from the gloomy and dense grounds of *Manet/Romance* and *Heads Up D.H.* Rodin frolics in his studio in a pair of women's boots. Bazille looks at us over the shoulder of a corsetted model, his brushes and palette fallen in disarray, while his naked posterior points upward at an improbable angle. *Nadar* reprises imagery from the early *Parade in Top Hat City,* with the difference that now, instead of watching a balloon float away in the distance, we have a close-up view of the top-hatted photographer in the balloon, engaging in champagne-fueled revelry high above Paris.

Rrose Selavy (1980), the last print Grooms would do with Melby, takes up this theme of sexual subplots for famous artists, this time directly referencing a famous photograph by Man Ray of Marcel Duchamp dressed as a woman. A sexual tension also underlies a silkscreen Grooms produced in 1978 with Chromacomp, Inc., entitled *You Can Have a Body Like Mine.* The overlapping of semi-nude male bodies with those of fully clothed women gives the impression, again, of men in women's clothing. Cross-dressing in Grooms's prints, and other sexual themes, are never the entire subject of a print. Rather, they provide visual excitement which, in the case of *You Can Have a Body Like Mine,* is engendered also by the punchy red background, the abrupt shifts of scale, and the fleet of green cars that careens across the upper portion of the print.

In 1979, Grooms went to Minneapolis to work with Steve Andersen, whose operation was then called Vermillion Editions and is now Akasha Studio. Andersen was a skilled printer of silkscreen, lithography, and woodcut, who liked to combine multiple techniques in one project. In ten working days, Grooms and Andersen initiated about ten projects. The results of printmaking, especially in the spontaneous way Grooms engages in it, depend to a great extent upon the personal interaction between artist and printer. "Steve is a guy who has no qualms about using the most

elaborate approach," Grooms relates. "To get the work the way it should be, the way the artist wants it to be, he will bend over backwards without any concern for time or expense. He's very good at improvising and picking up in any which way the thing lands."

They conceived of a portfolio to be entitled *Sex in the Midwest* and prepared the lithographic stones. Ultimately, however, prints were issued separately, not as a portfolio. The first two to appear were *Lorna Doone* (1980), a large print on two sheets featuring a New Wave girl in a leopard-skin jumpsuit lounging in a Midwestern field, and *The Tattoo Artist* (1981), which shows a redheaded man, naked except for ladies' stockings, garter, and stiletto heels, getting a tattoo from a similarly dressed lady. A much more intricate piece, *Pancake Eater,* was editioned in 1981. It started as a simple lithograph, but as Grooms had already produced two fully three-dimensional prints by then, he and Andersen decided to give this one a more lavish treatment as well. It ended up being a three-dimensional box depicting a house, with a Mylar sheet printed with silkscreen images of a whip, boots, and lace curtains. Then came a standard vinyl window shade, on which was silkscreened a silhouetted image of a lady with a whip and two slaves. After one lifts the shade, one finally gets to see the lithograph, which shows the eponymous pancake eater, an elderly lady, fully dressed, being served by two young bare-chested men in collars and chains.

Two lithographs from *Sex in the Midwest* were editioned only very recently, although they were part of the original group whose stones were drawn in 1979. *Rosie's Closet* was published in 1997, and the *Sex in the Midwest* title sheet was published in 1998. Times have changed, and alterations to these two images prove the social climate is not as tolerant in the 1990s as it was in the 1970s. *Rosie's Closet* is a charming, rather large print, depicting two women engaged in a game of doctor in a closet filled with hats, shoes, a Clue gameboard, and a toy railroad train (a phallic image Grooms had already used in *Heads Up D.H.*). There is nothing vulgar about the image, and the expression of the woman facing us is one of Grooms's most delicate evocations of female beauty. However, it was determined that the stethoscope placed over her frontally exposed vagina was too disturbing an image, and for the 1997 version a collaged panty has been inserted. The revision for *Sex in the Midwest,* originally meant to be glued onto a portfolio cover, is even more direct. Across the mid-section of a naked couple embracing in front of an open window, a large black bar has been silkscreened with the word "CENSORED." Two other images remain uneditioned, while an additional two stones have been destroyed.

In the 1980s, Grooms would move into a new phase, dominated by three-dimensional prints and images from modern art history. Grooms would treat the city again, but it would not be the New York of *Nervous*

City. In 1983, in the serigraph *Saskia Down the Metro,* Grooms even referenced his own work, including seated figures taken from his subway installation in *Ruckus Manhattan.* While the print is graphically interesting, it has an air of nostalgia about it. Danger has been modulated. Grooms's period of sexually explicit subject matter had also come to an end.

3. Making History

After the early linocut *Five Futurists* (1958), which both played on re-creating photographic imagery in a hand-done technique and referred to a group of real, historical artists, we have to wait until the mid-1970s before encountering Grooms's next prints of historical subjects. The overwhelming number of artists Grooms has chosen to depict are French, indicating that French modernism is a leading source of his inspiration. *Picasso Goes to Heaven* (etching and pochoir, 1976, color and black-and-white versions) is a complicated image. As Picasso rises on a swing, he is surrounded by a coterie of artist-associates, including the Douanier Rousseau, Gertrude Stein, Cézanne, Stravinsky, Apollinaire, Braque, Marie Laurencin, Max Jacob, Matisse, Diaghilev, and Nijinsky. True to Grooms's form, he complements these contemporaneous personalities with figures from Picasso's paintings and a group of old masters.

The only large-scale woodcut Grooms has ever done, and his largest print in any medium, is *The Existentialist* (1984, 72¼ × 42″), published by the Experimental Workshop in San Francisco.[3] The subject is Alberto Giacometti, whom Grooms remembers seeing in Paris in 1960. He evoked the same postwar Parisian ambiance in *Les Deux Magots* (1985, published in 1987), which emerged from his first session with the master French etcher Aldo Crommelynck, who printed extensively for Picasso. The Deux Magots was an important meeting place for many of the people featured in the print. The actual combination of all these personages at one time—not to mention the spatial distortions that enable Grooms to show everybody simultaneously—sprang directly from the imagination of Red Grooms. The scene, which comes with a legend identifying Brassai, Giacometti, Camus, Françoise Gilot, Prévert, Juliette Greco, Cocteau, Sartre, and Simone de Beauvoir, among others, was the result of a research effort not uncommon for Grooms, carried out this time by Grooms's wife, Lysiane Luong, and her Parisian family.

In 1988, Grooms made a color lithograph entitled *Van Gogh with Sunflowers,* printed by Bud Shark, with whom Grooms began working in 1981. Grooms's masterful drawing technique is well-suited to lithography, and in this print his sequential marks pay homage to one of Van Gogh's techniques. Another color lithograph from Shark is Grooms's *Matisse in Nice* (1992), a good-sized (22¼ × 30″) interior showing Matisse painting a nude. With only eight colors, artist and printer have created the impression of a rich panoply of tones. The bravura performance of Grooms's

drawing in the two paintings within the print, the letter on the coffee table, and other details is matched by the precise application of tones.

From the School of Paris, Grooms moved to the New York School, developing unusual techniques in emulation of the formal inventiveness of its artists. He made *De Kooning Breaks Through* (1987) and *Jackson in Action* (1997), two three-dimensional prints done with Bud Shark; *Elaine de Kooning at the Cedar Bar* (1991), a stratograph printed by Joe Wilfer; and *The Cedar Bar* (1987), an offset lithograph printed by Maurice Sanchez and Joe Petruzelli of Derrière L'Etoile Studios. This last piece is based on a photograph of a large maquette Grooms made of the famous bar where artists congregated in the 1950s. One can make out De Kooning, Pollock, Guston, Rothko, and Newman. Following his predilection for mixing media, Grooms made new drawings of Mike Kanemitsu, Theodore Stamos, and others, which were printed together with the photographic image of the maquette, creating a juxtaposition of esthetic realities, and an abrupt juncture between background and foreground.

Grooms has also made prints that have contemporary artists as their subjects. During his great homage to *Nineteenth-Century Artists* in 1976, Grooms felt moved to include his friend Rudy Burckhardt in the series and made the etching *Rudy Burckhardt as a Nineteenth-Century Artist*. Since Burckhardt was born in 1914 and exuded old world charm, it did not seem like such a stretch. Two prints from 1980, which combine etching and aquatint, feature contemporary realist painter Jack Beal. They are *Jack Beal Watching Super Bowl XIV* and *Dallas 14, Jack 6*.

Into this sprawling and ever-expanding set of heroes and superheroes, Grooms has often insinuated himself, a red-headed figure in the background. He has also made self-portraits in different print media, going back to *Self-Portrait in a Crowd*. More recent examples include *Self-Portrait with Mickey Mouse* (1976), a harrowing, crudely hatched view of the man who had just finished running the marathon of making *Ruckus Manhattan*. *Red Grooms, Martin Wiley Gallery* (1978) goes back to the gallery posters he did in the 1960s, combining photographic and drawn images. *Self-Portrait with Liz* (1982) is a look in the mirror, based on a watercolor, while *Red Grooms Drawing David Saunders Drawing Red Grooms* (1983) is a conceptual lithograph, featuring Grooms and his former assistant, artist David Saunders, shifted to different perspective axes within the same print.

Increasingly, in the 1980s and 1990s, Grooms would look to technical challenges as a motivating factor, while constantly mining his fascination with historical figures and the question of the artist's own position as a practitioner of traditional and untraditional artworks. He no longer seems affected by the danger the city may provoke. From a calmer, more worldly point of view, the artist gazes upon eternity and smiles.

4. Three-Dimensional Prints?

How did Grooms ever arrive at the idea of bringing the staid, stable, two-dimensional print into the arena of sculpture and pop-up books? "When I was a kid," he notes, "I used to make model airplanes out of paper. I got them in a kit which contained a simple page, a flat sheet with tabs, and you cut them out and glued them together. Actually, old toys were made exactly like these three-dimensional prints. They were printed on tin sheets and then cut out and assembled."

The immediate impetus for the three-dimensional prints were paper sculptures Grooms made in the early 1970s using a hot glue gun. Grooms is naturally attracted to a sculptural aesthetic. He also likes to combine media, blurring traditional distinctions. In that sense, his extensive foray into three-dimensional printmaking is akin to the Cubists' modernist innovation with collage. In both cases, a conceptual development from technical experimentation led to a new form. Grooms's first attempt to go beyond the flat sheet in printmaking was in the lithograph *Aarrrrrrhh* from the *No Gas* portfolio, which includes a fire truck that folds away from the surface of the print. His first fully three-dimensional print, however, was *Gertrude,* printed by Mauro Giuffrida at Circle Workshop in 1975, two years after his discovery of the glue gun. *Gertrude* was composed like a tab toy, printed on a flat sheet, with sections to be cut out and tabs to be inserted.

When Grooms next wanted to do three-dimensional prints, he turned to Steve Andersen. Their first three-dimensional piece was *Peking Delight* (1979), a wall piece like *Gertrude,* as opposed to some later three-dimensional prints, which are free-standing and can be seen from all sides. *Peking Delight* is hand-painted and printed in 21 colors, using pochoir stencils, silk screens, and rubber stamps. Unlike *Gertrude,* it is made of wood, to which the colors have been applied. Grooms and Andersen then made *Dali Salad* (1980) in two slightly different versions. *Dali Salad* bears the mark of Steve Andersen's careful complexity, combining lithograph and silkscreen on two types of paper and vinyl, with Ping-Pong balls for the eyes. The hair is simple black Arches paper cut to Grooms's specifications. The mustache is painted aluminum.

Grooms and Andersen have recently teamed up on another blockbuster, *Katherine, Marcel, and the Bride* (1998), which depicts, three-dimensionally, the home of Katherine Dreier, the famous collector, with artworks by Brancusi, Duchamp, and Léger. This time, 130 separately editioned colors were silkscreened onto an elaborate support structure of board, cut by laser and assembled by hand. It took

Red Grooms with his three-dimensional lithograph Gertrude, *1975. Photo courtesy Brooke Alexander.*

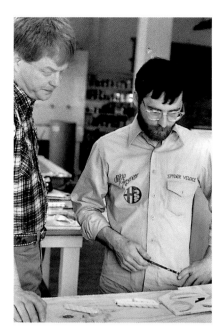

Red Grooms with Steve Andersen at Vermillion Editions, Minneapolis, Minnesota, 1979, working on the three-dimensional print Peking Delight. *Photo courtesy Vermillion.*

over four years to complete and is yet another example of Grooms's love of theatrics and showmanship.

In 1981, Grooms made his first print with Bud Shark, a lithographer who also works in woodcut, marking the beginning of what has become Grooms's most prolific relationship with a printer. Grooms's first print with Shark, *Mountaintime* (1981), although not fully three-dimensional, already contained paper and string additions that took it beyond a simple flat sheet. The following year, they made their first three-dimensional print, *Ruckus Taxi* (1982). Grooms's first free-standing print, it comes in a Plexiglas box and can be viewed from all sides. With only five colors, they managed to capture the excitement of Grooms's early city work and reference a huge walk-in taxi created for a revival of *Ruckus Manhattan*.

Among their other three-dimensional prints, Grooms and Shark, who co-publish many of their efforts, have done a bullfight, a cut-away subway train, and a basketball player, who rises high above everyone else in the scene to dunk the ball. Then there is the remarkable *De Kooning Breaks Through* (1987). Its conceit is to have the artist physically breaking through his canvas of *Woman and Bicycle* by riding a bicycle through it, thereby making literal his smashing of the prohibition among Abstract Expressionist painters against painting illusionistically (or "penetrating the picture plane").

The most spectacular three-dimensional prints by Grooms and Shark are three of artists. *South Sea Sonata* (1992) shows Paul Gauguin making an ink drawing in Tahiti. The artist's large head dominates the scene, a little ponderously, while a two-dimensional backdrop reveals women in the back of a grass shack. The relationship of head to body to room is more lively in the recent *Picasso* (1997). In this piece and another from the same year, *Jackson in Action* (1997), Grooms has reached a new level of execution. *Picasso* uses only six colors, printed on two sheets from ten plates, and comes away with astonishing details such as the lighted cigarette, the owl

Bud Shark with Red Grooms at Shark's Incorporated, Ltd., Boulder, Colorado, 1997, with the three-dimensional lithograph Jackson in Action *in progress. Photo courtesy Shark's.*

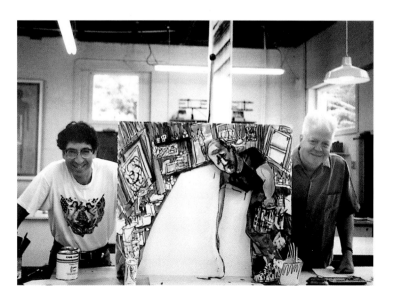

sculpture, and the mandolins and paintings hanging on the wall. The relationship between the body of Picasso and the background is perfect. The same is true in *Jackson in Action,* despite a much higher degree of compression. The latter image includes the stop-frame effect of Pollock in different positions with dripping paint and actual paper versions of those famous skeins. The figures of Lee Krasner in the doorway and Rudy Burckhardt photographing Pollock round out this terrific scene that draws upon the energy that inspired the Happenings.

5. Collaboration

The work of a master printer is identifiable from artist to artist. When an artist is happy with a print, he signs it. The story of printmaking is the story of people working together to achieve a common end. Red Grooms has relied on collaboration since early in his career, first in performances, then films, then in huge installations, and also in prints. As Grooms has pointed out, the chemistry between an artist and a printer will determine what types of projects they will undertake together. One printer will encourage outrageous subject matter. Another will propose a new technique. Another will give plates to the artist to take home and do with whatever he will.

Chromacomp, Inc., was a silkscreen printer Grooms worked with from 1971 to 1978. They produced some of Grooms's most vibrant prints, including *Mango Mango* (1973), *Bicentennial Bandwagon* (1975, published in 1976), and *You Can Have a Body Like Mine* (1978). For the first two prints, Grooms, wanting to expand technical possibilities, made maquettes using cut-out pieces of brightly colored paper. Its effect is apparent in the floral patterns on the woman's dress in *Mango Mango* and a squared-off quality to the lines. *Mango Mango* was a large print for the time at 40 × 28¾″. *Bicentennial Bandwagon* is only 26½ × 34¾″, but it seems larger because of the graphic punch it packs, partially as a result of the cut-paper technique and partially because the print is a compressed version of its maquette, which was about twice its size. Echoing the cut-paper original, the figures seem to be two-dimensional, freestanding cut-outs, with the grass behind them a flat, as in a stage set, and the active sky a further backdrop. The print gains much of its dynamism from the baroque nuance of detail, reminiscent of Grooms's New York City street scenes. There are hints of the sexuality we have observed in other Grooms prints from this period in the phallic red rockets bursting and the outrageous platform pumps worn by the bearded figure (presumably male) riding a big-wheel bicycle across an impossible tightrope, suspended from a bamboo pole and a detached architectural dome. The vehicle on which all this activity takes place is a faithful if improvised version of a circus bandwagon, an

example of how Grooms combines historical accuracy with ludic fancy.

Grooms did 27 prints with Jennifer Melby from 1973 to 1980, most of them black-and-white etchings, some with aquatint. One of their later pieces, *Coney Island* (1978), was an aquatint in four colors. It is the only print in which Grooms has taken on the locale that so appealed to Reginald Marsh, who reveled in the Baroque quality of the place "where a million near-naked bodies could be seen at once, a phenomenon unparalleled in history." Grooms was more attracted to the carnival atmosphere. He had tackled the subject before in the cover art he did for Richard Snow's poetry book *The Funny Place* (Adventures in Poetry, 1973). There, he had been in the thick of his *Nervous City* mode and drew a dense tableau of disparate types jammed together in suffocating proximity. For the print *Coney Island,* Grooms went back to the overlapping grounds he had realized in *Manet/Romance* and *Heads Up D.H.* and gave them a whirlpool figuration, inspired by rides at the amusement park.

In the early 1980s, Grooms made three silkscreens with Alexander Heinrici. For *Fred and Ginger* (1982), Heinrici gave Grooms a special paint that would adhere to clear plastic Mylar, enabling Grooms to make the color separations himself, which he found liberating: "That was good because I could get out of this trap where the print is a reproduction of a work. In lithography, it's so hands-on; you're actually drawing on the

The Funny Place, *poems by Richard Snow, cover by Red Grooms, Adventures in Poetry, 1973. Collection of Walter G. Knestrick.*

stones or plates and doing the color separations yourself. That's going to have an immediate effect that's different from when somebody does a reproduction of a work, which was usually the case with silkscreen." Grooms also used the Mylar on his next print with Heinrici, *Franklin's Reception at the Court of France* (1982), drawing with pencil and bamboo pen. These prints have a lively appeal similar to that of *Bicentennial Bandwagon,* even though they were arrived at differently.

After working with Aldo Crommelynck in Paris in 1985, Grooms looked forward to another chance, which arose when Crommelynck had a studio in New York in the 1990s. They did a series of eight etchings with aquatint based on Grand Central Station, a topical subject since the installation of *Ruckus Manhattan* there in 1993. Their major effort was a rich-toned color etching, *Main Concourse Terminal, Grand Central Station* (1994). They also did a set of six smaller etchings on related subjects. In one, we see the master printer Crommelynck at work, a thickly outlined form sketching with a compass on an etching plate to describe the precise arc of the Main Concourse ceiling, while in the background an imaginary ruin extends, full of similar arches.

Grooms got to work with Joe Wilfer before Wilfer's untimely death and made two unusual prints, *Elaine de Kooning at the Cedar Bar* (1991) and *A Light Madam* (1992), using Wilfer's stratograph technique of building up paper to form a relief surface similar to a woodblock. Where a woodblock often reveals the texture of the wood, a stratograph reflects the more muted texture it receives from the paper, which suits the darkly lit settings of these subjects.

Epilogue: Marginalia

Printmaking for Grooms began in making gifts for friends. Later, it became a vehicle to disseminate his vision of the city as a site of invigorating chaos. Finally, it provided an opportunity to work with master craftsmen and to align himself with great artists from the past. Recently, he has made prints in the margins of his three-dimensional sheets—marginalia, which he improvises in the print studio. *Liberty Front and Back* (1998), a color woodcut on rice paper no bigger than a postage stamp, has the informality of Grooms's earliest woodcuts. He keeps devising ways to refresh techniques, working at breakneck speed, molding and reshaping the world he sees.

NOTES
1. All quotations of the artist are from interviews with the author during June 1999.
2. *The Prints of Reginald Marsh* by Norman Sasowsky (Clarkson N. Potter, Inc., 1976).
3. All measurements in this essay refer to image size, which may differ from paper size.

The Graphic Work

Section I
Early Prints, 1956–1971

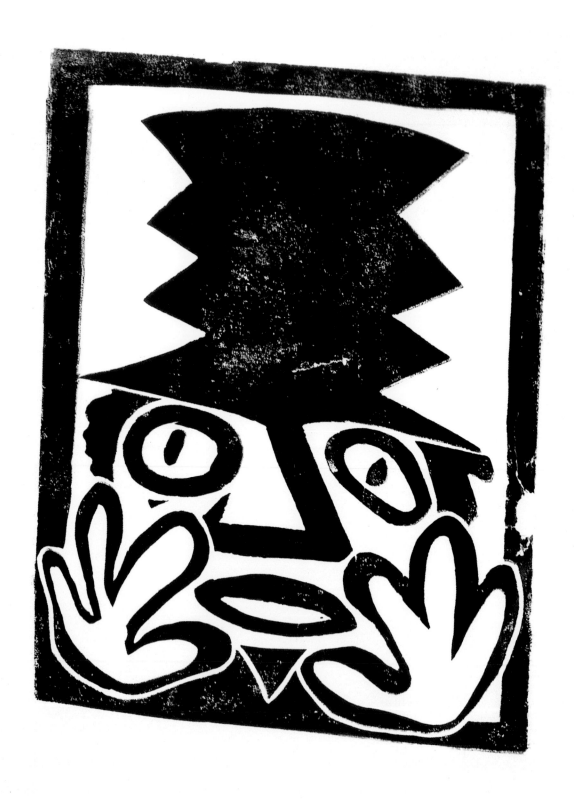

Minstrel, 1956. Linocut 15 × 13″ (38.1 × 33.0 cm). Cat. no. 1.

"In the beginning there were no publishers or master printers or completed editions. There was just the simple desire to see one's image forced out of a block by the insistent pressure of the hand with a spoon. This image, in fact, is the unspecified announcement of a 'show'."

—Red Grooms

Pencil Man, 1958. Metal plate printed on a letter-press, a loose collection of drawings and poems entitled *City* 7 × 5¼″ (17.8 × 13.3 cm). Cat. no. 2.

"A monster child made up of his own scrawls with his big pencil neatly balanced on an ele-phant-like appendage, ready to draw his way out of the maze." —Red Grooms

Black Man, 1958. Metal plate printed on a letter-press, a loose collection of drawings and poems entitled *City* 8 × 6″ (20.3 × 15.2 cm). Cat. no. 3.

"I was in a big city in 1958, liberated from home and enjoying the mystery and presence of strangers. The black man is a special persona. He is my hero." —Red Grooms

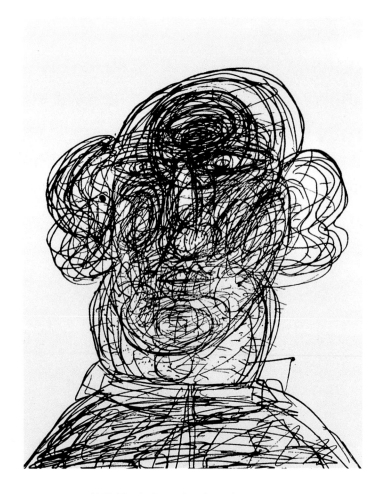

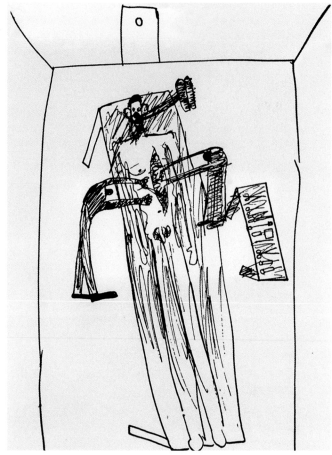

The Doctor, 1958. Metal plate printed on a letter-press, a loose collection of drawings and poems entitled *City* 7¼ × 5¼″ (18.4 × 13.3 cm). Cat. no. 4.

"The doctor, along with the nurse, was a recurring image in my drawings at this time; probably relating to the uncertainty of a new life cut off from home."—Red Grooms

The Operation, 1958. Metal plate printed on a letter-press, a loose collection of drawings and poems entitled *City* 7¼ × 5¼″ (18.4 × 13.3 cm). Cat. no. 5.

"I had been extremely worried about my mother's health just a few years earlier. I had a feeling of the great vulnerability of the human condition and perhaps I was hoping to fix it with surgery."—Red Grooms

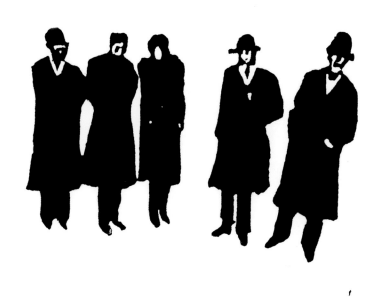

Five Futurists, 1958. Linocut 5 × 8½″ (12.7 × 21.6 cm). Cat. no. 6.

*"This little print may mark the beginning of my infatuation
with the likeness and work of other artists."*—Red Grooms

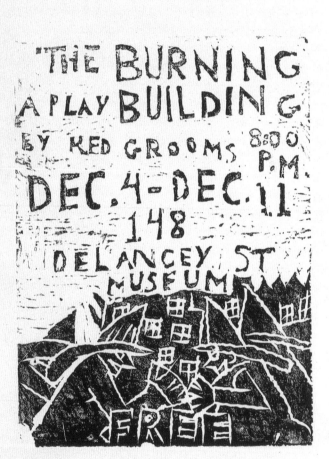

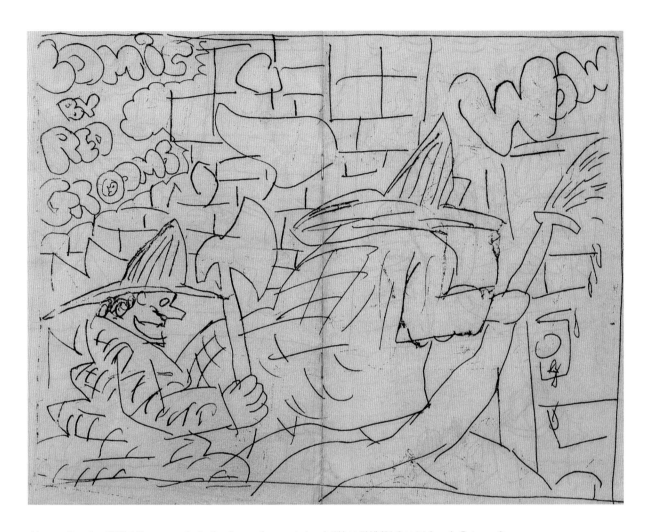

Above: **Comic**, 1959. Mimeograph, in the form of a comic book 8½ × 5½″ (21.6 × 14.0 cm). Cat. no. 8.

"Claes and I had plans to join forces on a street sculpture to be shown at The City Gallery. This never happened. But Oldenburg soon put on his Ray Gun Show at the Judson Gallery. He asked several friends including Jim Dine, Robert Whitman, Dick Higgens, and me to produce a comic book. These little pamphlets were produced on a mimeograph machine located in the basement of the Judson Church."—Red Grooms

Opposite: **The Burning Building**, 1959. Woodcut, 27¾ × 20″ (70.5 × 50.8 cm). Cat. no. 7.

"The 'Show' is coming, the 'Show' is coming, a simple print, the ideal way to announce its arrival."—Red Grooms

43/70 GROOMS

Ruckus, 1961. Linocut 7 × 6″ (17.8 × 15.2 cm). Cat. no. 9.

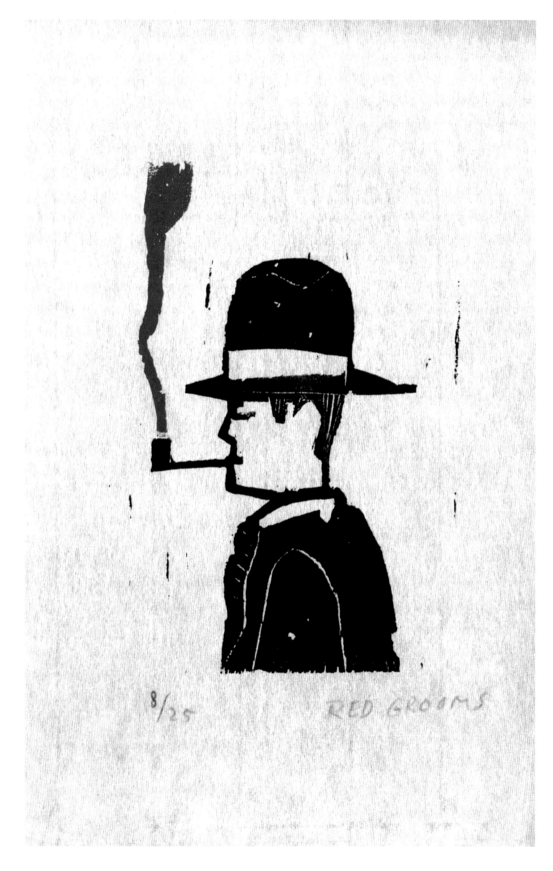

Man with Bowler, 1961. Woodcut 9½ × 6″ (24.1 × 15.2 cm). Cat. no. 10.

*"A man wearing a bowler or top hat was a favorite subject of mine
and appeared often in my early work. These 'chapeaux' reflect my
love of the late nineteenth century."* —Red Grooms

Crucifix, 1962 (begun 1961). Woodcut 11 × 9¾″ (27.9 × 24.8 cm). Cat. no. 11.

"This image has always seemed one of singular power to me. As it is one of the cornerstones of western art, I suppose, that is no wonder."
　　　　　　　　　　　　　　　　　　　　　　—Red Grooms

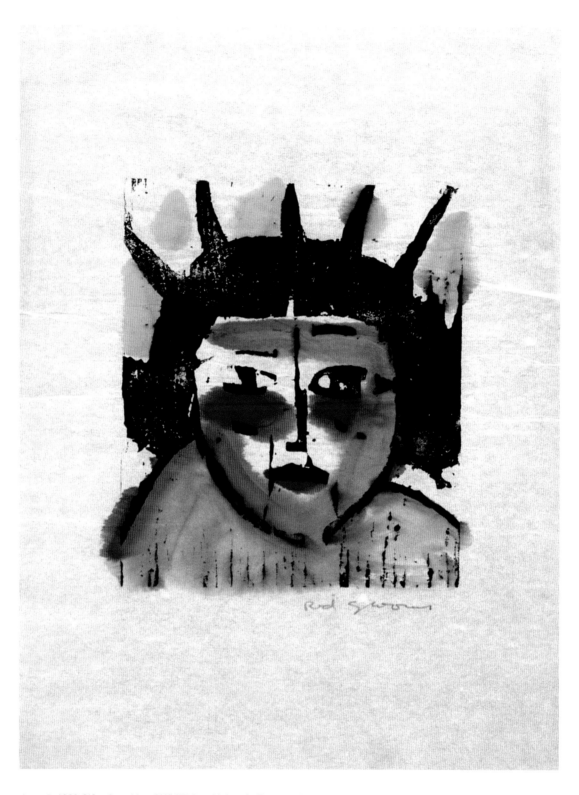

Angel, 1962. Woodcut 11 × 8⅛″ (27.9 × 20.6 cm). Cat. no. 12.

"Sometimes an artist just wants to be sentimental. Angel was one of those times for me."—Red Grooms

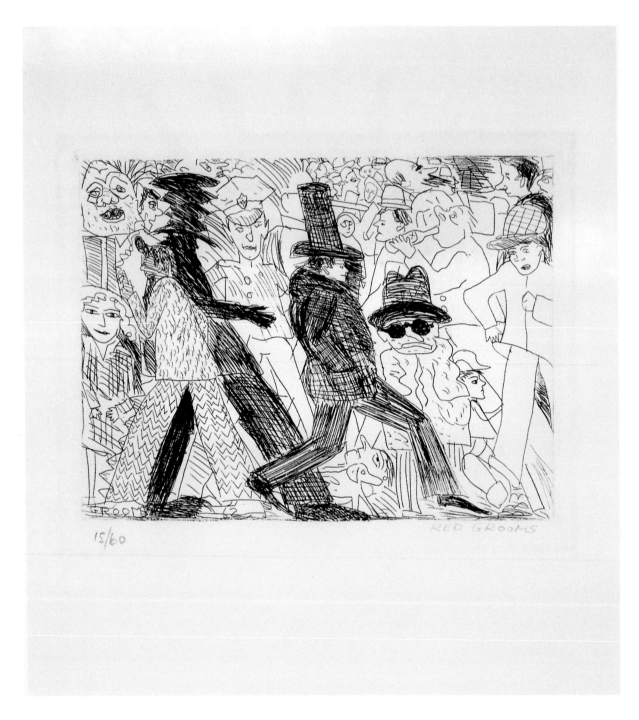

Self-Portrait in a Crowd, 1962 (published in 1964). Etching, from *The International Anthology of Contemporary Engraving, The International Avant-Garde: America Discovered*, Volume 5, 1964, 8½ × 7⅜" (21.6 × 19.4 cm). Cat. no. 13.

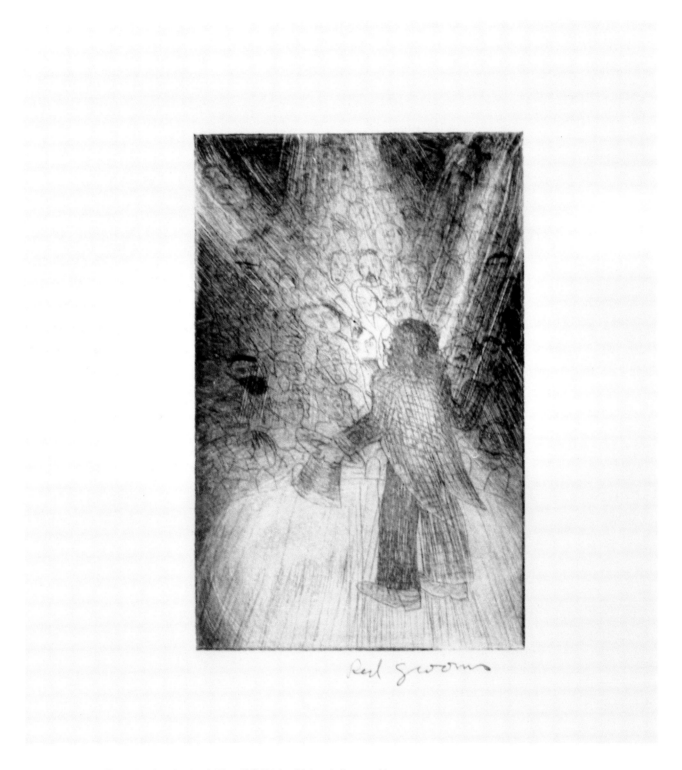

Spotlight, 1963. Drypoint, hand-wiped 9½ × 8¾" (24.1 × 22.2 cm). Cat. no. 14.

"In 1963, an artist, Barbara Erdman, who owned an etching press, invited a small group of friends to evening printmaking sessions on West 24th Street, New York. Spotlight was proofed during one of these gatherings." —Red Grooms

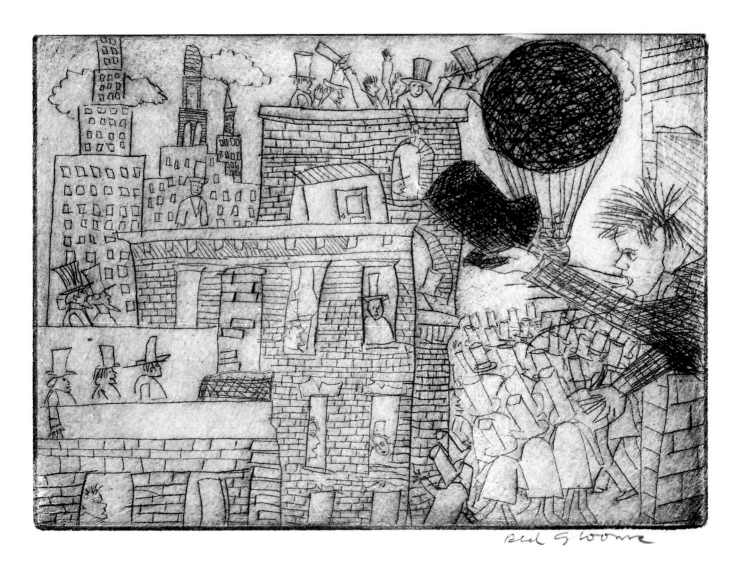

Parade in Top Hat City, 1963. Drypoint 6⅛ × 9½″ (15.6 × 21.6 cm). Cat. no. 15.

"The spirit of this little print relates to the black-and-white film Shoot the Moon, *shot only a few blocks away from Barbara Erdman's loft, at my studio on 26th Street. The film made with Rudy Burckhardt in 1962 is our homage to Jules Verne and Georges Méliès."*—Red Grooms

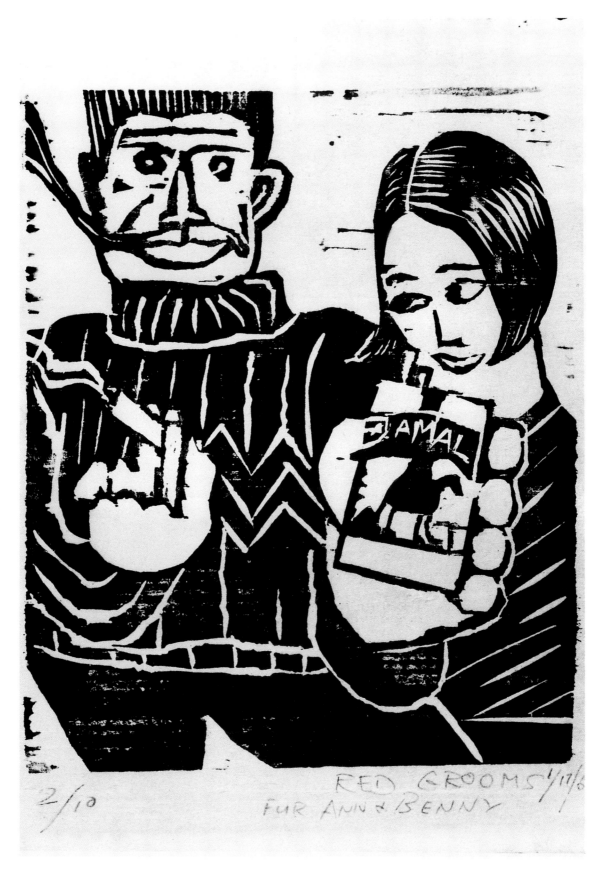

Camal, 1965. Linocut 25 × 18½″ (63.5 × 47.0 cm) irregular. Cat. no. 16.

"I attempted to deal with the powerful influence of 'Pop' in this home-grown emblem of a commercial icon, jokingly misspelling 'Camel'."
—Red Grooms

Mayan Self-Portrait, 1966. Linocut 25 × 18½″ (63.5 × 47.0 cm). Cat. no. 17.

"To achieve full color, I used multiple blocks in registration for the first time. The subject is a self-portrait inspired by Mayan sculpture after a trip to the Yucatan. This was my first full-color print." —Red Grooms

Mayan with Cigarette, 1966. Woodcut 20¾ × 17½" (52.7 × 44.5 cm). Cat. no. 18.

"This portrait of Mimi Gross is a companion piece to Self-Portrait as a Mayan; *I didn't get around to doing the color blocks. Mimi had been doing woodcuts for sometime, including an ambitious Bible series."*
—Red Grooms

The Philosopher, 1966. Woodcut 13 × 9½″ (33.0 × 24.1 cm). Cat. no. 19.

"This one was cut directly from life on New Year's Day and instantly printed." —Red Grooms

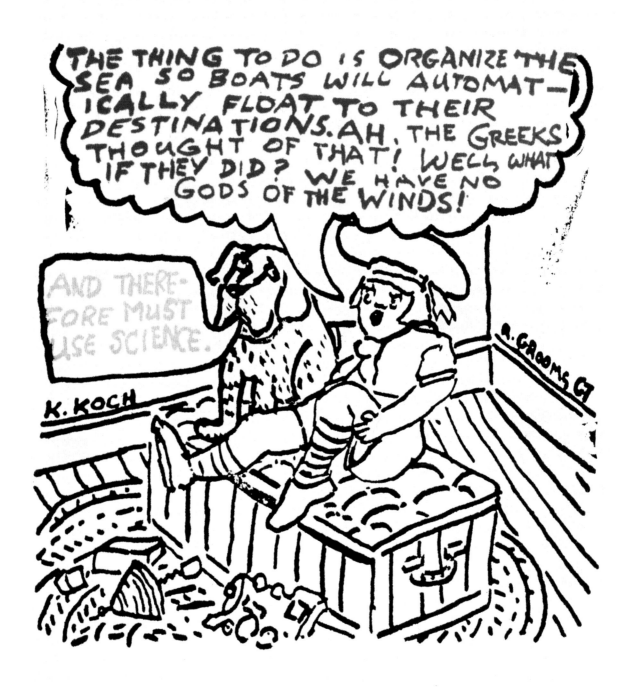

Organize the Sea, 1967. Rubber stamps, from Stamped Indelibly, 11½ × 9″ (29.2 × 22.9 cm). Cat. no. 20.

"This was the first of a number of images inspired by the texts of Kenneth Koch." —Red Grooms

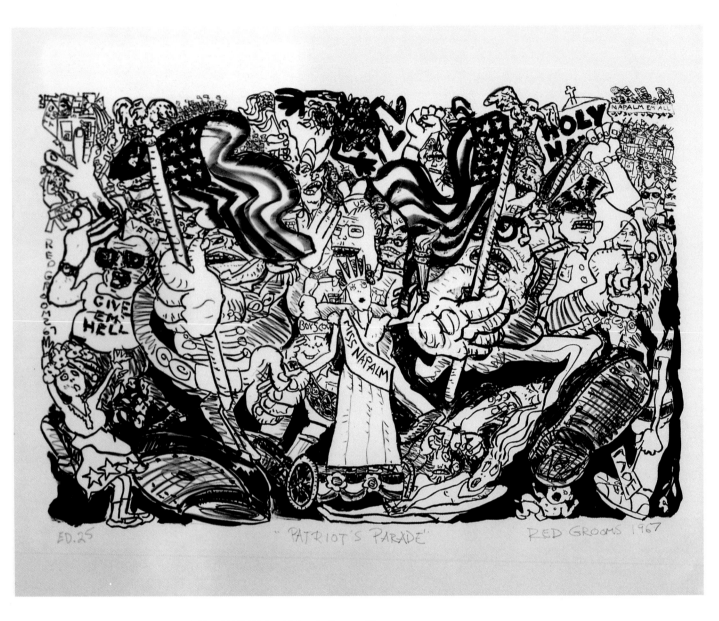

Patriot's Parade, 1967. Lithograph 28½ × 38⅜″ (72.4 × 97.5 cm). Cat. no. 21.

Saskia Leah Grooms, 1970. Woodcut 13⅝ × 9½″ (34.6 × 24.1 cm). Cat. no. 22.

"I knew vaguely that there was an artist's tradition for birth announcements. I was very proud to join it with this portrait of my daughter Saskia." —Red Grooms

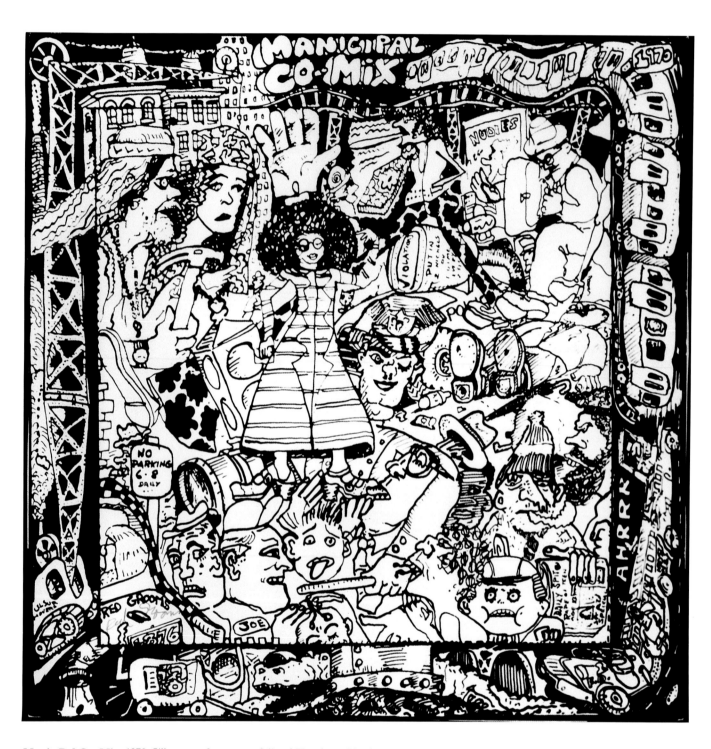

Manic Pal Co. Mix, 1970. Silkscreen, from a portfolio of *76 artists—78 prints*,
15 × 15″ (38.1 × 38.1 cm). Cat. no. 23.

*"I lived in Chicago for seven months and became friends with a
number of Chicago artists. Some are included in this portfolio. The
jumbled image is a visual return to the city that inspired my first
sculpto-pictorama* The City of Chicago, *1967–68."* —Red Grooms

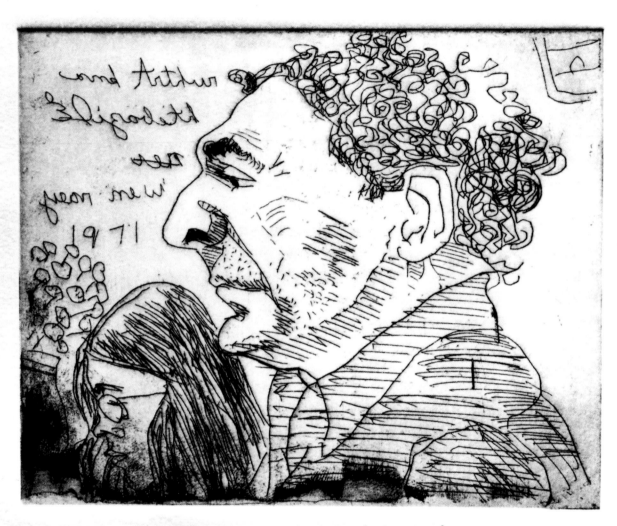

Arthur and Elizabeth, 1971. Etching 11 × 8″ (27.9 × 20.3 cm). Cat. no. 24.

"Arthur is a terrific artist, the 'Canaletto' of Provincetown. We worked on lots of movie projects together. He's a masterful sound-effects man using only his voice. He also is an excellent engraver, printing his own work with an ancient press. His wife, Elizabeth, is an accomplished pianist."—Red Grooms

Section II
Signed and Numbered Editions

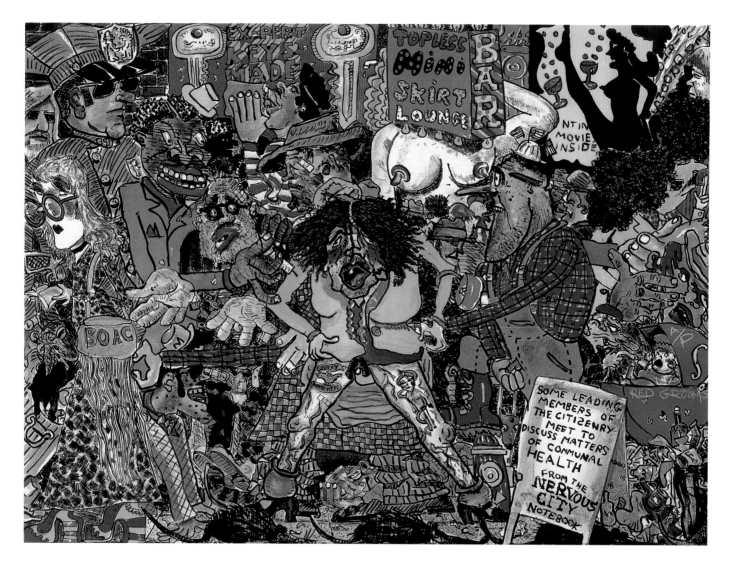

Nervous City, 1971. Lithograph, from *Ten Lithographs by Ten Artists* portfolio 22 × 30″ (55.9 × 76.2 cm). Cat. no. 25.

"This print was really a big breakthrough for me. It was my first chance to work in a professional print shop. I fell in love with the smell of ink and the thud of stones rolling under the pressure of powerful lithography presses. I was hooked."—Red Grooms

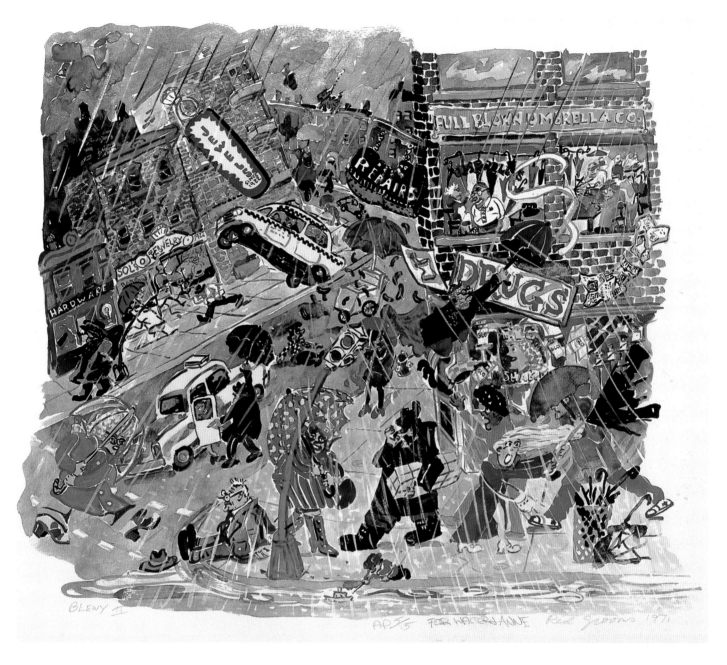

Blewy II, 1971. Offset silkscreen 23¾ × 34¼″ (60.3 × 87.0 cm). Cat. no. 27.

"Licht Editions was a large New York silkscreen company doing commercial work. At the suggestion of Joe Levi, an artist who did a print for the project, they decided to try their hand at a fine-art limited edition. Joe was a friend of mine and he recommended me to Licht. The image is one of the first versions of two of my favorite themes: the chaos of nature and the ubiquitous hot dog vendors of New York."

—Red Grooms

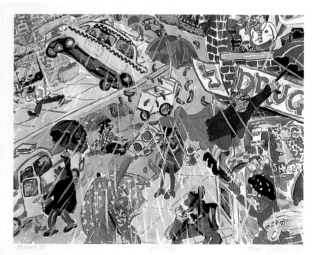

Blewy I, 1971. Offset silkscreen 14 × 18″ (35.6 × 45.7 cm). Cat. no. 26.

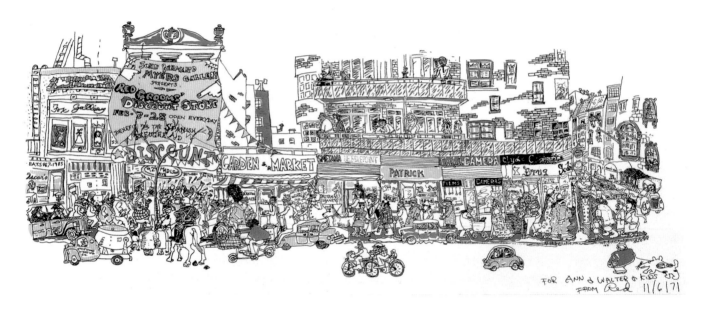

Discount Store, 1971. (Image of poster edition) silkscreen 19¾ × 41½″ (50.2 × 105.4 cm). Cat. no. 28.

"Johnny Myers was my art dealer from 1963–1974. He arranged to have the large sculpto-pictorama Discount Store shown in a temporary gallery across from the Whitney Museum. The show attracted crowds of New Yorkers during the month of February 1971. Myers commissioned me to do a silkscreen to commemorate the exhibition. I responded by doing a portrait of the whole block on the west side of Madison Avenue between 73rd and 74th Streets. This print was reproduced as an unlimited-edition poster that was sold at the temporary gallery during the run of the show."—Red Grooms

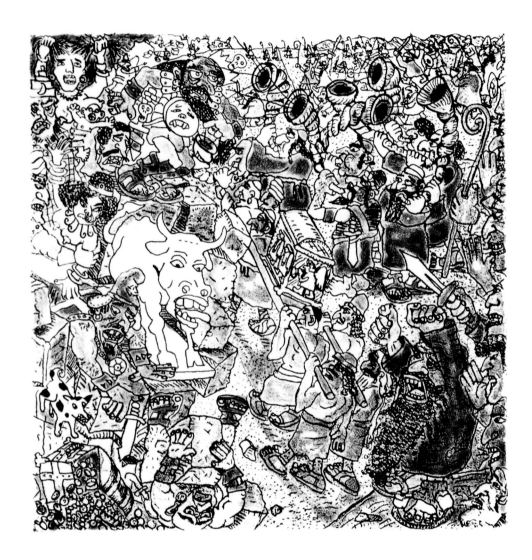

Fall of Jericho, 1971. Soft-ground etching 12¾ × 12¾″ (32.4 × 32.4 cm). Cat. no. 29.

"The Fall of Jericho *is a costume epic. I cut my teeth on the great biblical films of the 1940s and 1950s. The Lists were movers and shakers in the art world of the 1960s and 1970s, and this was a real command performance for me. More soldiers C.B.!"*—Red Grooms

No Gas—Portfolio Cover, 1971.
Silkscreen on linen covered box 22⅞ × 29
× ½" (58.1 × 73.7 × 1.3 cm). Cat. no. 30.

*"For quite awhile, 'The Old Lady'
was a big character for me. The
prototype for the No Gas 'Old Lady'
was acted by Mimi Gross in the
1966 film* Fat Feet. *I planned the
image with cut paper to increase
the graphic punch."*—Red Grooms

*"Red Grooms walks into Atelier!
Red has this wonderful smile to go
with his slow southern accent while
discussing a portfolio of images of
New York City; sounds and smells—
views that evoke the essences of the
city. I printed. Red drew changing
colors, sanding and priming plates
for textural and tonal effects, push-
ing each other, pouncing from
image to image. It was like a
dance—Red and I directing each
other. It was a wonderful, fulfilling
collaboration!"*

—Mauro Giuffrida

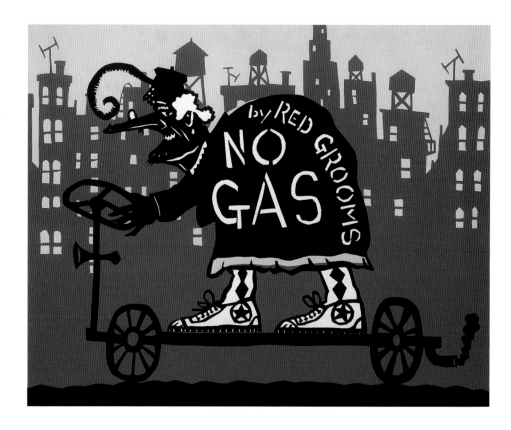

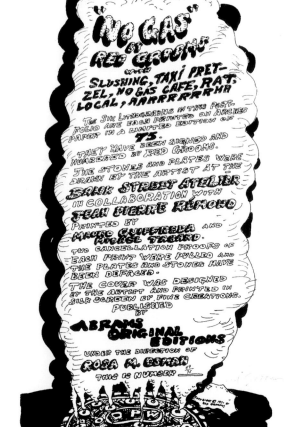

No Gas—Portfolio Title Sheet, 1971.
Silkscreen 28 × 22" (71.1 × 55.9 cm).
Cat. no. 31.

*"A New York phenomenon, the
volcanic steaming manholes of
New York. I thought it would be
appropriate for the title sheet of a
series on New York."*—Red Grooms

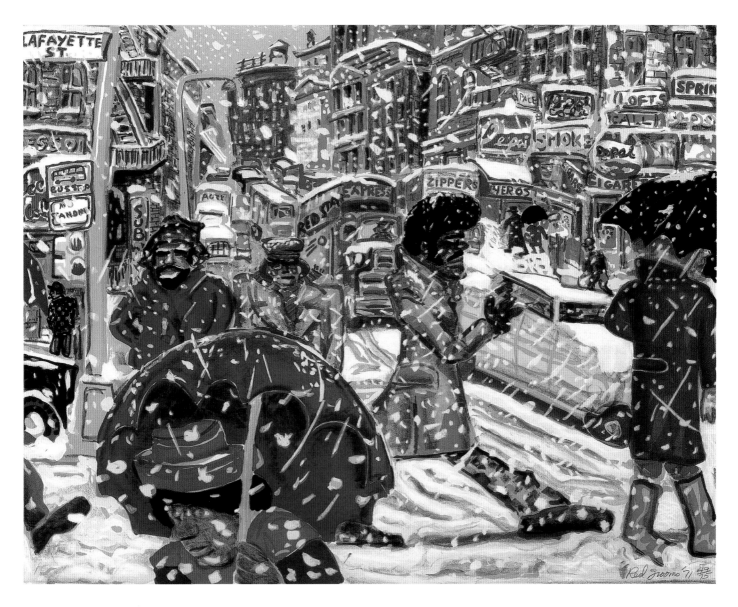

Slushing, 1971. Lithograph from *No Gas* portfolio 22 × 28″ (55.9 × 71.1 cm). Cat. no. 32.

"Jean-Pierre Remond had a great method for keeping the snowflakes bright white. He took great pains to stop out with gum arabic every snowflake on all ten plates so that the white paper in those spots remained uninked."
<div align="right">—Red Grooms</div>

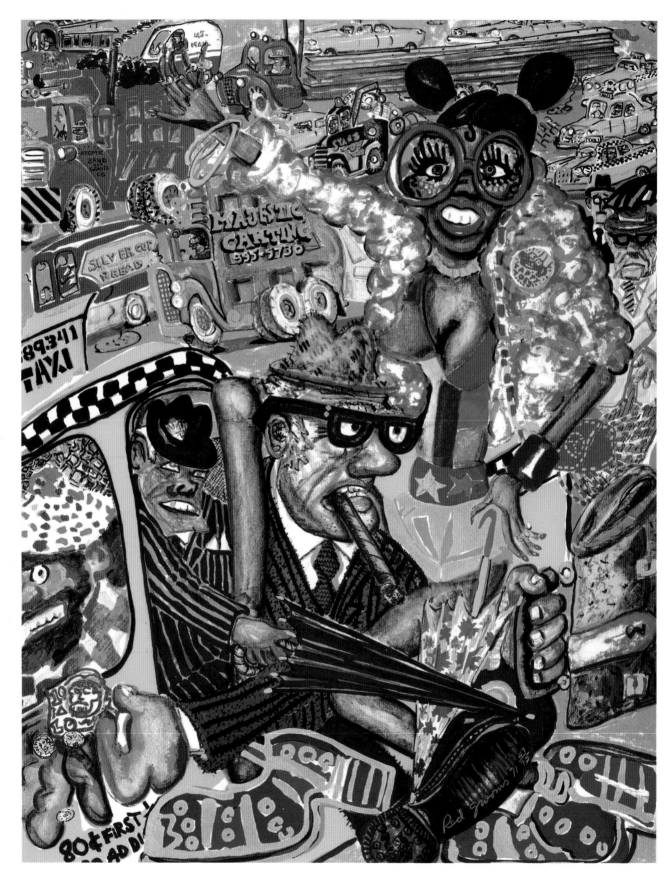

Taxi Pretzel, 1971. Lithograph from *No Gas* portfolio 28 × 22″ (71.1 × 55.9 cm). Cat. no. 33.

"Seeing a real New Yorker hail a cab is a splendid sight. And any woman getting in or out of one is a sexy sight indeed." —Red Grooms

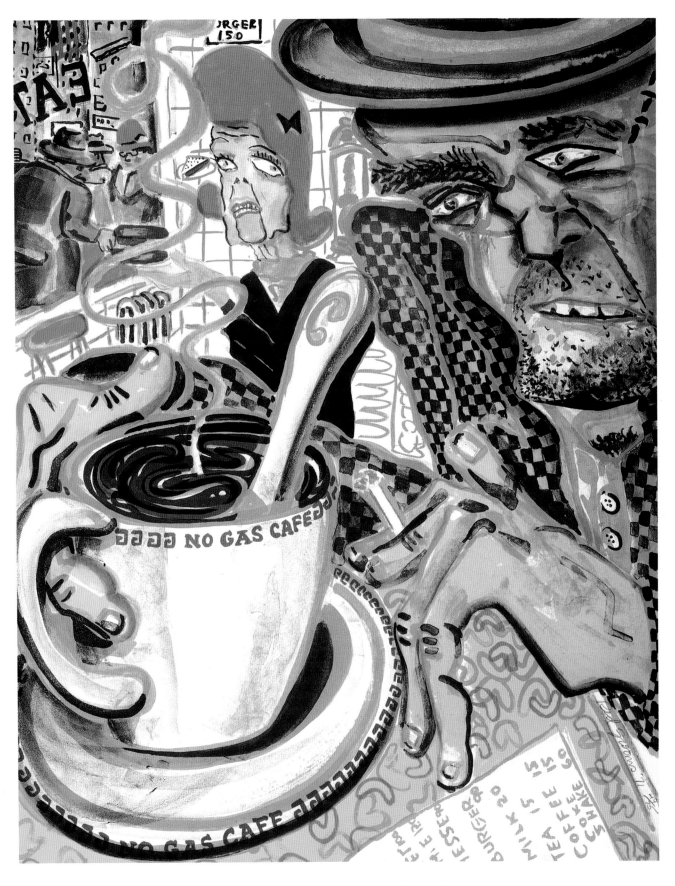

No Gas Café, 1971. Lithograph from *No Gas* portfolio 28 × 22″ (71.1 × 55.9 cm). Cat. no. 34.

"I was really into this low-down, hard-knocks imaginary café. I like the two 'types' (a waitress and a 'Hobo') a lot. Doing the boomerang motif on the counter nearly drove me crazy." —Red Grooms

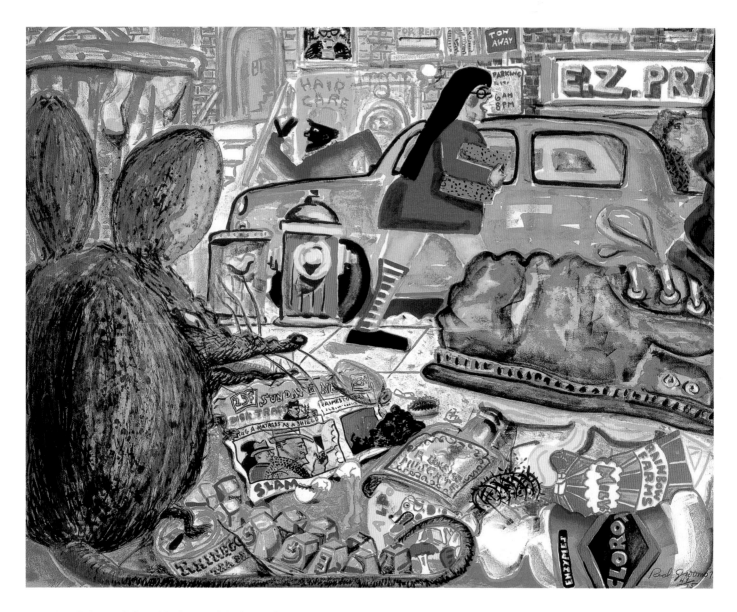

Rat, 1971. Lithograph from *No Gas* portfolio 22 × 28″ (55.9 × 71.1 cm). Cat. no. 35.

"Golly, it's tough to have a rat as the star of your image. I tried to get away with it anyway. Girls were wearing their hair long and blunt cut and the miniskirt was huge." —Red Grooms

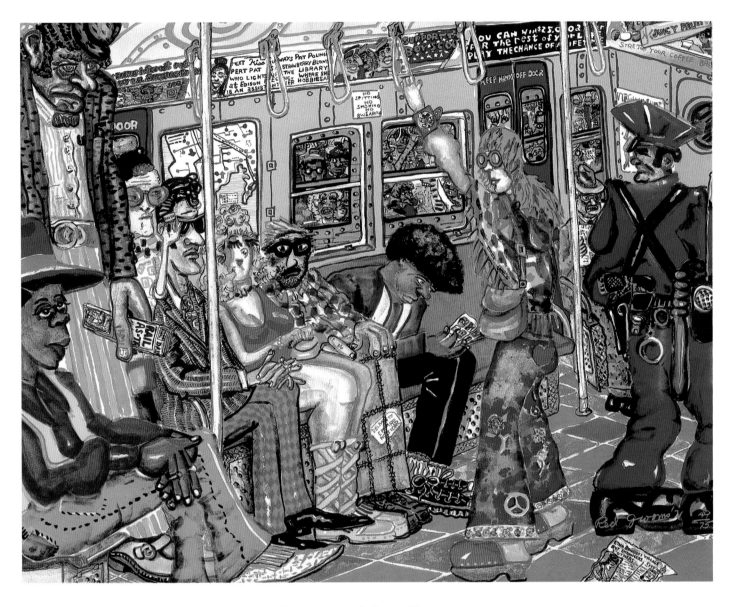

Local, 1971. Lithograph from *No Gas* portfolio 22 × 28″ (55.9 × 71.1 cm). Cat. no. 36.

"In many ways No Gas *is the precursor of* Ruckus Manhattan, *the very large sculpto-pictorama which was to be completed five years later.* Local *is a '2D' version of the full-scale walk-through subway car built for* Ruckus Manhattan.*"* —Red Grooms

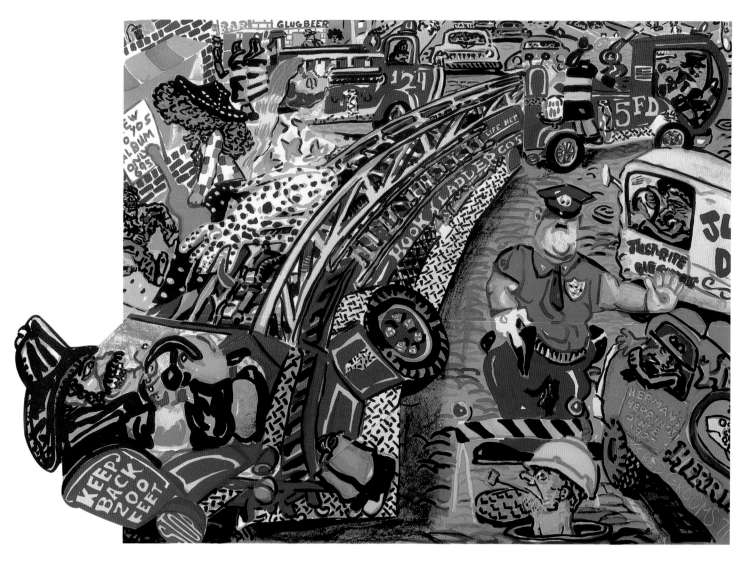

Aarrrrrhh, 1971. Three-dimensional lithograph, from *No Gas* portfolio 20 × 28 × 2" (50.8 × 71.1 × 5.1 cm). Cat. no. 37.

"George Goodstadt was running Bank Street and he was very lively and imaginative. I mentioned to him that I was thinking of doing something three-dimensional for the No Gas portfolio. George not only encouraged me, but also helped with the design." —Red Grooms

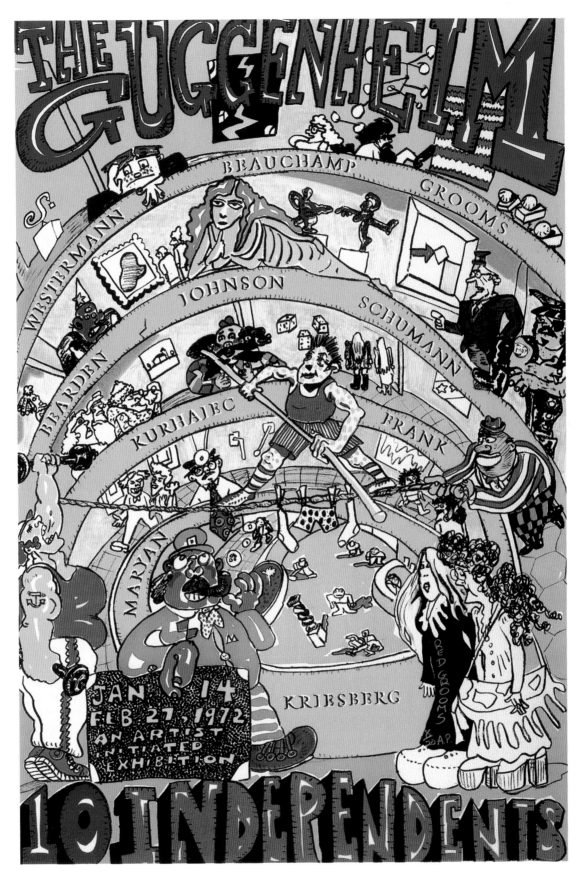

Guggenheim, 1971. Lithograph 38½ × 26″ (97.8 × 66.0 cm). Cat. no. 38.

*"This is one of the few lithographs where I didn't do the color separation.
The job was done by the 'master chromist' Jean-Pierre Remond. He was
at home working in anyone's style and with amazing speed."*—Red Grooms

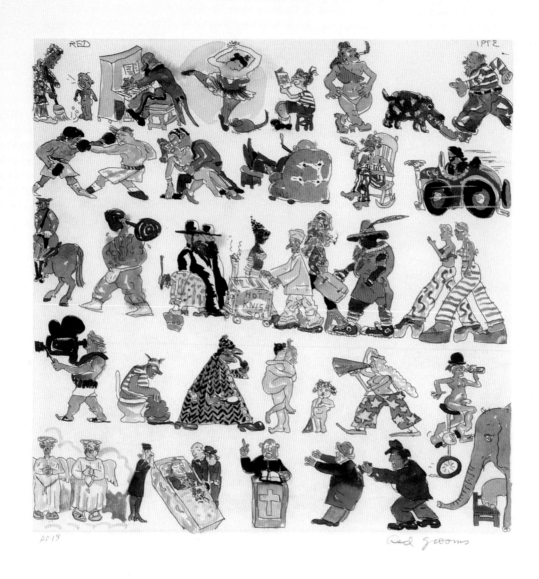

45 Characters, 1973. Etching hand-colored with watercolor 19 × 17¾″
(48.3 × 45.1 cm). Cat. no. 39.

"*I was told that Balzac amused himself by making up dozens of
character descriptions out of his head, so I tried it on a copper
plate and it almost became a narrative.*"—Red Grooms

"*It almost became a finished etching with aquatint. Too bad—a
narrative à la Balzac was a great idea.*"—Jennifer Melby

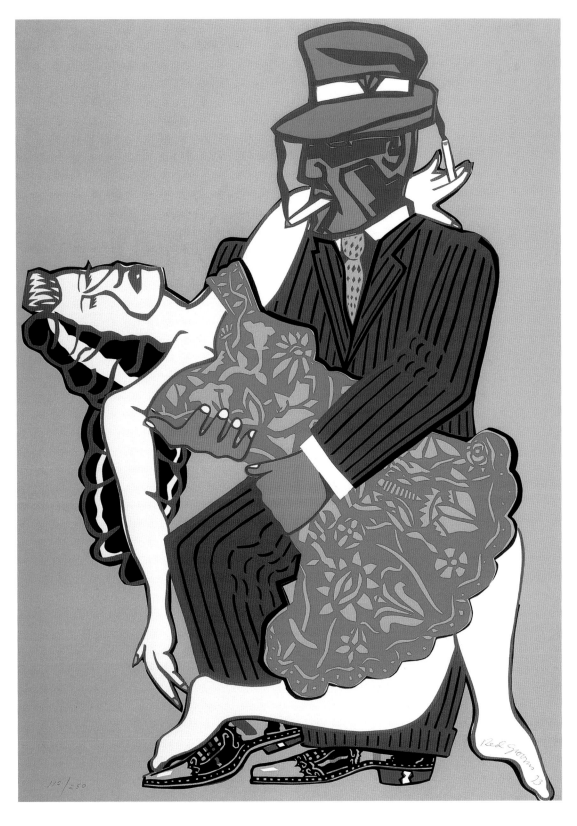

Mango Mango, 1973. Silkscreen 40 × 28¾″ (101.6 × 73.0 cm). Cat. no. 40.

"During this period I remember Kitty Myers, the publisher of this silkscreen, as a lively personality on the art scene. —Red Grooms

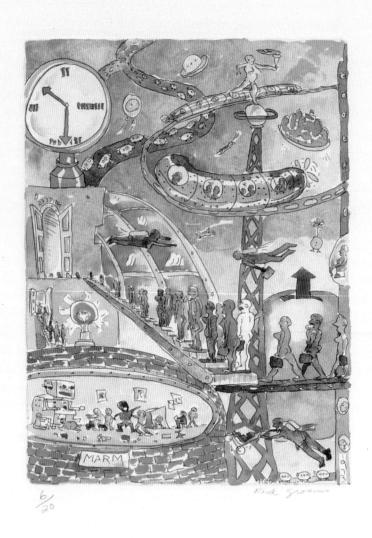

Nashville 2001 A.D., 1973. Etching, hand-colored with watercolor, 15 × 12″
(38.1 × 30.5 cm). Cat. no. 41.

"Brooke would give me some etching plates to keep around the studio waiting for an inspiration. I don't remember the reason for doing Nashville 2001 A.D., *perhaps it was nothing more than a fleeting notion. However, when I took up the copper plate it became a permanently engraved doodle."* —Red Grooms

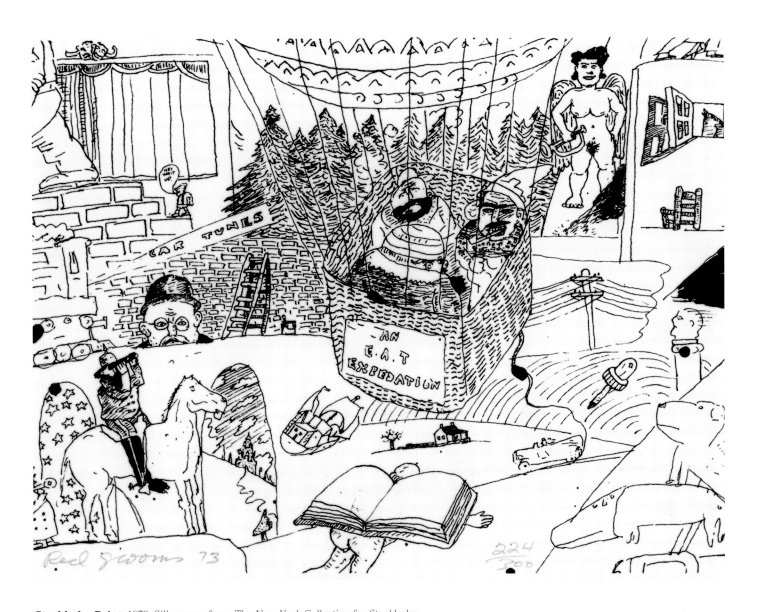

Stockholm Print, 1973. Silkscreen, from *The New York Collection for Stockholm*, 9 × 12″ (22.9 × 30.5 cm). Cat. no. 42.

"Billy Klüver asked me to do an image for the portfolio E.A.T. *was producing in connection with* The New York Collection for Stockholm. *Rather than coming up with a concrete image I opted for a visual stream of consciousness."* —Red Grooms

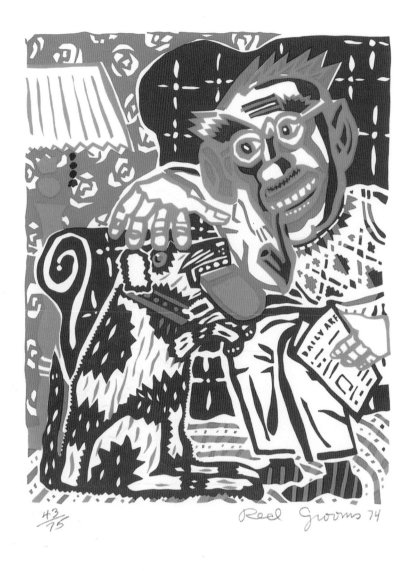

The Daily Arf, 1974. Silkscreen and blind intaglio 20¾ × 15½″ (52.7 × 39.4 cm). Cat. no. 43.

"The embossing was done by a lovely middle-aged couple. I wish I could remember their names. They seemed to work out of their own living room doing this unusual art form, embossing. The print looked great without color or line on white paper. But when the color was added it killed the dimensional effect." —Red Grooms

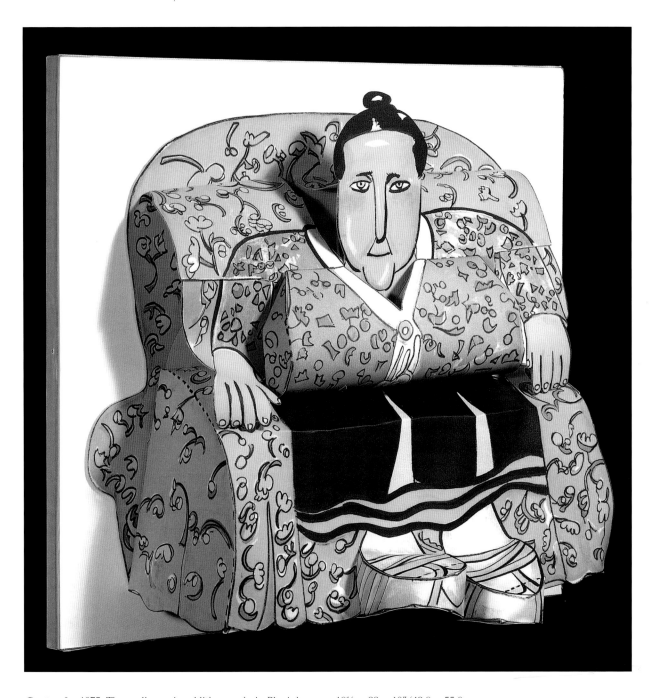

Gertrude, 1975. Three-dimensional lithograph, in Plexiglas case 19¼ × 22 × 10″ (48.9 × 55.9 × 25.4 cm). Cat. no. 44.

"Mauro Giuffrida, who printed the No Gas portfolio at the Bank Street Atelier had moved to the Circle Workshop. I was pleased that Brooke put us together again for my second three-dimensional project. I struggled to add Alice B. Toklas but her skinniness didn't seem to balance Gertrude's roundness. I had been working with a hot melt glue gun since 1973. This new technology allowed me to go fully round with the paper, and Mauro and I were able to de-glue the maquette, press it flat, and trace it onto two zinc plates. Chip Elwell came to my studio and put everything together using a glue gun, then mounted it into the Plexiglas boxes made by Stanley Poler." —Red Grooms

"Red wanted to do a 'folded' print (like cutouts of paper dolls), with tabs indicating where to fold and bend. Through a series of logical steps, with trial and error, images were finally placed on two sheets of paper to complete the three-dimensional piece." —Mauro Giuffrida

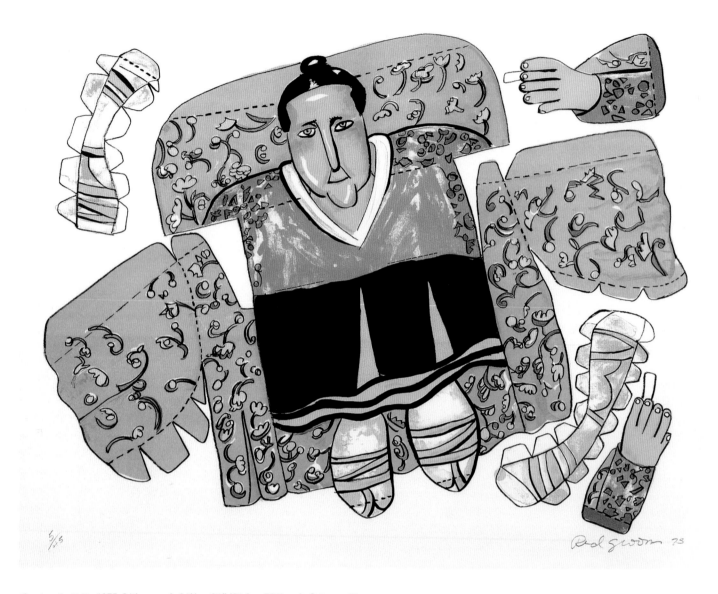

Gertrude 2 D, 1975. Lithograph 24⅛ × 31″ (61.3 × 78.7 cm). Cat. no. 45.

"Brooke Alexander chose to do this sheet as a separate print after the three-dimensional Gertrude. There was another sheet with parts of the chair and body that along with this sheet made the complete three-dimensional version."—Red Grooms

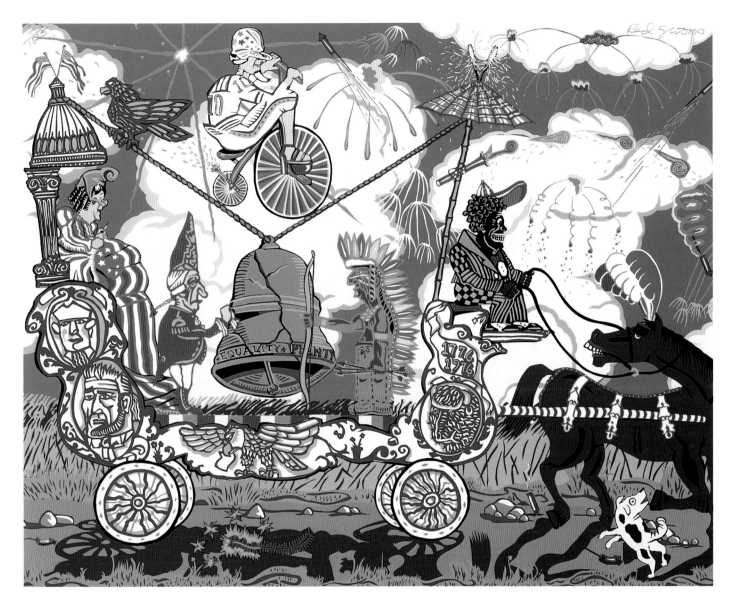

Bicentennial Bandwagon, 1975 (published in 1976). Silkscreen, from the *Kent Bicentennial Portfolio, Spirit of Independence* 26½ × 34¾″ (67.3 × 88.3 cm). Cat. no. 46.

"The print impresario Steven Lyon asked me to be part of the Bicentennial Portfolio. *I remember being hard pressed to complete my study for the print, as I was on the verge of starting* Ruckus Manhattan. *My assistant at this time was the artist Andrew Ginzel and he helped me cutting and gluing all the paper shapes for the maquette. I did have a patriotic streak in me while doing the bandwagon and so I indulged in a bit of flag waving."*

—Red Grooms

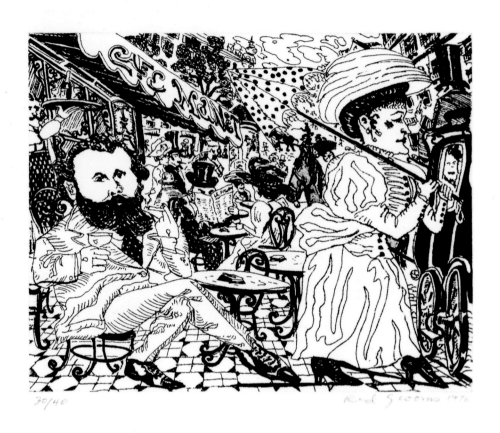

30/40 Red Grooms 1976

Café Manet, 1976. Etching and aquatint 13¼ × 14¾″ (33.7 × 37.5 cm). Cat. no. 47.

"Ruckus Manhattan was shown at Marlborough Gallery from April 1 to June 31, 1976. The 25 people I worked with had been laid off. It was a good time for me to focus on intimate projects. Brooke Alexander wanted to try publishing some prints and hooked me up with Jennifer Melby. She had been a production manager at the Bank Street Atelier while I was working there in 1971 on the No Gas portfolio. Jennifer started her own print shop soon after that, keeping it simple and doing everything herself. I found her very easy to work with and her printing technique was excellent. Café Manet was one of our most successful prints. I was proud when the New York Public Library bought one for their collection." —Red Grooms

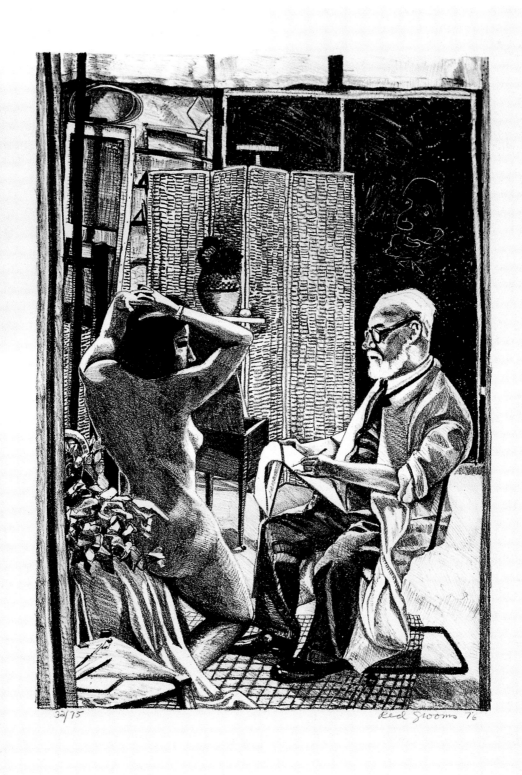

Matisse, 1976. Lithograph 34½ × 25½″ (87.6 × 64.8 cm). Cat. no. 48.

*"Brooke got the printer Paul Narkiewicz to bring a stone to my studio.
The studio had been cleared out (wiped out really) by the* Ruckus
Manhattan *project. In contrast to the manic drive to churn out a por-
trait of Manhattan, I felt a great sense of peace sitting quietly by myself
copying the photograph by Brassai of Matisse serenely drawing."*
—Red Grooms

Corot, 1976. Soft ground etching with monoprinting 18¼ × 13¾″ (46.4 × 34.9 cm). Cat. no. 49.

"This was a lot of fun. The line drawing was already engraved in the plate. I painted the plate freely before Jennifer printed it. There was no restriction on color. Brooke was there during the whole procedure, cheering us on."—Red Grooms

"A great day in the studio—a wonderful collaboration among printer, artist, and publisher. Red had an instinctive touch with monoprinting—there were no duds. I only regret not having kept one."—Jennifer Melby

Saskia Doing Homework, 1976. Etching 13 × 11⅛" (33.0 × 28.3 cm). Cat. no. 50.

"Saskia grew up in two separate studios, her mother's and mine. She went back and forth every two weeks, as our studios were only a block apart. Not having been a very good student myself I was very proud of Saskia's academic achievements, which are exhibited here at an early age."—Red Grooms

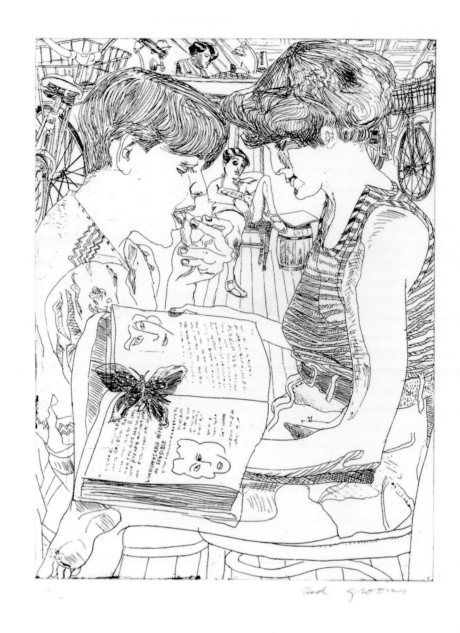

Double Portrait with Butterfly, 1976. Etching 17⅝ × 14″ (44.8 × 35.6 cm). Cat. no. 51.

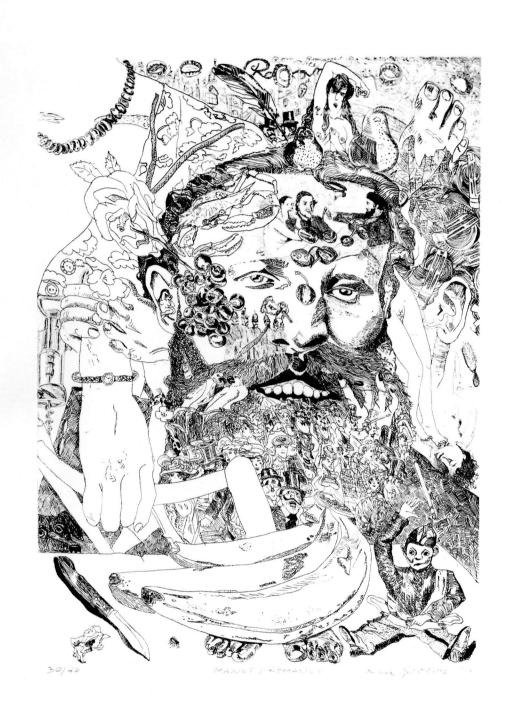

Manet/Romance, 1976. Etching 33¾ × 26″ (85.7 × 66.0 cm). Cat. no. 52.

"This large etching was a spin-off of the Nineteenth-Century
Artists *portfolio. It seems I was using Manet as the scapegoat
for some personal trials and tribulations."* —Red Grooms

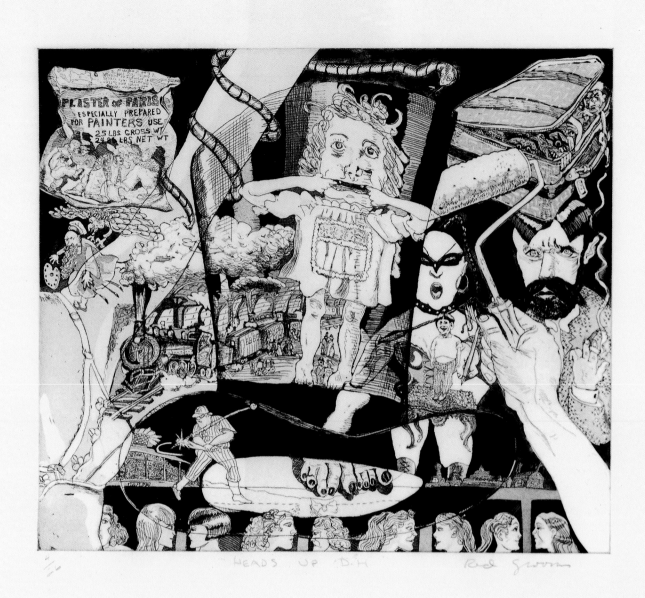

Heads Up D.H., 1976 (published 1980). Etching and aquatint 26¾ × 30″ (68.0 × 76.2 cm). Cat. no. 53.

"A very diary-like image. This plate was around for a long time. I kept adding to it bit by bit. The subject is personal and masked by a stream-of-consciousness juxtaposition of images including a portrait of D. H. Lawrence. And my daughter Saskia making a face." —Red Grooms

"A really difficult etching to print because of the very subtle aquatint tones. I've been told it's a difficult print to like—provocative or irritating would be more accurate." —Jennifer Melby

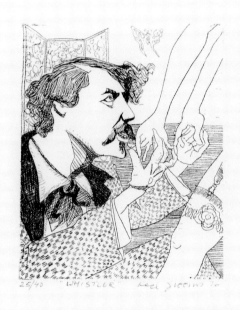

Whistler, 1976. Etching from *Nineteenth-Century Artists* portfolio 15 × 11″ (38.1 × 27.9 cm). Cat. no. 54.

"I suppose I took the old line 'Come up and see my etchings' literally, presuming that there is something sexy about an etched line. It was easy to imagine and also a lot of fun to put these famous nineteenth-century artists into risqué situations."—Red Grooms

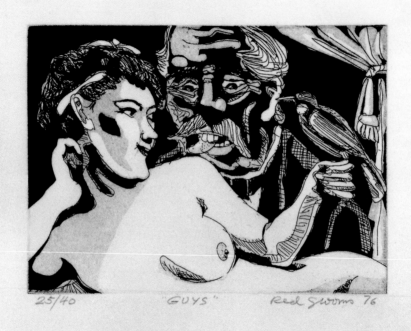

Guys, 1976. Etching and aquatint from *Nineteenth-Century Artists* portfolio
15 × 11″ (38.1 × 27.9 cm). Cat. no. 55.

"The Nineteenth-Century Artists *portfolio was the final word on a
short and private period in my life. It became increasingly clear that I
needed to rely on artists of a certain sophistication as surrogates for
my own personal foibles and adventures. In a way I feel I owe these
great artists an apology. I certainly hope that I did not besmudge any
of their reputations."*—Red Grooms

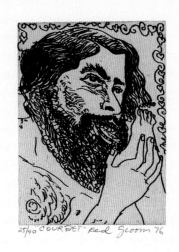

Courbet, 1976. Etching, from *Nineteenth-Century Artists* portfolio 15 × 11″
(38.1 × 27.9 cm). Cat. no. 56.

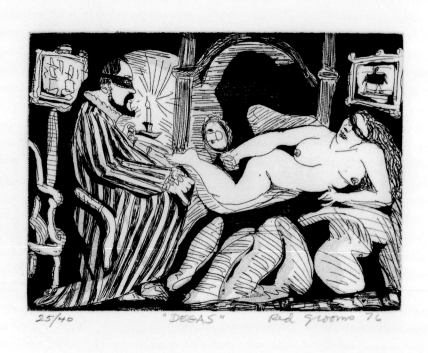

25/40　　　　"DEGAS"　　　Red Grooms 76

Degas, 1976. Etching and aquatint from *Nineteenth-Century Artists* portfolio
15 × 11″ (38.1 × 27.9 cm). Cat. no. 57.

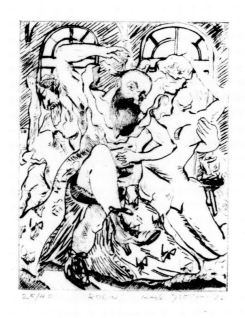

Rodin, 1976. Drypoint from *Nineteenth-Century Artists* portfolio 15 × 11″
(38.1 × 27.9 cm). Cat. no. 58.

*"This was really a big project in terms of the total number of prints.
Each artist is instantly recognizable and given Red's critical stamp and
slant. I think his decision to do Rodin only in drypoint was brilliant."*
—Jennifer Melby

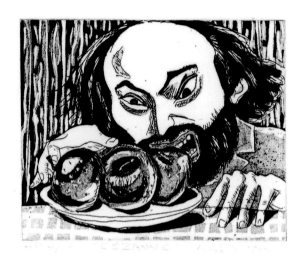

Cézanne, 1976. Etching and aquatint from *Nineteenth-Century Artists* portfolio
15 × 11″ (38.1 × 27.9 cm). Cat. no. 59.

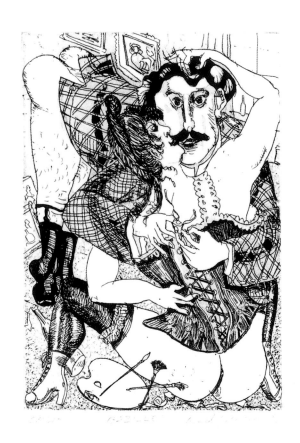

Bazille, 1976. Etching and aquatint from *Nineteenth-Century Artists* portfolio
15 × 11″ (38.1 × 27.9 cm). Cat. no. 60.

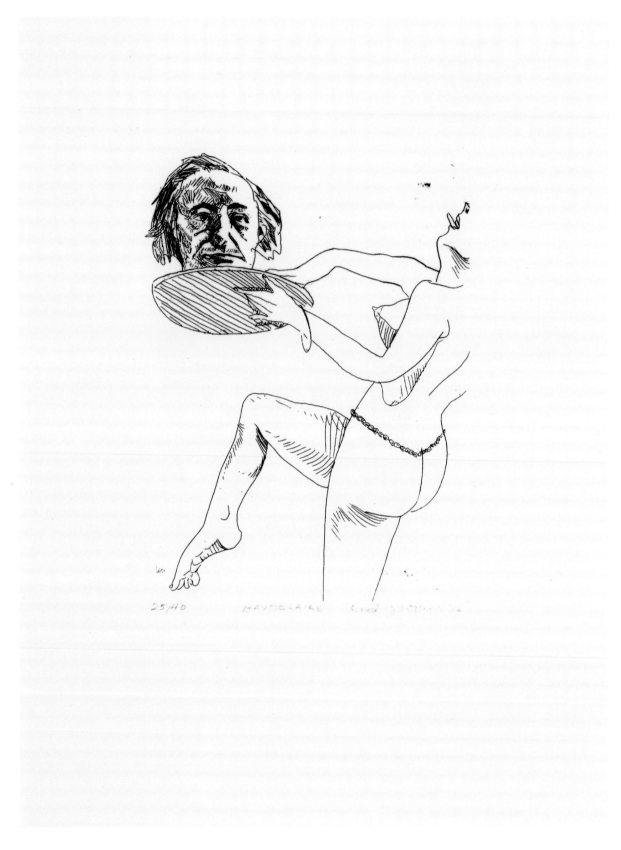

Baudelaire, 1976. Etching from *Nineteenth-Century Artists* portfolio
15 × 11″ (38.1 × 27.9 cm). Cat. no. 61.

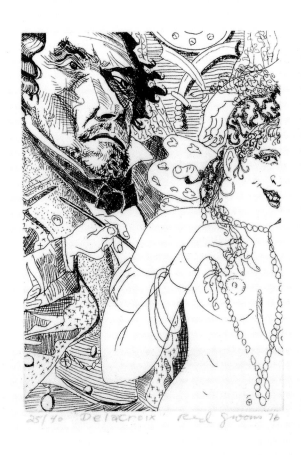

Delacroix, 1976. Etching from *Nineteenth-Century Artists* portfolio
15 × 11″ (38.1 × 27.9 cm). Cat. no. 62.

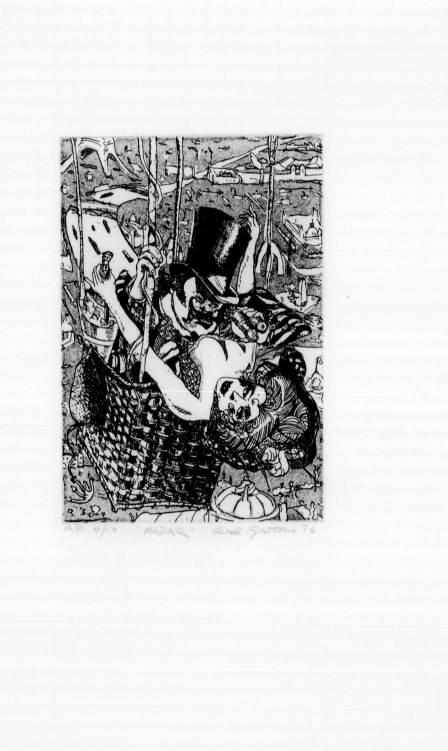

Nadar, 1976. Etching, aquatint, and drypoint from *Nineteenth-Century Artists*
portfolio 15 × 11″ (38.1 × 27.9 cm). Cat. no. 63.

Rudy Burckhardt as a Nineteenth-Century Artist, 1976. Etching 15 × 10½″ (38.1 × 26.7 cm). Cat. no. 64.

"Rudy Burckhardt was a great friend and mentor. We met through Alex Katz in 1958. Rudy was a real 'triple threat' as a filmmaker, painter, and photographer. We made the movie 'Shoot the Moon' together in 1962. I was an actor in Rudy's films, 'Miracle on the BMT' 1963, 'Lurk' 1964 and 'Money' 1966. Rudy was cameraman on my films 'Hippodrome Hardware' and 'Little Red Ridinghood'. Rudy's muse here is his wife, the painter Yvonne Jacquette. Rudy died in Maine while I was working on the comments for this book. He was 85."—Red Grooms

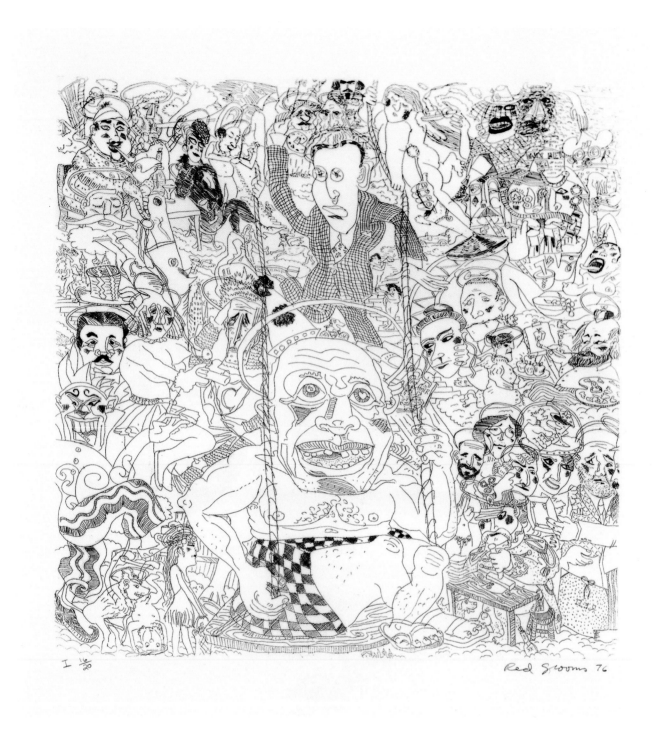

Picasso Goes to Heaven I, 1976. Etching 29½ × 30½" (74.9 × 77.5 cm). Cat. no. 65.

"Brooke got a 'twofer' out of this print, publishing the key plate
as a separate edition from the colored version." —Red Grooms

"The pochoir version is so brilliant because Chip was brilliant.
Still, the key plate holds its own." —Jennifer Melby

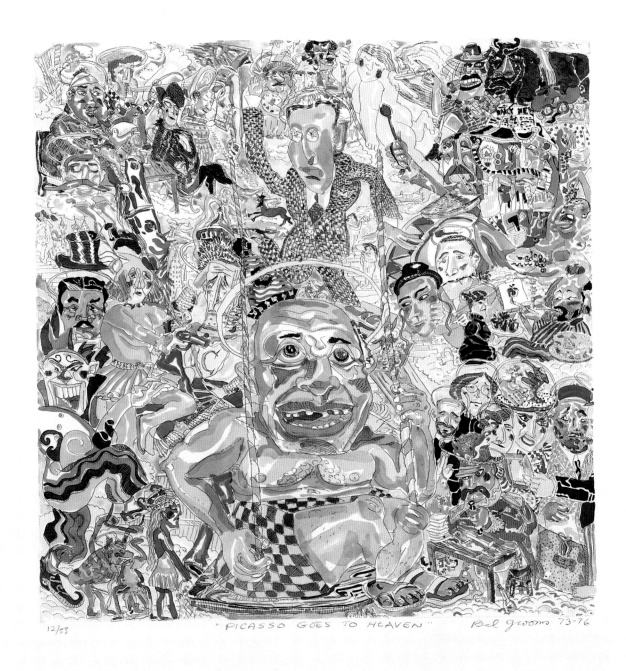

Picasso Goes to Heaven II, 1976. Etching and pochoir 29½ × 30½"
(74.9 × 77.5 cm). Cat. no. 66.

"Chip Elwell became extremely good at the pochoir technique. I gave him a proof of the line drawing, which I had colored freely with watercolor. Chip did the color separations for each print by meticulously painting watercolor through the 54 stencils he had prepared. Chip later became a master of woodcut printing and helped create a vogue for the medium among contemporary artists in the 1980s." —Red Grooms

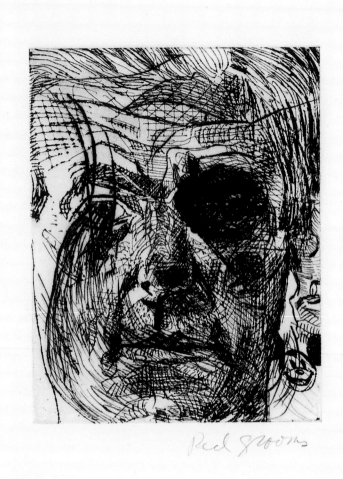

Self-Portrait with Mickey Mouse, 1976. Etching 22¼ × 15⅜″ (56.5 × 39.1 cm). Cat. no. 67.

"I started an image on the plate, and being dissatisfied, I turned the plate upside down and did a self-portrait. The Mickey Mouse was a whim. A woman's profile is upside down on the right above Mickey."—Red Grooms

"When I teach, this is one of the prints I often show the students. Quite a few 'happy accidents' happened on this print—not the least that the hard ground was somewhat brittle so some of the lines cracked as Red drew. The drawing has a life of its own."—Jennifer Melby

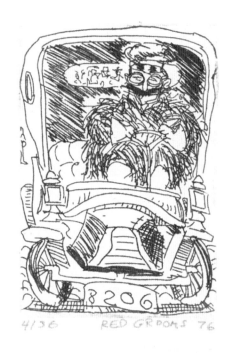

Taxi, 1976. Etching 7¾ × 6½″ (19.7 × 16.5 cm). Cat. no. 68.

"A popular little print, proving that the audience is not always demanding a magnum opus." —Red Grooms

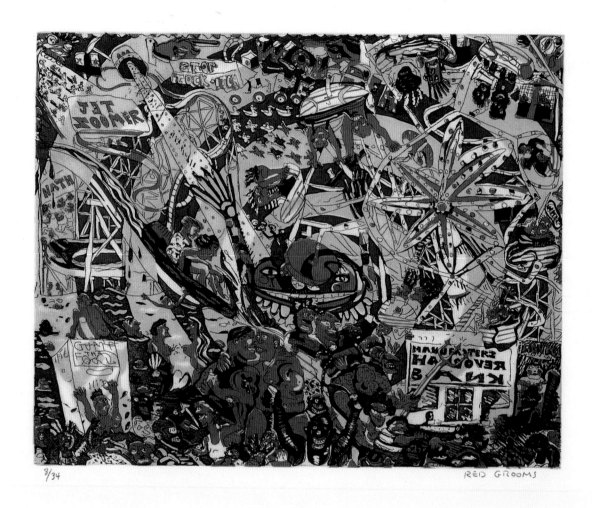

Coney Island, 1978. Aquatint 22 × 25¾″ (55.9 × 65.4 cm). Cat. no. 69.

"An ambitious project. The first and only colored aquatint that Jennifer and I tried. The drawing is wildly undisciplined. A subject that has always fascinated me."—Red Grooms

"Just like the subject, this was a wild and crazy print like my other early experiments with color plate projects. I struggled with unbelievable registration."—Jennifer Melby

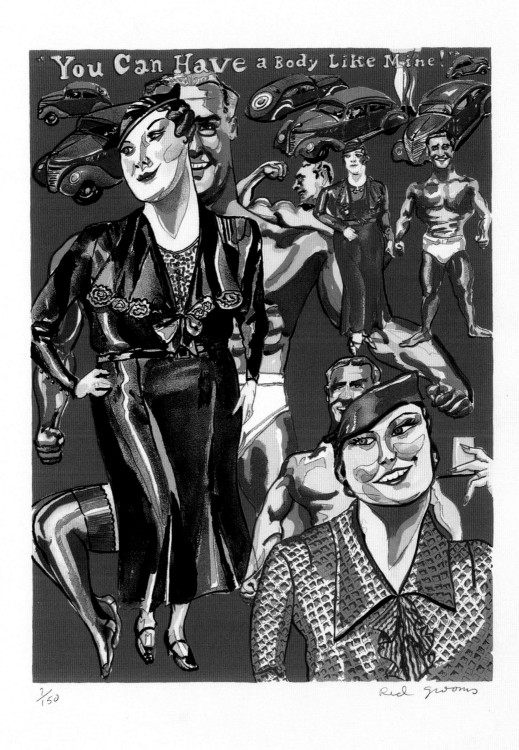

2/50

Red Grooms

You Can Have a Body Like Mine, 1978. Silkscreen 24 × 18″ (61.0 × 45.7 cm). Cat. no. 70.

"This print and the Chuck Berry were done as tax shelters, which dominated print publishing for several years in the late 1970s. I was crazy about old Sears and Roebuck catalogues during the 1970s. The ladies were inspired by those illustrations. The muscle man is none other than the Charles Atlas of 'don't kick sand in my face' fame."—Red Grooms

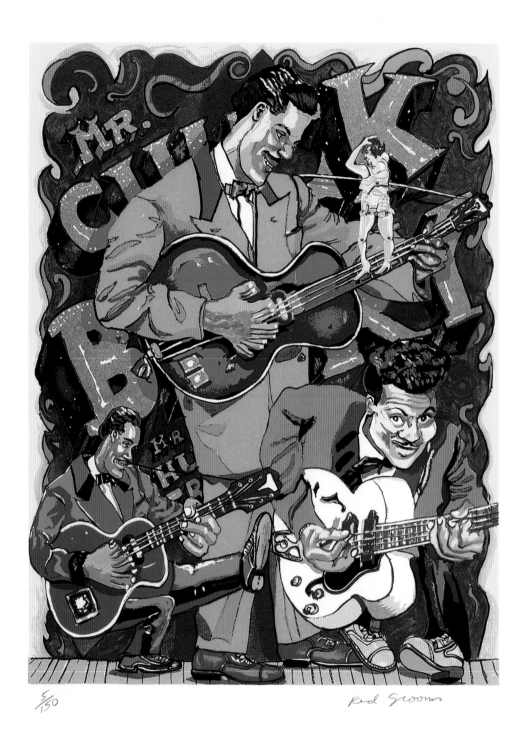

5/150

Red Grooms

Chuck Berry, 1978. Silkscreen with die-cut 31½ × 25″ (80.0 × 63.5 cm). Cat. no. 71.

"I gave the great Rock and Roller the futurist treatment and made sure the color scheme would work in any cool cats parlor. Maybelline's legs were hinged like a puppet. She was supposed to vibrate as the viewer passed by, but the construction of most floors is too solid."—Red Grooms

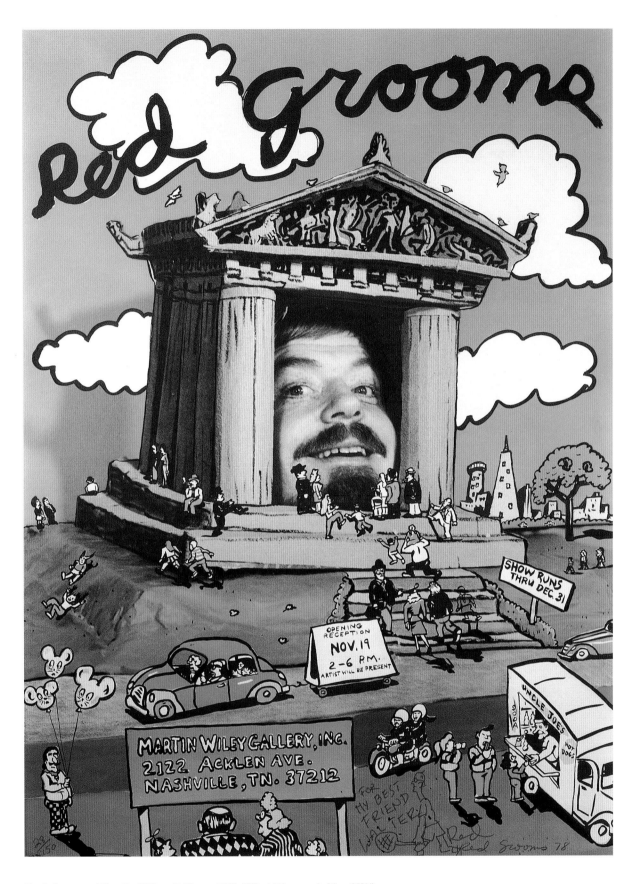

Red Grooms, Martin Wiley Gallery, 1978. Offset lithograph 28 × 20¾"
(71.1 × 52.7 cm). Cat. no. 72.

*"Back at the scene of the crime where my career began. This
photolitho technique reminded me of old-time animated cartoons."*
 —Red Grooms

Museum, 1978. Offset lithograph 10¼ × 23¾" (26.0 × 60.3 cm). Cat. no. 73.

"This was fun—a free kick at the art world with no penalty box. Brooke, always clever with his 'twofers,' got a fine art-edition and the cover for a catalogue from this offset."—Red Grooms

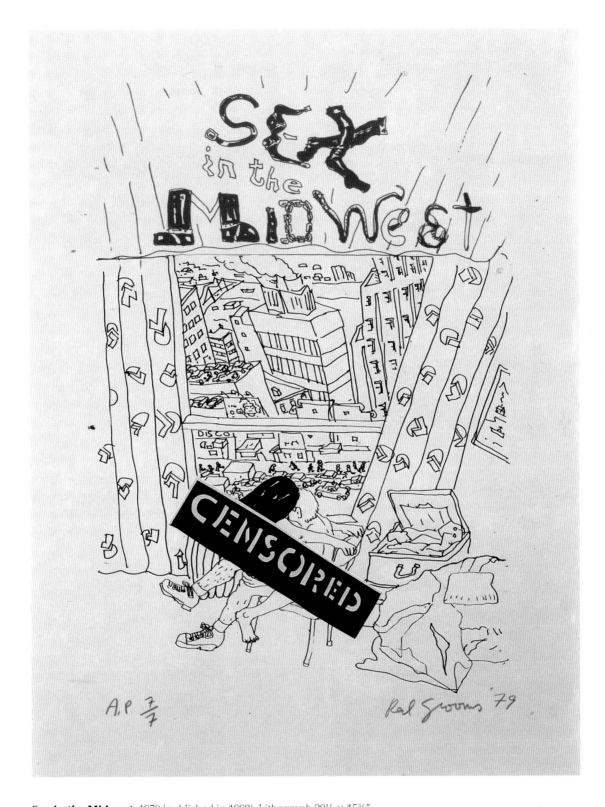

Sex in the Midwest, 1979 (published in 1998). Lithograph 20½ × 15¾″ (52.1 × 40.06 cm). Cat. no. 74.

"Rosie's Closet, Lorna Doone, Pancake Eater, *and* The Tattoo Artist *were all intended to be part of* Sex in the Midwest."—Red Grooms

"*This print was originally intended to be glued down onto the cover of the portfolio case that was to house the* Sex in the Midwest *series of prints. The suite would have included the* Croissant Crusher *and the* Lion Licker. The Lion Licker *remains on the original stone upon which it was drawn, awaiting a decision to edition.*"—Steve Andersen

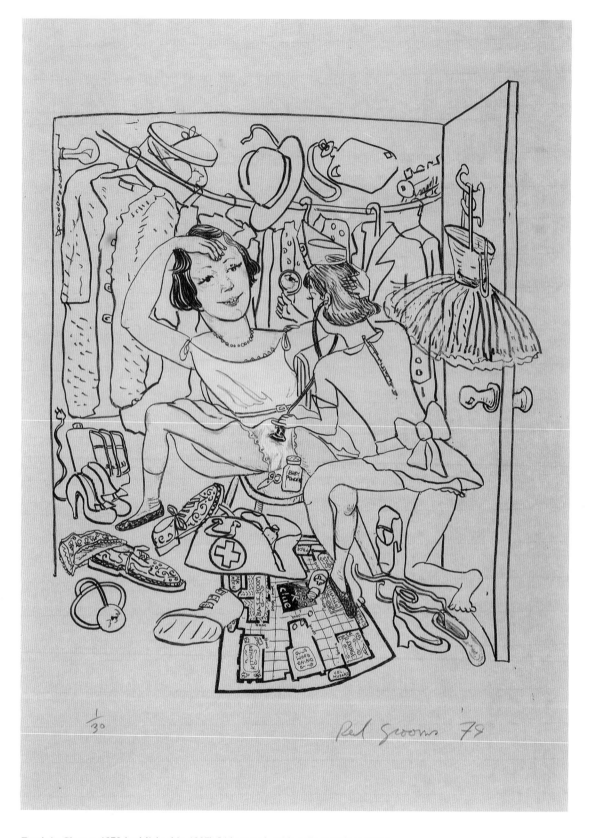

Rosie's Closet, 1979 (published in 1997). Lithograph with collage 34¼ × 25¼"
(87.0 × 64.1 cm). Cat. no. 75.

"Rosie's Closet *was drawn on a litho stone and proofed in 1979 then
abandoned for eighteen years. I went out to Minneapolis in 1997 to
sign* Katherine, Marcel and the Bride *and I signed this print edition
as well, after Steve and I decided on a discreet collage addition that
would satisfy the censors.*" —Red Grooms

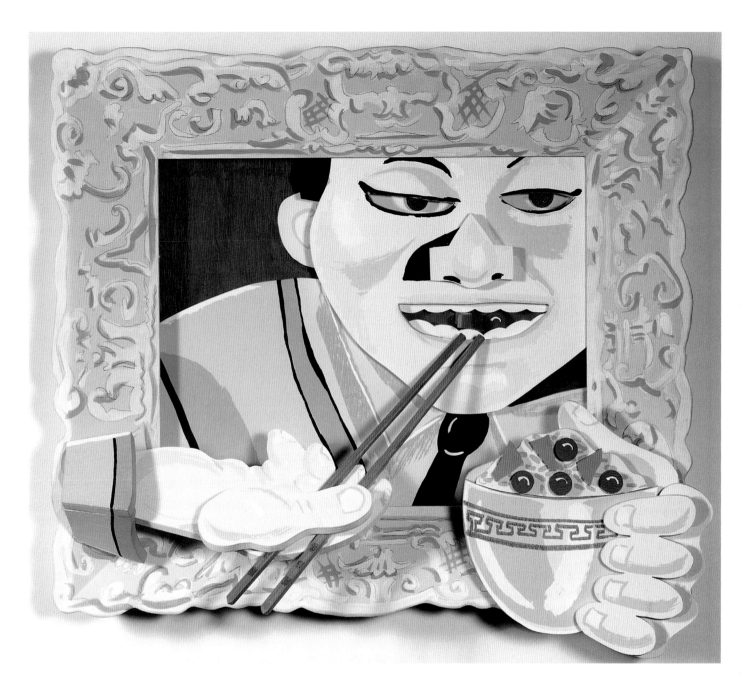

Peking Delight, 1979. Three-dimensional silkscreen, pochoir, stencil, and rubber stamp impressions on wood 18¼ × 20½ × 8¼″ (46.4 × 52.1 × 21.0 cm). Cat. no. 76.

"I had an old picture frame sitting around for a long while in my studio. I suddenly had an inspiration and used my saber saw to cut out the elements of Peking Delight—the man's face, shoulders, hands, rice bowl, and carrots. I glued them quickly into my old frame. That piece became the maquette for the multiple I did with Steve. Of course, the whole thing was set up to use a real pair of chopsticks as the 'punch line'."—Red Grooms

"This was the piece that Red initially came to Minneapolis to produce. It was not too complicated and was quite easy to assimilate into project status. This resulted in providing a fair amount of free time for Red and me to consider more projects. During the following two weeks we produced enough projects to keep me and my staff busy for the next two years."

—Steve Andersen

Truck, 1979. Lithograph 24½ × 61¾" (62.2 × 156.9 cm). Cat. no. 77.

"Brooke again took advantage of a highly worked-up key plate and published this black-and-white version of Truck *separate from the color* Truck II.*"*—Red Grooms

Truck II, 1979. Lithograph, silkscreen, and rubber stamp impressions 24½ × 61¾″ (62.2 × 156.9 cm). Cat. no. 78.

"My New York studio is on an alternate route to Canal Street. Back in 1979 the street still had its original cobblestones. Big trucks constantly pass by heading east to the Manhattan Bridge. I was intrigued by the tactile 'pun' of the sensuous female hosiery loaded inside the cavernous masculine truck."—Red Grooms

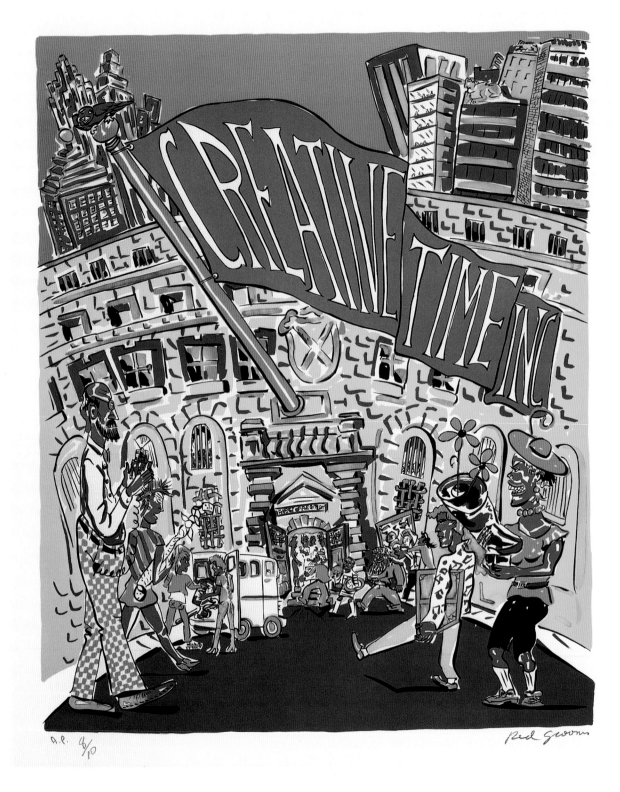

a.p. 4/p Red Grooms

Benefit for Creative Time, 1980. Offset lithograph 27 × 22″ (68.6 × 55.9 cm). Cat. no. 79.

"Creative Time was directly responsible for obtaining the work space at 88 Pine Street, New York, which was the main studio for the creation of Ruckus Manhattan, *1975–1976. I later worked with Creative Time in 1982, when the organization provided a large temporary exhibition space on 54th Street and 6th Avenue for a revival of* Ruckus Manhattan. *The complete edition of this print was given for the benefit of Creative Time, which had set up an exhibition space in an old prison located near the southern end of Manhattan. The image depicts crowds of art lovers descending on the fort-like structure."* —Red Grooms

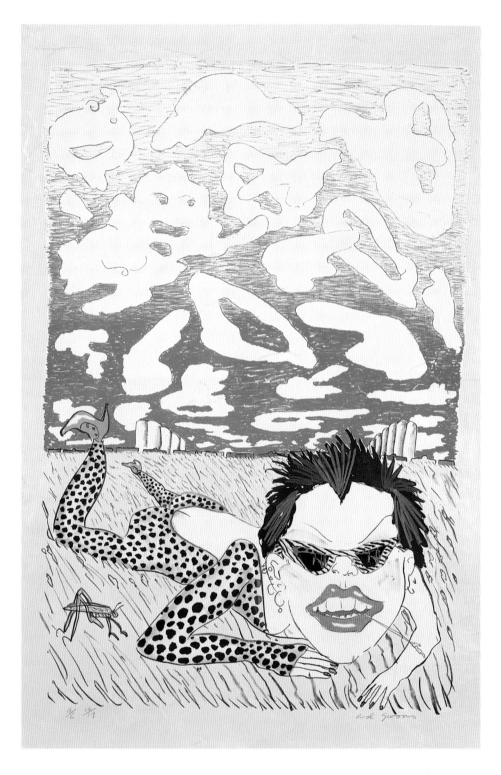

Lorna Doone, 1980. Lithograph with collage and rubber stamp impressions 49 × 32″
(124.5 × 81.3 cm) two sheets each 24½ × 32″ (62.2 × 81.3 cm). Cat. no. 80.

*"Lorna Doone is worth recounting in full: Once when Red was here, he needed to send a card to some
friends back in New York, so he left the studio for a few minutes to drop into a card shop he'd seen down
the street. Well, a few minutes later he came running back in shouting, 'Quick, where's something I can
draw on!' There were some lithographic stones laid out on the counter, and he began to draw right onto
one of them a caricature of this new-wave girl who was the clerk at the card shop. She had purple hair
and sunglasses, and he put her in this leopard-skin outfit. Then behind her he added some silos and put
the reflection of a truck in her sunglasses. She was supposed to be the Minneapolis version of* Christina's
World*. . . . He couldn't think of a name for her, though, so he went back to the card shop and asked what
her name was. It was Lorna Doone. That name absolutely made Red's day—his week."* —Steve Andersen

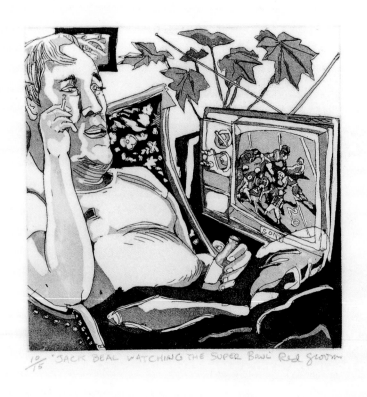

"JACK BEAL WATCHING THE SUPER BOWL Red Grooms

Jack Beal Watching Super Bowl XIV, 1980. Etching and aquatint 18 × 14¾"
(45.7 × 37.5 cm). Cat. no. 81.

"This was the more commercially successful of the two Super Bowl etchings."
—Red Grooms

*"I've always carried sketchbooks around and drew friends and strangers
alike. When Jack asked me over to watch the Super Bowl, I decided to bring
copper plates instead of my usual sketchbook. Jack is one of the most avid
sports fans I've ever known. I remember he and his wife, Sandy, giving a
big party in their lower Manhattan loft on the night Cassius Clay defeated
Sonny Liston for the Heavyweight title."*—Red Grooms

*"I like the way Red used fine, subtle aquatint tones to make two lively,
interesting prints of what I consider a boring pastime!"*—Jennifer Melby

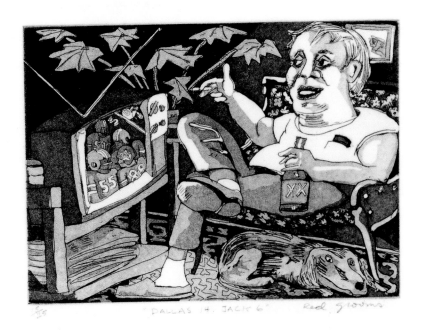

Dallas 14, Jack 6, 1980. Etching and aquatint 14⅛ × 13⅞″ (35.2 × 35.9 cm).
Cat. no. 82.

*"Actually Pittsburgh beat Los Angeles 31–19 in Super Bowl XIV, well
so much for* Dallas 14, Jack 6.*"* —Red Grooms

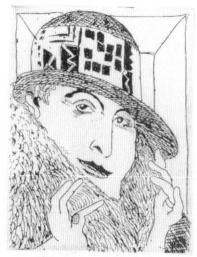

Rrose Selavy, 1980. Etching 10½ × 7½″ (26.7 × 19.1 cm). Cat. no. 83.

"The subject is after the famous photograph by Man Ray of Marcel Duchamp dressed as his alter ego, Rrose Selavy." —Red Grooms

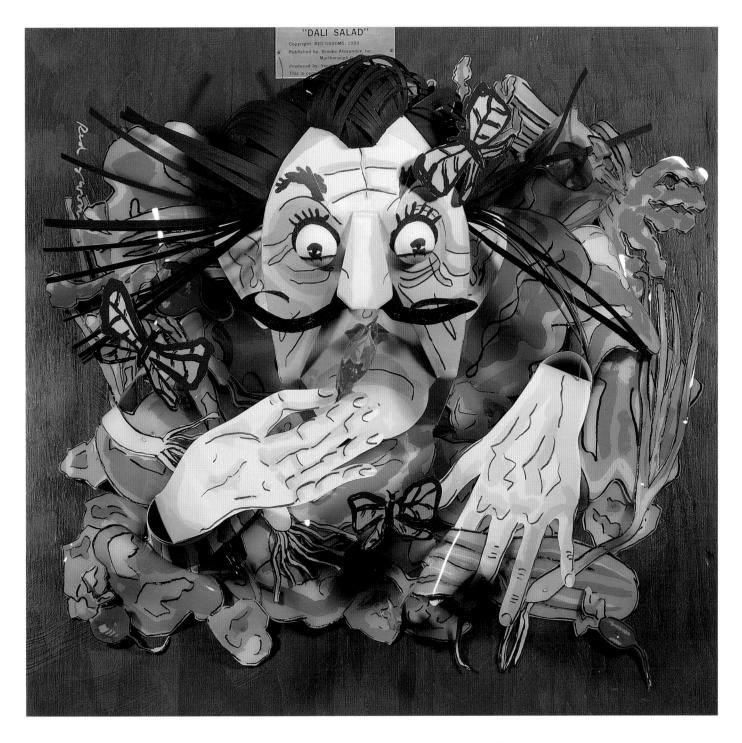

Dali Salad, 1980. Three-dimensional lithograph and silkscreen in Plexiglas dome 26½ × 27½ × 12½"
(67.3 × 69.9 × 31.8 cm). Cat. no. 84.

*"I really admire Dali, but of course his presentation of himself was to say the least a bit over
ripe. So, thinking along these lines I came up with a salad bar approach to him."*—Red Grooms

*"Dali Salad is just what the name implies: a portrait of the mustachioed surrealist Salvador
Dali rising out of a tureen of salad fixings—lettuce and celery and green onions and radishes.
The piece was inspired by an eventful trip to Byerly's Grocery. When Andersen and Grooms
stopped for groceries, Grooms was struck by the Hollywood quality of the glamorama super-
market. Purchasing bags and bags of food, Grooms decided to create a work that would have
the surreal flavor of a grocery store where you can buy a head of lettuce or an object d'art at
3 A.M., littering Vermillions's studio with edible greens."*—Erika Doss

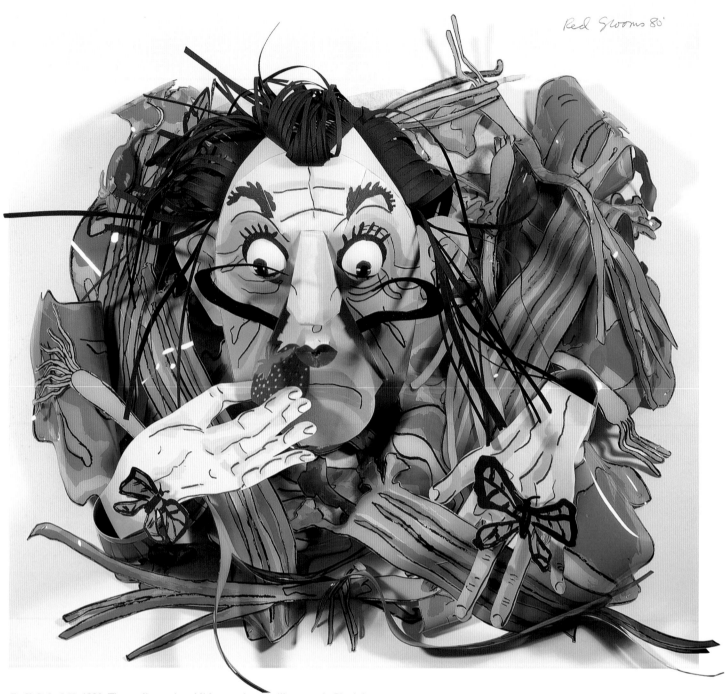

Red Grooms 80'

Dali Salad II, 1980. Three-dimensional lithograph and silkscreen in Plexiglas dome 26½ × 27½ × 12½" (68.9 × 69.9 × 31.8 cm). Cat. no. 85.

"Brooke was dissatisfied with the first version on a roughly textured hand-painted navy blue background, so he called a 'pow wow' of Steve, Chip Elwell, and myself and decided to 'clean up' the piece, starting by getting rid of the navy blue. I was under the influence of the 'punk' music scene at the time and I wanted something dissonant to set Dali ajar. However, I respected Brooke's taste and modernist eye and fell in line with the changes. Today, both versions have their adherents."—Red Grooms

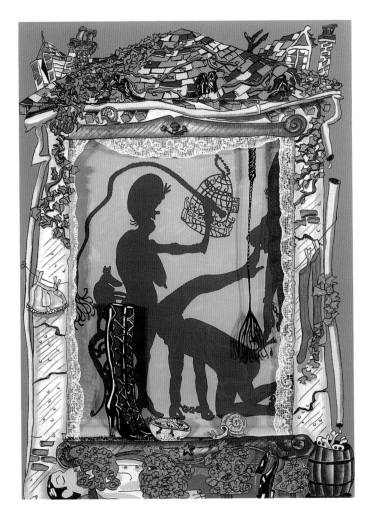

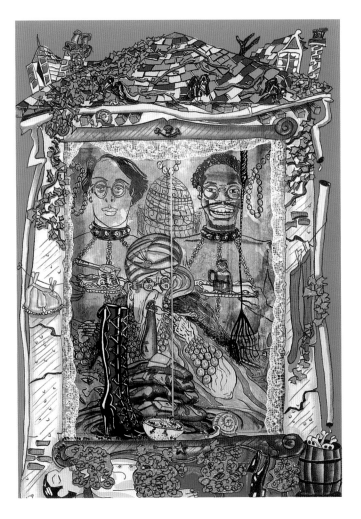

Pancake Eater, 1981 (closed). Lithograph and silkscreen with gold radiance powder, covered with Plexiglas 42½ × 30½ × 3″ (108.0 × 77.5 × 7.6 cm). Cat. no. 86.

Pancake Eater, 1981 (open). Cat. no. 86a.

"During the couple of weeks I worked with Steve, I was getting up early and having breakfast at a downtown Minneapolis joint that served pancakes, bacon and eggs, etc. The clientele was a nice mix of derelicts, traveling salesmen, and interesting ladies who looked like they might have money hidden in their socks. I suspected everyone had a secret or two. I concocted a fantasy about one of these ladies and her imaginary staff. Originally it was one flat sheet intended to be part of Sex in the Midwest, but it seemed to need a more developed plot line so Steve and I added the action on the shade and the house to act as a frame and to ensure privacy." —Red Grooms

"I still wonder from time to time who exactly the dead guy in the bushes is." —Steve Andersen

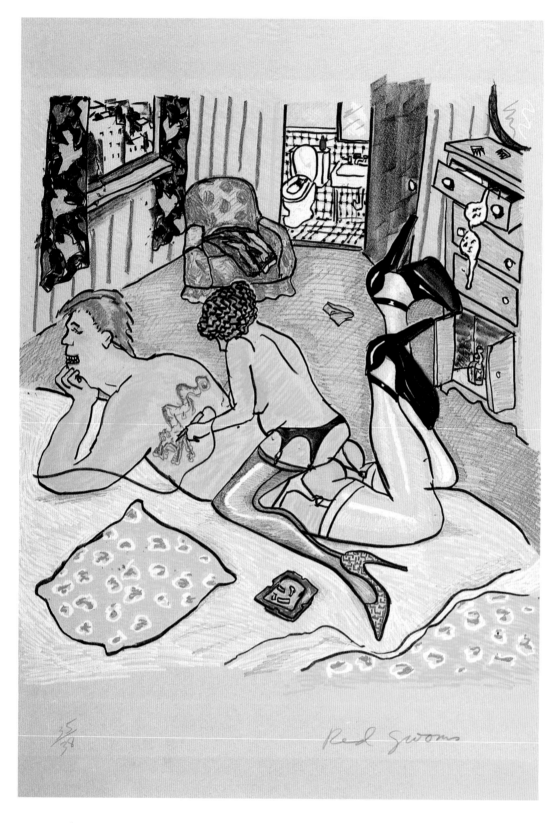

The Tattoo Artist, 1981. Lithograph 36 × 25″ (91.4 × 63.5 cm). Cat. no. 87.

"When I began to draw this stone I could feel my face turning red so I knew it was a good candidate for the Sex in the Midwest *portfolio."*
—Red Grooms

"I thoroughly loved making this print. Red's consummate drawing skills made the litho plates as alive as fresh ink on virgin paper. The color and quality of the paper also has a very real skin-like feel."—Steve Andersen

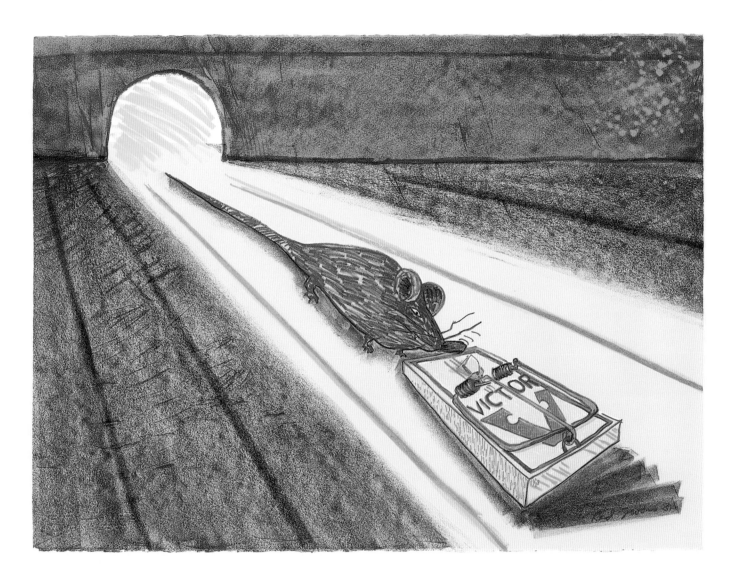

Mid-Rats, 1981. Lithograph 22⅜ × 30″ (56.8 × 76.2 cm). Cat. no. 88.

"Rats are a staple in my work, see Nervous City *'71,* Rat *'71,
and the flattened rat in* Truck *'79."*—Red Grooms

Mountaintime, 1981. Lithograph with collage 30 × 22″ (76.2 × 56.5 cm). Cat. no. 89.

"This print marks the beginning of my most productive print collaboration, 1981 to the present. It all began when I received a call from Jeffery Moore, the director of Andersen Ranch, in Snowmass, Colorado. Jeffery asked me to come out to Colorado and work with Bud Shark. I accepted and it was a landmark event for my career. Being in Colorado and working with Bud seemed to open up a whole new horizon."

—Red Grooms

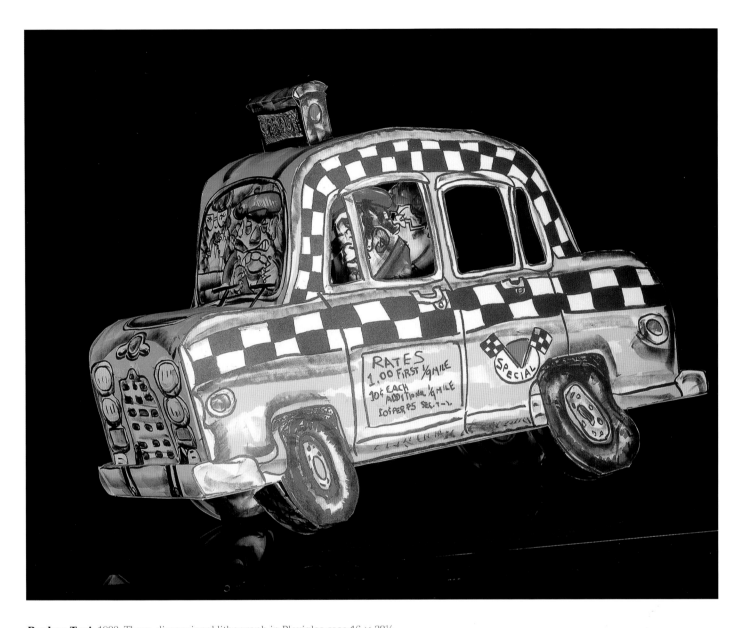

Ruckus Taxi, 1982. Three-dimensional lithograph in Plexiglas case 16 × 28½ × 14″ (40.6 × 72.4 × 35.6 cm). Cat. no. 90.

"I had just made a very large walk-in taxi (20 × 30 × 12′) for the Revival of Ruckus Manhattan *and I was keen on getting out a practical-sized version of this image, which I liked a lot and thought would go over well with print collectors."* —Red Grooms

"My first three-dimensional print with Red is truly ruckus with the cut, folds and fit of tabs very casually done. The print is mounted in a Plexiglas case tilted up on two wheels as if in a 'skid.'" —Bud Shark

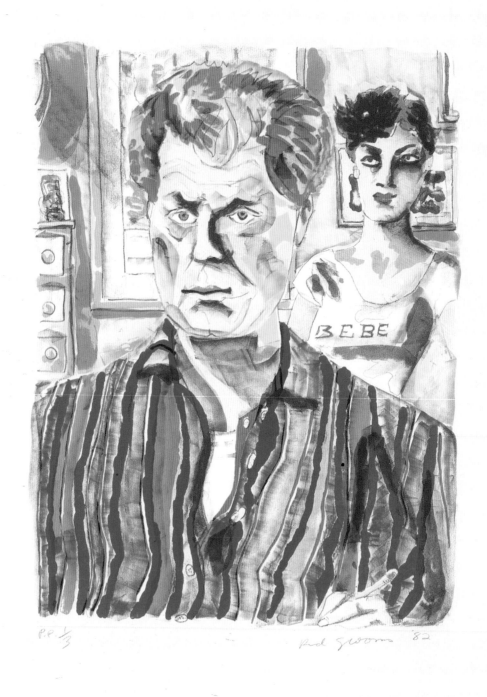

Above: **Self-Portrait with Liz**, 1982. Lithograph 20 × 16″ (50.8 × 40.6 cm). Cat. no. 91.

"I was going crazy working on the stripes of my shirt, I needed to loosen up and have some fun. I decided to go cartoonish and plunge into Ruckus Taxi, *which Bud and I started during the same work period."*—Red Grooms

Opposite: **Fred and Ginger**, 1982. Silkscreen 40 × 26″ (101.6 × 66.0 cm). Cat. no. 92.

"I donated the edition of Fred and Ginger *to Senator Howard Metzenbaum's re-election campaign. The senator and his wife, Shirley, love dancing, which sparked my idea for this version of the famous musical motion picture couple."*—Red Grooms

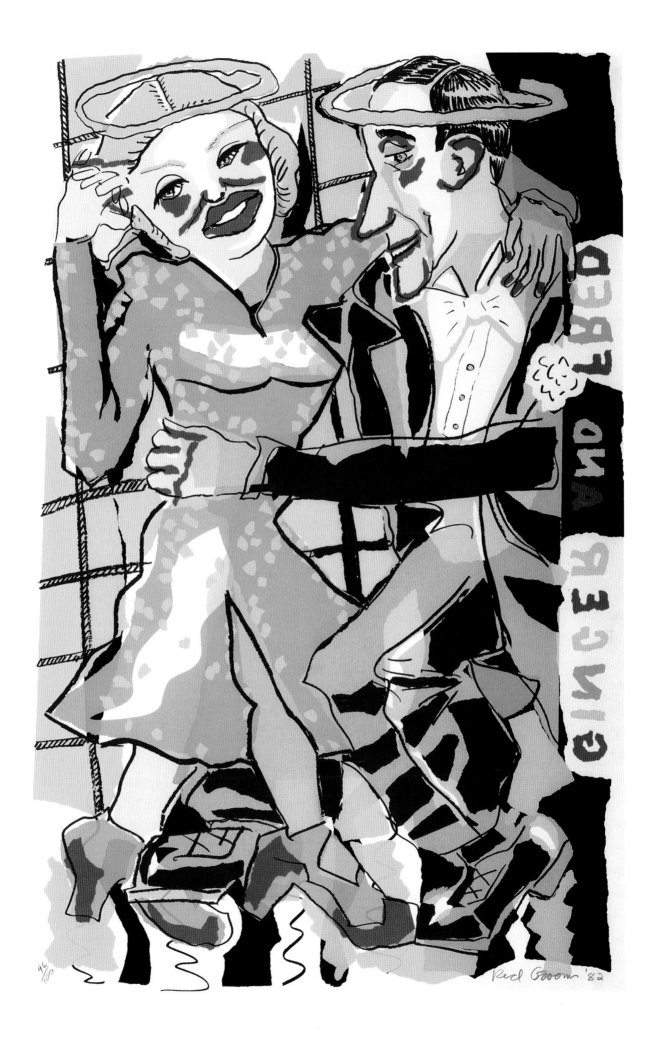

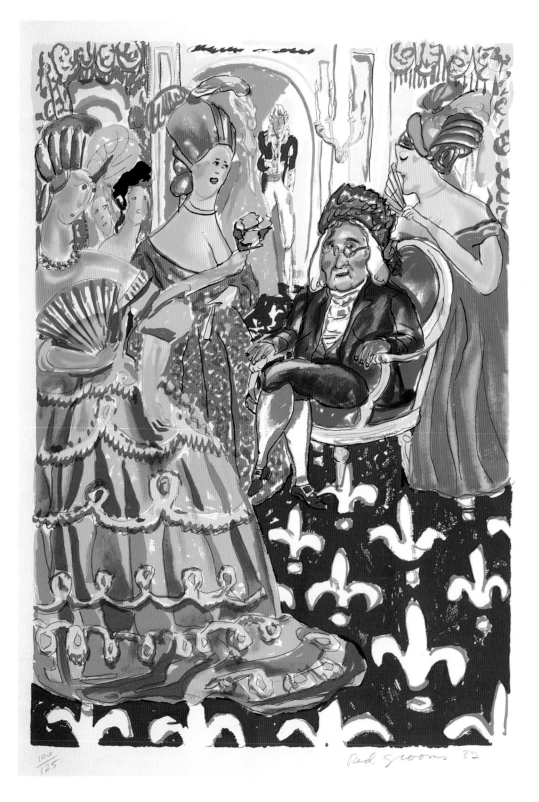

Franklin's Reception at the Court of France, 1982. Silkscreen 45 × 31½″ (114.3 × 80.0 cm). Cat. no. 93.

"After the Clinton scandal, I was asked to suggest a print for purchase by the graduating class at a prominent medical school. I sent Franklin's Reception at the Court of France *for their approval. A short time later a representative of the school telephoned and explained nervously that my suggested print was not considered suitable for the student gift. Suddenly realizing the climate of the times, I suggested several other non-co-educational prints."*—Red Grooms

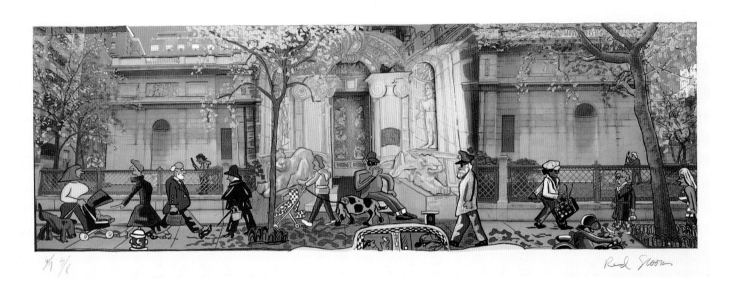

Pierpont Morgan Library, 1982. Offset lithograph 15 × 37¹¹⁄₁₆″ (38.1 × 95.7 cm). Cat. no. 94.

"This print was inspired by a sculpto-pictorama project I completed for the Hudson River Museum in 1979. The middle part of the façade of the Pierpont Morgan Library is actually a photograph of part of the sculpture I made for the museum. The rest of the building is the real McCoy. The people are not real New Yorkers, but phantasms of my imagination."—Red Grooms

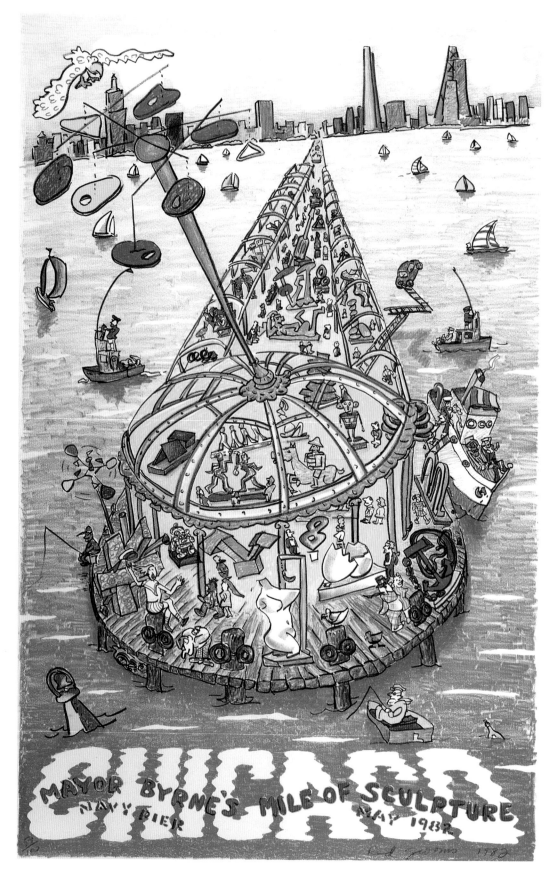

Mayor Byrne's Mile of Sculpture, 1982. Lithograph 36 × 23¼"
(91.4 × 59.1 cm). Cat. no. 95.

*"Another of the few prints for which I had the color separations
'Ghosted.' This time Steve did the honors."* —Red Grooms

"This was my high Colorado period. I was so excited to be in that part of the country, I was looking for local subject matter on each visit with Bud. But soon afterward we started selecting more 'universal subjects'."
—Red Grooms

"The concept for the print was first worked on in 1981 at Andersen Ranch. It took some time to work out a simple but effective method of moving the parts. 'The Mesa & Gas Station' were spotted by Red and me on a camping trip while driving through Kremmling, Colorado. So we actually saw the scene that became the print."
—Bud Shark

Tonto—Condo (Tonto) 1983. Three-dimensional lithograph with moving parts, in Plexiglas case 23¼ × 30⅝ × 6¾" (59.1 × 77.9 × 17.2 cm). Cat. no. 96.

Tonto—Condo (Condo) 1983. Cat. no. 96a.

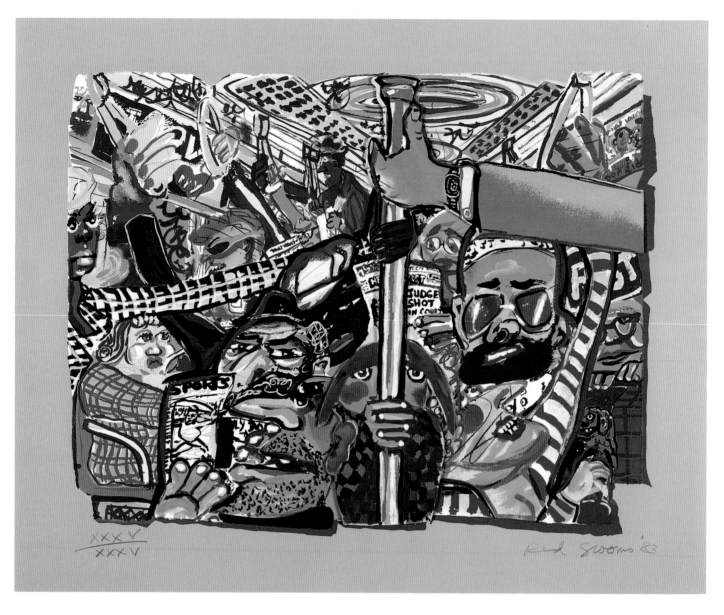

Saskia Down the Metro, 1983. Silkscreen, in two separate prints, one die-cut and laminated to the other, from *New York, New York* portfolio. 29½ × 36¼″ (75.0 × 92.1 cm). Cat. no. 97.

"I was intrigued by the French film Zazie Dans Le Metro *and wanted to do an image of my daughter Saskia in a similar predicament. While commuting by subway to her junior high school in New York, Saskia and her girlfriends had to avoid the known creeps who always hung out in the same spots like trolls. Some of the suspects here were also sculpted on the Ruckus Manhattan* Subway.*"*

—Red Grooms

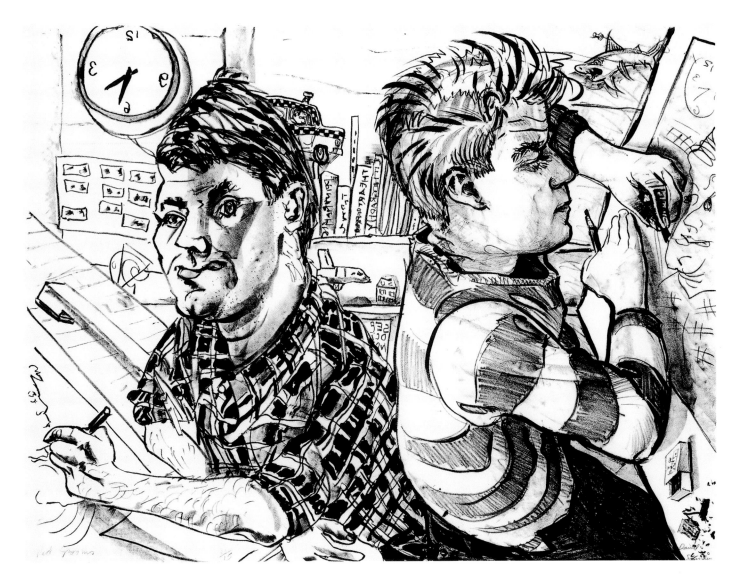

Red Grooms Drawing David Saunders Drawing Red Grooms, 1983.
Lithograph 22 × 30″ (55.9 × 76.2 cm). Cat. no. 98.

"David traveled to Japan in 1982 to help install my exhibition at the Seibu Museum in Tokyo. Subsequently, David traveled to Japan in 1993 for the four-city tour of my work; he also spearheaded the painting of a trolley car I designed for the city of Koichi, Japan."

—Red Grooms

Downhiller, 1983. Lithograph 41½ × 29″ (105.4 × 73.7 cm). Cat. no. 99.

*"Matt Christie, Bud's faithful assistant, is renowned for his fine
posterior. And it certainly came in handy for this rear view of a
Downhiller."* —Red Grooms

London Bus, 1983. Three-dimensional lithograph in Plexiglas case 20 × 22 × 14″ (50.8 × 55.9 × 35.6 cm). Cat. no. 100.

"My father, Roger Gerald Grooms, worked most of his career for the Tennessee Highway Department. He was the equipment engineer responsible for purchasing large road-building equipment. Perhaps this gave me a reason to be fascinated by all manner of vehicles, large and small. After the taxi what next? The bus." —Red Grooms

"Typical of three-dimensional prints, Red brought a maquette, which we then broke down to figure out folds, tags, and layout on the printed sheet. We went through several revisions to adjust fit for assembly. Hidden on the bottom of the bus are a teapot and plate of 'crumpets'."
—Bud Shark

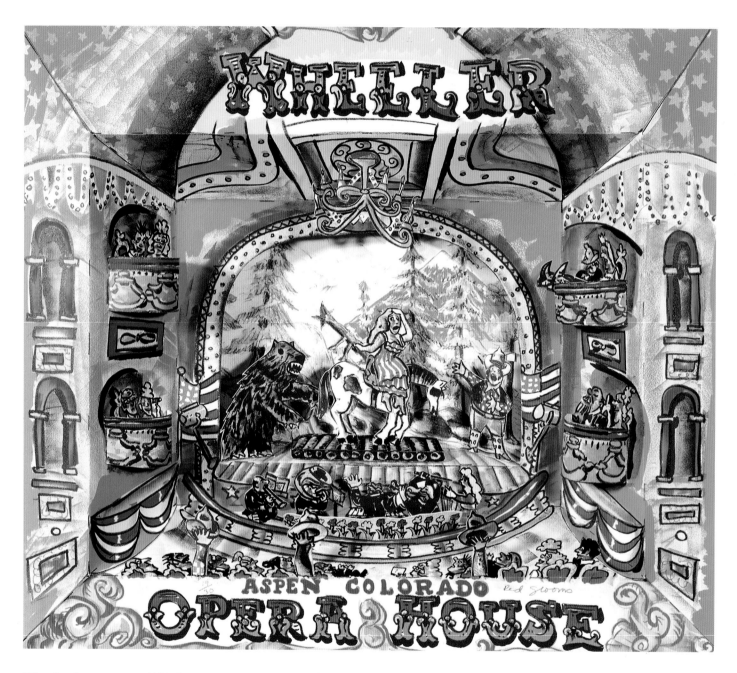

Wheeler Opera House, 1984. Three-dimensional lithograph in Plexiglas case 17½ × 20 × 4¾″ (44.5 × 50.8 × 12.1 cm). Cat. no. 101.

"One of the prime sources for my 'pop-up' lithographs is the paper Procenium Theaters produced for children around 1900. Wonderfully drawn lithographs, they were composed on flat paper sheets to be cut and pasted into three-dimensional parlor entertainments. The Wheeler Opera House was a natural for a similar kind of treatment."
—Red Grooms

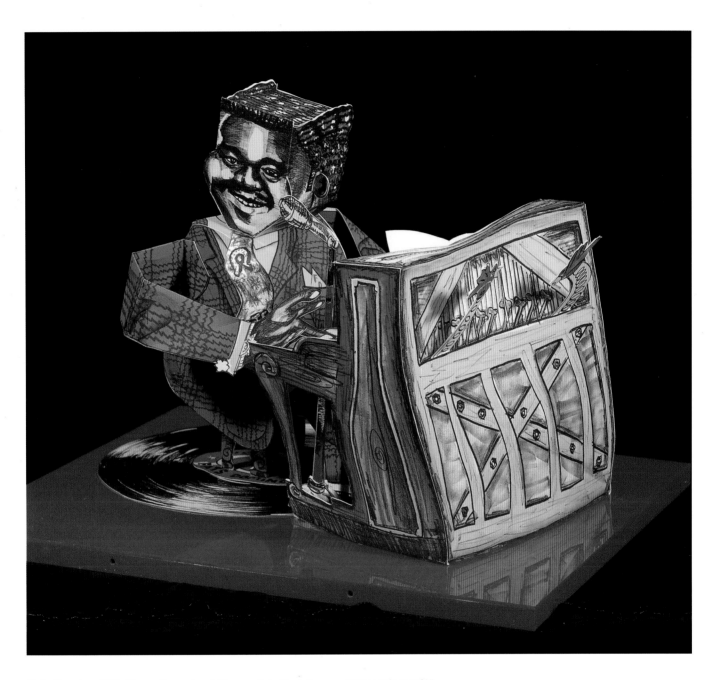

Fats Domino, 1984. Three-dimensional lithograph in Plexiglas case 17¼ × 20⅜ × 17⅜″ (43.8 × 51.8 × 44.1 cm). Cat. no. 102.

"Bud has a very regular work schedule: 8:00 A.M. to 5:00 P.M. on the dot, lunch from 12:00 Noon to 1:00 P.M. But I remember somehow that, on Fats we got so involved in the portrait work on his face that we looked up and to our surprise it was 10:00 P.M."—Red Grooms

"We played a lot of '50s and '60s Rock-n-Roll in the studio. It was part of Red's (and my) culture while growing up. This was a tribute to Fats Domino and relates to other musicians he has portrayed including Elvis Presley and Chuck Berry and the little known Ersel Hickey."—Bud Shark

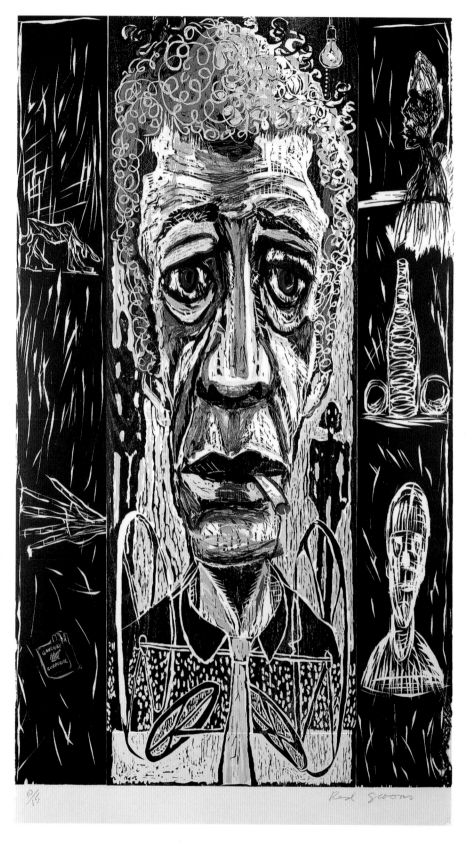

The Existentialist, 1984. Woodcut 77 × 42″ (195.6 × 106.7 cm). Cat. no. 103.

"Garner Tullis brought a very large woodblock to my studio and handed me a reciprocating chisel. I proceeded to carve the line plate for my largest print to date. The subject is the great Swiss artist Alberto Giacometti, a favorite of mine. I had difficulty getting a likeness of his ruggedly handsome face."—Red Grooms

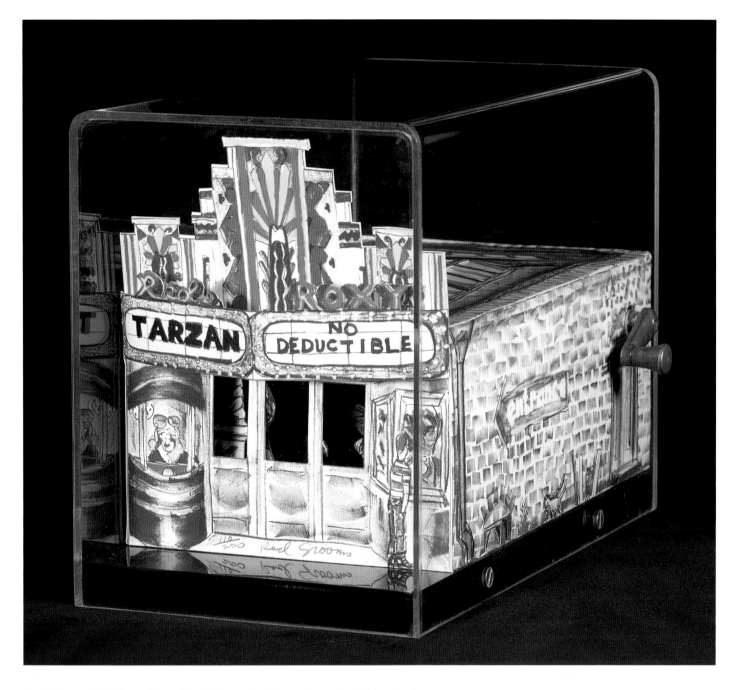

Red's Roxy, 1985. Three-dimensional lithograph with crank operated Mylar film in Plexiglas case. 8¼ × 6½ × 11⅝″ (21.0 × 16.5 × 29.5 cm). Cat. no. 104.

"I started making 'Paper Movies' back in the 1960s. Little scrolls of paper placed behind a cardboard frame cranked by on cardboard tubes. Bud really improved the mechanism for Red's Roxy. *It was a thrill for me to see our little theater rolling off the assembly line ready to work. This was really like playing; I started imagining that we were movie moguls making films in miniature."*—Red Grooms

"Red had made several short movies using simple cranks, some with toilet paper rolls as the rollers. For the editions, we thought we could do something equally simple but it got increasingly complicated and we ended up designing a complete mechanism with nylon gearing and a vacuum-formed housing for the film mechanism. The filmstrip was done on Mylar. The story line shows Tarzan has his insurance canceled because his lifestyle is too dangerous. Title: 'Tarzan: NO Deductible'."—Bud Shark

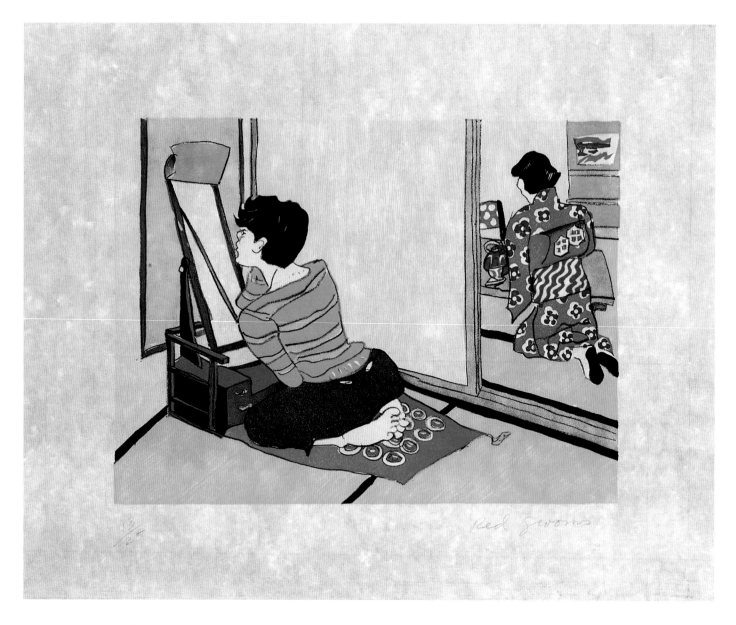

American Geisha, 1985. Lithograph, woodcut, and linocut 18½ × 22½" (47.0 × 57.2 cm). Cat. no. 105.

"This was the first time I had the option to work in the field on a print. Bud had gotten hold of special paper and pencils, which I could use like a sketchpad. Later the 'live' image could be transferred to a metal plate. This litho plate became the line or 'key plate.' I colored a proof for Bud. He then cut wood and linoleum blocks for all the colors. I have always loved to draw while traveling so I was particularly excited by the possibilities this medium offered me." —Red Grooms

"Our first relieve print with Red. It came from our trip to Japan for the installation of Ruckus Manhattan *at the Seibu Museum in Tokyo. I had brought along some transfer paper for Red to work on during our travels. This portrait of an American woman applying her makeup before a mirror while sitting on a mat was one of the drawings Red did, which I transferred to a plate. After proofing it in black, Red watercolored a proof and the wood & linoleum blocks were cut for the color printings. It was printed on Suzuki paper to enhance the 'Japanese' feel of the print."*
—Bud Shark

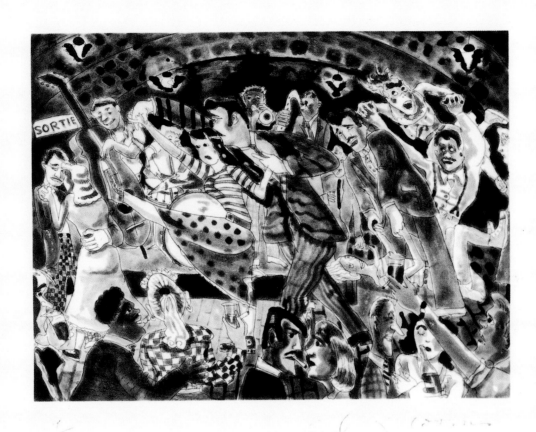

Café Tabou, 1985 (published in 1986). Etching and aquatint 14 × 15⅝″ (35.6 × 39.7 cm). Cat. no. 106.

"This aquatint was a warm up for the big Les Deux Magots. *I needed to understand Aldo Crommelynck's working methods and he kindly showed me how to use the spit-bite technique. The acid flows into the spittle and is carried to the copper by a brush. It has a greenish-yellow color and sits up on the plate in a way that defines the shape it is applied to. Aldo wanted me to get a sense of how long to leave it before wiping it off with a rag. The longer it is left, the darker the area will become. Done properly, it gives a soft tone and feathered edge. I went to underground clubs like this one on my first visit to Paris in 1960."* —Red Grooms

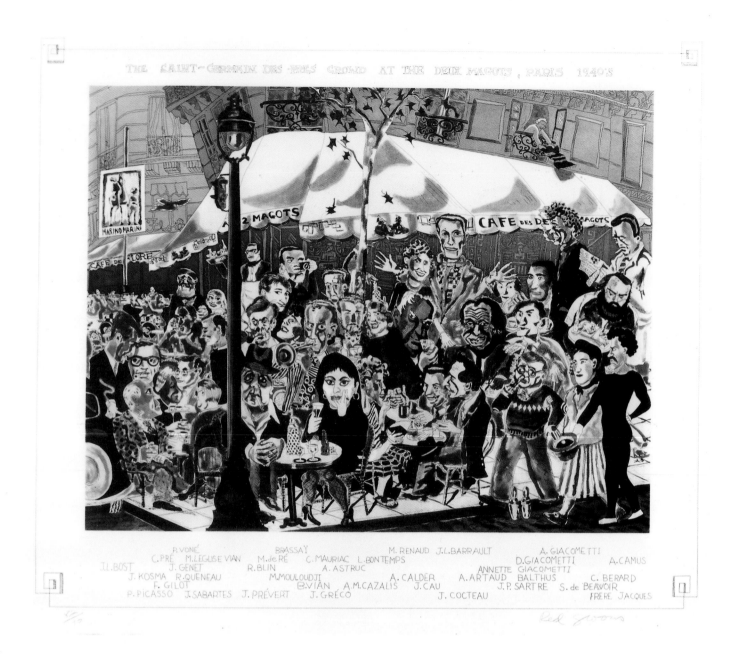

Les Deux Magots, 1985 (published in 1987). Etching and aquatint 26¼ × 31⅜" (66.7 × 79.7 cm). Cat. no. 107.

"*I really wanted to do an ambitious project with Aldo Crommelynck and I was inspired to be working in Paris, as well as by the quiet, professional atmosphere of his studio. My wife, Lysiane, who is Parisian and grew up in the Latin Quarter, was very helpful with the research, as was her mother, Jeannine Hao, her stepfather, Raymond Mason, and her sister Iris. They supplied me with the names and photographs of important artists and writers of the postwar era who frequented the cafés on Boulevard Montparnasse. This print really is a homage to the French culture that has shaped my view of art and philosophy.*"—Red Grooms

"*The print entitled Les Deux Magots created using etching and aquatint techniques by Red Grooms in 1985, is an ambitious project which I was able to work on from beginning to end. I choose a complicated subject from among the ones I have had the pleasure to work with him on because it illustrates the originality of his creative method. Red improvised without a preparatory transfer on to the copperplate of any sort of sketch, nor even a schematic tracing that would have established the balance of the composition. Using an etching needle, guided by his usual verve and enthusiasm, he made a fluid line across the hard-grounded plate. The image began on one side of the plate, developed methodically and in detail; toward the opposite side, a little like a musician's melody written on a score. Little by little, this slow progression revealed to us the artist's total vision. An interior vision, where each of the numerous characters on the stage took shape and one by one inserted him/herself into the crowd and amongst the many decorative elements. This process is riddled with dangers. The major risk is the accumulation of confusing, intersecting lines. If these lines are too numerous they could cloud the clarity of the work. Miraculously, these unfixable mistakes are very rare in this work. Bravo!*"—Aldo Crommelynck

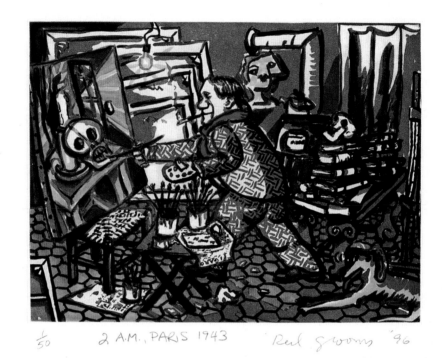

1/50 2 A.M., PARIS 1943 Red Grooms '96

2 A.M., Paris 1943, 1985 (published in 1996). Aquatint 14⅜ × 16"
(36.5 × 40.6 cm). Cat. no. 108.

*"The mood and many of the details of this little print were
echoed in a large painting I completed in 1995 entitled* Rue
des Grands-Augustins.*"*—Red Grooms

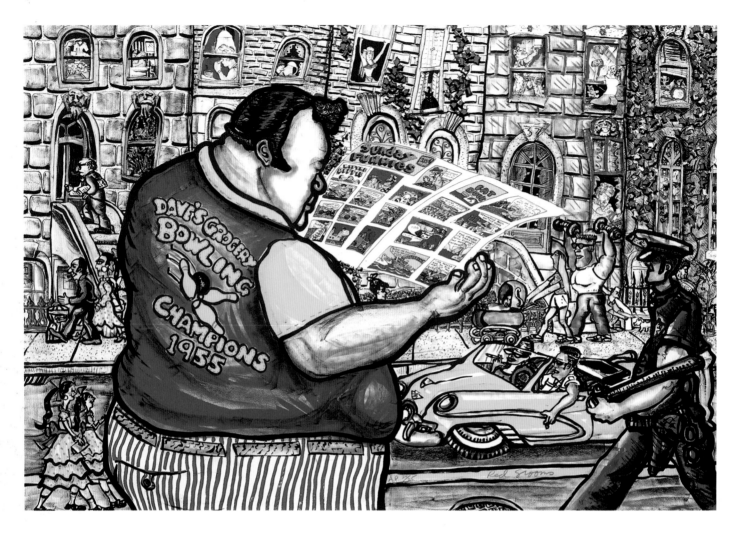

Sunday Funnies, 1985. Lithograph and photo lithograph 30¼ × 44½"
(76.8 × 113.0 cm). Cat. no. 109.

*"Bud had a great technique for doing the funny paper. Ron Trujillo,
Bud's assistant, did some nice work with benday dots to give it a special
graphic look."* —Red Grooms

*"Red's street scene includes portraits of Marvin and Sheila Friedman
and their two daughters, Chloe and Natasha, walking on the sidewalk.
The Friedmans were collectors and friends who arranged for the
print to be done for the MJHHA. The 'funny' paper was done as a
photo lithograph from Mylar drawn by Red."* —Bud Shark

Charlie Chaplin, 1986. Three-dimensional lithograph in Plexiglas case 23 × 18½ × 11¼″ (58.4 × 47.0 × 28.6 cm). Cat. no. 110.

"Making the 'pop-up' prints with Bud has always seemed like a vaudeville act and this time we chose the 'great' Chaplin. . . . Sometimes I've wondered how I could have the nerve to do yet another image of such a well-known personality. All I can say is, I just 'felt' it at the time." —Red Grooms

"Red's portrait of Chaplin 'On the Road' was the first freestanding full figure to be done as a three-dimensional Lithograph. The flat version of this image (sheet 1) was reproduced as a poster for the Smithsonian Institutions Traveling Exhibition: 'Hollywood Legend and Reality' 1986–1988. The three-dimensional Chaplin lithograph was reproduced on the cover of Smithsonian *Magazine July 1986."* —Bud Shark

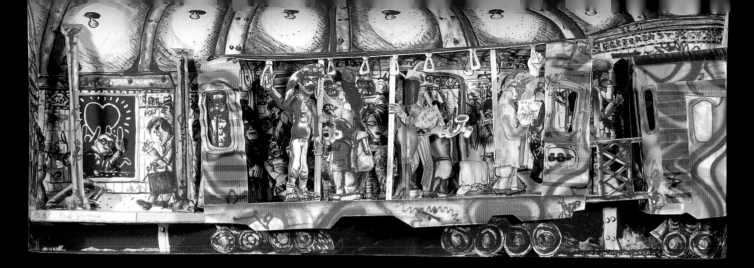

Above: **Subway**, 1986. Three-dimensional lithograph in Plexiglas case 14½ × 40⅜ × 7″ (36.8 × 102.6 × 17.8 cm). Cat. no. 111.

"Transportation again! How to show a subway car loaded with people, and in the tunnel no less? The old reliable cross-section view I guess. On the platform to the left is the great graffiti artist Keith Haring at work on one of his famous creations."—Red Grooms

Opposite: **De Kooning Breaks Through**, 1987. Three-dimensional lithograph in Plexiglas case 47 × 33 × 8¾″ (119.4 × 83.8 × 22.2 cm). Cat. no. 112.

"We came up with a nice combination of high-art (De Kooning) and low-art (pop-ups) to create one of our most successful wall reliefs. The title De Kooning Breaks Through *refers to the ab-ex painters concern with the picture planes purity."*—Red Grooms

"Done after Red's series of artist's portraits for his Marlborough exhibition in 1987. A real challenge to make this construction look as if De Kooning had burst through the painting Woman with Bicycle. *We had to make Plexiglas templates to tear each of the prints exactly the same. Red duplicated the background of the painting* Woman with Bicycle *(Whitney Museum Collection) as closely as possible, using washes and tusche—even drawing in the nails on the edge of the canvas."*—Bud Shark

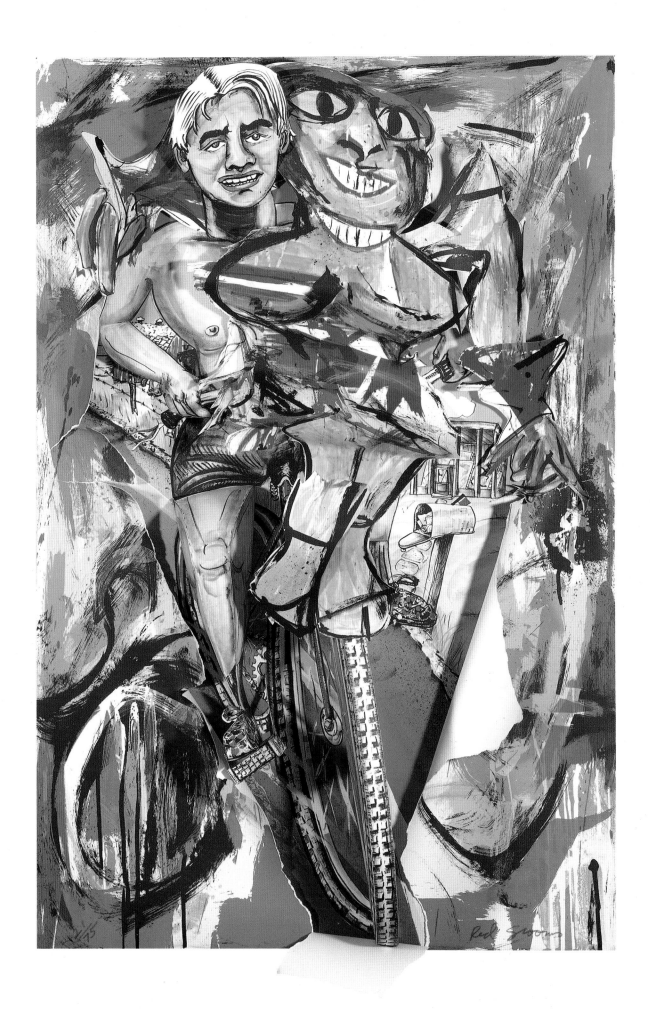

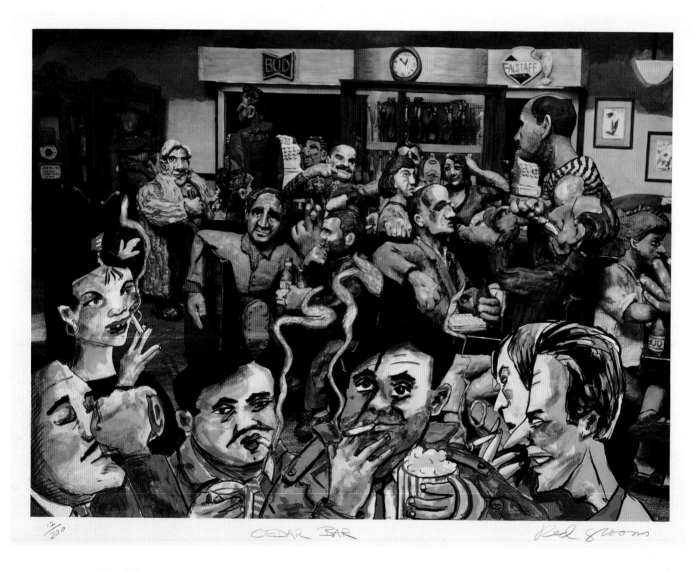

¹²/₂₀₀ CEDAR BAR Red Grooms

The Cedar Bar, 1987. Offset lithograph 24½ × 32″ (62.2 × 81.3 cm). Cat. no. 113.

"As a youth I spent time mixing with my elders at this legendary artist's bar. This print continues where I left off with Pierpont Morgan Library, *1982, combining a photograph of a three-dimensional work with an overlay of two-dimensional characters in the foreground. The sculpto-pictorama was a maquette for a full-scale* Cedar Bar *that wasn't realized."*—Red Grooms

"Red is a natural. He drew his images with such ease. The blending of the images with the photo image had been done by Joe Petrocelli before with Red on the Pierpont Morgan Library *print, so we had a good example for the print. Whenever we have visitors at the studio we offer a free print if they can name all the characters in the* Cedar Bar *print. So far, no winners. Last spring a collector purchased a proof for the Palm Springs Museum, and the curator asked for a diagram of the characters. I called Red and we went through all the people in the sculpture 'photo' part, but Red couldn't remember putting in Mike Kanemitsu and Aris Kaldis in the foreground figures. Still no winners."*—Maurice Sanchez

Lysiane and Red's Wedding Invitation, 1987. Three-dimensional lithograph in Plexiglas case 9¼ × 12¼ × 2¼" (23.5 × 31.1 × 5.7 cm). Cat. no. 114.

"Bud and Barbara were really sweet to give us this great wedding present. It is the only miniaturized Red-Bud pop-up print."

—Red Grooms

Elvis, 1987. Lithograph 44½ × 30″ (113.0 × 76.2 cm). Cat. no. 115.

"Bud did a wonderful job airbrushing the car, and the highlights he added on the hood and grill really make this print slick enough maybe even for 'Elvis' (again we were taking on an icon)." —Red Grooms

"Red's portrait of the pop icon 'Elvis.' Several plates were drawn with airbrush to achieve the 'satin' look of the suit. Split-fount inking was used to achieve the metallic sheen on the hood of the Cadillac." —Bud Shark

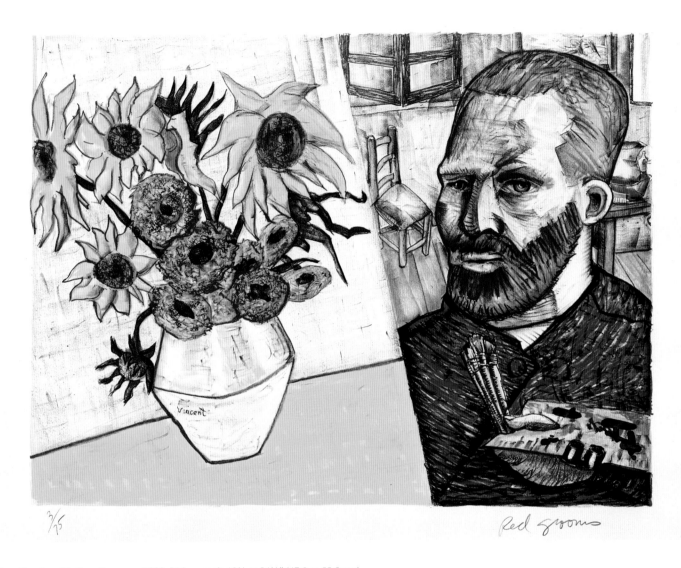

3/75 Red Grooms

Van Gogh with Sunflowers, 1988. Lithograph 18½ × 24½″ (47.0 × 62.2 cm) irregular. Cat. no. 116.

I am not only indebted to Vincent, the artist, but also to Vincent Minnelli, the director, who made a film on the life of Van Gogh, Lust for Life, *starring Kirk Douglas, which was an early influence upon my decision to become an artist."* —Red Grooms

"Red has often portrayed Vincent Van Gogh. This print was inspired by the record sale price of the sunflower painting in 1988. Red's skewed perspective allows the viewer to see both the painter and painting. We had paper especially made for this edition by Twinrocker, with an exaggerated deckle edge." —Bud Shark

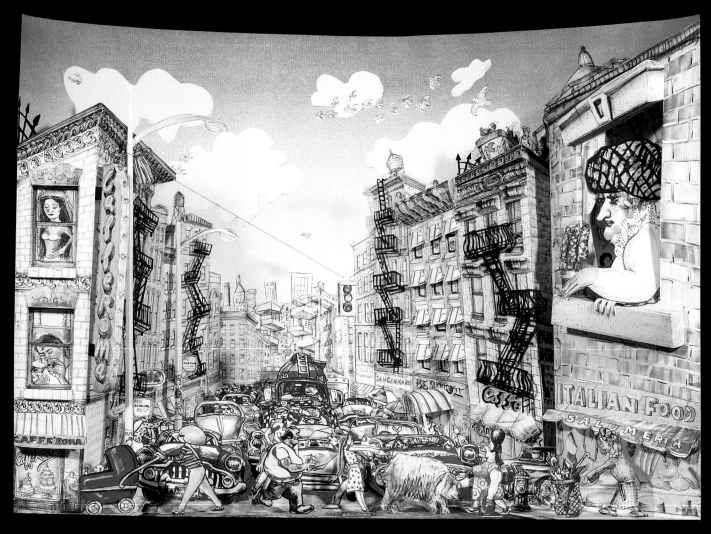

Little Italy, 1989. Three-dimensional lithograph with die cut in Plexiglas case 27 × 38½ × 16½″ (68.6 × 97.8 × 41.9 cm). Cat. no. 117.

"I had a lot of fun remembering Little Italy, my neighborhood in New York from 1965 to 1976. The view is the corner of Broome Street looking south down Mulberry Street. The Café Roma is on the left. David Saunders posed for the man in the apartment above the café and Lysiane posed for the woman in the window of the apartment above him. The lady with the curlers on the right is the star of the scene, as she rests comfortably on her windowsill watching the street action. Bud Shark can be seen negotiating the traffic on his mountain bike."
—Red Grooms

"An extremely ambitious project and the most complex we had done until Los Aficionados. Printed from 19 plates and on 5 sheets of paper. In addition the fire escapes, balconies, and ladies hairnet were all die cut from black Arches paper." —Bud Shark

Henry Moore in a Sheep Meadow, 1989. Lithograph 5⅝ × 17″ (14.3 × 43.2 cm). Cat. no. 118.

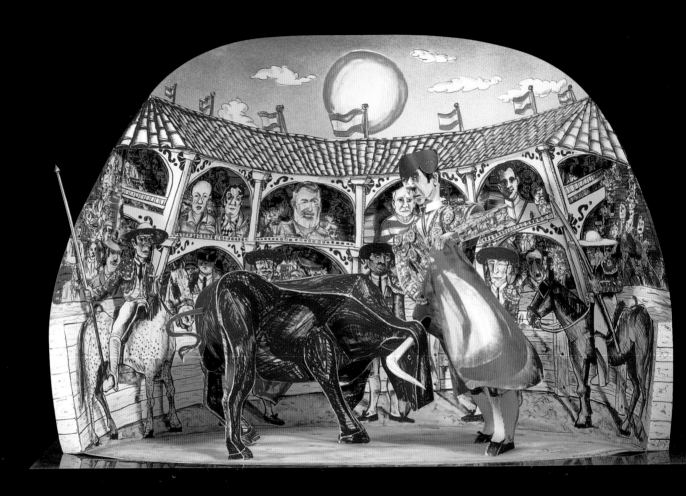

Los Aficionados, 1990. Three-dimensional lithograph in Plexiglas case 26½ × 37¼ × 25″ (67.3 × 94.6 × 63.5 cm). Cat. no. 119.

"Two very ambitious prints in a row (Los Aficionados is the size of a large television set. We were going for all the marbles when, BINGO, the art market recession stepped in and sales died halfway through the run of the edition." —Red Grooms

"Among the aficionados observing the bullfight are Ernest Hemingway, Federico Garcia Lorca, Francisco Goya, and Pablo Picasso. The subject was suggested by Pierre Levai, Red's art dealer—a true aficionado. Pierre is also part of the celebrity crowd." —Bud Shark

Grooms's Mother, On Her 81st Birthday, 1990. Lithograph 21½ × 25½"
(54.6 × 63.5 cm). Cat. no. 120.

*"It was nice to work with Mauro Giuffrida again for the first time since
Gertrude in 1975. He gave me the special paper and pencils that I had
used before on* American Geisha. *This technique allowed me to do
portraiture on the spot. I was inspired by Whistler to choose my Mom
as my subject, and, as usual, Daddy was close by her side. I did all the
color separations while my Mom and Dad posed."* —Red Grooms

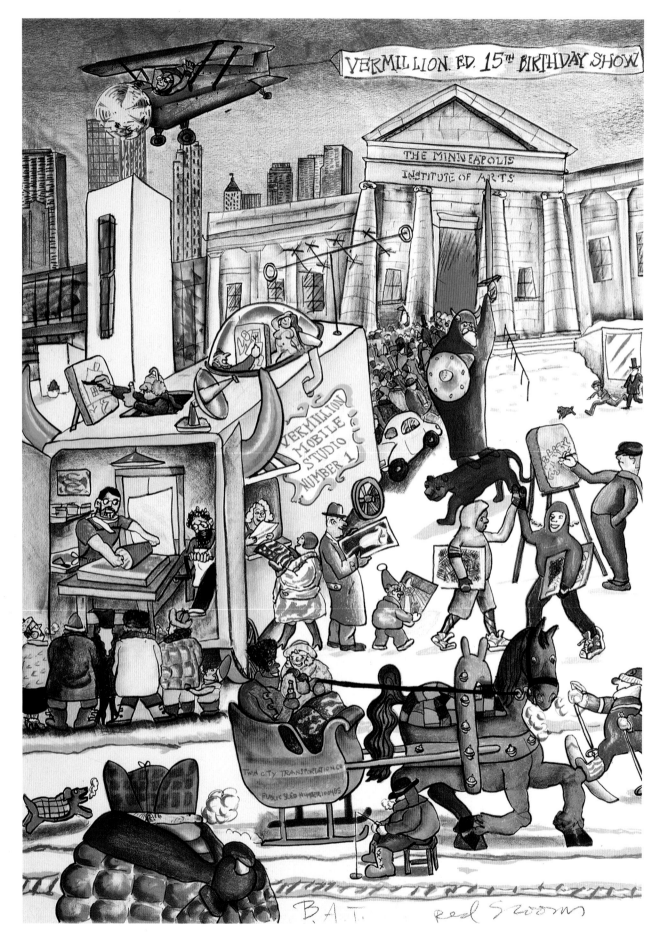

Sno-Show I, 1991. Lithograph 41½ × 29½″ (105.4 × 74.9 cm). Cat. no. 121.

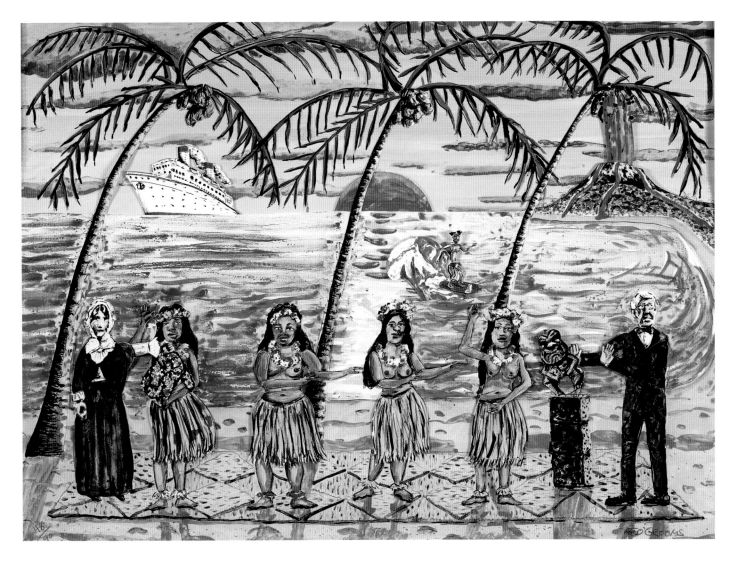

Holy Hula, 1991 (up position). Lithograph with moving parts 28½ × 36½ × 1½"
(72.4 × 92.7 × 3.8 cm). Cat. no. 122.

*"We were deep in the print recession and there apparently was no
market for missionaries, or even hula girls in 1991. Sad to say,* Holy
Hula *was a bomb. Bud did a great job to set up a real action print
but it was all lost on the public."* —Red Grooms

*"Created in my studio in Holualoa, Hawaii. The action includes
the eruption of a volcano, appearance of a ship on the horizon,
a sunrise/sunset, a surfing Duke Kahanamoku, missionaries who
attempt to cover up the bare-breasted hula girls and overthrow
a 'Tiki' god, as well as four moving 'hula girls.'"* —Bud Shark

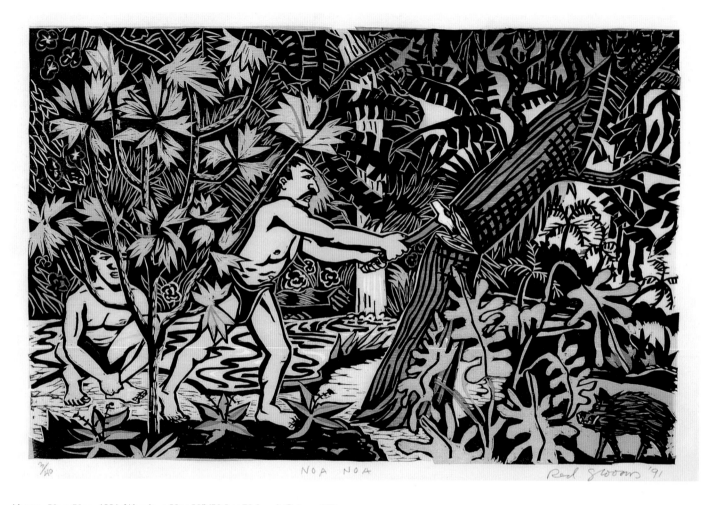

Above: **Noa-Noa**, 1991. Woodcut 20 × 30″ (50.8 × 76.2 cm). Cat. no. 123.

"Bud has a wonderful jungle studio on the Big Island of Hawaii. I was so excited to be in this new part of the world. I was filtering my experiences through all I'd read about Gauguin in Tahiti."—Red Grooms

"Noa-Noa was titled after, and inspired by, Paul Gauguin's Tahitian journal of the same name. It depicts Gauguin cutting down a rosewood tree in the tropical Tahitian forest with his friend and guide Totefa."—Bud Shark

Opposite: **Stenciled Elvis**, 1991. Stencil, Krylon spray paint 48¾ × 27½″ (123.8 × 69.9 cm). Cat. no. 124.

"This was printed in my studio. This stencil print is a spin-off from a large relief called Rashomon, *which followed the plot of the famous film by Kurosawa in a stream-of-consciousness way. I was thinking of Elvis as a gun-slinging Samurai, but I was also lifting from Warhol's famous painting taken from a movie still of Elvis."*—Red Grooms

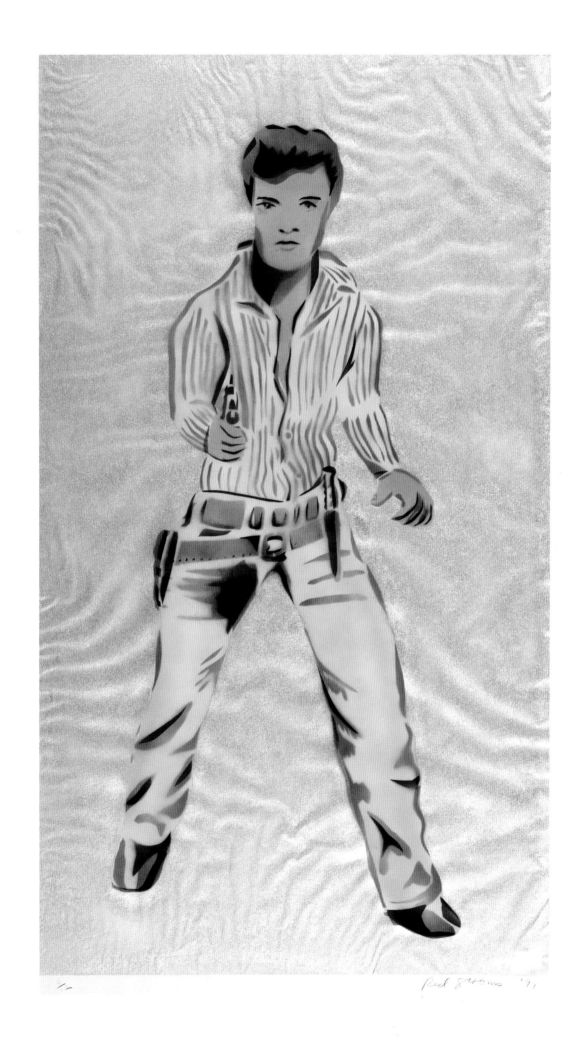

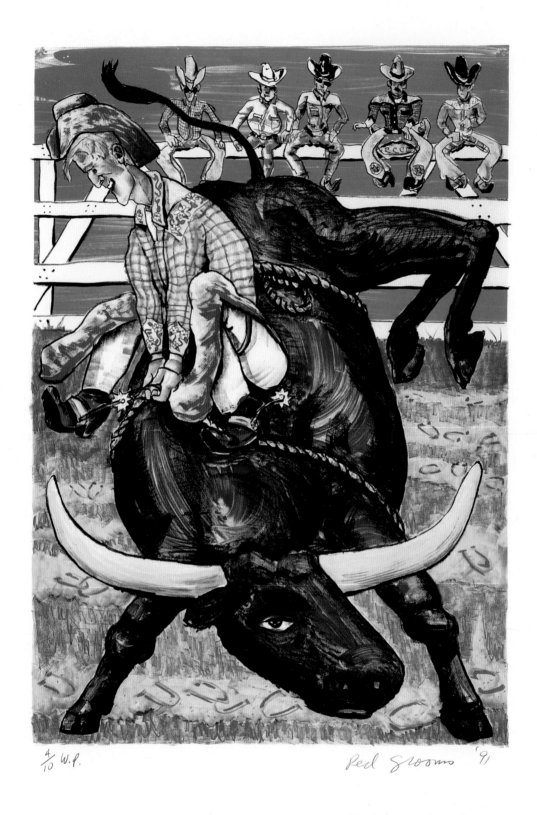

₄/₁₀ W.P. Red Grooms '91

Bull Rider, 1991. Lithograph 30 × 22¼″ (76.2 × 56.5 cm). Cat. no. 125.

"It was fun going back to the imagery of my sculpto-pictorama
Ruckus Rodeo, *1976. Drawing with lithographic crayons can be quite*
physical and matches up well with sports subjects, i.e., George
Bellows black-and-white lithograph Stag Night at Sharkies, *one of*
my favorites."—Red Grooms

"My assistants Tom Burckhardt and Michael Staats became very effective with this stencil technique, which is an update on the French pochoir method using spray paint instead of watercolor. Japanese subjects have intrigued me since my first visit to Japan in 1982. Currently I have made nine trips to Japan."—Red Grooms

Coolsan, 1991. Stencil, Krylon spray paint from *Sprayed Haiku* portfolio 8 × 8″ (20.3 × 20.3 cm). Cat. no. 126.

Fat Man Down, 1991. Stencil, Krylon spray paint from *Sprayed Haiku* portfolio 8 × 8″ (20.3 × 20.3 cm). Cat. no. 127.

Fuji Friendly, 1991. Stencil, Krylon spray paint from *Sprayed Haiku* portfolio 8 × 8″ (20.3 × 20.3 cm). Cat. no. 128.

Gracious Geisha, 1991. Stencil, Krylon spray paint from *Sprayed Haiku* portfolio 8 × 8″ (20.3 × 20.3 cm). Cat. no. 129.

Into the Wind, 1991. Stencil, Krylon spray paint from *Sprayed Haiku* portfolio 8 × 8″ (20.3 × 20.3 cm). Cat. no. 130.

Sake Souls, 1991. Stencil, Krylon spray paint from *Sprayed Haiku* portfolio 8 × 8″ (20.3 × 20.3 cm). Cat. no. 131.

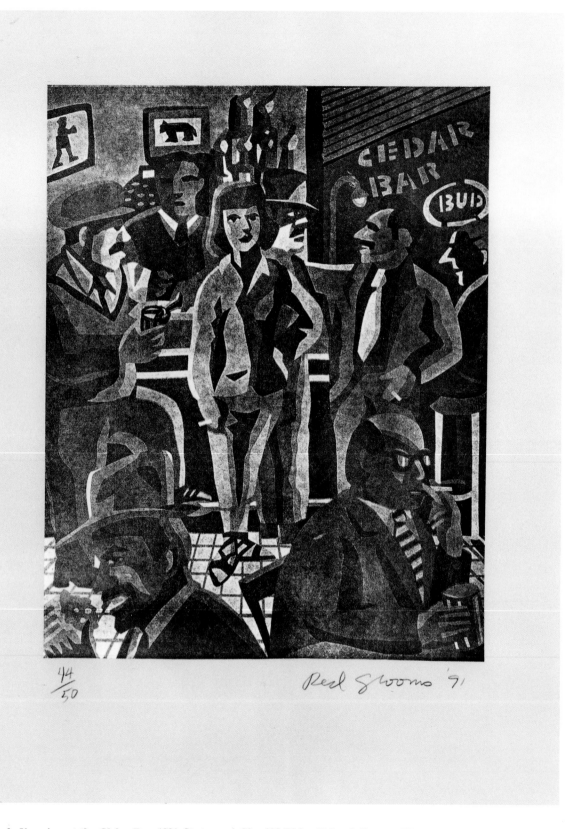

44/50 Red Grooms '91

Elaine de Kooning at the Cedar Bar, 1991. Stratograph 30 × 22″ (76.2 × 55.9 cm). Cat. no. 132.

"Joe Wilfer was so full of enthusiasm for his stratograph technique. He showed me how to build up a relief out of any kind of paper, even toilet paper. I was somewhat mystified by the process, but Joe helped me by cutting out the layers of paper to create the tones. Joe's method with layered paper was a kind of reduction print. This was a revisit to my large drawing of The Cedar Bar. I was very pleased to provide this homage to the very wonderful Elaine de Kooning." —Red Grooms

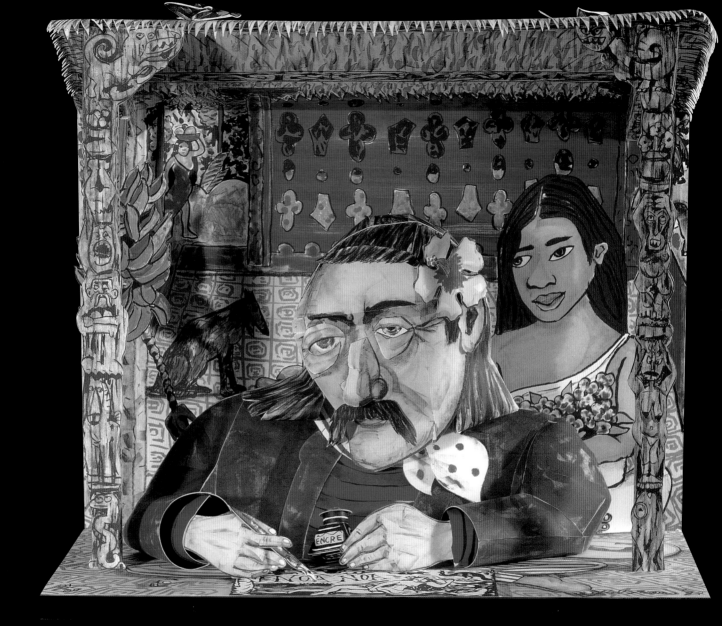

South Sea Sonata, 1992. Three-dimensional lithograph in Plexiglas case
20⅜ × 21¾ × 11⅜″ (51.8 × 55.3 × 28.9 cm). Cat. no. 133.

"Lysiane and I were staying at a friend's home on the big island of
Hawaii. I made the maquette for this portrait of Gauguin on the lanai
overlooking the harbor of Kona. We were surrounded by a beautiful
tropical landscape often softened by veils of rain descending from
the volcano behind us." —Red Grooms

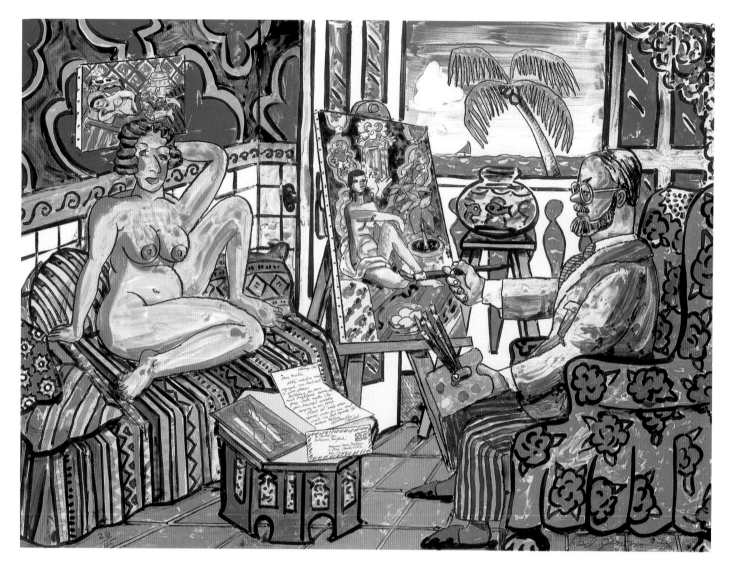

Matisse in Nice, 1992. Lithograph 22¼ × 30″ (56.5 × 76.2 cm). Cat. no. 134.

"I had gotten hold of a terrific catalogue from a MOMA show of Matisse's paintings done in Nice. There were diagrams of his whole apartment, which looked out onto the Mediterranean. It was great fun locating this perfectly attired artist musing over his perfectly undressed model in this setting."—Red Grooms

Bronco Buster, 1992. Lithograph 8⅝ × 8⅜" (21.9 × 21.3 cm). Cat. no. 135.

"I discovered that I could tuck little images around the margins of the 'pop-up' prints. They were paper waste areas that would be thrown out otherwise when the three-dimensional parts were cut out for assemblage. At first they were very casual presents for our daughters Saskia and Zoe, but then Bud and I became more self-conscious about developing them into editioned prints—after all, the color came along for free." —Red Grooms

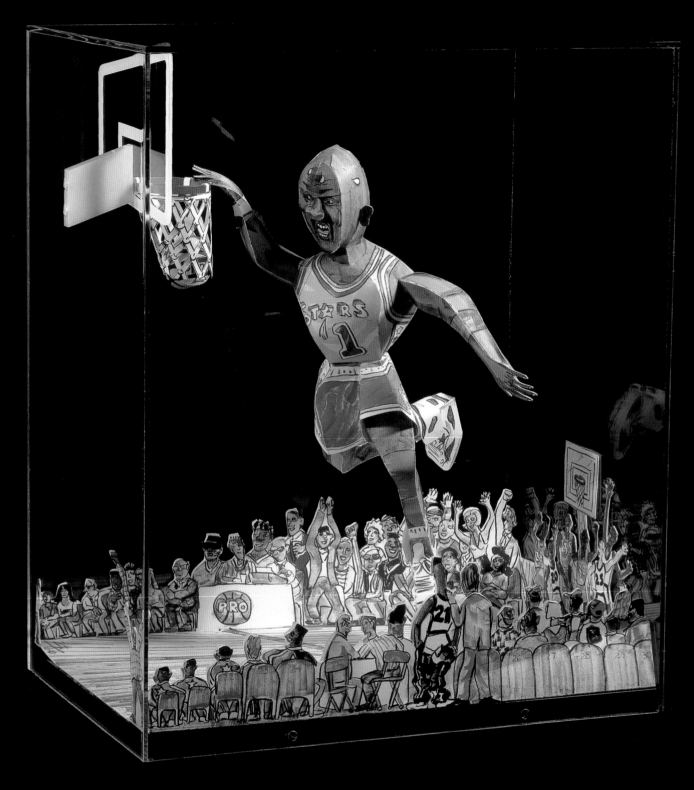

Slam Dunk, 1992. Three-dimensional lithograph in Plexiglas case 21⅜ × 18⅛ × 12½″ (54.3 × 46.0 × 31.8 cm). Cat. no. 136.

"AAAHH if only we could have called the print 'Air Jordan.' It was really fun to do, but not a great commercial hit. Bud did wonders engineering a pipe running through the body of the player, the basketball, and the goal post." —Red Grooms

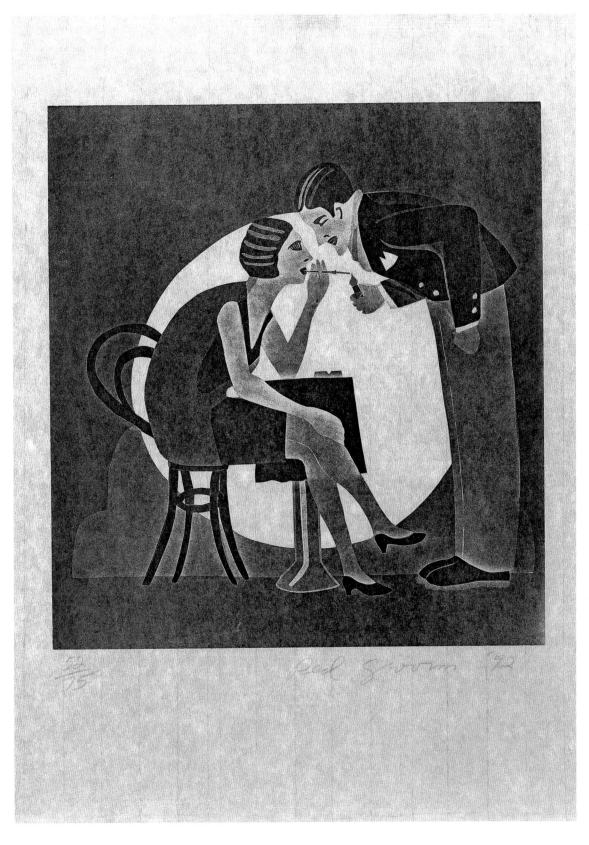

A Light Madam, 1992. Stratograph 25¾ × 18½″ (65.4 × 47.0 cm). Cat. no. 137.

"It was terrific to work with Joe again. He was just a wizard with his letterpress. He presented me with all kinds of proofs using different papers. He was always willing to go to any length to achieve the most effective results. Intimacy between a man and a woman has always been a favorite subject of mine."—Red Grooms

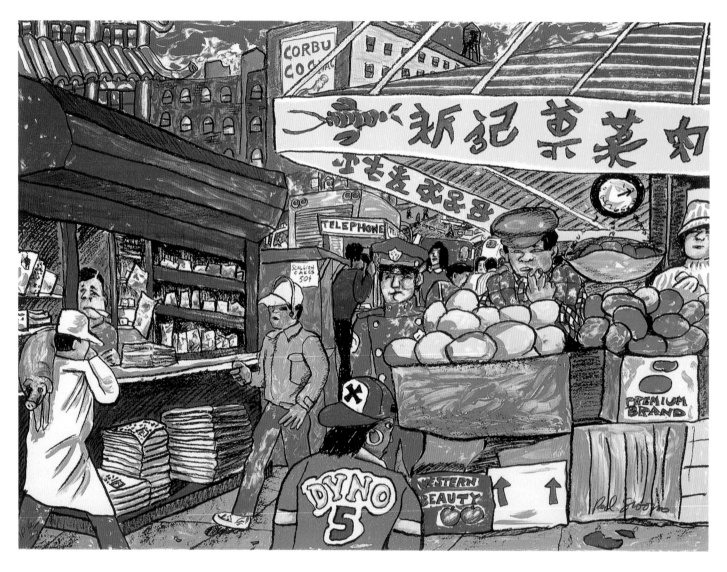

Corner of Canal, 1993. Lithograph 22¼ × 30″ (56.5 × 76.2 cm). Cat. no. 138.

"Lysiane and I were staying in her Paris apartment and that's where I did the work on this print. It was strange how a 22 × 30 inch sheet seemed so large in the metric-scaled French living room. I was able to do the color separations on Mylar sheets Bud had provided. I followed Bud's instructions on 'smoking' the Xerox washes by putting my finished sheets under a cardboard box top with a rag soaked in acetone. This is the 'top-secret' process that fixes the image until Bud can transfer it to a metal plate."—Red Grooms

"Corner of Canal *is a view of the market right around the corner from Red's studio, on the edge of Chinatown.*"—Bud Shark

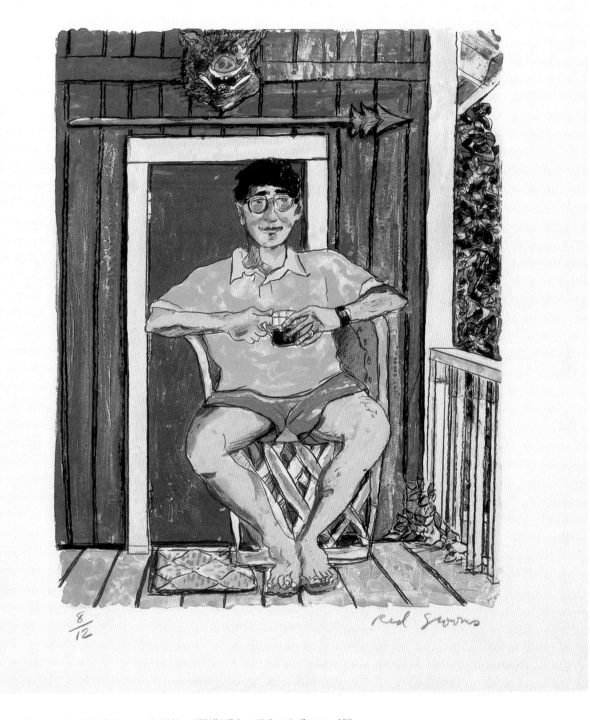

Bud on the Lanai, 1993. Lithograph 18½ × 15¾" (47.0 × 40.0 cm). Cat. no. 139.

"Bud really knows how to relax when he's in Hawaii, as this picture proves. My first shot at doing an on-the-spot Mylar color separation since the one I did à la Whistler's mother (my Mom) back in 1990."
—Red Grooms

"The images were drawn on Mylar during our first trip together to Hawaii in 1990. It rained pretty heavily and we all spent much of the time on the Lanai (porch) drawing. The Mylars were transformed to plates in Boulder and proofed in January. '93."—Bud Shark

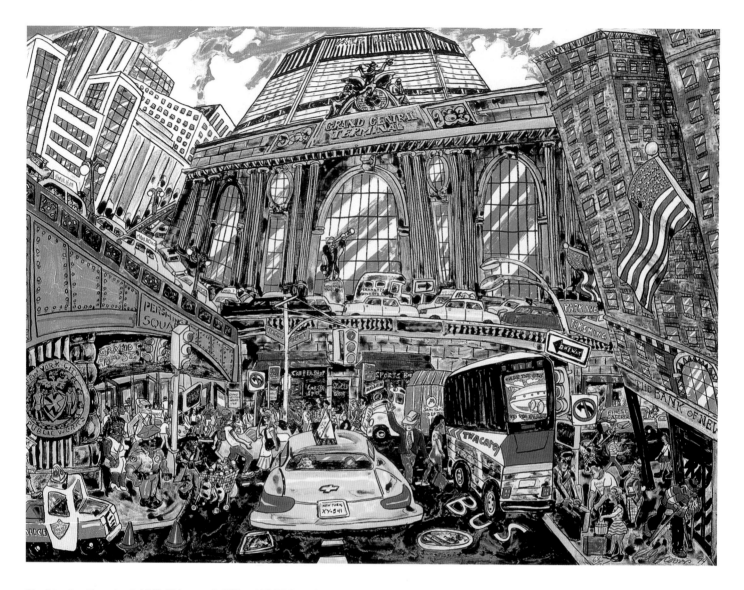

Taxi to the Terminal, 1993. Lithograph 22¼ × 30″ (56.5 × 76.2 cm). Cat. no. 140.

"Can you believe I did this print in Bud's jungle litho studio? Instead of car horns all I heard were avocados plunking to the ground."
　　　　　　　　　　　　　　　　—Red Grooms

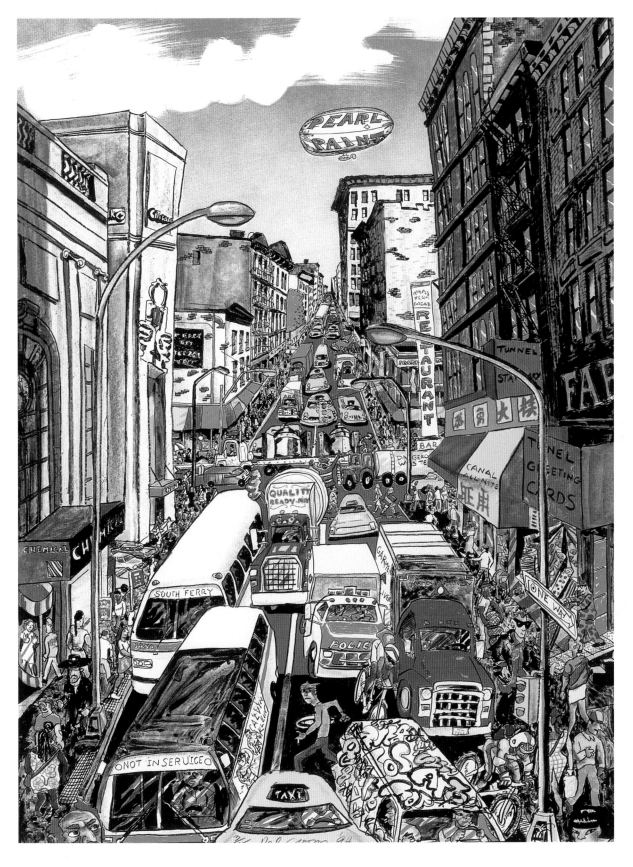

Looking Up Broadway, Again, 1993. Lithograph. 30 × 22¼ (76.2 × 56.5 cm) Cat. no. 141.

"What moved me to give free advertising space to my art supply store, Pearl Paint, I'll never know (see the blimp flying over Manhattan). This is another try at capturing the view looking north along Broadway from just south of Canal Street."—Red Grooms

Hot Dog Vendor, 1994. Three-dimensional lithograph, linocut, and chine collé in Plexiglas case 33¼ × 26¼ × 10″ (84.5 × 66.7 × 25.4 cm). Cat. no. 142.

"This was a successful print and got Red-Bud 'pop-ups' back on track after a period of financial derailment. I have continued to work on the Hot Dog Vendor

Red Bud Diner, 1994. Lithograph 24¼ × 62½" (61.6 × 158.8 cm). Cat. no. 143.

"A quarter of an inch shorter, but three-quarters of an inch longer than Truck, 1979, this is my largest lithograph and, after The Existentialist, my second largest print. I got everyone in Bud's shop to pose for the various characters and took Polaroids changing the likenesses to protect their identities. However, Bud, Barbara, and Lysiane are still recognizable despite their new roles. Once again, the old 'cross-section' allowed me to get it all in." —Red Grooms

"We worked on various versions of this image, including some three-dimensional studies. But this long format with both interior and exterior views seemed to have the best arrangement to really get into all aspects of the diner. We had lots of research material from books Red had bought. The diner is a composite from many different actual diners from various parts of the country and years. Red really took advantage of the full range of tones that litho can achieve. The metallic silver ink gave the print the right diner-like sheen." —Bud Shark

39/75 Red Grooms '94

Dixie's, 1994. Lithograph 11¼ × 9½″ (28.6 × 24.1 cm). Cat. no. 144.

"Dixie's is an actual store, Eileen's Cheesecake, on the corner of Kenmare and Cleveland Place near Little Italy in New York (arguably maker of the best cheesecake in New York). When I did the original piece Walking the Dogs, *the owner liked it and I got free cheesecake for several months afterward. I changed the name to Dixie's this time around because my wife, Lysiane, doesn't eat cheesecake."*

—Red Grooms

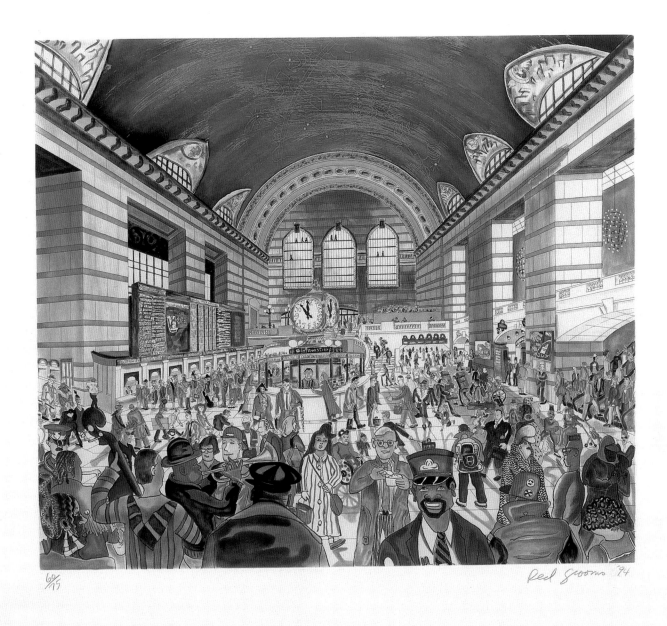

Main Concourse, Grand Central Terminal I., 1994. Etching, aquatint, and soft ground 31½ × 33¾" (80.0 × 85.7 cm). Cat. no. 145.

"Once again I wanted to take advantage of Aldo's great skill with the medium and so I went after a subject that I have always wanted to tackle, that beehive of action, the epicenter of New York, the Main Concourse of Grand Central Station. The ceiling of the great room had not been cleaned in 1994 but peering up I could see an exposed section where restorers had removed the soot. I got a jump on the restoration doing the whole ceiling of the print in the original turquoise blue. We worked on the plates at Pace Editions, Spring Street Shop, the printing took place in the bowels of Crommelynck's Atelier in Paris, and it was an extraordinarily complex printing process."
—Red Grooms

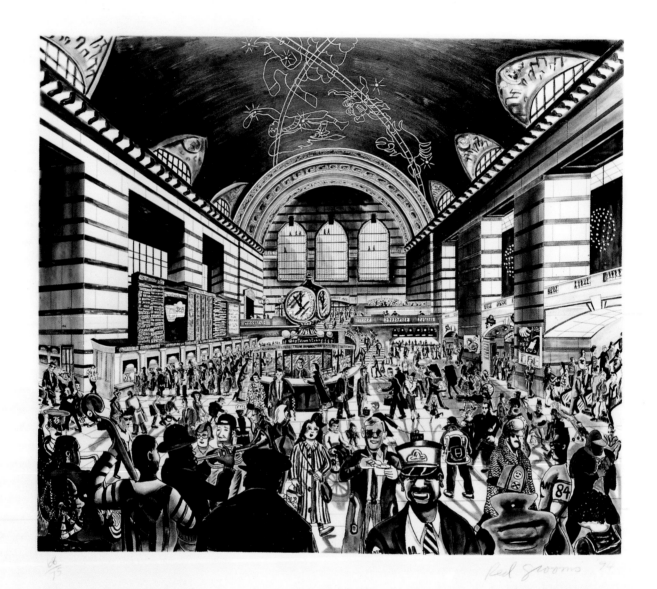

Main Concourse, Grand Central Terminal II, 1994. Etching, aquatint, and soft ground 31½ × 33¾″ (80.0 × 85.7 cm). Cat. no. 146.

"All the extras got additional pay standing-in for this black-and-white version of the main concourse. I really enjoyed reworking the line plate with the spit-bite technique to achieve rich tones. The Crommelynck velvet touch is evident in this print." —Red Grooms

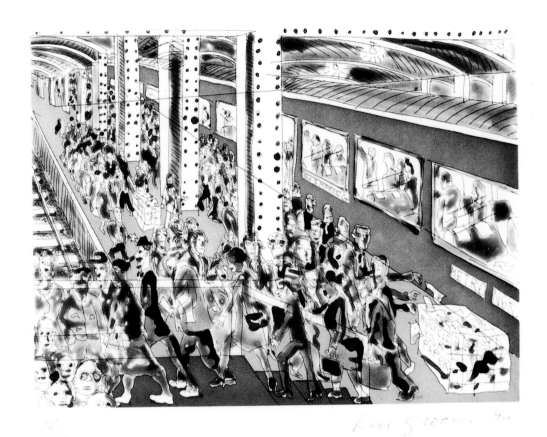

Underground Platforms, 1994. Etching and aquatint from *The Main Concourse, Grand Central Terminal and Other Thoughts on Trains and Engravings* series 13¾ × 16¼" (34.9 × 41.3 cm). Cat. no. 147.

"Dick Solomon thought it would be a good idea to do five or six smaller etchings based on the drawings I did at Grand Central Station. This gave me an opportunity to expand on the terminal and railroad theme. Underground Platforms popped out of my head as I remembered the hordes of commuters disembarking during the morning rush hour."
—Red Grooms

Commodore Vanderbilt, 1994. Etching and aquatint from *The Main Concourse, Grand Central Terminal and Other Thoughts on Trains and Engravings* series 13¾ × 16¼" (34.9 × 41.3 cm). Cat. no. 148.

"I found this series to be a good excuse to draw steam engines and also Commodores and Generals." —Red Grooms

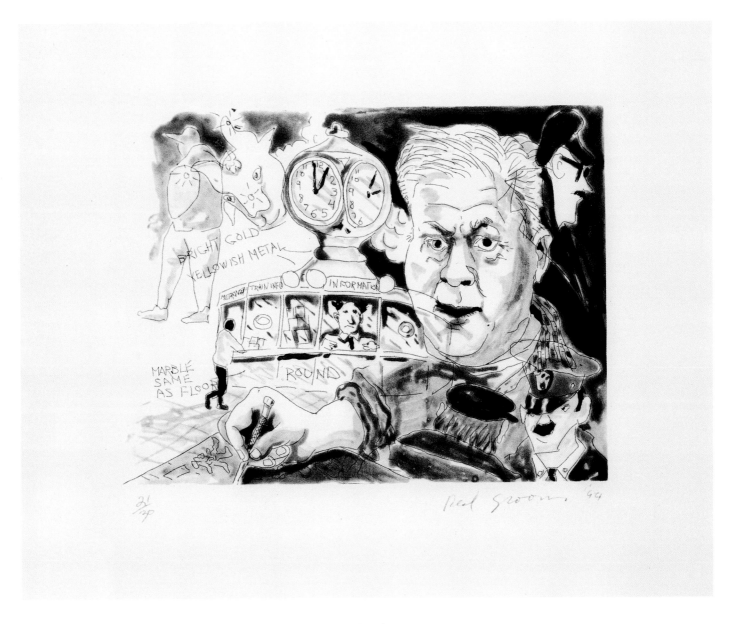

Self-Portrait, 1994. Etching and aquatint from *The Main Concourse, Grand Central Terminal and Other Thoughts on Trains and Engravings* series 13¾ × 16¼" (34.9 × 41.3 cm). Cat. no. 149.

"I added a self-portrait to random studies drawn in preparation for the big main concourse aquatint." —Red Grooms

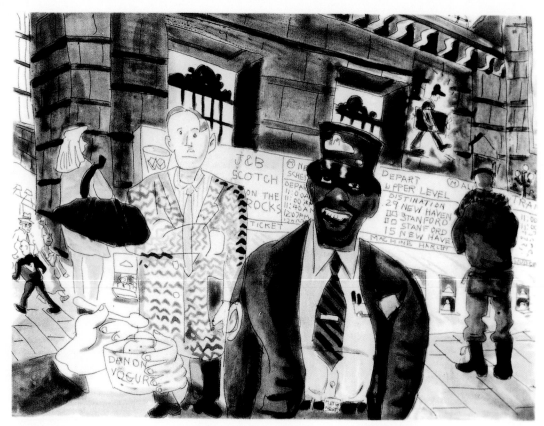

Grand Central, 1994. Etching and aquatint from *The Main Concourse, Grand Central Terminal and Other Thoughts on Trains and Engravings* series 13¾ × 16¼″ (34.9 × 41.3 cm). Cat. no. 150.

"All aboard! Timetables and those backward hands again, holding a yogurt cup." —Red Grooms

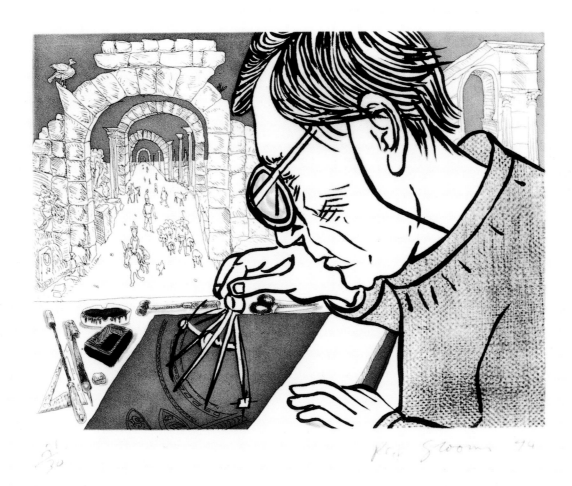

Portrait of A. C., 1994. Etching and aquatint from *The Main Concourse,*
Grand Central Terminal and Other Thoughts on Trains and Engravings series
13¾ × 16¼" (34.9 × 41.3 cm). Cat. no. 151.

"The Maestro himself, plotting the curve for the ceiling arch in the
main concourse epic. We tried several materials to get the texture
on Aldo's sweater including a pair of knit gloves I bought from an
African street vendor selling his wares on Broadway." —Red Grooms

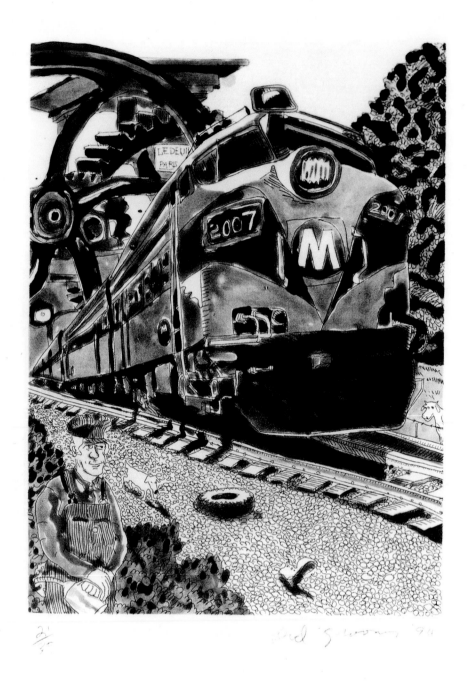

Train 2007, 1994. Etching and aquatint from *The Main Concourse, Grand Central Terminal and Other Thoughts on Trains and Engravings* series 16¼ × 13¾" (41.3 × 34.9 cm). Cat. no. 152.

"That's the wheel of Aldo's etching press looming up behind the Metroliner. I guess it's a stretch but, hey, trains and etching plates, it's all about metal." —Red Grooms

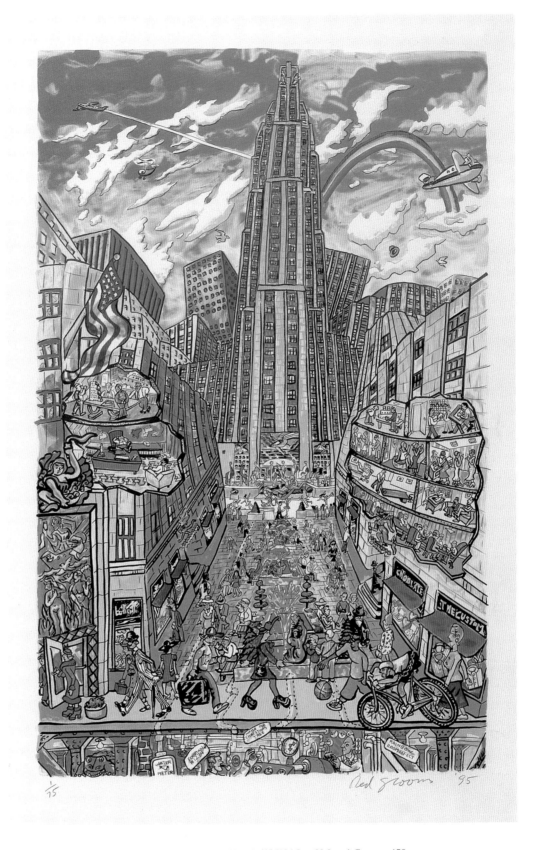

Rockefeller Center, 1995. Offset lithograph 41¼ × 27½" (104.8 × 69.9 cm).Cat. no. 153.

"Maurice Sanchez is a master of subtle touch with his offset press. I worked over a light box on Mylar. When he proofed each color I was often surprised at how much depth he could produce from what looked like a pale effort on my part. Maurice was willing to do as many deletions as I wanted, and in this print there were several hundred." —Red Grooms

Train to Potsdam, 1995. Woodcut 28 × 22″ (71.1 × 55.9 cm). Cat. no. 154.

"A real mom-and-pop special, Lysiane and I worked on the printing together in her studio."—Red Grooms

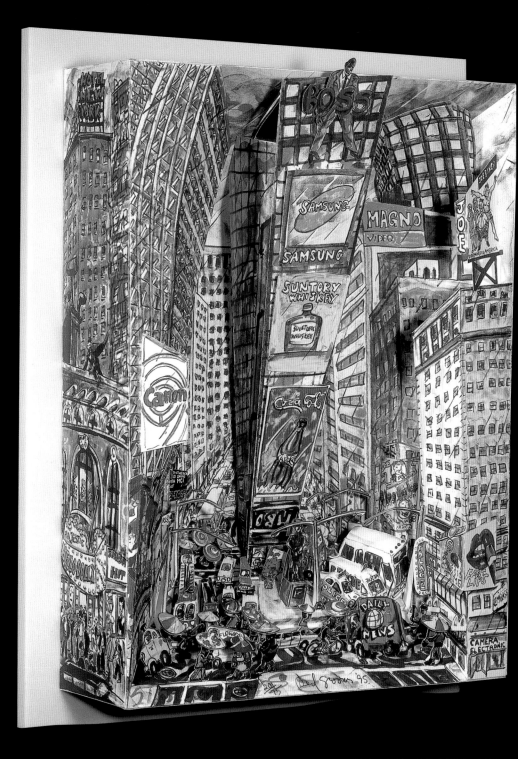

Times Square, 1995. Three-dimensional lithograph in Plexiglas case 27⅛ × 21⅜ × 8 ³⁄₁₆″ (68.9 × 54.3 × 20.8 cm). Cat. no. 155.

"Lysiane and I were staying, as usual, at the Boulderado Hotel, in Boulder, Colorado for the upcoming ten-day work session with Bud. It was Monday morning and I still had not hit on a likely subject. I was looking at a copy of The New York Times *while Lysiane was fixing her hair, when an article on new signage for Times Square grabbed my attention. Twenty minutes later in Bud's shop I began working up a paper maquette for the new* Times Square *print. Seat of the pants planning came to the rescue once again."*
—Red Grooms

"The extremely distorted perspective and small scale, add to the 'feel' of the print."
—Bud Shark

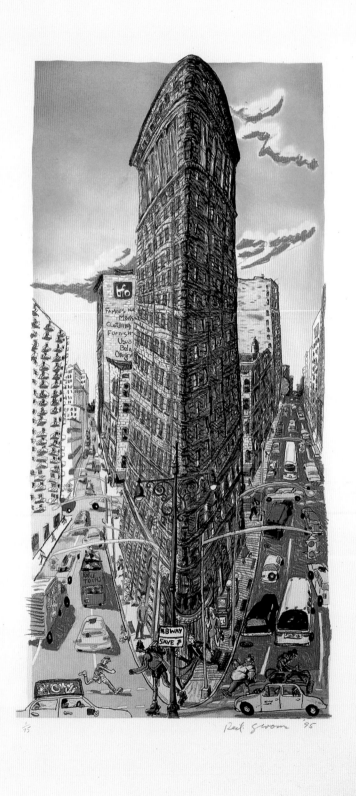

Flatiron Building, 1996. Etching, soft ground and aquatint 45 × 26″ (114.3 × 66.0 cm). Cat. no. 156.

"I had very much wanted to include a version of the Flatiron Building as part of Ruckus Manhattan, 1975–76, but there wasn't enough time to build it. I got another chance in 1995 while doing New York Stories. This version was sculpted out of Styrofoam and coated with epoxy resin. It has its own interior lighting system. Tara Reddi, Director of Marlborough Graphics introduced me to Carol Weaver and Felix Harlan and we agreed to do a work session together in the summer of 1995. Tara thought the Flatiron Building would make a good subject for a colored intaglio and I was happy to give it another go."
— Red Grooms

"When approached by Tara Reddi of Marlborough Graphics, we were very excited to work with Red Grooms. On visiting Red's studio, we saw No Gas Café from 1971 and were struck by its grotesque and energetic depiction of a familiar but now disappearing downtown scene. We wanted to relate the work we did with Red to his earlier prints such as the No Gas series. The Flatiron began with a loose drawing, which was used to separate the image onto five plates. The main elements of the composition were drawn using the soft ground technique. Red used aquatint and line to clarify and tighten the image."
— Carol Weaver & Felix Harlan

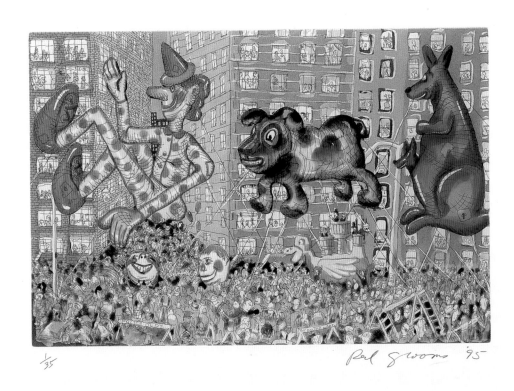

$\frac{1}{35}$ *Red Grooms* '95

Macy's Thanksgiving Day Parade, 1995 (published in 1996). Etching and aquatint 20¾ × 26" (52.7 × 66.0 cm). Cat. no. 157.

"I had hoped to make a unique relief of the Macy's Thanksgiving Day Parade *for the* New York Stories, *but I had not been able to pin it down specifically. Carol and Felix gave me extra copperplates to experiment with. Suddenly, I had a brainstorm about how to do the parade two-dimensional as an etching. One of my favorite etchings is James Ensor's crowd surging around a Cathedral. I wanted to echo the Ensor spirit in this print."* —Red Grooms

"Red began with great confidence. He drew the balloons in the negative with stop-out varnish as one continuous series of brush strokes beginning on the right and ending with precision on the left. The buildings and crowded street were blocked in, also working with light on dark using a soft litho crayon. The plate was etched to medium gray. To this first state Red added detail and tone to the black plate with line etching and spit-bite. Red painted a black proof with dilute etching ink to establish the exact hues that he wanted in the balloons. The hand-colored proof was interpreted as a series of four aquatint plates printed in sequence, with multiple color inkings on each plate." —Carol Weaver & Felix Harlan

Hallelujah Hall, 1995 (published in 1996). Etching, aquatint, and sugar-lift, spit-bite, from *New York Sweet* portfolio 17½ × 20½″ (44.5 × 52.1 cm). Cat. no. 158.

"Lysiane and I were married at Saint John The Divine in 1987. Hallelujah Hall *is my homage to this great church, to which I have such a personal attachment. Dean Morton is leading a group of parishioners on the left."* —Red Grooms

"To prepare for the large Flatiron Building *print, Red wanted to experiment with all the techniques the studio had to offer. In true 'Ruckus' fashion, Red threw everything we had at a series of smaller (9 × 12″) plates. Before we knew it, the* New York Sweet *emerged.* Hallelujah Hall *was begun in tandem with* Graveyard Ruckus *so Red could explore the difference between nitric and ferric chloride etches. Here, nitric was added onto a plate prepared with rosin, which was quickly flooded with water to soften the etch. After seeing the printed result, Red drew the cathedral using sugarlift and line etch. When Red was signing the edition he commented that it would be interesting to collect prints depicting cathedrals, and this print reminds us of etchings by Ensor, Meryon, and others."* —Carol Weaver & Felix Harlan

$\frac{1}{30}$ Red Grooms '95

Piebald Blue, 1995 (published in 1996). Etching, roulette, aquatint, and drypoint, from *New York Sweet* portfolio 20½ × 17½″ (52.1 × 44.5 cm). Cat. no. 159.

"Around the time I made Piebald Blue *I had also done a large relief version of the Plaza Hotel for the* New York Stories *exhibition at Marlborough. As I can never get enough of the carriage horses that are stationed across from the hotel, I made sure that a horse carriage and a little girl like Eloise became features in the print."* —Red Grooms

"After sketching Piebald Blue *with sugarlift, Red experimented with various types of drypoint techniques. The use of irregular roulette complemented the drypoint line."* —Carol Weaver & Felix Harlan

¹⁄₃₀ Red Grooms '95

Tootin' Tug, 1995 (published in 1996). Etching, roulette, and aquatint, from *New York Sweet* portfolio 17½ × 20½″ (44.5 × 52.1 cm). Cat. no. 160.

"Tugboats are just something I love about New York and it seems other people love them too, since this little print did very well commercially. Carol and Felix introduced me to a new tool and I got carried away using it on the East River's waves." —Red Grooms

"Red decided to work with a roulette pressed through a hard ground. He chose an unusual roulette that we had bought years earlier on sale from a mark-down bin. Red made perfect use of its unique pattern on the waves of Tootin' Tug*."* —Carol Weaver & Felix Harlan

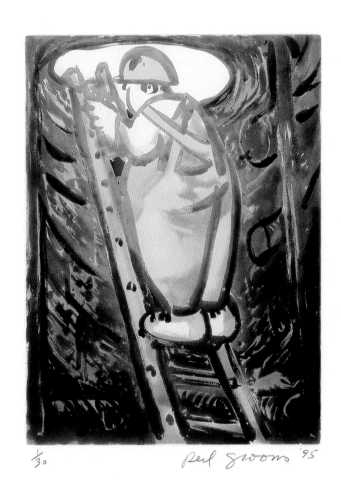

¹⁄₃₀ Red Grooms '95

Down Under, 1995 (published in 1996). Aquatint and sugarlift, from *New York Sweet* portfolio 20½ × 17½" (52.1 × 44.5 cm). Cat. no. 161.

"Another favorite subject: men at work. This is the reverse angle to the one I used in Aarrrrrhh, 1971—in that print the hard hat is sticking out of the manhole like a gopher."—Red Grooms

"Around the time Red was working in our studio, the MTA had undertaken a major renovation of the subway station that runs beneath Canal Street from Broadway to Center Street. On the walk from his studio to our etching shop further east on Canal, Red would likely have seen workers in yellow safety gear emerging from underground. We like to think that scenes such as this were the inspiration for New York Sweet.*"*—Carol Weaver & Felix Harlan

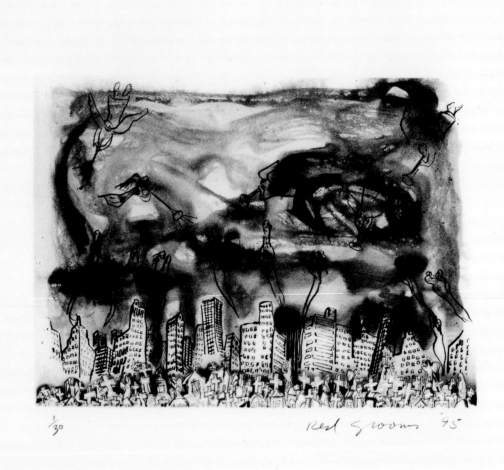

1/30

Red Grooms '95

Graveyard Ruckus, 1995 (published in 1996). Drypoint, etching, sugarlift, and aquatint, from *New York Sweet* portfolio 17½ × 20½″ (44.5 × 52.1 cm). Cat. no. 162.

"I started New York Sweet *experimenting with acid washes on a copper plate. That experiment turned into the whirling spirits of* Graveyard Ruckus. *Carol and Felix were great at encouraging a loose approach and keeping a lot of technical options open to me."*—Red Grooms

*"*Graveyard Ruckus *began as an experiment with spit-bite using ferric chloride etch. The viscous quality of brushed-on ferric can be seen in the sky above the graves. Red completed the image using drypoint for the spirits, and etch for the monuments. A nitric acid wash was applied by brush to shade the gravestones and statuary."*

—Carol Weaver & Felix Harlan

Les Baigneuses after Picasso, 1996. Stencil, Krylon spray paint 29½ × 23½"
(74.9 × 59.7 cm). Cat. no. 163.

"Les Baigneuses de Biarritz *is the title of a wonderful small painting*
by Picasso. I was additionally inspired by this subject as my long-term
art dealer Pierre Levai is a native of Biarritz. Tom Burckhardt showed
an excellent control of his spray cans and vented stencils to achieve
nice modulation for skin, sand, sea, and sky tones."—Red Grooms

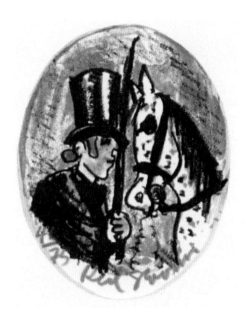

Balcony, 1996. Lithograph, a series of 4 miniature prints 3½ × 2½" (8.9 × 6.4 cm) irregular. Cat. no. 164.

"More marginalia . . . this time Lysiane's company, TWO ONE TWO Inc., became the publisher and initiated a sales gimmick by pre-framing the prints and including the frame in the price. Lots of need for miniature prints especially among collectors with over-hung walls. Balcony is a small homage to Goya." —Red Grooms

Dappled Gray, 1996. Lithograph, from a series of 4 miniature prints 3½ × 2½" (8.9 × 6.4 cm) irregular. Cat. no. 165.

"The horse and coachman from Piebald Blue *appear together again."* —Red Grooms

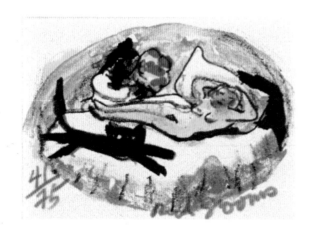

Olympia, 1996. Lithograph, from a series of 4 miniature prints 2 × 3" (5.1 × 7.6 cm). Cat. no. 166.

"A miniature homage to Manet. I was able to keep the drawing really small in these four marginalias from 1996. Something I had trouble doing on later attempts." —Red Grooms

Rover, 1996. Lithograph, from a series of 4 miniature prints 2½ × 2¾" (6.4 × 7.0 cm). Cat. no. 167.

"Good Ole Rover . . . quite the star this pup. Could dogs be a printmaker's best friend?" —Red Grooms

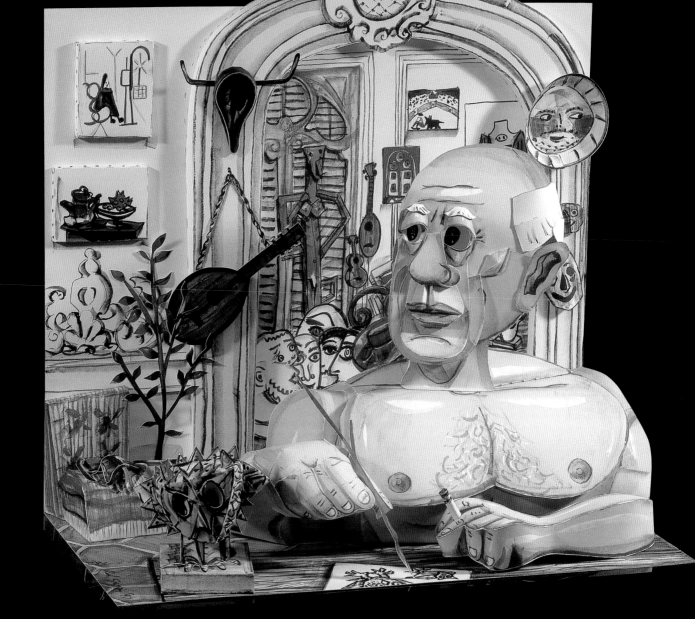

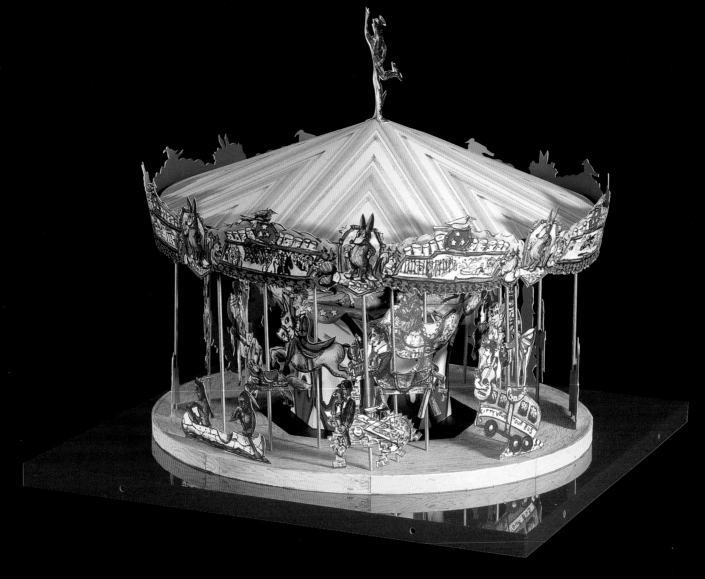

Tennessee Fox Trot Carousel, 1997. Three-dimensional lithograph in Plexiglas case 17 × 18⅜ × 18⅜" (43.2 × 46.7 × 46.7cm). Cat. no. 169.

"I really did this print in order to have the color separations ready to do an unlimited edition poster, as Bud and I had done with the Taxi, London Bus, Charlie, etc. Unfortunately, the sheets became so packed with details and the put together procedure so hard that it was decided not to try a poster version." —Red Grooms

"Red had produced a very complete and detailed maquette of the carousel before coming to Boulder to work on the print, so the structure and scale of the print were set. We had to do some additional engineering to make sure the paper version would support itself, and to get the correct curve of the roof and the 'rounding boards'." —Bud Shark

Red Grooms

Tennessee Fox Trot Carousel

Tennessee Fox Trot Carousel Portfolio Cover, 1997. Lithograph 12 × 10″ (30.5 × 25.4 cm). Cat. no. 170.

"The Tennessee Fox Trot Carousel portfolio was commissioned by the 'Tennessee Fox Trot Carousel' committee. The donated money was used to sculpt, cast, and paint thirty-six unique figures representing Tennessee history. Lysiane and I brainstormed for quite a while before coming up with Mr. Fox Trot as a mascot for the Nashville Carousel. I had fun giving him a girlfriend for the portfolio's cover."
 —Red Grooms

William Strickland, 1997. Lithograph, from *Tennessee Fox Trot Carousel* portfolio.
11⅞ × 9⅞" (30.2 × 25.1 cm). Cat. no. 171.

"William Strickland, the architect, had a distinguished career in Philadelphia before spending the rest of his life in Tennessee. He designed and built the Tennessee State Capitol in the mid-nineteenth century." —Red Grooms

Cornelia Clark-Fort, 1997. Lithograph, from *Tennessee Fox Trot Carousel* portfolio 11⅞ × 9⅞" (30.2 × 25.1 cm). Cat. no. 172.

"Cornelia Clark-Fort, the aviatrix, was a training pilot during World War II. She was flying the only American plane in the air when the Japanese bombing squadrons arrived over Pearl Harbor. She later became the first U.S. woman aviator to die in the war, when her plane went down during a training flight. Sometimes the print preceded the sculpture. In this case, the sculpture became a 'stander' instead of a 'jumper.' The plane's wing tip and a spiral of smoke support the figure and the whole is attached to the carousel platform." —Red Grooms

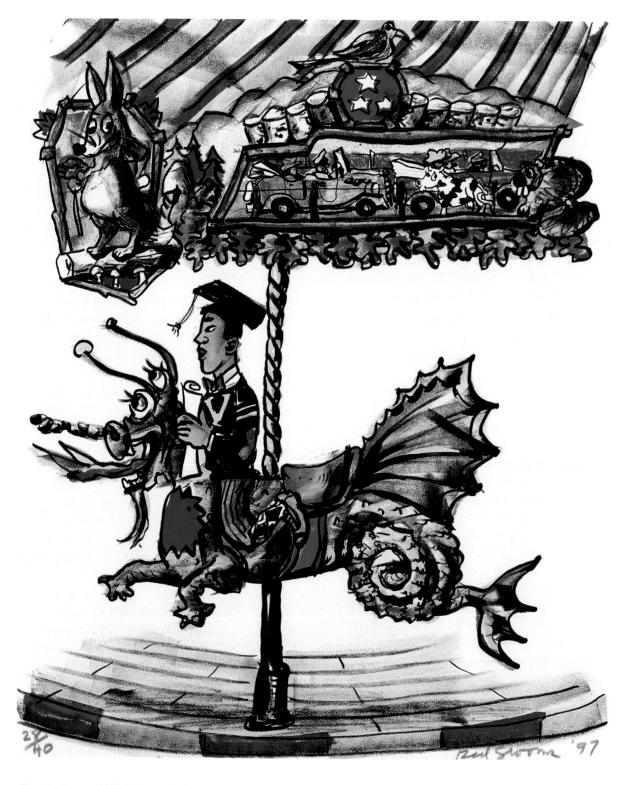

Charlie Soong, 1997. Lithograph, from *Tennessee Fox Trot Carousel* portfolio. 11⅞ × 9⅞" (30.2 × 25.1 cm). Cat. no. 173.

"Charlie Soong was the first Chinese student to graduate from Vanderbilt. He became very rich publishing Bibles in China. He had three daughters, one of whom married Sun Yat-Sen, the second of whom married General Chiang Kai-shek, and the third of whom married the richest man in China, H. H. K'ung. This figure was changed from a jumper to a stander. The dragon's body was expanded with the feet and tail firmly attached to the platform." —Red Grooms

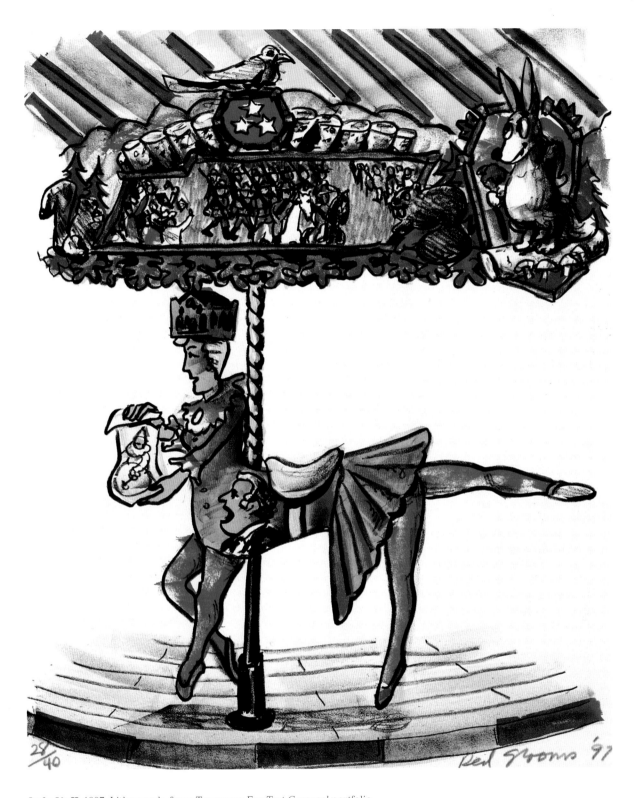

Lula Naff, 1997. Lithograph, from *Tennessee Fox Trot Carousel* portfolio. 11⅞ × 9⅞″ (30.2 × 25.1 cm). Cat. no. 174.

"Lula Naff was the booking agent for the Ryman Auditorium for thirty years. She turned the theater into a 'must stop' for big-name entertainers long before country music took over the hall. Her dynamic direction brought in McGormick, Pavlova, Blackstone, Lily Pons, to name but a few. I put the Ryman on her head for fun and had her legs in ballet tights!" —Red Grooms

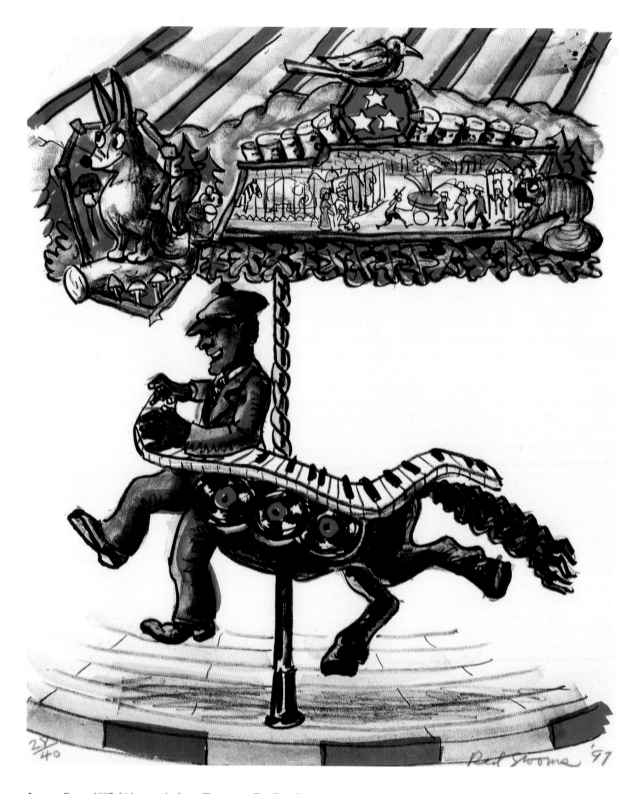

Leroy Carr, 1997. Lithograph, from *Tennessee Fox Trot Carousel* portfolio.
11⅞ × 9⅞" (30.2 × 25.1 cm). Cat. no. 175.

"Leroy Carr, bluesman extraordinaire, created many hits including 'Aggravating Papa.' His tunes are played today by Eric Clapton. His figure was changed from a 'jumper' to become a 'stander' in the actual carousel. His weight is resting on a gramophone. One of Carr's legs extends from the horn while the other one struts ahead for balance."

—Red Grooms

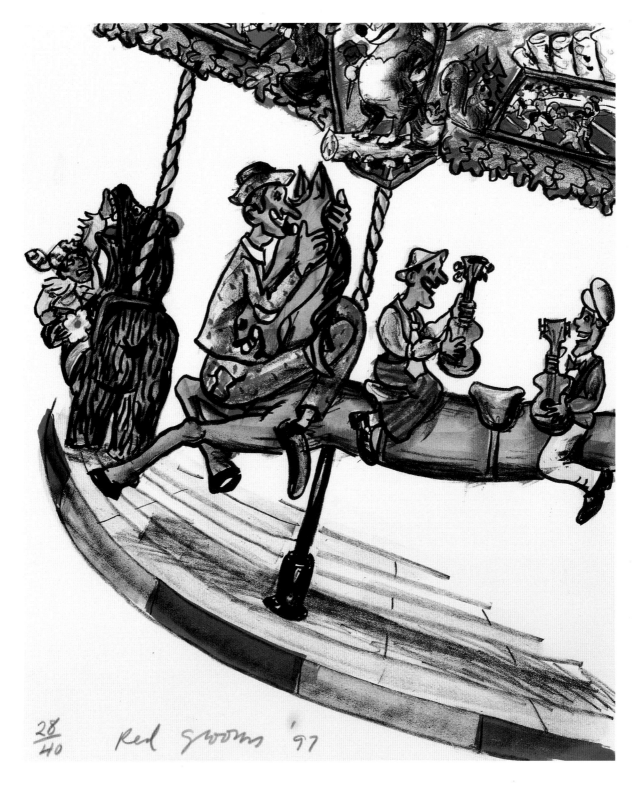

28/40 Red Grooms '97

Hot Dog Horse, 1997. Lithograph, from *Tennessee Fox Trot Carousel* portfolio.
11⅞ × 9⅞″ (30.2 × 25.1 cm). Cat. no. 176.

*"The Hot Dog Horse is an unusual carousel figure. It is suspended
from two poles and can seat four riders. The likeness of five Grand
Ole Opry clowns are sculpted on the horse, three of whom we see
in the print (Ron Daggerfield, Lonzo, and Oscar). Out of view are
'Speck' Rhoades and Cousin Jody. I tried to give the print more
whirl by tilting the platform."* —Red Grooms

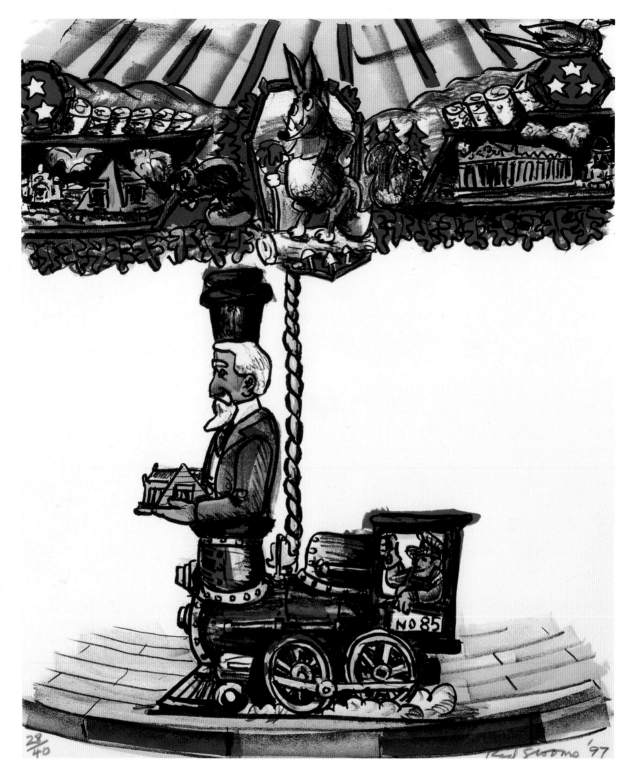

Eugene Lewis, 1997. Lithograph, from *Tennessee Fox Trot Carousel* portfolio. 11⅞ × 9⅞″ (30.2 × 25.1 cm). Cat. no. 177.

"Eugene Lewis was an impresario who masterminded the Tennessee Centennial Exposition of 1897 in Nashville. It was his idea to construct the Parthenon, as an exact copy of the original in Athens, for the fair. He also oversaw the building of Union Station in 1900. Both buildings are major landmarks of Nashville today. I also show him holding an Egyptian Pyramid, which he built for the fair, but unfortunately it was torn down when the fair closed." —Red Grooms

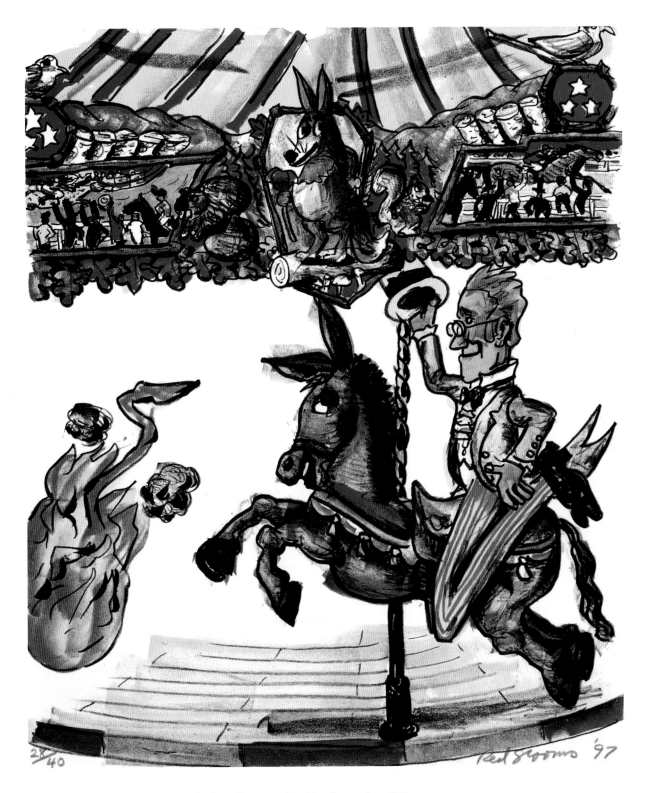

Andrew Jackson, 1997. Lithograph, from *Tennessee Fox Trot Carousel* portfolio.
11⅞ × 9⅞″ (30.2 × 25.1 cm). Cat. no. 178.

*"Andy Jackson riding a democratic donkey was a lot of fun to design.
The figure of 'Old Hickory' has been changed in the carousel sculpture
to allow a rider to swing his or her leg over the rear of the donkey for
easier mounting. To the left is the fiery tail of Sam Jones, the Revivalist."*
—Red Grooms

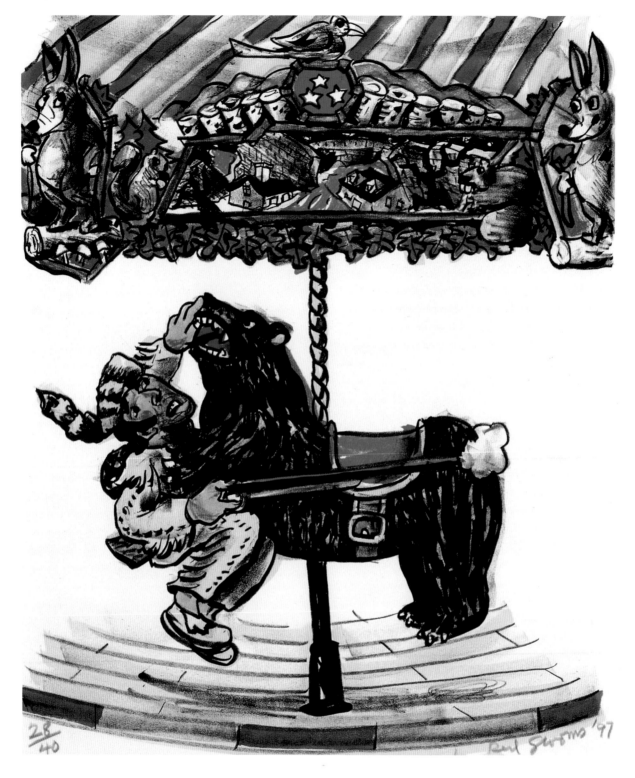

Davy Crockett, 1997. Lithograph, from *Tennessee Fox Trot Carousel* portfolio.
11⅞ × 9⅞" (30.2 × 25.1 cm). Cat. no. 179.

"Davy Crockett was (of course), a number-one choice for a carousel figure." —Red Grooms

$\frac{8}{40}$

Red Grooms '97

Western Pals, 1997. Lithograph 8½ × 12½″ (21.6 × 31.8 cm). Cat. no. 180.

"Like Dixie's, Western Pals *is appropriated from a unique wall relief done thirty-one years earlier. I really enjoy recycling my work in other mediums."*—Red Grooms

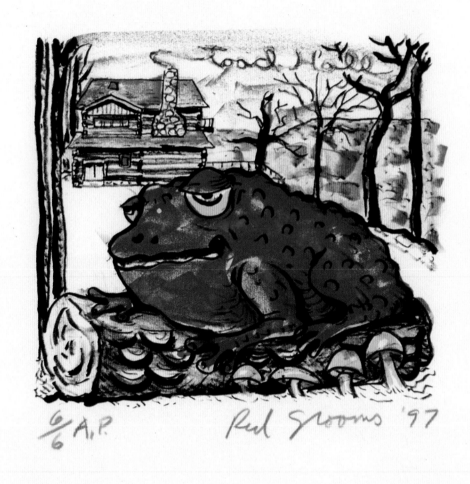

Toad Hall, 1997. Lithograph 8½ × 9¼″ (21.6 × 23.5 cm). Cat. no. 181.

"This is a view of our log cabin in east Tennessee. Lysiane is the architect and she named it 'Toad Hall'."—Red Grooms

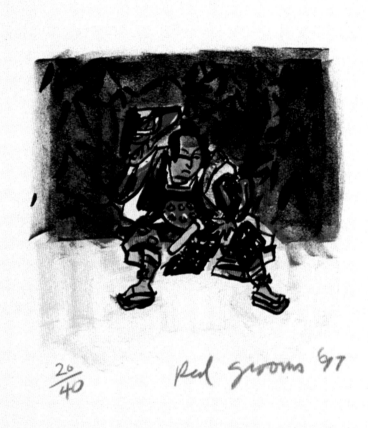

Samurai, 1997. Lithograph 8½ × 8⅜″ (21.6 × 22.0 cm). Cat. no. 182.

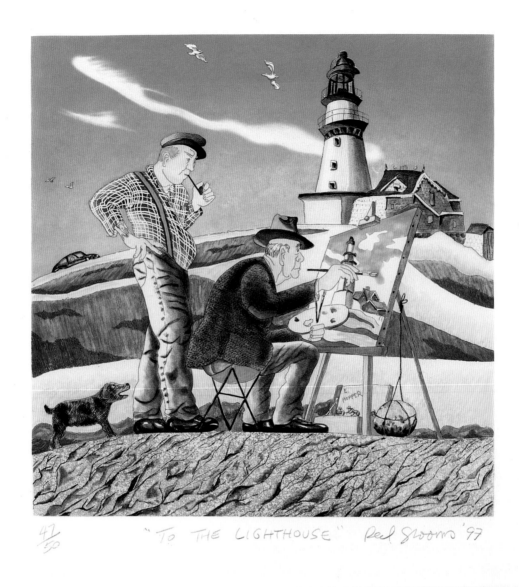

47/50 "To THE LIGHTHOUSE" Red Grooms '97

To the Lighthouse, 1997. Etching, soft ground and aquatint 22 × 20″ (55.9 × 50.8 cm). Cat. no. 183.

"This etching teamed me up with the master again. We were after a more practical effort this time, after the kind of 'Cleopatra' that Main Concourse Grand Central turned out to be. I made Lysiane a birthday present of this image in colored pencils. Aldo saw it in our apartment and he thought the image could be translated into an etching. My conceit was that the lighthouse keeper is looking over Edward Hopper's shoulder, perhaps with a critical eye—a situation that I surmise to be uncomfortable for most artists who are painting the homeowner's property. I worked up a careful tracing and we plotted out the colors to utilize the fewest number of plates. I posed for both Hopper and the lighthouse keeper."—Red Grooms

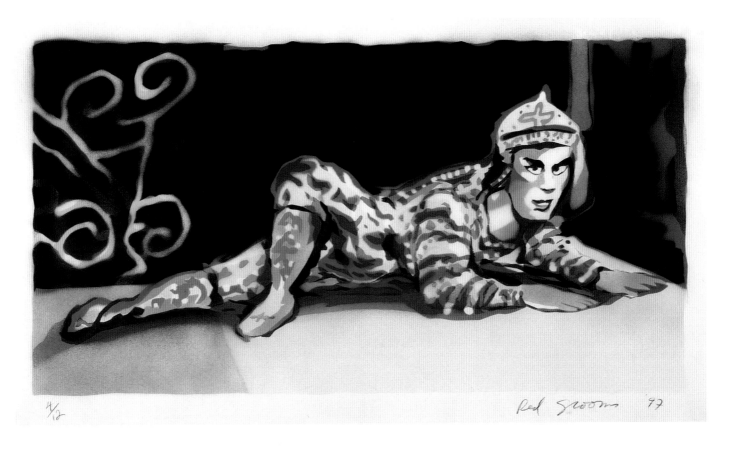

4/18 Red Grooms '97

Nijinsky, 1997. Stencil, Krylon spray paint 18¼ × 31¾″ (46.4 × 80.7 cm). Cat. no. 184.

"Another in-house spray-paint 'special.' Marlborough was doing the print fair in New York that fall and Tara Reddi asked if I had any new editions. Since I was empty-handed, I decided to do one right on the spot. The edition was completed in about a week. Tom Burckhardt worked from a gouache I had made from a famous photograph by Druet of Nijinsky." —Red Grooms

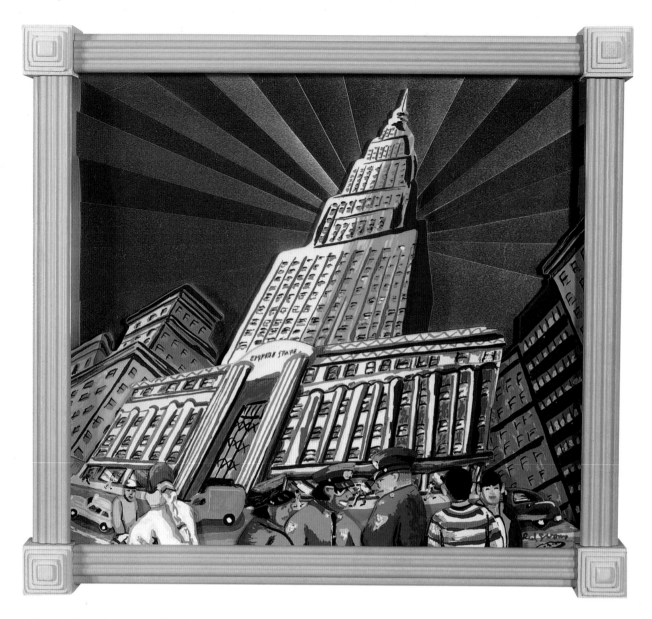

Empire State Building, 1997. Silkscreen with crease-folded aluminum in custom modular framework 13 × 14¼ × 2¾″ (33 × 36.2 × 7.0 cm). Cat. no. 185.

"*The* Empire State Building *was a renewal of sorts. Steve and I were doing our first 'woody' since* Peking Delight, *sixteen years earlier. The seed for doing* Empire State Building *started when I purchased an art deco department-store window frame on speculation. The frame sat around my studio for several years before it dawned on me that it could work as a frame for a large unique wall relief of the Empire State Building. I had started but didn't finish the* Empire State Building *for the New York Stories Exhibition in 1995. I finished it for a group show at Marlborough Gallery that summer, where it was purchased. By that time, Steve and I had begun the elaborate* Katherine, Marcel and the Bride, *which turned out to be a slow-moving project. I thought the* Empire State Building *on a small scale would be a snappy 'woody' multiple. Right and wrong: The* Empire State Building *did beat 'K.M.A.T.B.' to the wire, but to date it has been slow off the shelf. I think it is a sharp piece and Steve got another chance to show off his technical prowess.*"—Red Grooms

"*This project was manufactured exclusively from dimensionally sound Baltic Birch, printed on 3 separate layers: ½, ¼, and ⅛″ in thickness. The image areas are printed in 42 colors from 40 silk screens. All internal components are mounted on one sheet of scored and crease-folded aluminum and contained within a custom modular framework consisting of 16 separate wooden parts each individually assembled and painted by hand in 4 colors. All parts were laser cut, with some specific edges finish-painted by hand to match the front surfaces.*"—Steve Andersen

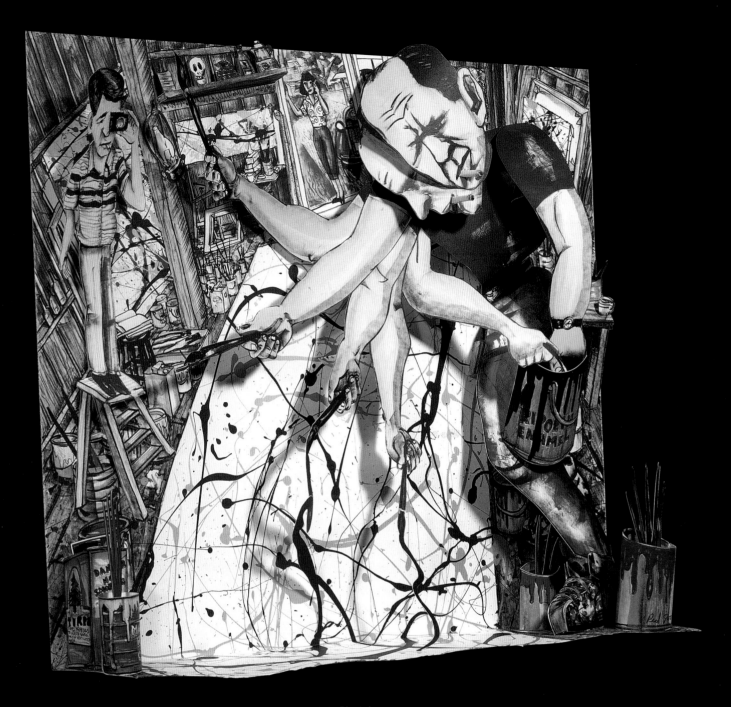

Jackson in Action, 1997. Three-dimensional lithograph in Plexiglas case
26 × 33 × 7¼″ (66.0 × 83.8 × 18.4 cm). Cat. no. 186.

*"Bud came up with a brilliant strategy for the drip painting, and I
followed his instructions on exactly where to sling the paint. Well, it
was sexy and fun for a while to get the right Zen touch, but by
lunchtime I was emotionally exhausted. Both Rudy Burckhardt and
Hans Namuth made famous photographs from an overhead view of
Pollack while painting."* —Red Grooms

*"Red's portrait of Pollock shows him at work in his Springs studio.
We added multiple arms and heads to give a sense of motion—like a
stop-action film. In the print are Rudy Burckhardt, photographer,
and Pollock's wife, Lee Krasner, and Pollock's beloved Model A out-
side the door of the studio. Note that typical of the period…all have
cigarettes in hand or mouth!"* —Bud Shark

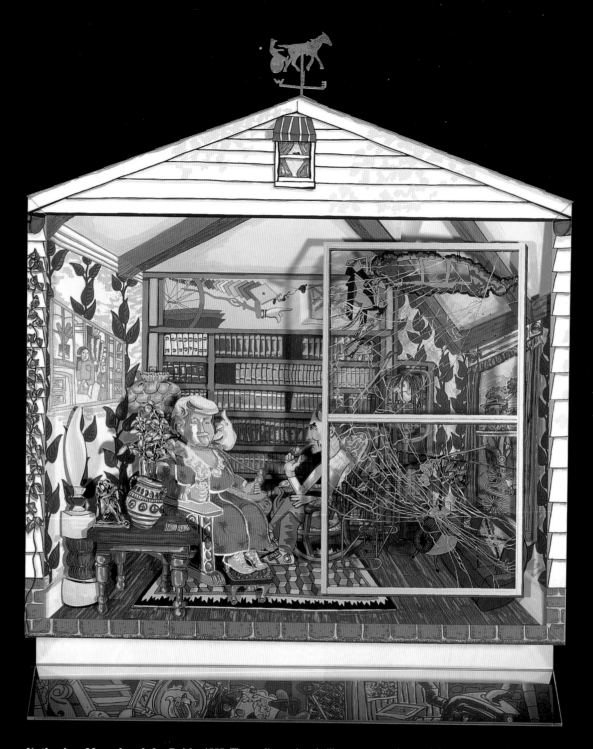

Katherine, Marcel and the Bride, 1998. Three-dimensional silkscreens on plywood, Lexan, cast polyester resin, steel, and copper 44 × 35½ × 5¼″ (111.8 × 90.2 × 13.3 cm). Cat. no. 187.

"Well, what can I say about this multiple except that it really has stretched the talents, pocketbook, and patience of all concerned. This is the ultimate printer's 'show off' piece, nearly five years in the making. But after all is said and done, I think Steve got the feel of my hand despite his own huge input, a very good translation. After three years of work on the project he sent me a trial proof and I went so far as to design the hidden basement and peaked roof with weather vane. This added another couple of years on the timetable. This could be a case of first the print and then the movie." —Red Grooms

"This project was manufactured exclusively from dimensionally stable Baltic Birch plywood, Plexiglas (³⁄₁₆″ front; ¼″ mirror with ½″ supports), cast acrylic (bottle brush in the painting Tu m' over the bookcase), copper (weather vane) and mild steel (support materials). It was printed in 130 separately editioned silkscreened colors by hand on six individual substrate layers. Each free-standing part making up the interior of the house (the contents of the room) was cut from each printed board by laser technology and assembled by hand using both glue and mechanical fasteners. The interior and exterior structures of the house and all roof tiles were cut and assembled by hand. Copper weather vanes were cut by water jet technology, assembled and painted by hand." —Steve Andersen

Pollock's Model A, 1998. Lithograph 13½ × 19¾" (34.3 × 50.2 cm). Cat. no. 188.

"The photograph by Hans Namuth of Pollock behind the wheel of his Model A has always had a great appeal to me. This print, big for a marginalia, is my memory version of that photograph." —Red Grooms

"Shows Jackson Pollock and Lee Krasner, with Pollock's Model A, in front of their Long Island studio, 'The Springs.' Pollock's love for this car was well known even though the car was very unreliable. Pollock often had to be driven to or from his destinations when the car broke down." —Bud Shark

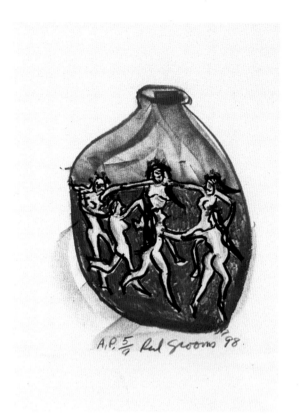

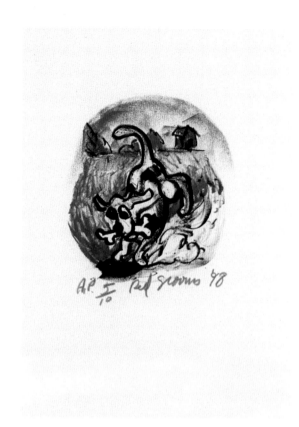

Nymphs in a Bottle, 1998. Lithograph 7 × 5″ (17.8 × 12.7 cm). Cat. no. 189.

"This second miniature series includes Manet again and those 'Secessionist' nymphs, and obviously, I'm trying to turn Rover into another Lassie."
—Red Grooms

Rover's Treasure, 1998. Lithograph 7⅜ × 5⅛″ (18.7 × 12.9 cm). Cat. no. 190.

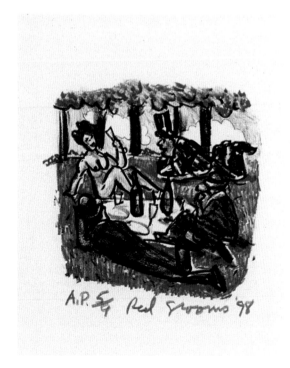

Liberty Front and Back, 1998. Woodcut 3⅜ × 5¾″ (8.6 × 14.6 cm). Cat. no. 192.

"Boy! Talk about last but not least, full circle around to the beginning. A block of wood, a few cutting tools, and a spoon."—Red Grooms

Lunch on the Grass, 1998. Lithograph 6¼ × 5⅛″ (15.9 × 13.0 cm). Cat. no. 191.

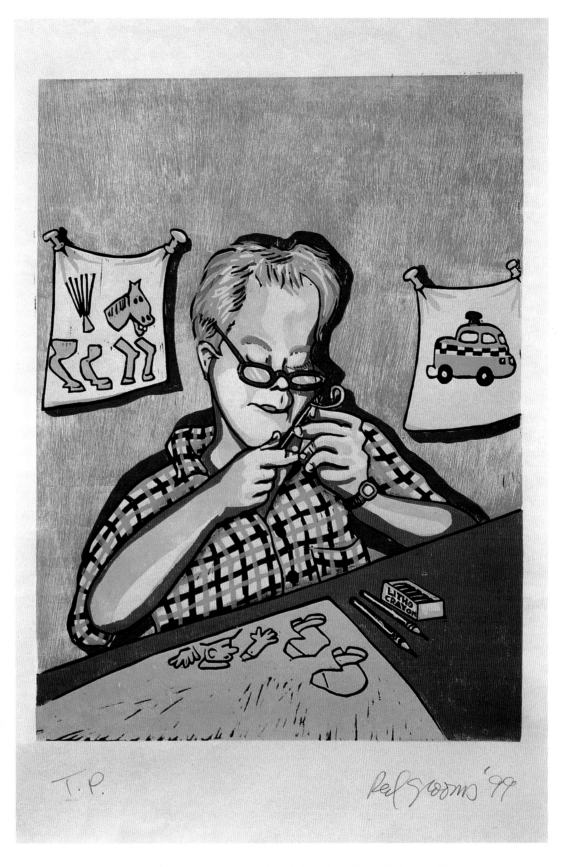

Self-Portrait with Litho Pencil, 1999. Woodcut 30¼ × 20¼″ (76.8 × 51.4 cm). Cat. no. 193.

"Lithography pencils are very demanding tools whose points break constantly if you don't have the lightest of touches. It takes a lot of patience to unravel the paper and get to a new point. The self-portrait shows me trying to look my nemesis right in the eye." —Red Grooms

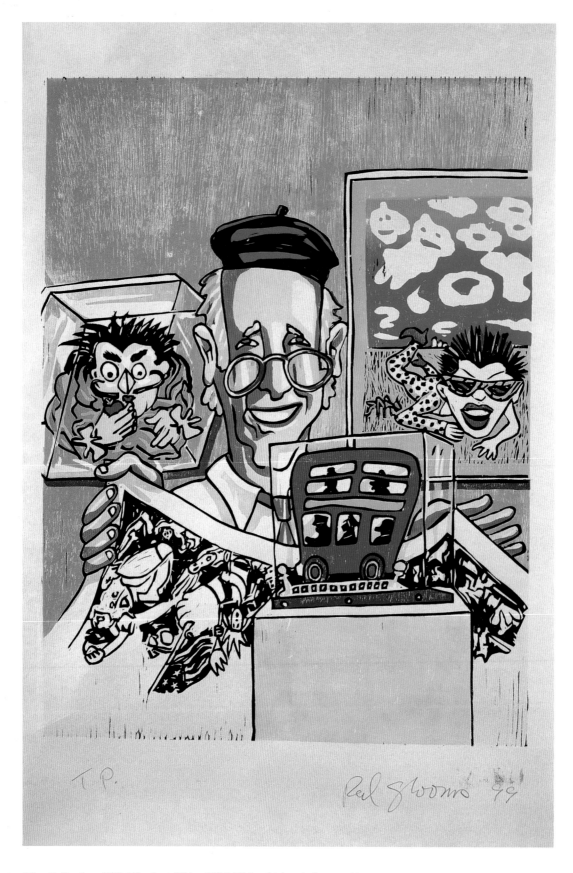

The Collector, 1999. Woodcut 30¼ × 20¼" (76.8 × 51.4 cm). Cat. no. 194.

"I wanted to do Walter's portrait with a sampling of his complete collection of my prints. That's part of the Patriot's Parade *upside down that Walter is holding. Behind him on the left is* Dali Salad; Lorna Doone *is on the right;* London Bus *is front and center."* —Red Grooms

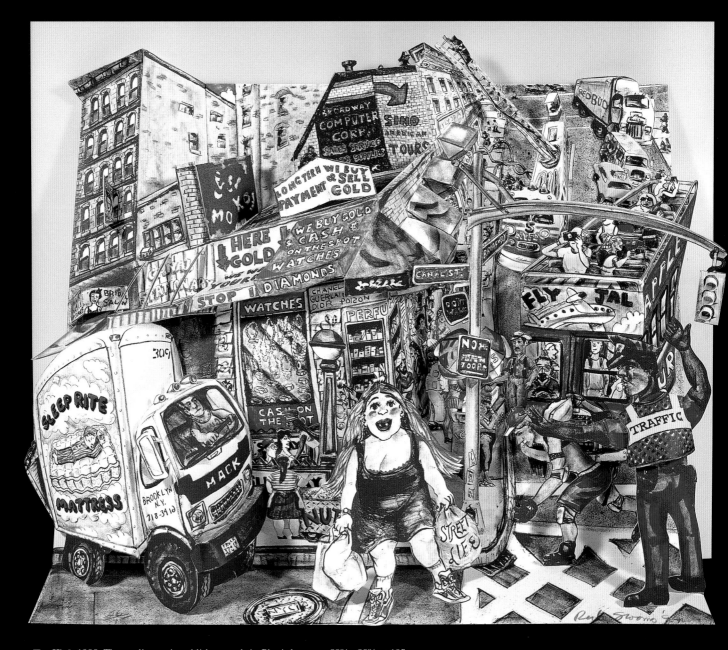

Traffic!, 1999. Three-dimensional lithograph in Plexiglas case 23⅜ x28⅜ × 10″ (59.4 × 72.1 × 25.4 cm). Cat. no. 195.

"I made all the plates for Traffic! *in Hawaii. Just before leaving New York I took some photographs of the northwest corner of Canal and Broadway. These helped me with the details. I had actually photographed the central figure, the woman with the shopping bags, from the back. It was fun trying to capture the action of a typical day at this very busy intersection. And so, as we fade into the sunset over New York Harbor. Happy printing, collecting, and looking."* —Red Grooms

Section III
Posters and Announcements

"Walter and I shared boyhood experiences, horsing around on dangerous railroad bridges, digging underground tunnels and challenging the boys from the other side of the tracks to rock fights. In our backyards we played tremendously contested tackle football games (without pads or helmets). All along we backed each other's interest in art. Walter was driving before I could so he would pick me up to look for watercolor locations. Our favorite subjects were run-down Victorian houses or industrial sites, preferably with a grain mill or two. We were excited to show and sell our work. Myron King, owner of Lyzon's Gallery and Frame Shop, gave us a great opportunity to get into the "biz."
—Red Grooms

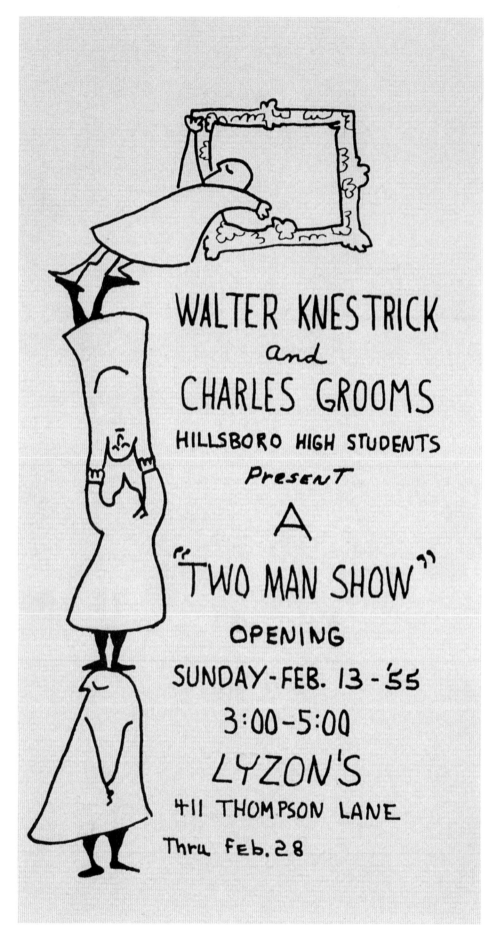

A Two Man Show, 1955. Offset lithograph 9½ × 5″ (24.1 × 12.7). Cat. no. 196.

Drawings, 1958. Offset lithograph 9 × 5″ (22.9 × 12.7 cm). Cat. no. 197.

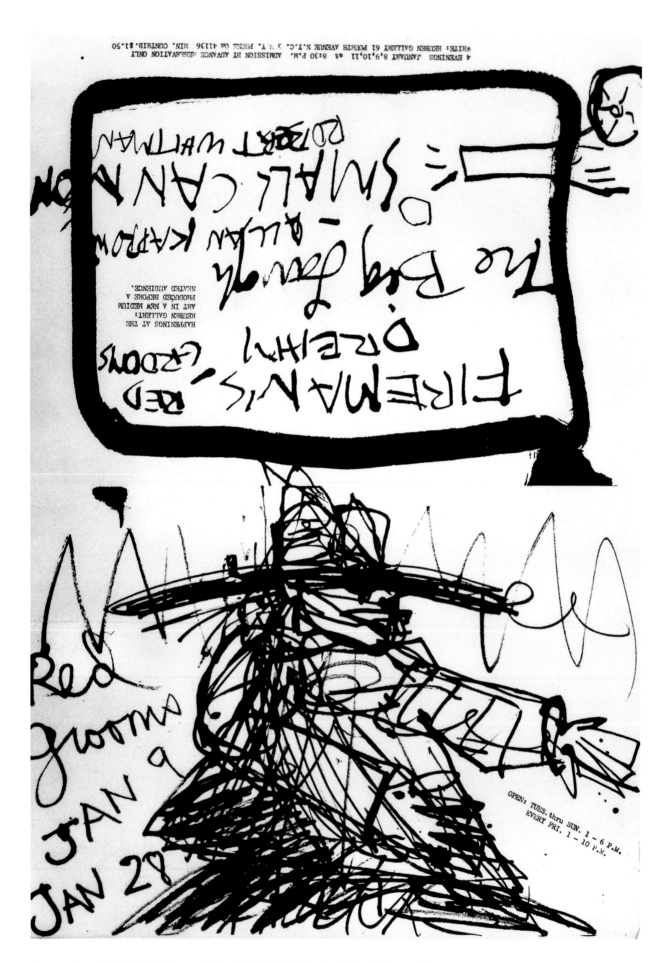

Happenings, 1960. Offset lithograph 17 × 12″ (43.2 × 30.5 cm) unfolded. Cat. no. 198.

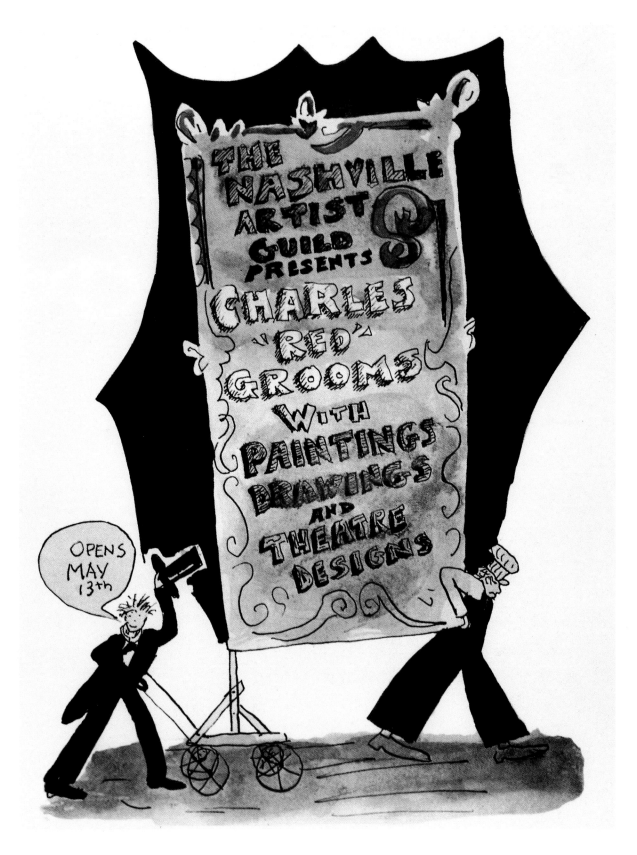

The Nashville Artist's Guild Presents Charles "Red" Grooms, 1961. Offset lithograph 11 × 8½" (27.9 × 21.6 cm). Cat. no. 199.

"This was my first show after returning from a year and a half stay in Europe. It seems I was uncertain of my identity in Nashville, using both my given name and the professional name "Red" that I took in 1957."
<div align="right">—Red Grooms</div>

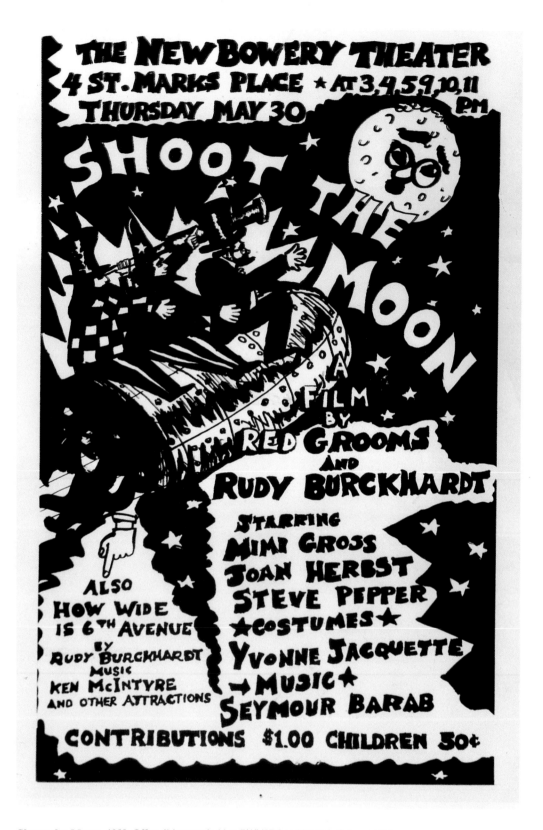

Shoot the Moon, 1963. Offset lithograph 11 × 7½″ (27.9 × 19.1cm). Cat. no. 200.

"The New Bowery was a very sympathetic house to the underground film and theater world of '63. I saw a great play, Loves Labor Lost, *there and movies by the Kuchar Brothers. We tried to attract a crowd by having some of our costumed Moononauts parade down St. Mark's Place. But* Shoot the Moon *was a little too tame for an audience expecting the sex and drugs exploited in other underground films of the day."* —Red Grooms

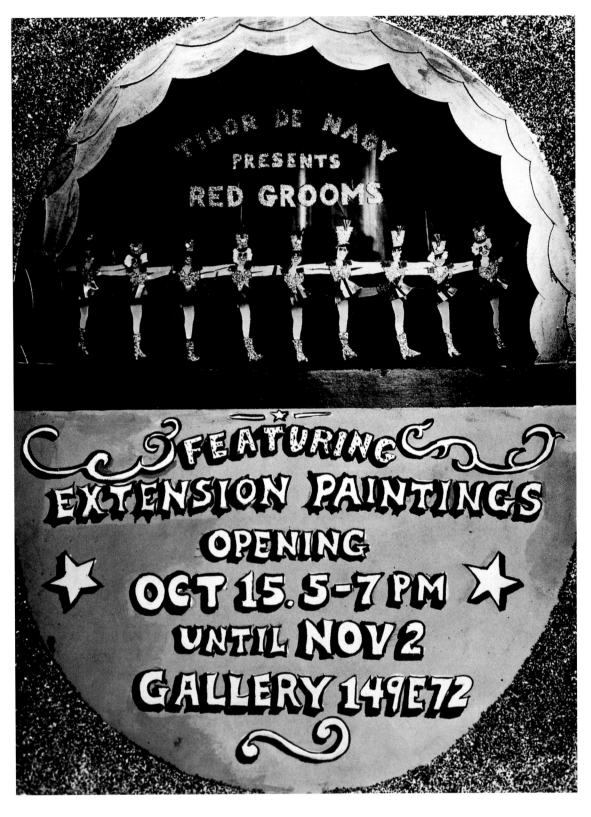

Tibor de Nagy Presents Red Grooms, 1963. Offset lithograph with glitter
12 × 9″ (30.5 × 22.9 cm). Cat. no. 201.

*"This was my first 'uptown' show. I had worked as an usher at the
Roxy Theater in '57 and '58. I was fascinated by the backstage
machinery at Radio City Music Hall. I applied but failed to get a job
there. This flyer depicts the Rockettes on that great stage. People who
received it were complaining for months after about the glitter all
over their house and even in their beds."* —Red Grooms

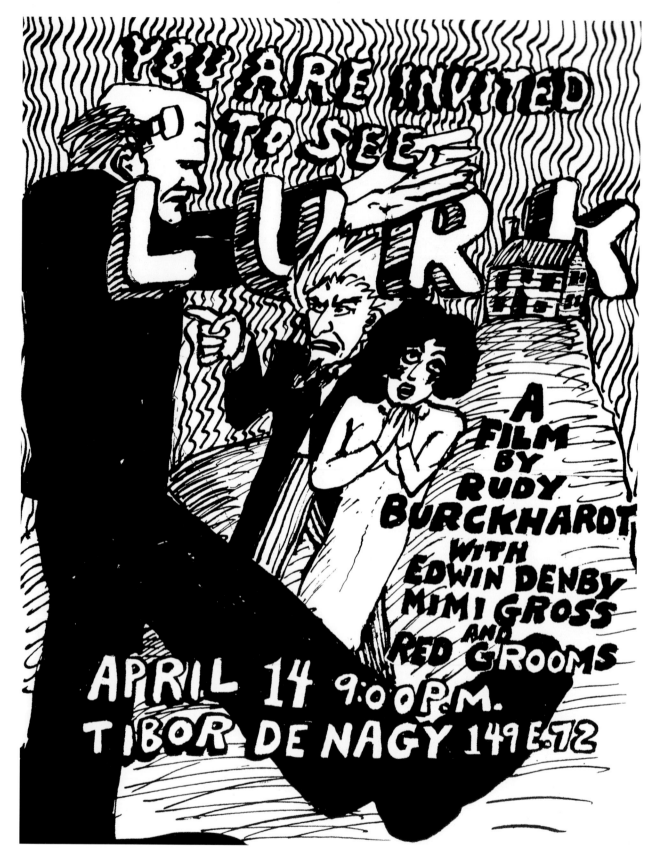

Lurk, 1965. Offset lithograph 11 × 8½″ (28.0 × 21.6 cm). Cat. no. 202.

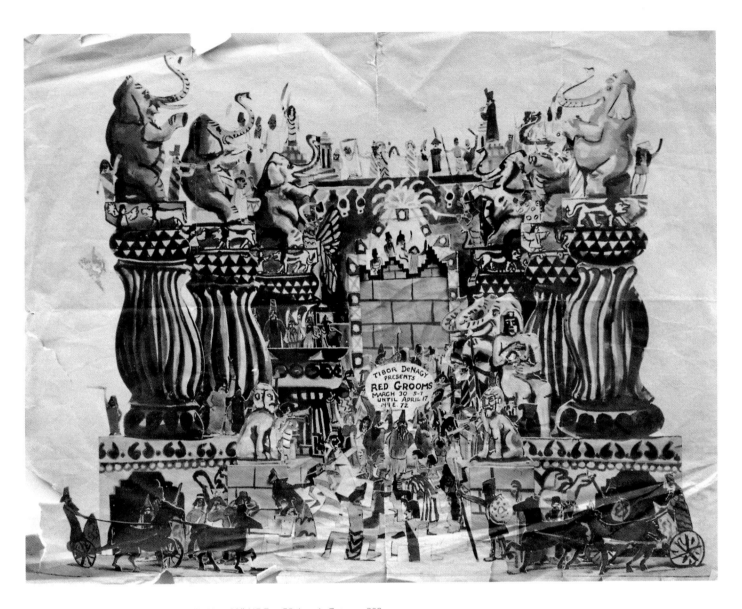

Intolerance, 1965. Offset lithograph 18 × 23″ (45.7 × 58.4 cm). Cat. no. 203.

"In the 1960s, there was a great deal of interest in the films of D. W. Griffith. I, too, was swept up in reading everything I could about him and his epic productions. This scene from Griffith's 1915 film Intolerance, *famously shot from a tethered balloon, was to me the height of outrageous theatricality and much to my liking."* —Red Grooms

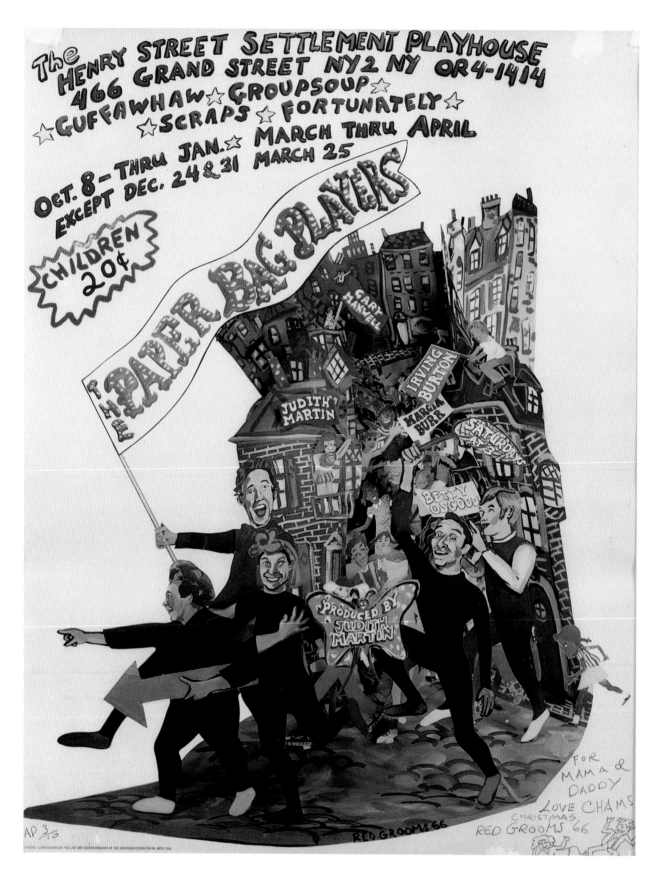

Paper Bag Players, 1966. Offset lithograph 11 × 8½" (27.9 × 21.6 cm). Cat. no. 204.

"My concept here was to build a big set piece and show the dancers leading their audience of children in Pied Piper fashion down a fairy tale street. The Paper Bag Players are a very original troupe who have performed for decades for New York City kids." —Red Grooms

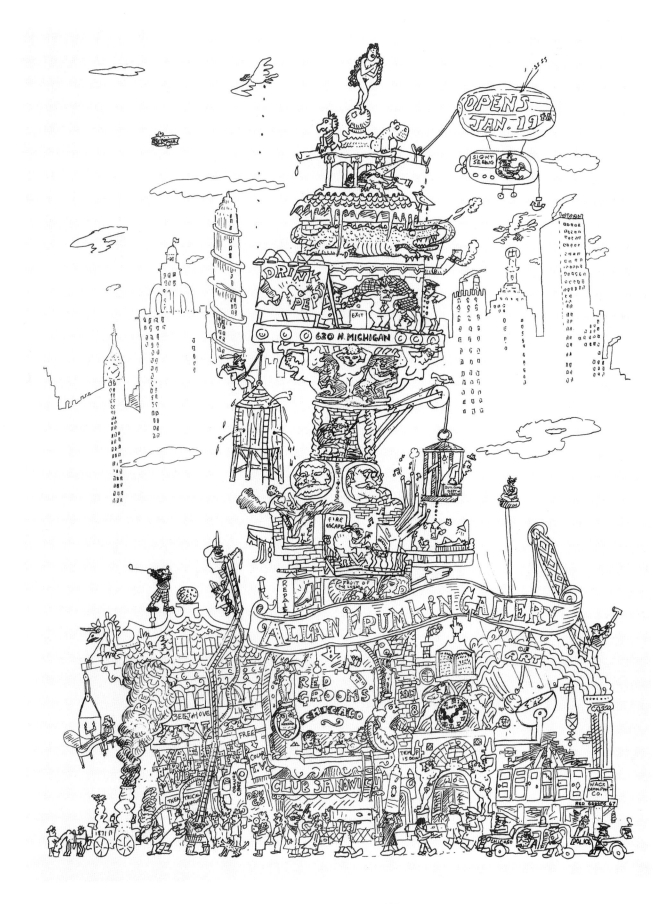

City of Chicago, 1968. Offset lithograph 28¾ × 21⅞" (73.0 x 55.6). Cat. no. 205.

"This poster is an example of my 'busy' style—I kind of let it all hang out. I hand colored a few for friends."—Red Grooms

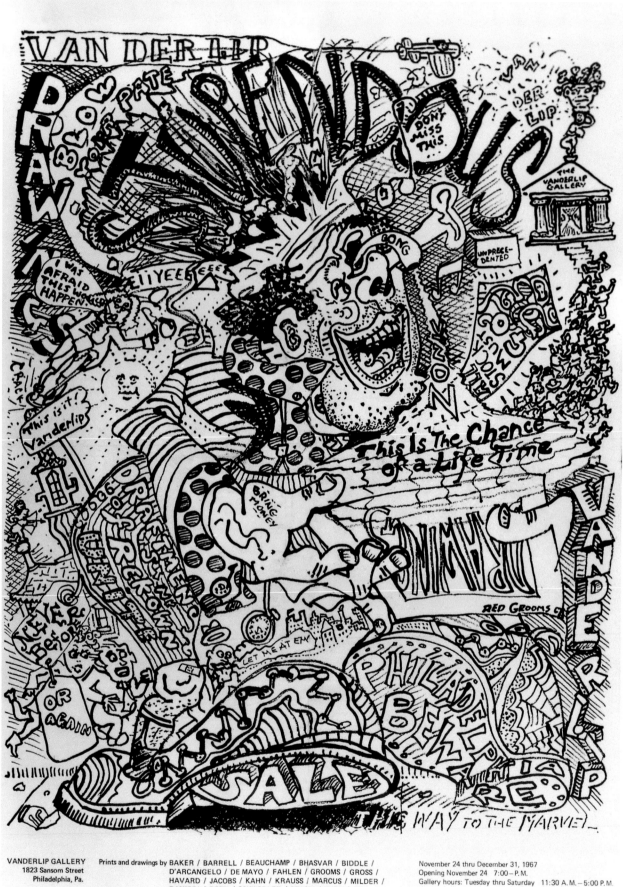

VANDERLIP GALLERY Prints and drawings by BAKER / BARRELL / BEAUCHAMP / BHASVAR / BIDDLE / November 24 thru December 31, 1967
1823 Sansom Street D'ARCANGELO / DE MAYO / FAHLEN / GROOMS / GROSS / Opening November 24 7:00 – P. M.
Philadelphia, Pa. HAVARD / JACOBS / KAHN / KRAUSS / MARCUS / MILDER / Gallery hours: Tuesday thru Saturday 11:30 A. M. – 5:00 P. M.
 RANIERI / ROTH / SCHWEDLER / STASIK / THEK / ZOX

This Way to the Marvel, 1967. Offset lithograph 19 × 13″ (48.3 × 33.0 cm). Cat. no. 206.

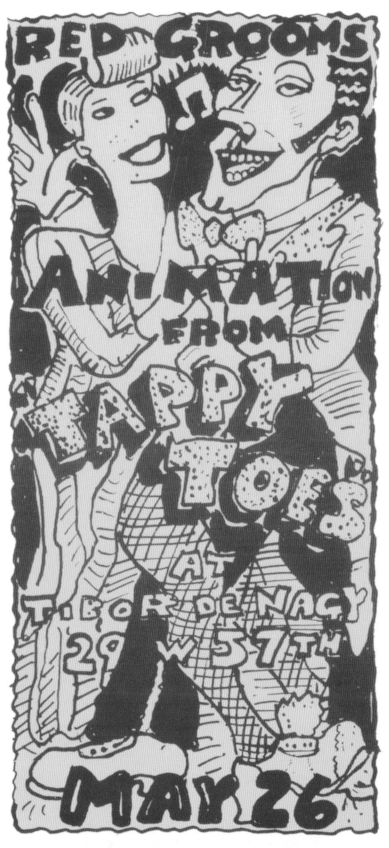

Animation from Tappy Toes, 1968. Offset lithograph 11¼ × 5½″ (28.6 × 14.0 cm). Cat. no. 207.

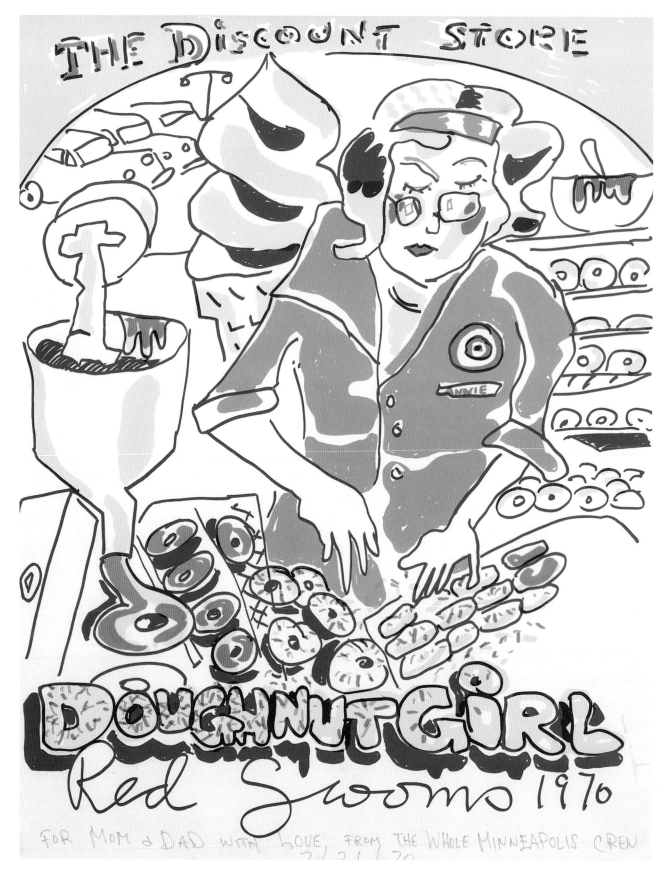

Doughnut Girl, 1970. Offset silkscreen 28¾ × 21¾" (73.0 × 55.3 cm). Cat. no. 208.

"I liked working with the Johnsons. They gave me a free rein on the image for this poster and it paid off for them, too. They were given an Art Director's Award for the poster of the year. They also designed the Great American Rodeo poster 1975."—Red Grooms

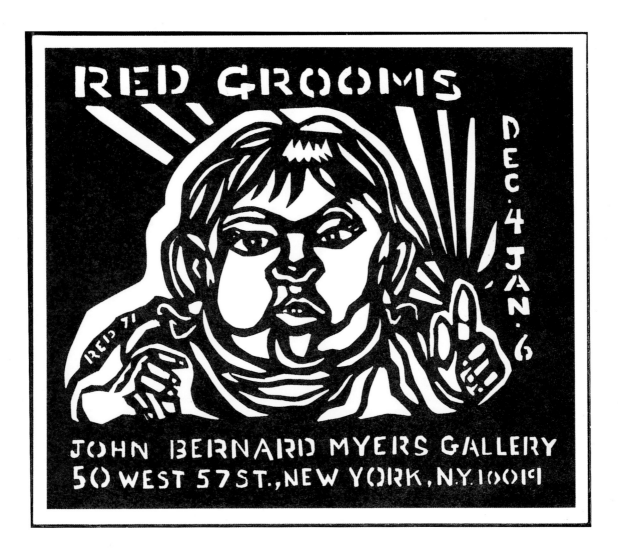

Saskia, 1971. Stencil 8 × 9½″ (20.3 × 24.1 cm). Cat. no. 209.

"I was once again trying to get more flatness and graphic impact into this show announcement by doing the original in a cut and paste paper technique." —Red Grooms

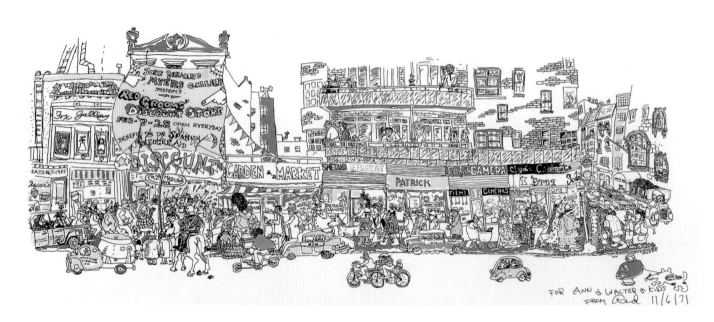

Discount Store, 1971. Offset silkscreen 11¾ × 29″ (29.9 × 73.7 cm). Cat. no. 210.

"This depicts the surrounding neighborhood around the gallery Johnny Myers rented for the Discount Store exhibition between 73rd and 74th Street."—Red Grooms

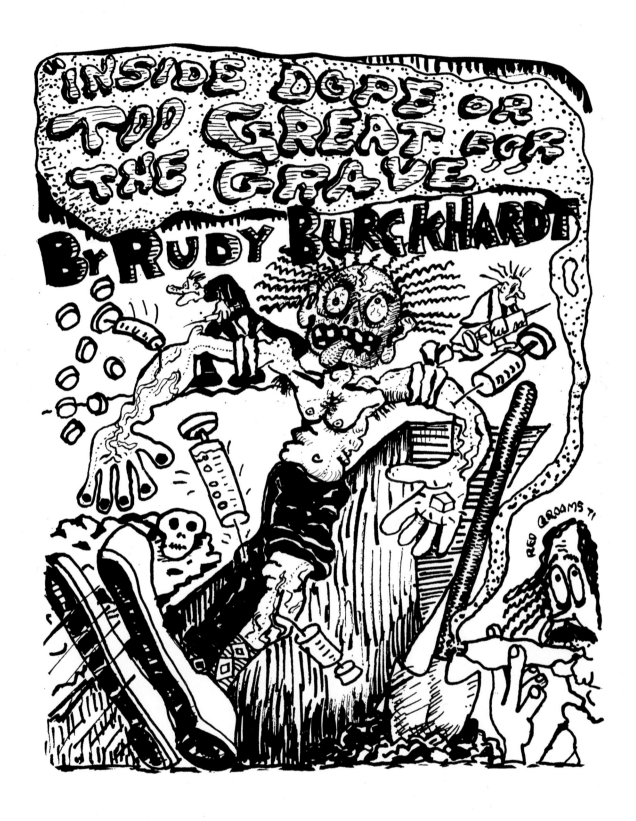

Inside Dope, 1971. Memograph 23½ × 18″ (58.8 × 45.7 cm). Cat. no. 211.

"Rudy, by now, had gotten into the swing of things by doing this spoof of the drug culture. I, too, was trying to look as hip and depraved as the next downtown artist. The manic style of this poster relates to my first color lithograph, Nervous City, also released in 1971." —Red Grooms

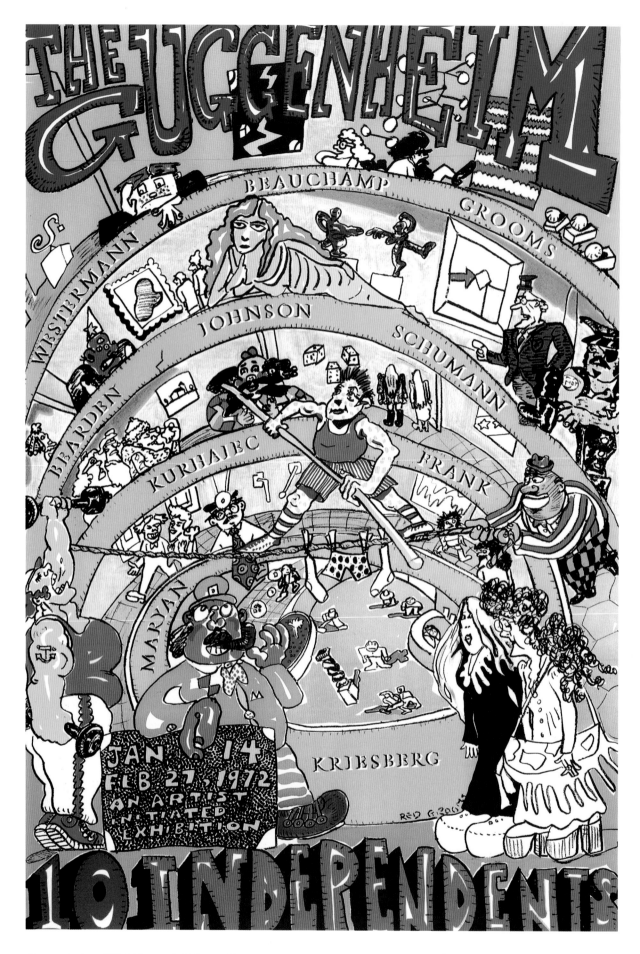

Guggenheim, 1971. Lithograph 38⅛ × 26⅛″ (96.8 × 66.4 cm). Cat. no. 212.

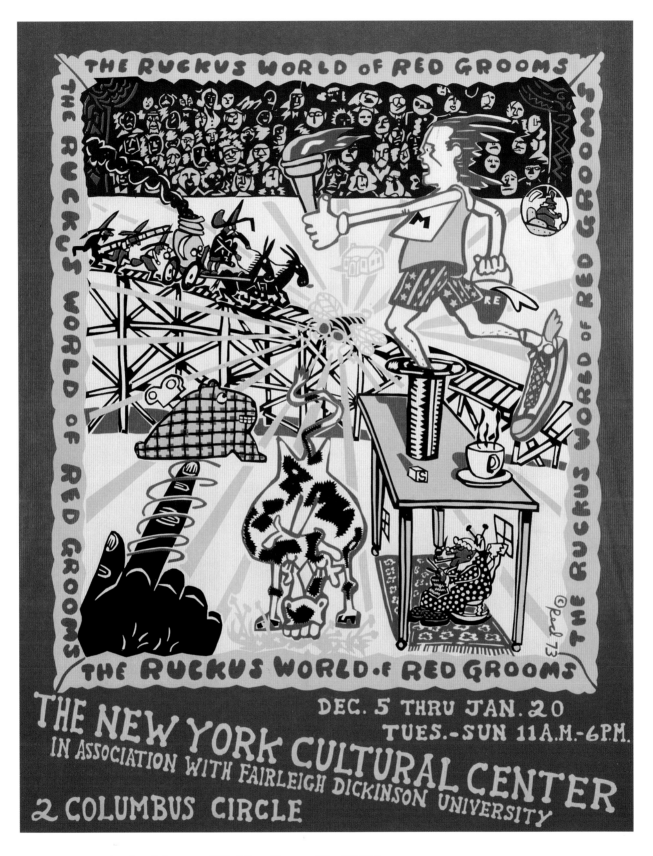

The Ruckus World of Red Grooms, 1973. Offset silkscreen 28 × 22″ (71.1 × 55.9 cm). Cat. no. 213.

"I put my heart into this one, creating a complicated cutout in three colors first. I let free association take over the image. The paper technique used here led to the silkscreens Mango, Mango, *1973, and* Bicentennial Bandwagon, *1995."*—Red Grooms

Red Grooms—Caracas, 1974. Offset lithograph 25⅛ × 18¼ " (63.8 × 46.4 cm).
Cat. no. 214.

"Three major sculpto-pictoramas were sent by boat to Caracas: City
of Chicago, Discount Store, *and* Astronauts on the Moon. *In the
poster they are seen popping out of the ultramodern Museo De Arte
Contemporano. I made the drawing for the poster in Caracas."*

—Red Grooms

THE GREAT AMERICAN RODEO

John Alberty Mimi Gross Grooms Robert Rauschenberg January 25-
Terry Allen Red Grooms Garry Winogrand April 11
Ed Blackburn Joe Hobbs Joe Zucker
George Green Andy Mann

Free admission to Art Museum Members and children under 12 Non-members $1.00 Tuesday Free

This exhibition is made possible by a grant from the Texas Commission on the Arts and Humanities

The Great American Rodeo, 1975. Offset lithograph 29 × 17½" (73.7 × 44.5 cm). Cat. no. 215.

Red Grooms à Paris, 1977. Lithograph 29 × 19⅝″ (73.7 × 49.9 cm). Cat. no. 216.

"This poster was placed in many bars and cafés around Paris. Parisians are great dog lovers and dog defecation has always been a civic problem. I was taking a long shot on the French sense of humor here."
—Red Grooms

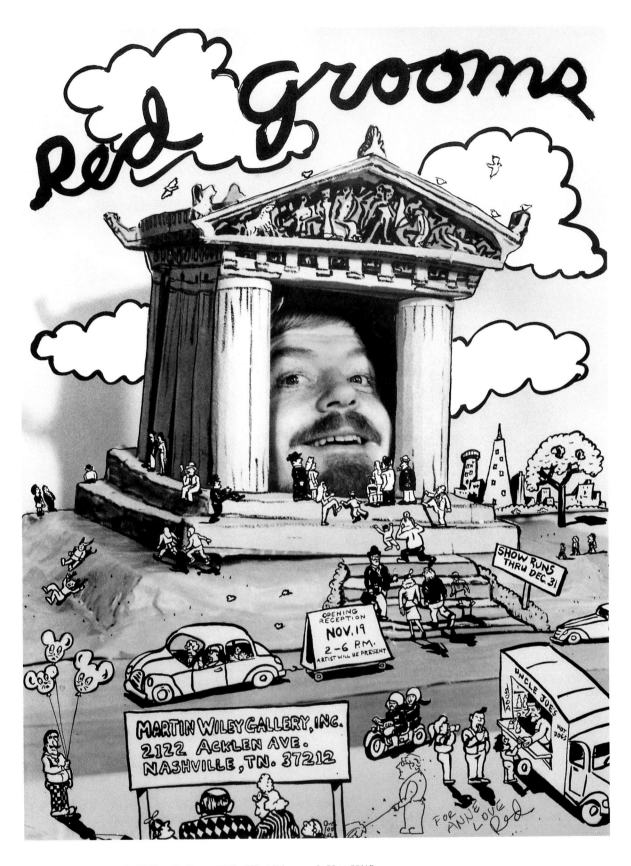

Red Grooms, Martin Wiley Gallery, 1978. Offset lithograph 28 × 20½"
(71.1 × 52.1 cm). Cat. no. 217.

*"I used this combination of photograph and hand drawing again in
1982 while working with Joe Petrocelli in the offset lithograph* Pierpont
Morgan Library, *1982, and* The Cedar Bar, *1987, printed by Maurice
Sanchez."* —Red Grooms

PLAY BALL! A CENTURY OF SPORTS IN ART

THE QUEENS MUSEUM 24 JUNE-10 SEPTEMBER 1978

New York City Building, Flushing Meadow-Corona Park, Flushing, New York. Tel: (212) 592-2405. Hours: Tues-Sat 10-5; Sun 1-5.

This exhibition is made possible with a Grant from Smirnoff Vodka.

Play Ball!, 1978. Offset lithograph 23⅝ × 19″ (60.1 × 48.3 cm). Cat. no. 218.

"The original was made with cut paper. I've always felt this was one of my best poster designs." —Red Grooms

Ruckus Manhattan, 1981. Offset lithograph 11 × 28″ (27.9 × 71.1 cm). Cat no. 219.

"The stretch proportions of this poster were designed for advertising space on a city bus. Bob Abrams wanted to help Creative Time Inc., so he paid for the publication of the poster. As I remember it we tried to sell the poster for seven bucks or something like that. I guess pink and black was not in at the time, because sales totaled about zero."

—Red Grooms

Mayor Byrne's Mile of Sculpture, 1982. Lithograph 35 × 22¼″ (88.9 × 56.5 cm). Cat. no. 220.

"One of the few posters ever printed in an edition of 10,000 in 12 colors from original hand-drawn litho plates." —Steve Andersen

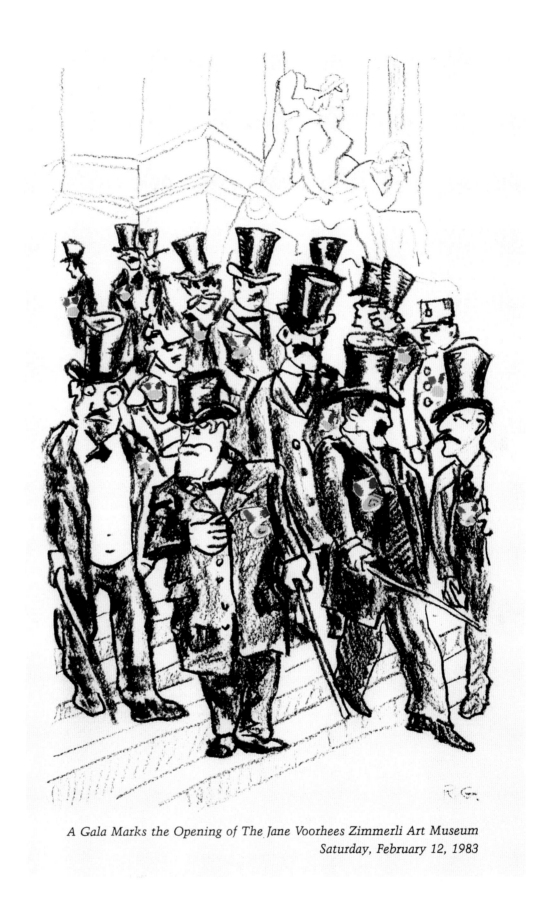

A Gala Marks the Opening of The Jane Voorhees Zimmerli Art Museum
Saturday, February 12, 1983

Museum Opening, 1983. Offset lithography 13 × 8″ (33.0 × 20.3 cm). Cat. no. 221.

"I harked back to my Parade in Top Hat City *days in this homage to the French salons of the 19th century."* —Red Grooms

 MICHAEL LEONARD PRESENTS

MICHAEL LEONARD AND ASSOCIATES GALLERY
LOCATED AT 419 BROOME STREET NEW YORK 212 226-6709

"FAT FREE" SURREALISM
CURATED BY RED GROOMS

★ **4** ★ **STAR** ★ **BOUT** ★

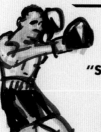

JEFF **STARR** 6'2"
"BOOM-BOOM" 165 POUNDS

JOHN R. **FUDGE** 6'8"
"MOUNTAIN MAN" 310 POUNDS

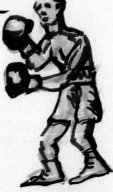

TOM **BURCKHARDT** 5'11"
"SKEETER" 105 POUNDS

ART **STAATS** 5'10"
"SWAMPTHING" 180 POUNDS

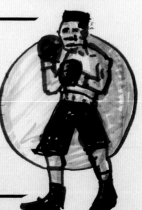

GALLERY HOURS TUESDAY THROUGH SATURDAY NOON TO 6

★ **DEC 6 '90 – JAN 5 '91** ★

"Fat Free" Surrealism, 1990. Offset lithograph 22 × 17" (55.4 × 43.2 cm). Cat. no. 222.

"In the dead of night Michael Staats blitzed downtown Manhattan walls and lamp posts with the 'Fat Free' Surrealism *poster."* —Red Grooms

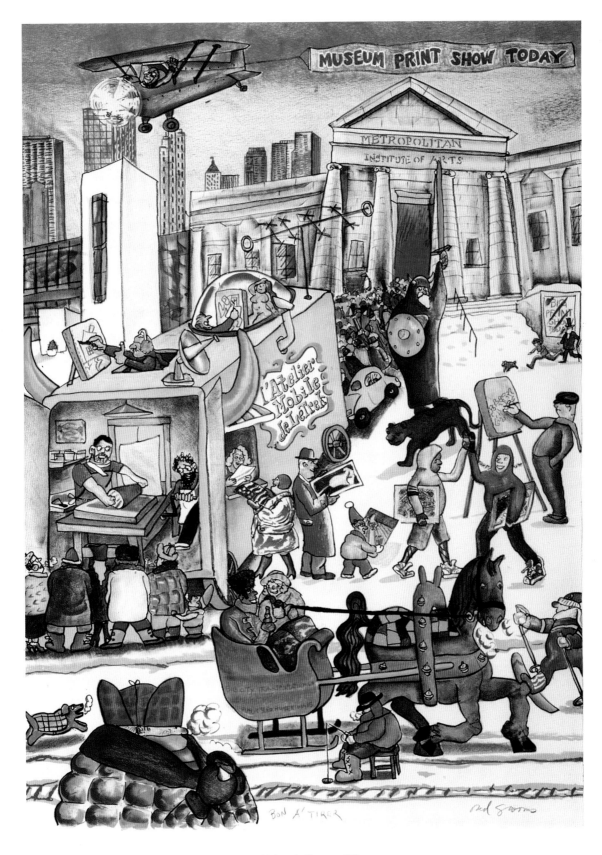

Sno-Show II, 1991. Lithograph 37 × 24″ (94.0 × 61.0 cm). Cat. no. 223.

"I was having some fun with my friends in Minneapolis, alluding to their deep winters (just joking, of course). Steve wanted to get a small edition out of the plates made for Sno-Show I. We tried to make it more 'universal' by changing the signs but the public was not fooled."
 —Red Grooms

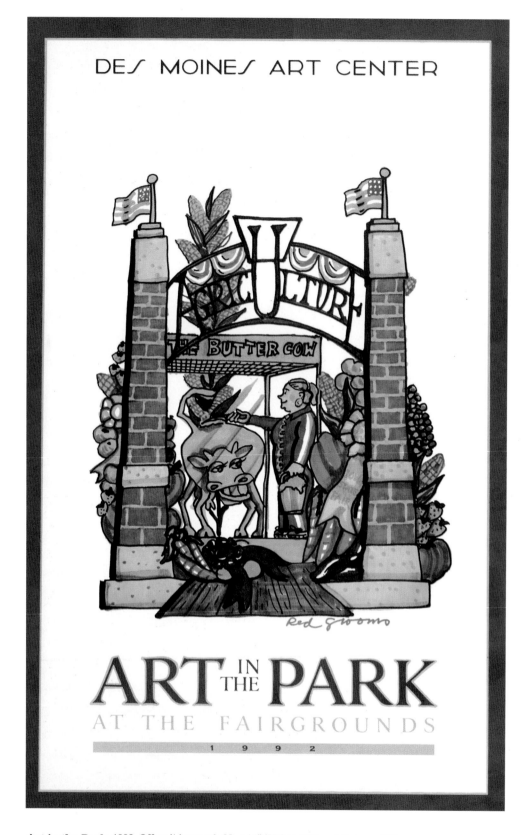

Art in the Park, 1992. Offset lithograph 22 × 14″ (55.9 × 35.6 cm). Cat. no. 224.

"In 1992, I was commissioned by the Des Moines Art Center to make a piece about the Iowa State Fair. I chose the agricultural building and made a large sculpto-pictorama. The star attraction was the sculptress who made a life-sized cow out of butter in her refrigerated studio."
<div align="right">—Red Grooms</div>

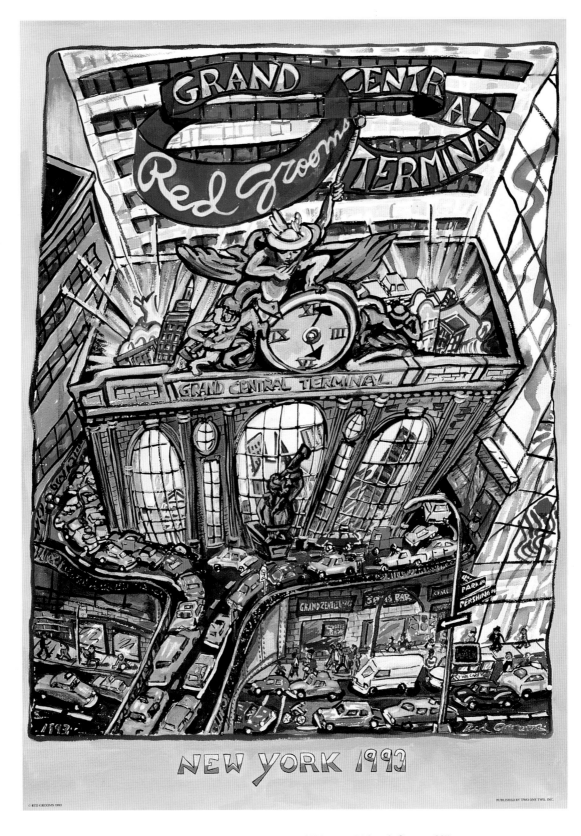

Grand Central Terminal, 1993. Offset lithograph 33⅝ × 24⅛″ (85.4 × 61.3 cm). Cat. no. 225.

"Lysiane and Rosi Lavai opened a souvenir stand at the large exhibition I had in the waiting rooms of Grand Central Terminal. Lysiane designed hats, watches, clocks, and luggage tags from some of my images. Metro North also wanted a poster to advertise the show. Lysiane and Rosi produced it through their company "TWO ONE TWO." The image is literally the show seen from an overhead view through a cut away in the terminal's roof. Sometimes on the weekends Lysiane and I would visit the gift shop and I would sign posters and other items for a long line of fans. This was fun as it gave us the temporary feeling of making money hand over fist."—Red Grooms

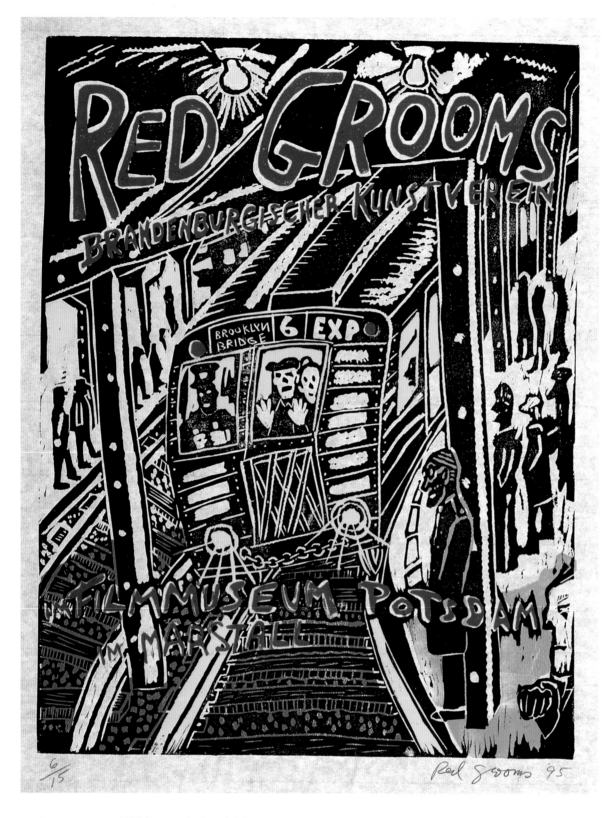

Train to Potsdam, 1995. (Image of edition). Offset lithograph. (Dimensions unknown). Cat. no. 226.

"Our host, Fredrich Meschede, who had nicely picked Lysiane and me up at the Berlin Airport, happened to have a flat tire on the Autobahn on our way to Potsdam. We all piled out of the car and helped Fredrich unload the whole poster edition of Train to Potsdam *so he could get to his car jack. Fredrich changed the tire successfully and we and the poster edition made it to Potsdam."*—Red Grooms

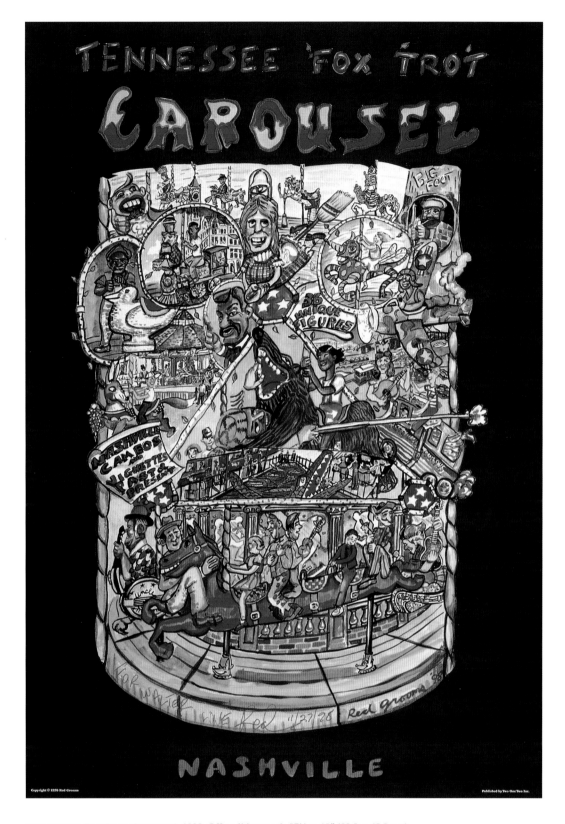

Tennessee Fox Trot Carousel, 1998. Offset lithograph 27¼ × 19″ (69.2 × 48.3 cm).
Cat. no. 227.

*"I found out that it was hard to tackle the whole carousel image.
Partly, its specific whole is made up of so many distinct details, that the
effort to get at it all in a rush is thwarted by having to define each part.
In this image for a carousel poster I tried another tack, segmenting
individual figures in the manner of an old Buffalo Bill poster."*

—Red Grooms

Section IV
Miscellaneous

Art Cash, 1971. Photo-offset lithographs, set of 3, 27 × 22″ (68.6 × 55.9 cm). Cat. no. 228.

"What I remember is all the artists sitting along one side of a long table ready to sign the money poster and when it got to [Andy] Warhol he pulls out a rubber stamp and smacks it down, leaving his signature. Boy, was he cool. I can tell you, we were impressed."—Red Grooms

"We printed a couple of million dollars at the U.S. Banknote company in the Bronx, which actually prints money for countries that don't feel safe printing their own. The security was incredible: they count every sheet of paper coming in and coming out of the plant. Art Cash printed on the same paper regular U.S. money is printed on, but without the threads. The money was bundled in increments of 500 bills."—Billy Klüver

Menu, 1973 (outside). Silkscreen 12 × 9″ (30.5 × 22.9 cm). Cat. no. 229.

"Billy Klüver has always been a good agent for me, including me in many of his projects. As far back as 1964 it was Billy who suggested that I do a print for the Swartz Avant Garde portfolio. In 1973 Billy asked me to do this menu, which was used for the evening meal on a flight full of collectors and artists bound for Stockholm and the opening of the New York collection. Billy also arranged for my short 16mm film The Conquest of Libaya *to be part of the in-flight movie program."*

—Red Grooms

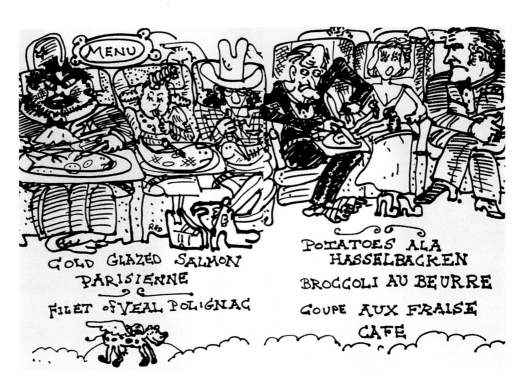

Menu, 1973 (inside). Silkscreen 12 × 18″ (30.5 × 45.7 cm). Cat. no. 229a.

TRIAL PROOF 1/2 "MILLET" Red Grooms

Millet, 1976. Etching 14¾ × 11″ (37.5 × 27.9 cm). Cat. no. 230.

"I made Millet *as part of the* Nineteenth-Century Artists *portfolio but he didn't make the cut. This rejected print is one of my rarest."*
—Red Grooms

Sunday Afternoon in the Park with Monet, 1976. Drypoint 30 × 22¼″ (76.2 × 56.5 cm). Cat. no. 231.

"The subject is the nineteenth-century French artist Claude Monet. This print was a favorite of mine but for some reason there was no edition made. Prints are rarely casual; perhaps Sunday Afternoon in the Park with Monet *was just too relaxed."*—Red Grooms

Roger, Wayne, and Nephew, 1980. Drypoint 11⅝ × 15⅛″ (29.5 × 38.4 cm). Cat. no. 232.

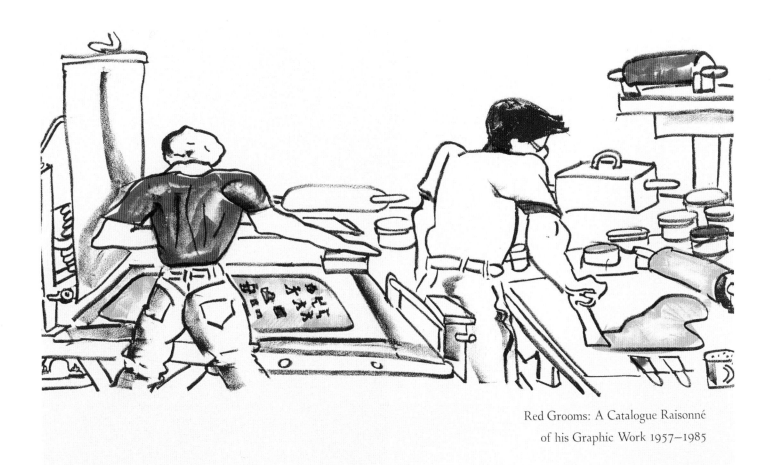

Red Grooms: A Catalogue Raisonné
of his Graphic Work 1957–1985

Shark's Ink, 1981. Offset lithograph 11 × 22½″ (27.9 × 57.2 cm). Cat. no. 233.

"Bud is mixing up a batch of sticky printer's ink while Matt is sponging the aluminum plate with water. I like the atmosphere of printing shops and I'm often tempted to turn my co-workers into subject matter."
—Red Grooms

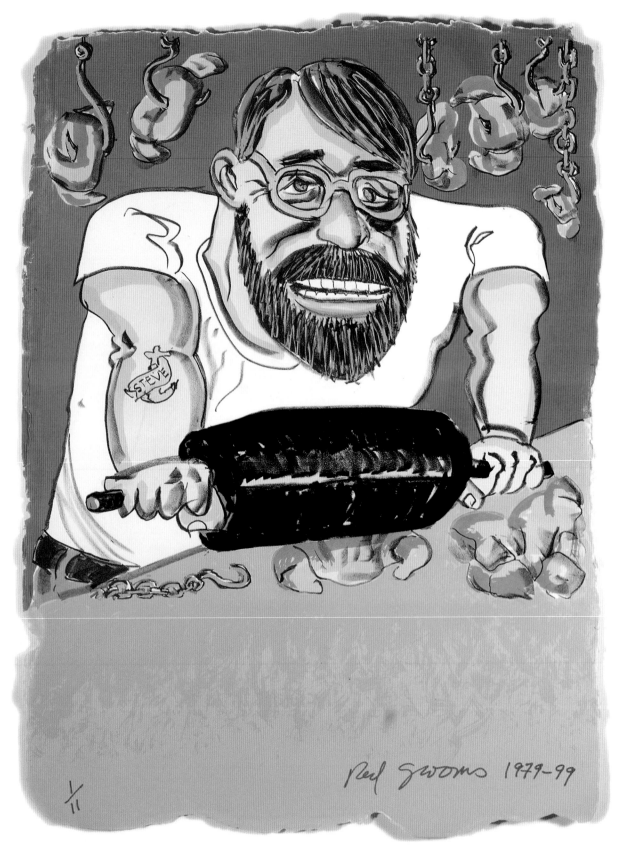

Croissant Crusher, 1979 (published in 1999). Lithograph 29 × 21½″ (73.7 × 54.6 cm).
Cat. no. 234.

"This is a portrait of Steve Andersen with a tattoo which was removed shortly afterwards. It was intended to be part of Sex in the Midwest *as a tongue-in-cheek comment on the mildly sadomasochistic relations between printers and artists."*—Red Grooms

BOULDER 3/20/(c

A CHARLIE FOR SASKIA

WITH
LOVE Daddy

A Charlie for Saskia, 1986. Lithograph
15 × 4″ (38.1 × 10.2 cm). Cat. no. 235.

*"This is one of the first marginalia I
did and it is unique. I made several
others over a few years in the mar-
gins of sheets that were cut up to do
the pop-up prints."*—Red Grooms

Self-Portrait with Bow Tie, 1987. Lithograph, hand-colored with pencil
16¼ × 11½″ (41.3 × 29.2 cm). Cat. no. 236.

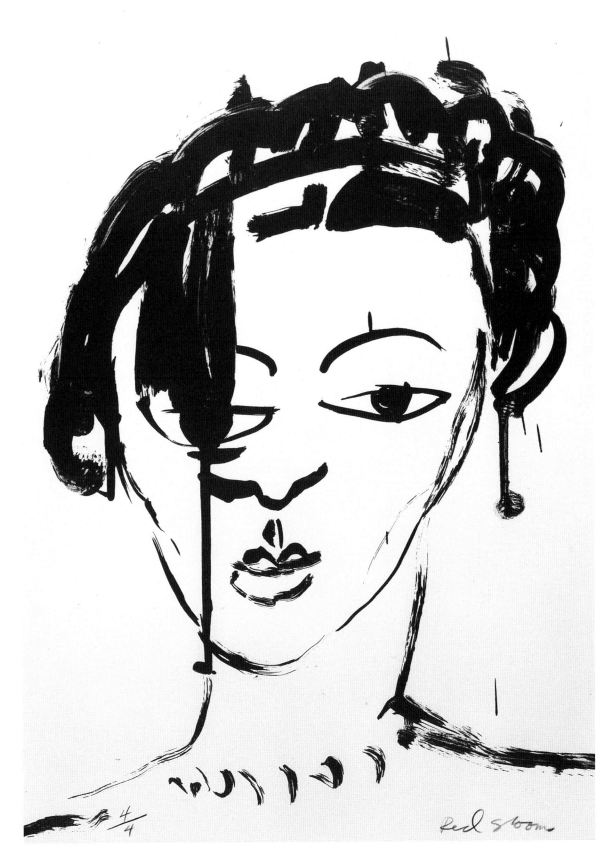

Lysiane in Blue, 1987. Lithograph 6¼ × 11½″ (41.3 × 29.2 cm). Cat. no. 237.

"Lysiane wears her hair in classic braids. The effect is always completed with a ribbon, which, in this case, is drooping over her right eye."
— Red Grooms

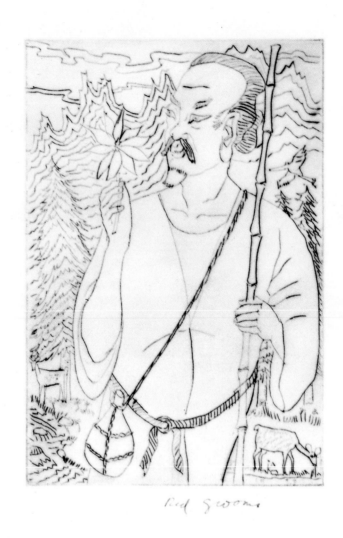

Red Grooms

Chinese Poet, 1990. Drypoint 13 × 9⅞″ (33.0 × 25.1 cm). Cat. no. 238.

"This etching was intended as a frontispiece for a book of poems by an ancient Chinese poet translated by Iris Hao (Lysiane's sister)."

—Red Grooms

Catalogue

Key to the Catalogue

Documentation: Every effort has been made (including consultations with the Artist), to accurately record all prints and provide all available documentation. For some of the very early prints in the 1960s, little documentation exists and information depends in part on the memories of the Artist, his friends, and colleagues, many of whom collected or were given these prints at the time they were produced. Even in the 1970s, many of the printers did not use written forms for documentation and some are no longer in the business. The available documentation was often full of discrepancies and further research was often required. Various proofs may exist that have not been recorded. Monotypes have been excluded, since almost all were hand-touched or repainted by the Artist. Etchings which were hand-colored or monoprinted have been included

Catalogue Sequence: The catalogue has been divided into four sections. Early prints, 1956-1971 (Section I), Signed and Numbered Editions (Section II), Posters and Announcements (Section III), and Miscellaneous (Section IV). The poster section only includes posters created originally by the Artist for a particular exhibition. The miscellaneous section includes selected works and is not intended to represent all work produced by the Artist.

Title: Titles of the prints are the Artist's intended titles and may vary from those found in earlier documentation.

Date: The date the Artist signed the print. Many of the very early works were not signed. These works were assigned a date after consultation with the Artist. If the print was begun at an earlier date or published after the date signed, it is so noted in parentheses.

Medium: Printing process followed by the paper. The paper has been described in terms of color, thickness, and surface texture. The name of the paper is used when known. Unless otherwise indicated, the paper color is white. If the print is part of a series or portfolio, this is noted.

Measurements: Measurements indicate size of paper and image in inches followed by centimeters in parentheses. In the case of intaglios, the measurements indicate size of paper and plate marks. When a print is assembled in a case the case measurements are outside to outside, height precedes width precedes depth.

Edition and Proofs: The number of prints in a published or unpublished edition. For unnumbered editions, the edition size has been given after consultation with the Artist. The term *approximately* or *unknown* has been used when the edition size cannot be verified.

For works produced by master printers who issued documentation sheets, edition size and proofs are given as they appear on these sheets. The master printer's abbreviations for the various types of proofs have been used throughout the catalogue.

A	Archive Impression
AP	Artist's Proofs
TP	Trial Proof
PP	Printer's Proof
BAT	bon á tirer
CSP	Color Separation Proof
CTP	Color Trial Proof
WP	Working Proof
WSP	Workshop Proof
SP	Special Proof
S	State Proof
A	Archive Proof
C	Cancellation Proof
HC	Hors Commerce Proof
PC	Publisher's Copy

Inscriptions: Information on the style and media of signatures, dates, numbering, inscriptions, and chop marks. Inscriptions on verso are also noted. In some cases the print illustrated is a proof, not the published edition and may be inscribed with personal inscriptions not included in the edition. Many prints of the 1960s were not signed nor numbered; however, some exist that were signed at a later date. All of the Artist's prints are either signed, R.G., Grooms, or Red Grooms, printed or written.

Publisher: The name and location of the publisher of a given edition. When the Artist was his own publisher, he is listed.

Printers: The name and location of the printers, studio assistants, collaborators, and workshop involved in printing a given edition. When the Artist did his own printing, he is listed.

Selected Literature and Exhibitions: A selected listing of books, exhibition catalogues, magazine and newspaper articles, and selected exhibitions (one man or group) in which a given print has been discussed or shown. Citations are listed chronologically by year, then chronologically by month within each year.

Comments: May include information relating to the subjects in the print, related imagery, historical commentary, related text by the Artist and others. There may also be references to other prints and other artists represented in a portfolio or series.

Section 1

1. *Minstrel* 1956

Linocut in one color on heavy weight poster paper
SHEET: 15 × 13″ (38.1 × 33.0 cm)
IMAGE: 13½ × 10″ (34.3 × 25.4 cm)
INSCRIPTION: None
EDITION: 1
PUBLISHER: The Artist
PRINTER: The Artist
COMMENTS: First print in any media, produced by the Artist at
 Peabody College, Nashville, Tennessee. The "Top Hat" reappears
 in three later prints, *Self-Portrait in a Crowd*, 1962, *Parade in Top
 Hat City*, 1963, and *Nadar*, 1976.

2. *Pencil Man* 1958

Metal plate printed in one color on a letterpress on drawing paper, a
loose collection of drawings and poems entitled *City*
SHEETS: 7 × 5¼″ (17.8 × 13.3 cm)
IMAGES: 6¾ × 5¼″ (17.2 × 13.3 cm)
INSCRIPTION: Envelope containing drawings and poems is numbered
 in pencil on inside flap.
EDITION: 92
PUBLISHER: Expression Press, New York
PRINTER: Yvonne Andersen (Sun Press), Provincetown, Massachusetts
COMMENTS: A loose portfolio of four printed drawings by the Artist
 (*Pencil Man*, *Black Man*, *The Doctor*, and *The Operation*), three
 printed drawings by Lester Johnson entitled *Street Scene*,
 Crouching Figure & Woman, and five poems by Dominic Falcone
 entitled *A Longer Piece*, *She*, *New York*, *Too Many Eyes*, and
 Running. All of the above printed on a small hand table model
 printing press purchased by the group.

3. *Black Man* 1958

Metal plate printed in one color on a letterpress on drawing paper, a
loose collection of drawings and poems entitled *City*
SHEETS: 8 × 6″ (20.3 × 15.2 cm)
IMAGES: 6¼ × 5½″ (15.9 × 14.0 cm)
INSCRIPTION: Envelope containing drawings and poems is numbered
 in pencil on inside flap.
EDITION: 92
PUBLISHER: Expression Press, New York
PRINTER: Yvonne Andersen (Sun Press), Provincetown, Massachusetts
COMMENTS: A loose portfolio of four printed drawings by the Artist
 (*Pencil Man*, *Black Man*, *The Doctor*, and *The Operation*), three
 printed drawings by Lester Johnson entitled *Street Scene*,
 Crouching Figure & Woman, and five poems by Dominic Falcone
 entitled *A Longer Piece*, *She*, *New York*, *Too Many Eyes*, and
 Running. All of the above printed on a small hand table model
 printing press purchased by the group.

4. *The Doctor* 1958

Metal plate printed in one color on a letterpress on drawing paper, a
loose collection of drawings and poems entitled *City*
SHEETS: 7¼ × 5¼″ (18.4 × 13.3 cm)
IMAGES: 6 × 5¼″ (15.2 × 13.3 cm)
INSCRIPTION: Envelope containing drawings and poems is numbered
 in pencil on inside flap.
EDITION: 92
PUBLISHER: Expression Press, New York
PRINTER: Yvonne Andersen (Sun Press), Provincetown, Massachusetts

COMMENTS: A loose portfolio of four printed drawings by the Artist
 (*Pencil Man*, *Black Man*, *The Doctor*, and *The Operation*), three
 printed drawings by Lester Johnson entitled *Street Scene*,
 Crouching Figure & Woman, and five poems by Dominic Falcone
 entitled *A Longer Piece*, *She*, *New York*, *Too Many Eyes*, and
 Running. All of the above printed on a small hand table model
 printing press purchased by the group.

5. *The Operation* 1958

Metal plate printed in one color on a letterpress on drawing paper, a
loose collection of drawings and poems entitled *City*
SHEETS: 7¼ × 5¼″ (18.4 × 13.3 cm)
IMAGES: 7¼ × 5¼″ (18.4 × 13.3 cm)
INSCRIPTION: Envelope containing drawings and poems is numbered
 in pencil on inside flap.
EDITION: 92
PUBLISHER: Expression Press, New York
PRINTER: Yvonne Andersen (Sun Press), Provincetown,
 Massachusetts
COMMENTS: A loose portfolio of four printed drawings by the Artist
 (*Pencil Man*, *Black Man*, *The Doctor*, and *The Operation*), three
 printed drawings by Lester Johnson entitled *Street Scene*,
 Crouching Figure & Woman, and five poems by Dominic Falcone
 entitled *A Longer Piece*, *She*, *New York*, *Too Many Eyes*, and
 Running. All of the above printed on a small hand table model
 printing press purchased by the group.

6. *Five Futurists* 1958

Linocut in one color on off-white wove paper
SHEET: 5 × 8½″ (12.7 × 21.6 cm)
IMAGE: 3¼ × 4½″ (8.3 × 11.4 cm)
INSCRIPTION: Some signed in pencil, lower right: *Red Grooms* (possi-
 bly signed at a later date).
EDITION: Approximately 10
PROOFS: 1 TP
PUBLISHER: The Artist
PRINTER: The Artist
COMMENTS: The subject relates to a famous photograph of the
 Futurists taken in Paris, 1912. The five futurists from left to right
 are Luigi Russolo, Carlo Carrá, F. T. Marinetti, Umberto Boccioni,
 and Gino Severini. Sheet sizes vary.

7. *The Burning Building* 1959

Woodcut in one color on assorted bond paper
SHEET: 27¾ × 20″ (70.5 × 50.8 cm)
IMAGE: 12⅛ × 9″ (30.8 × 22.9 cm)
INSCRIPTION: Some signed in pencil, lower right: *Red Grooms* (possi-
 bly signed at a later date).
EDITION: Unknown
PUBLISHER: The Artist
PRINTER: The Artist
COMMENTS: First woodcut

8. *Comic* 1959

Mimeograph in one color on pink Gestetner #62 stencil paper of
eight pages, in the form of a comic book
SHEETS: 8½ × 5½″ (21.6 × 14.0 cm), stapled
IMAGE: 8¼ × 5¼″ (21.0 × 13.3 cm)
INSCRIPTION: None

EDITION: Unknown
PUBLISHER: Claes Oldenburg, New York
PRINTER: Claes Oldenburg, New York

9. *Ruckus* 1961

Linocut in one color on rice paper
SHEET: 7 × 6″ (17.8 × 15.2 cm)
IMAGE: 3 × 3″ (7.6 × 7.6 cm)
INSCRIPTIONS: Signed in pencil, lower right: GROOMS; numbered in pencil, lower left.
EDITION: 70
PUBLISHER: The Artist
PRINTER: The Artist
COMMENTS: First-known signed and numbered linocut. Ruckus was the name of the horse who pulled a cart and puppeteers from Florence to Venice by way of Verona, eventually returning to Florence. This 1961 band included Mimi Gross, Katharine Kean, "Paperino," Peter Stanley, and Red. The print, along with *Man with Bowler,* was often inserted and included with a book entitled *Drawings, Mimi Gross and Red Grooms,* 1961, sketches of travels in Italy, Greece, and the Middle East.

10. *Man with Bowler* 1961

Woodcut in two colors on rice paper
SHEET: 9½ × 6″ (24.1 × 15. 2 cm)
IMAGE: 5¾ × 3⅛″ (14.6 × 7.9 cm)
INSCRIPTIONS: Signed in pencil, lower right: RED GROOMS, numbered in pencil, lower left.
EDITION: 25
PUBLISHER: The Artist
PRINTER: The Artist
COMMENTS: First known signed and numbered woodcut. This print, along with *Ruckus,* was often inserted in a book entitled *Drawings, Mimi Gross and Red Grooms,* 1961, sketches of travels in Italy, Greece, and the Middle East.

11. *Crucifix* 1962 (begun 1961)

Woodcut in one color on off-white wove paper
SHEET: 11 × 9¾″ (27.9 × 24.8 cm) irregular
IMAGE: 7½ × 4″ (19.1 × 10.2 cm)
INSCRIPTION: Some signed in pencil, lower center: *Red Grooms* (possibly signed at a later date).
EDITION: Approximately 10, some hand-colored with ink
PUBLISHER: The Artist
PRINTER: The Artist

12. *Angel* 1962

Woodcut in one color on rice paper
SHEET: 11 × 8⅛″ (27.9 × 20.6 cm) irregular
IMAGE: 6 × 5½″ (15.2 × 14.0 cm)
INSCRIPTIONS: Some signed in pencil, lower right: *Red Grooms* (possibly signed at a later date).
EDITION: Approximately 10, some hand-colored with ink
PUBLISHER: The Artist
PRINTER: The Artist

13. *Self Portrait in a Crowd* 1962 (published in 1964)

Etching in one color on BFK Rives paper, from *The International Anthology of Contemporary Engraving, The International Avant-Garde: America Discovered,* Volume 5, 1964, a bound portfolio of 30 artists.
SHEET: 8½ × 7⅝″ (21.6 × 19.4 cm)
PLATE: 4½ × 6″ (11.4 × 15.2 cm)

INSCRIPTIONS: Signed in pencil, lower right: RED GROOMS, numbered in pencil, lower left.
EDITION: 60
PROOFS: 15 AP, 25 RTP, plus a few unsigned proofs
PUBLISHER: Galleria Schwarz, Milan, Italy 1964
PRINTER: Atelier Georges Leblanc, Paris
COMMENTS: This print constitutes two firsts for the Artist, his first etching and his first commissioned print. The payment was a choice between one hundred United States dollars or the portfolio. The Artist chose the portfolio. Main subject is the Artist in a top hat walking on a crowded street in New York. The "Top Hat" reappears in three other prints, *Minstrel,* 1956, *Nadar,* 1976, and *Parade in Top Hat City,* 1963. *The International Anthology of Contemporary Engraving* was published in seven volumes, two volumes called the *Forerunners of the Avant Garde* and five volumes called the *International Avant-Garde.* Each of the twenty artists were selected by Arturo Swartz (pen name-Tristen Sauvag) and Billy Klüver. The artists chosen for the portfolio were: George Brecht, Allen D'Arcangelo, Jim Dine, Stephen Durkee, Lette Eisenhauer, Stanley Fisher, Sam Goodman, Red Grooms, Robert Indiana, Allen Kaprow, Roy Lichtenstein, Boris Lurie, Claes Oldenburg, James Rosenquist, George Segal, Richard Stankiewicz, Wayne Thiebaud, Andy Warhol, Robert Watts, and Robert Whitman.

14. *Spotlight* 1963

Drypoint in one color hand-wiped on off-white wove paper
SHEET: 9½ × 8¾″ (24.1 × 22.2 cm) irregular
IMAGE: 6 × 4″ (15.2 × 10.2 cm)
INSCRIPTIONS: Some signed in pencil, lower right: *Red Grooms 63* (possibly signed at a later date).
EDITION: approximately 6
PUBLISHER: The Artist
PRINTER: The Artist
COMMENTS: The print was hand-wiped by the Artist.

15. *Parade in Top Hat City* 1963

Drypoint in one color on wove paper
SHEET: 6⅛ × 9½″ (15.6 × 21.6 cm)
IMAGE: 4⅞ × 6⅞″ (12.4 × 17.5 cm)
INSCRIPTION: Signed in pencil, lower right: *Red Grooms* (possibly signed at a later date).
EDITION: Approximately 6
PUBLISHER: The Artist
PRINTER: The Artist
COMMENTS: The "Top Hat" reappears in three other prints, *Minstrel,* 1956, *Self Portrait in a Crowd,* 1962, and *Nadar,* 1976. The print was produced in Barbara Erdman's Workshop, New York.

16. *Camal* 1965

Linocut in one color on rice paper
SHEET: 25 × 18½″ (63.5 × 47.0 cm) irregular
IMAGE: 8½ × 7″ (21.6 × 17.8 cm)
INSCRIPTIONS: Signed in pencil, lower right: RED GROOMS, numbered in pencil, lower left.
EDITION: 10
PUBLISHER: The Artist
PRINTER: The Artist

17. *Mayan Self-Portrait* 1966

Linocut in one color on rice paper
SHEET: 25 × 18½″ (63.5 × 47.0 cm)
IMAGE: 11 × 11½″ (27.9 × 29.2 cm)

INSCRIPTIONS: Some signed in pencil, lower right: *Red Grooms* (possibly signed at a later date).
EDITION: Approximately 10
PROOFS: 1 TP (reworked from original block with the date revised to 1996)
PUBLISHER: The Artist
PRINTER: The Artist

18. *Mayan with Cigarette* 1966

Woodcut in one color on rice paper
SHEET: 20¾ × 17½" (52.7 × 44.5 cm)
IMAGE: 11 × 11½" (27.9 × 29.2 cm)
INSCRIPTION: Some signed in pencil, lower right: *Red Grooms* (possibly signed at a later date)
EDITION: Approximately 10
PUBLISHER: The Artist
PRINTER: The Artist

19. *The Philosopher* 1966

Woodcut in one color on rice paper
SHEET: 13 × 9½" (33.0 × 24.1 cm)
IMAGE: 9 × 8" (22.9 × 20.3 cm)
INSCRIPTIONS: Signed and dated in pencil, lower right: RED GROOMS *1/1/66*, numbered in pencil, lower left.
EDITION: 12
PUBLISHER: The Artist
PRINTER: The Artist
COMMENTS: The subject is a portrait of Edmund Leites, who is now a renowned philosophy teacher at Queens College, New York.

20. *Organize the Sea* 1967

Rubber stamps in three colors on Rives paper, from *Stamped Indelibly,* a clothbound book of 14 rubber stamps by 15 artists
SHEET: 11½ × 9" (29.2 × 22.9 cm)
IMAGE: 5½ × 5⅜" (14.0 × 13.7 cm)
INSCRIPTIONS: Signed: *R. Grooms CT and K. Koch* in the rubber stamp.
EDITION: 225
PUBLISHER: Indiana Katz Production, New York
PRINTER: William Katz, New York
COMMENTS: A hardbound book with linen cover that contains 14 rubber stamp prints by 15 artists. The artists were Claes Oldenburg, Robert Creeley, Allen Ginsberg, Red Grooms, Kenneth Koch, Robert Indiana, Allen Jones, Josef Levi, Roy Lichtenstein, Gerard Malanga, Marisol Escobar, Peter Saul, Andy Warhol, Tom Wesselmann, and John Willenbecher. Only 110 of the edition of 225 were available for sale through Multiples, Inc., New York.

21. *Patriot's Parade* 1967

Lithograph in one color on Rives BFK paper
SHEET: 28½ × 38⅜" (72.4 × 97.5 cm)
IMAGE: 21 × 32¼" (53.3 × 81.9 cm)

INSCRIPTIONS: Signed and dated in pencil, lower right: RED GROOMS *1967,* numbered in pencil, lower left, inscribed in pencil, lower center: "PATRIOT'S PARADE."
EDITION: 25
PROOFS: Various AP
PUBLISHER: The Artist
PRINTER: George Clark, Jr., New York
COMMENTS: First lithograph and also marks his first time working in a professional shop. "Question Authority," a slogan of the demonstrators, is one of the themes of this work. Grooms uses the wording of the title's "Patriot" ironically. This print image, along with the parent sculpture remains one of the most powerful examples of protest art from the Vietnam era.

22. *Saskia Leah Grooms* 1970

Woodcut in five colors on rice paper
SHEET: 13⅝ × 9½" (34.6 × 24.1 cm)
IMAGE: 12¾ × 8" (32.4 × 20.3 cm)
INSCRIPTIONS: Some signed and dated in pencil, lower right: *Red Grooms '70* (possibly signed at a later date).
EDITION: Approximately 50
PUBLISHER: The Artist
PRINTER: The Artist

23. *Manic Pal Co. Mix* 1970

Silkscreen in one color on glossy lightweight poster paper from a portfolio of *76 artists—78 prints,* organized and produced by Sonia Sheridan, Chicago, Illinois
SHEET: 15 × 15" (38.1 × 38.1 cm)
IMAGE: 15 × 15" (38.1 × 38.1 cm)
INSCRIPTIONS: Signed *Red Grooms* in silkscreen, lower left, signed again in red ink *Red Grooms,* lower left, possibly at a later date.
EDITION: 200
PUBLISHERS: The Artists, School of the Art Institute of Chicago, and Advance Screen Company, Chicago, Illinois
PRINTER: Kathy Dulen, Guy Herman, Don Kingman, Dennis Kugler, Bernard Van Marm, Chicago, Illinois
COMMENTS: First silkscreen. This portfolio was produced through the joint efforts of the Artists, School of the Art Institute of Chicago and Advance Screen Company by Sonia Sheridan, Chicago, Ill. A 33⅓ RPM LP record with jacket accompanied the portfolio.

24. *Arthur and Elizabeth* 1971

Etching in one color on Arches Cover paper
SHEET: 11 × 8" (27.9 × 20.3 cm)
IMAGE: 3 × 4" (7.6 × 10.2 cm)
INSCRIPTION: None
EDITION: Approximately 5
PUBLISHER: Arthur Cohen, New York
PRINTER: Arthur Cohen, New York
COMMENTS: The subject is Arthur Cohen, a New York painter, and his wife, Elizabeth, who were close friends of the Artist's during the 1970s.

Section II

25. Nervous City 1971

Lithograph in seven colors on Arches Cover paper, from the portfolio *Ten Lithographs by Ten Artists*

SHEET: 22 × 30" (55.9 × 76.2 cm)

IMAGE: 22 × 30" (55.9 × 76.2 cm)

INSCRIPTIONS: Signed in white color pencil, mid-lower right: RED GROOMS, numbered in mid-lower right.

EDITION: 120

PROOFS: 10 AP

PUBLISHER: Shorewood-Bank Street Atelier, New York

PRINTER: Mauro Giuffrida, Bank Street Atelier, New York

COMMENTS: First color lithograph. The portfolio was published for the benefit of the Skowhegan School of Painting and Sculpture. The title page of the portfolio refers to the title, *Nervous City Street Scene*, the Artist prefers *Nervous City*. The ten artists with the titles of their prints were: Jack Beal, *Pond Lilies*; James Brooks, *The Springs*; Red Grooms, *Nervous City Street Scene*; Chaim Gross, *The Poet's Dream*; Philip Guston, *The Street*; Alex Katz, *Late July*; Richard Linder, *Redhead*; Robert Andrew Parker, *Sunday Driver For A Soldier*; Philip Pearlstein, *Two Reclining Nudes on Rug*; Fairfield Porter, *The Dog at the Door*.

26. Blewy I 1971

Offset four-color silkscreen on cartridge paper

SHEET: 14 × 18" (35.6 × 45.7 cm)

IMAGE: 12½ × 16½" (31.8 × 41.9 cm)

INSCRIPTIONS: Signed and dated in pencil, lower right: *Red Grooms '71,* numbered in pencil, lower center, inscribed in pencil, lower left: BLEWY I.

EDITION: 150

PROOFS: 20 AP

PUBLISHER: Licht Editions, Ltd., New York

PRINTER: Licht Editions, Ltd., New York

COMMENTS: This is the center section of *Blewy II*, 1971. This print represented March in a calendar suite. The other artists in the calendar suite are Anuykiewicz, Clark, Hinman, Levi, Milne, Nesbitt, Pearson, Ramos, Stanley, Van Hoeydonck, and Wesley. The calendar suite was never completed.

27. Blewy II 1971

Offset four-color silkscreen on wove paper

SHEET: 23¾ × 34¼" (60.3 × 87.0 cm)

IMAGE: 23 × 27¼" (58.4 × 69.2 cm)

INSCRIPTIONS: Signed and dated in pencil, lower right: *Red Grooms 1971,* numbered in pencil, lower center, inscribed in pencil, lower left: BLEWY II.

EDITION: 150

PROOFS: 15 AP

PUBLISHER: Licht Editions, Ltd., New York

PRINTER: Licht Editions, Ltd., New York

COMMENTS: First commercial print produced for sale.

28. Discount Store 1971

Silkscreen in three colors on Arches Cover paper

SHEET: 19¾ × 41½" (50.2 × 105.4 cm)

IMAGE: 10½ × 26½" (26.7 × 67.3 cm)

INSCRIPTIONS: Unknown

EDITION: 100

PUBLISHER: John Bernard Myers Gallery, New York

PRINTER: Chromacomp, Inc., New York

COMMENTS: This print represents a block slice of Madison Avenue showing the location of John Bernard Myers temporary store front gallery, which he rented to show *Discount Store* from February 3–28, a large sculpto-pictorama created for the Walker Art Centers, Minneapolis, Minn., "Figure in the Environment," 1970. For poster edition see Section III.

29. Fall of Jericho 1971

Soft-ground etching in one color on Rives BFK paper.

SHEET: 12¾ × 12¾" (32.4 × 32.4 cm)

PLATE: 8¾ × 8¾" (22.2 × 22.2 cm)

INSCRIPTIONS: Signed and dated in pencil, lower right: *Red Grooms '71,* numbered in pencil, lower left, inscribed in pencil, lower center: "FALL OF JERICHO," printer's chop, lower right.

EDITION: 100

PROOFS: 5 AP

PUBLISHER: Vera List, Byrone, Connecticut

PRINTER: Deli Saccialato, Bank Street Atelier, New York

COMMENTS: *Fall of Jericho* was commissioned by Vera List, Byrone, Connecticut, for her grandson Joshua Lincoln Mack's Bar Mitzvah in New York. It was mailed with the invitation to the guests.

30. No Gas—Portfolio Cover 1971

Silkscreen in three colors on linen-covered box

SHEET: 22⅞ × 29 × ½" (58.1 × 73.7 × 1.3 cm)

IMAGE: 22⅞ × 29 × ½" (58.1 × 73.7 × 1.3 cm)

EDITION: 75

PROOFS: 12 AP, 1 Presentation proof

PUBLISHER: Abrams Original Editions, New York

PRINTER: Chromacomp, Inc., New York

COMMENTS: The Artist's first portfolio, *No Gas* is one of Grooms's most ambitious graphic projects. He worked for a period of seven months in a small private studio at Bank Street Atelier. There, he invented images and produced all the plates for color separation under the tutelage of Jean-Pierre Remond, a master Chromist from Paris. This became the basis for Grooms's knowledge of lithographic technique. Here he also produced his first three-dimensional lithograph, *Aarrrrrrhh*. In 1971, New York was suffering under a critical gas shortage and filling stations were adorned with placards announcing "No Gas," thus the portfolio's title. Rosa Essman managed the production for Abrams Original Editions and at one point ordered a portfolio box equipped with a tape recorder, which would produce street sounds when opened. This scheme, a favorite of the Artist's, was dropped for practical reasons.

31. No Gas—Portfolio Title Sheet 1971

Silkscreen in one color on Arches Cover paper

SHEET: 28 × 22" (71.1 × 55.9 cm)

IMAGE: 27¼ × 15¼" (69.2 × 38.7 cm)

INSCRIPTIONS: Numbered in black felt pen, lower center.

EDITION: 75

PROOFS: 12 AP, 1 Presentation proof

PUBLISHER: Abrams Original Editions, New York

PRINTER: Mauro Giuffrida; Bank Street Atelier, New York

COMMENTS: The Artist's first portfolio.

32. **Slushing** 1971

Lithograph in ten colors on Arches Cover paper from *No Gas* portfolio of six prints
SHEET: 22 × 28″ (55.9 × 71.1 cm)
IMAGE: 22 × 28″ (55.9 × 71.1 cm)
INSCRIPTIONS: Signed and dated in pencil, lower right: *Red Grooms '71,* numbered in pencil, lower right, printer's chop, lower right.
EDITION: 75
PROOFS: 12 AP, 1 Presentation proof
PUBLISHER: Abrams Original Editions, New York
PRINTERS: Mauro Giuffrida, Michel Tabard, and Paul Volette; Bank Street Atelier, New York
COMMENTS: The Artist's first portfolio. The portfolio includes *Slushing, Taxi Pretzel, No Gas Café, Rat, Local,* and *Aarrrrrrhh.*

33. **Taxi Pretzel** 1971

Lithograph in ten colors on Arches Cover paper from *No Gas* portfolio of 6 prints
SHEET: 28 × 22″ (71.1 × 55.9 cm)
IMAGE: 28 × 22″ (71.1 × 55.9 cm)
INSCRIPTIONS: Signed and dated in white colored pencil, lower right: *Red Grooms '71,* numbered in blue colored pencil, lower right, printer's chop, lower right.
EDITION: 75
PROOFS: 12 AP, 1 Presentation proof
PUBLISHER: Abrams Original Editions, New York
PRINTERS: Mauro Giuffrida, Michel Tabard, and Paul Volette; Bank Street Atelier, New York
COMMENTS: The Artist's first portfolio. Portfolio includes *Slushing, Taxi Pretzel, No Gas Café, Rat, Local,* and *Aarrrrrrhh.*

34. **No Gas Café** 1971

Lithograph in ten colors on Arches Cover paper from No Gas portfolio of 6 prints
SHEET: 28 × 22″ (71.1 × 55.9 cm)
IMAGE: 28 × 22″ (71.1 × 55.9 cm)
INSCRIPTIONS: Signed and dated in pencil, lower right: *Red Grooms '71,* numbered in pencil, lower right, printer's chop, lower center.
EDITION: 75
PROOFS: 12 AP, 1 Presentation proof
PUBLISHER: Abrams Original Editions, New York
PRINTERS: Mauro Giuffrida, Michel Tabard, and Paul Volette; Bank Street Atelier, New York
COMMENTS: The Artist's first portfolio. Portfolio includes *Slushing, Taxi Pretzel, No Gas Café, Rat, Local,* and *Aarrrrrrhh.*

35. **Rat** 1971

Lithograph in ten colors on Arches Cover paper from *No Gas* portfolio of 6 prints
SHEET: 22 × 28″ (55.9 × 71.1 cm)
IMAGE: 22 × 28″ (55.9 × 71.1 cm)
INSCRIPTIONS: Signed and dated in blue colored pencil, lower right: *Red Grooms '71,* numbered in blue colored pencil, lower right, printer's chop, lower right.
EDITION: 75
PROOFS: 12 AP, 1 Presentation proof
PUBLISHER: Abrams Original Editions, New York
PRINTERS: Mauro Giuffrida, Michel Tabard, and Paul Volette; Bank Street Atelier, New York
COMMENTS: The Artist's first portfolio. Portfolio includes *Slushing, Taxi Pretzel, No Gas Café, Rat, Local,* and *Aarrrrrrhh.*

36. **Local** 1971

Lithograph in ten colors on Arches Cover paper from *No Gas* portfolio of 6 prints
SHEET: 22 × 28″ (55.9 × 71.1 cm)
IMAGE: 22 × 28″ (55.9 × 71.1 cm)
INSCRIPTIONS: Signed and dated in white colored pencil, lower right: *Red Grooms '71,* numbered in white colored pencil, lower right, printer's chop, lower right.
EDITION: 75
PROOFS: 12 AP, 1 Presentation proof
PUBLISHER: Abrams Original Editions, New York
PRINTERS: Mauro Giuffrida, Michel Tabard, and Paul Volette; Bank Street Atelier, New York
COMMENTS: The Artist's first portfolio. Portfolio includes *Slushing, Taxi Pretzel, No Gas Café, Rat, Local,* and *Aarrrrrrhh.*

37. **Aarrrrrrhh** 1971

Three-dimensional lithograph in ten colors on Arches Cover paper, from *No Gas* portfolio of 6 prints
SHEET: 20 × 28 × 2″ (50.8 × 71.1 × 5.1 cm)
IMAGE: 20 × 28 × 2″ (50.8 × 71.1 × 5.1 cm)
INSCRIPTIONS: Signed and dated in white colored pencil, lower right: *Red Grooms '71,* numbered in white colored pencil, lower right, printer's chop, lower right.
EDITION: 75
PROOFS: 12 AP, 1 Presentation proof
PUBLISHER: Abrams Original Editions, New York
PRINTERS: Mauro Giuffrida, Michel Tabard, and Paul Volette; Bank Street Atelier, New York
COMMENTS: The Artist's first portfolio. First three-dimensional lithograph. Portfolio includes *Slushing, Taxi Pretzel, No Gas Café, Rat, Local,* and *Aarrrrrrhh.*

38. **Guggenheim** 1971

Lithograph in nine colors on Arches Cover paper
SHEET: 38½ × 26″ (97.8 × 66.0 cm)
IMAGE: 38½ × 26″ (97.8 × 66.0 cm)
INSCRIPTIONS: Signed in white colored pencil, lower right: RED GROOMS, numbered in white colored pencil, lower right.
EDITION: 100
PROOFS: 20 AP
PUBLISHER: George Goodstadt, New York
PRINTER: Mauro Giuffrida; Bank Street Atelier, New York
CHROMIST: Jean-Pierre Remond
COMMENTS: Commissioned by the Soloman R. Guggenheim Museum, New York, for the exhibition of "Ten Independent Artists," January 14–February 27, 1972. The ten artists were H. C. Westermann, Robert Beauchamp, Red Grooms, Romaire Bearden, Lester Johnson, Peter Schumann, Jospeh Kurhajec, Mary Frank, Maryan and Irving Kriesburg. George Goodstadt was the director of the Bank Street Atelier. For poster edition see Section III.

39. **45 Characters** 1973

Etching in one color hand-colored with watercolor on Dutch etching paper
SHEET: 19 × 17¾″ (48.3 × 45.1 cm)
PLATE: 11¾ × 11⅞″ (29.9 × 30.2 cm)
INSCRIPTIONS: Signed and dated in pencil, lower right: *Red Grooms 1973,* numbered in pencil, lower left.
EDITION: 20 examples (numbered as AP's), 1 unsigned PP. (A few proofs of a black-and-white aquatint version exist but were rejected for editing.)
PUBLISHER: Brooke Alexander, Inc., New York

PRINTER: Jennifer Melby, New York

COMMENTS: First hand-colored etching commissioned by Brooke Alexander, Inc, New York.

40. *Mango Mango* 1973

Silkscreen in seven colors on Arches Cover paper

SHEET: 40 × 28¾″ (101.6 × 73.0 cm)

IMAGE: 40 × 28¾″ (101.6 × 73.0 cm)

INSCRIPTIONS: Signed and dated in pencil, lower right: *Red Grooms '73*, numbered in pencil, lower left.

EDITION: 250

PUBLISHER: Kitty Meyers, New York

PRINTER: Chromacomp, Inc., New York

COMMENTS: Published for the benefit of Nicaraguan earthquake victims.

41. *Nashville 2001* A.D. 1973

Etching in one color, hand-colored with watercolor on Dutch etching paper

SHEET: 15 × 12″ (38.1 × 30.5 cm)

PLATE: 7⅞ × 5⅞″ (20.0 × 14.9 cm)

INSCRIPTIONS: Signed in pencil, lower right: *Red Grooms*, numbered in pencil, lower left.

EDITION: 20

PUBLISHER: Brooke Alexander, Inc., New York

PRINTER: Jennifer Melby, New York

COMMENTS: A similar image, after this print, was produced as a temporary mural on the escalator wall of the Tennessee State Museum, in Nashville, for the 1986 exhibition of "Red Grooms A Retrospective" 1956–1984. After the exhibition closed, the museum decided to keep the mural in place.

42. *Stockholm Print* 1973

Silkscreen in one color on 100% rag paper, from *The New York Collection for Stockholm,* a portfolio of 30 artists

SHEET: 9 × 12″ (22.9 × 30.5 cm)

IMAGE: 9 × 12″ (22.9 × 30.5 cm)

INSCRIPTIONS: Signed and dated in black colored pencil, lower right: *Red Grooms '73,* numbered in black colored pencil, lower left.

EDITION: 300

PROOFS: 30 AP

PUBLISHER: Experiments in Art & Technology, Inc., New York

PRINTER: Adolph Rischner, Styria Studio, Inc., New York

COMMENTS: The New York Collection for Stockholm was a project initiated in 1971 (and realized in 1973) by Billy Klüver (Experiment in Arts and Technology, Inc.) for the creation of a collection of paintings and sculpture by the artists working in New York during the 1960s. Selected by Pontus Hultén (K. G. P. Hultén), the collection was eventually placed in the permanent collection of the Moderna Museet, Stockholm. The project was supported, in part, by the publication of this portfolio. The contributing artists were Lee Bontecou, Robert Breer, John Chamberlain, Walter de Maria, Jim Dine, Mark di Suvero, Öyvind Fahlström, Dan Flavin, Red Grooms, Hans Haacke, Alex Hay, Donald Judd, Ellsworth Kelly, Sol LeWitt, Roy Lichtenstein, Robert Morris, Louise Nevelson, Kenneth Noland, Claes Oldenburg, Nam June Paik, Robert Rauschenberg, Larry Rivers, James Rosenquist, George Segal, Richard Serra, Keith Sonnier, Richard Staniewicz, Cy Twombly, Andy Warhol, and Robert Whitman. Prints by Lichtenstein and Hans Haacke are numbered but not signed.

43. *The Daily Arf* 1974

Silkscreen in three colors and blind intaglio on Arches Cover paper

SHEET: 20¾ × 15½″ (52.7 × 39.4 cm)

IMAGE: 10 × 8″ (25.4 × 20.3 cm)

INSCRIPTIONS: Signed and dated in pencil, lower right: *Red Grooms '74,* numbered in pencil, lower left.

EDITION: 75

PUBLISHER: Ann Frank, New York

PRINTER: Chromacomp, Inc., New York

EMBOSSER: Unknown

COMMENTS: Only embossed print. The original image was a paper cutout.

44. *Gertrude* 1975

Three-dimensional lithograph in seven colors on Arches Cover paper with collage, cut out, glued, and mounted in Plexiglas case

CASE: 19¼ × 22 × 10″ (48.9 × 55.9 × 25.4 cm)

IMAGE: 17 × 20 × 9″ (43.2 × 50.8 × 22.9 cm)

INSCRIPTIONS: Signed in pencil, lower right: *Red Grooms,* numbered in pencil, lower left.

EDITION: 46

PROOFS: 6 AP, 2 HC

PUBLISHERS: Brooke Alexander, Inc., and Marlborough Graphics, New York

PRINTER: Mauro Giuffrida, Circle Workshop, New York; assembled by Chip Elwell

COMMENTS: The image is Gertrude Stein, the famous expatriate writer and collector of paintings by Picasso, Matisse, and others. It is the Artist's homespun parody of Picasso's celebrated portrait of Stein, 1906.

45. *Gertrude 2 D* 1975

Lithograph in six colors on Arches Cover Paper

SHEET: 24⅛ × 31″ (61.3 × 78.7 cm)

IMAGE: 21½ × 28½″ (54.6 × 72.4 cm)

INSCRIPTIONS: Signed and dated in pencil, lower right: *Red Grooms '75,* numbered in pencil, lower left.

EDITION: 45

PROOFS: 10 AP, 5 PP

PUBLISHERS: Brooke Alexander, Inc., and Marlborough Graphics, New York

PRINTER: Mauro Giuffrida, Circle Workshop, New York

COMMENTS: Plate was used to produce the three-dimensional *Gertrude,* 1975. The subject is Gertrude Stein.

46. *Bicentennial Bandwagon* 1975 (published in 1976)

Silkscreen in thirteen colors on Rives BFK paper, from the Kent *Bicentennial Portfolio, Spirit of Independence,* a portfolio of 12 artists

SHEET: 26½ × 34¾″ (67.3 × 88.3 cm)

IMAGE: 26½ × 34¾″ (67.3 × 88.3 cm)

INSCRIPTIONS: Signed in pencil, upper right: *Red Grooms,* numbered in pencil, upper left.

EDITION: 125

PROOFS: 10 AP

PUBLISHER: Lorillard Company, New York

PRINTER: Chromacomp, Inc., New York

COMMENTS: Twelve contemporary American Artists were selected for inclusion in a Bicentennial portfolio interpreting the theme, "The Spirit of Independence." The portfolio was given to nearly 100 American Museums. Each of the Artists was free to choose his subject and execute it as he desired. The portfolio of 12 lithographs and serigraphs only stipulation was the work should answer the question, What does independence mean to me? The twelve participating artists were Joseph Hirsch, Alex Katz, Larry Rivers, Robert Indiana, Red Grooms, Audrey Flack, Marisol, Ed Rusha, Jacob Lawrence, Fritz Scholder, Colleen Browning, and Will Barnet.

47. **Café Manet** 1976

Etching and aquatint in one color on Rives BFK paper
SHEET: 13¼ × 14¾" (33.7 × 37.5 cm)
PLATE: 7¾ × 9⅞" (19.7 × 25.1 cm)
INSCRIPTIONS: Signed and dated in pencil, lower right: *Red Grooms, 1976,* numbered in pencil, lower left.
EDITION: 40
PROOFS: 8 AP, 2 PP
PUBLISHERS: Brooke Alexander, Inc., and Marlborough Graphics, New York
PRINTER: Jennifer Melby, New York
COMMENTS: The subject is the nineteenth-century French artist Édouard Manet.

48. **Matisse** 1976

Lithograph in one color on Rives BFK paper
SHEET: 34½ × 25½" (87.6 × 64.8 cm)
IMAGE: 27 × 19½" (68.6 × 49.5 cm)
INSCRIPTIONS: Signed and dated in black colored pencil, lower right: *Red Grooms '76,* numbered in black colored pencil, lower left.
EDITION: 75
PROOFS: 10 AP, 1 BAT, 2 PP
PUBLISHERS: Brooke Alexander, Inc., and Marlborough Graphics, New York
PRINTER: Paul Narkiewicz, New York
COMMENTS: Henri Matisse, at work in his studio.

49. **Corot** 1976

Soft-ground etching in one color with monoprinting on Rives BFK paper
SHEET: 18¼ × 13¾" (46.4 × 34.9 cm)
PLATE: 9¾ × 7⅞" (24.8 × 20.0 cm)
INSCRIPTIONS: Signed and dated in pencil, lower right: *Red Grooms 1976,* numbered in roman numerals in pencil, lower left, inscribed in pencil, lower center: "COROT."
EDITION: XII
PROOFS: 1 known proof (etching in black) unsigned
PUBLISHER: Brooke Alexander, Inc., New York
PRINTER: Jennifer Melby, New York

50. **Saskia Doing Homework** 1976

Etching in one color on 100% rag paper
SHEET: 13 × 11⅛" (33.0 × 28.3 cm)
PLATE: 5 × 3⅞" (12.7 × 9.8 cm)
INSCRIPTIONS: Signed in pencil, lower right: *Red Grooms,* numbered in pencil, lower left.
EDITION: 6
PUBLISHER: The Artist
PRINTER: Jennifer Melby, New York
COMMENTS: Saskia is the Artist's daughter, who was learning to write at age six, thus the edition size.

51. **Double Portrait with Butterfly** 1976

Etching in one color on Arches Cover paper
SHEET: 17⅝ × 14" (44.8 × 35.6 cm)
PLATE: 11⅝ × 8⅞" (29.5 × 22.5 cm)
INSCRIPTIONS: Signed in pencil, lower right: *Red Grooms,* numbered in pencil, lower left, printer's chop, lower right.
EDITION: 10
PROOFS: 2 PP
PUBLISHER: The Artist
PRINTER: Jennifer Melby, New York

COMMENTS: Double portrait of Jill Sternberg, who worked as a crew member during the construction of *Ruckus Manhattan,* 1976.

52. **Manet/Romance** 1976

Etching in one color on Rives BFK paper
SHEET: 33¾ × 26" (85.7 × 66.0 cm)
PLATE: 25⅜ × 17¾" (64.5 × 45.1 cm)
INSCRIPTIONS: Signed and dated in pencil, lower right: *Red Grooms 1976,* numbered in pencil lower left, inscribed in pencil, lower center: "MANET/ROMANCE."
EDITION: 40
PROOFS: 8 AP, 2 PP, 1 PP (unsigned)
PUBLISHER: Brooke Alexander, Inc., New York
PRINTERS: Jennifer Melby and Anthony Kirk, New York
COMMENTS: A portrait of Édouard Manet; with a portrait of his mistress dressed as a soldier, located in lower right.

53. **Heads Up D. H.** 1976 (published in 1980)

Etching and aquatint in one color on Rives BFK paper
SHEET: 26¾ × 30" (68.0 × 76.2 cm)
PLATE: 19¾ × 23⅛" (50.2 × 58.7 cm)
INSCRIPTIONS: Signed in pencil, lower right: *Red Grooms;* numbered in pencil, lower left; inscribed in pencil, lower center: "HEADS UP D. H.," printer's chop lower right.
EDITION: 26
PROOFS: 10 AP, 2 PP
PUBLISHER: Brooke Alexander, Inc., New York
PRINTER: Jennifer Melby, New York
COMMENTS: D. H. Lawrence, the famous British novelist.

54. **Whistler** 1976

Etching in one color on Rives BFK paper from *Nineteenth-Century Artists* portfolio of 10 prints
SHEET: 15 × 11" (38.1 × 27.9 cm)
PLATE: 4⅞ × 5" (12.4 × 12.7 cm)
INSCRIPTIONS: Signed and dated in pencil, lower right: *Red Grooms '76,* numbered in pencil, lower left, inscribed in pencil, lower center, "WHISTLER," printer's chop, lower right.
EDITION: 40
PROOFS: 1 BAT, 2 PP
PUBLISHERS: Brooke Alexander, Inc., and Marlborough Graphics, New York
PRINTER: Jennifer Melby, New York
COMMENTS: The 10 Nineteenth-Century Artists included in the portfolio were: Whistler, Guys, Courbet, Degas, Rodin, Bazille, Baudelaire, Cézanne, Delacroix, and Nadar.

55. **Guys** 1976

Etching and aquatint in one color on Rives BFK paper from *Nineteenth-Century Artists* portfolio of 10 prints
SHEET: 15 × 11" (38.1 × 27.9 cm)
PLATE: 4⅞ × 6¾" (12.4 × 17.2 cm)
INSCRIPTIONS: Signed and dated in pencil, lower right: *Red Grooms '76,* numbered in pencil, lower left, inscribed in pencil, lower center "GUYS," printer's chop, lower right.
EDITION: 40
PROOFS: 10 AP, 1 BAT, 2 PP
PUBLISHERS: Brooke Alexander, Inc., and Marlborough Graphics, New York
PRINTER: Jennifer Melby, New York
COMMENTS: The 10 Nineteenth-Century Artists included in the portfolio were: Whistler, Guys, Courbet, Degas, Rodin, Bazille, Baudelaire, Cézanne, Delacroix, and Nadar.

56. **Courbet** 1976

Etching in one color on Kitikaka paper, laid down on Rives BFK paper from *Nineteenth-Century Artists* portfolio of 10 prints
SHEET: 15 × 11″ (38.1 × 27.9 cm)
PLATE: 3¾ × 2⅞″ (9.5 × 7.3 cm)
INSCRIPTIONS: Signed and dated in pencil, lower right: *Red Grooms '76*, numbered in pencil, lower left, inscribed in pencil, lower center: "COURBET," printer's chop, lower right.
EDITION: 40
PROOFS: 10 AP, 1 BAT, 2 PP
PUBLISHERS: Brooke Alexander, Inc., and Marlborough Graphics, New York
PRINTER: Jennifer Melby, New York
COMMENTS: The 10 Nineteenth-Century Artists included in the port-folio were: Whistler, Guys, Courbet, Degas, Rodin, Bazille, Baudelaire, Cézanne, Delacroix, and Nadar.

57. **Degas** 1976

Etching and aquatint in one color on Rives BFK paper from *Nineteenth-Century Artists* portfolio of 10 prints
SHEET: 15 × 11″ (38.1 × 27.9 cm)
PLATE: 4⅞ × 6⅞″ (12.4 × 17.3 cm)
INSCRIPTIONS: Signed and dated in pencil, lower right: *Red Grooms '76*, numbered in pencil, lower left, inscribed in pencil, lower center: "DEGAS," printer's chop, lower right.
EDITION: 40
PROOFS: 10 AP, 1 BAT, 2 PP
PUBLISHERS: Brooke Alexander, Inc., and Marlborough Graphics, New York
PRINTER: Jennifer Melby, New York
COMMENTS: The 10 Nineteenth-Century Artists included in the port-folio were: Whistler, Guys, Courbet, Degas, Rodin, Bazille, Baudelaire, Cézanne, Delacroix, and Nadar.

58. **Rodin** 1976

Drypoint in one color on Rives BFK paper from *Nineteenth-Century Artists* portfolio of 10 prints
SHEET: 15 × 11″ (38.1 × 27.9 cm)
PLATE: 5 × 4″ (12.7 × 10.2 cm)
INSCRIPTIONS: Signed and dated in pencil, lower right: *Red Grooms '76*, numbered in pencil, lower left, inscribed in pencil, lower center: "RODIN," printer's chop, lower right.
EDITION: 40
PROOFS: 10 AP, 1 BAT, 2 PP
PUBLISHERS: Brooke Alexander, Inc., and Marlborough Graphics, New York
PRINTER: Jennifer Melby, New York
COMMENTS: The 10 Nineteenth-Century Artists included in the port-folio were: Whistler, Guys, Courbet, Degas, Rodin, Bazille, Baudelaire, Cézanne, Delacroix, and Nadar.

59. **Cézanne** 1976

Etching and aquatint in one color on Rives BFK paper from *Nineteenth-Century Artists* portfolio of 10 prints
SHEET: 15 × 11″ (38.1 × 27.9 cm)
PLATE: 3⅞ × 4⅞″ (9.8 × 12.4 cm)
INSCRIPTIONS: Signed and dated in pencil, lower right: *Red Grooms '76*, numbered in pencil, lower left, inscribed in pencil, lower center: "CÉZANNE," printer's chop, lower right.
EDITION: 40
PROOFS: 10 AP, 1 BAT, 2 PP
PUBLISHERS: Brooke Alexander, Inc., and Marlborough Graphics, New York

PRINTER: Jennifer Melby, New York
COMMENTS: The 10 Nineteenth Century Artists included in the port-folio were: Whistler, Guys, Courbet, Degas, Rodin, Bazille, Baudelaire, Cézanne, Delacroix, and Nadar.

60. **Bazille** 1976

Etching and aquatint in one color on Rives BFK paper from *Nineteenth-Century Artists* portfolio of 10 prints
SHEET: 15 × 11″ (38.1 × 27.9 cm)
PLATE: 6⅞ × 4⅞″ (17.5 × 12.4 cm)
INSCRIPTIONS: Signed and dated in pencil, lower right: *Red Grooms '76*, numbered in pencil, lower left, inscribed in pencil, lower center: "BAZILLE," printer's chop, lower right.
EDITION: 40
PROOFS: 10 AP, 1 BAT, 2 PP
PUBLISHERS: Brooke Alexander, Inc., and Marlborough Graphics, New York
PRINTER: Jennifer Melby, New York
COMMENTS: The 10 Nineteenth-Century Artists included in the port-folio were: Whistler, Guys, Courbet, Degas, Rodin, Bazille, Baudelaire, Cézanne, Delacroix, and Nadar.

61. **Baudelaire** 1976

Etching in one color on Rives BFK paper from *Nineteenth-Century Artists* portfolio of 10 prints
SHEET: 15 × 11″ (38.1 × 27.9 cm)
PLATE: 6⅞ × 4⅞″ (17.5 × 12.4 cm)
INSCRIPTIONS: Signed in pencil, lower right: *Red Grooms '76*, num-bered in pencil, lower left; inscribed in pencil, lower center: "BAUDELAIRE," printer's chop, lower right.
EDITION: 40
PROOFS: 10 AP, 1 BAT, 2 PP
PUBLISHERS: Brooke Alexander, Inc., and Marlborough Graphics, New York
PRINTER: Jennifer Melby, New York
COMMENTS: The 10 Nineteenth-Century Artists included in the port-folio were: Whistler, Guys, Courbet, Degas, Rodin, Bazille, Baudelaire, Cézanne, Delacroix, and Nadar.

62. **Delacroix** 1976

Etching in one color on Rives BFK paper from *Nineteenth-Century Artists* portfolio of 10 prints
SHEET: 15 × 11″ (38.1 × 27.9 cm)
PLATE: 6⅞ × 4⅞″ (17.5 × 12.4 cm)
INSCRIPTIONS: Signed and dated in pencil, lower right: *Red Grooms '76*, numbered in pencil, lower left; inscribed in pencil, lower center: "DELACROIX," printer's chop, lower right.
EDITION: 40
PROOFS: 10 AP, 1 BAT, 2 PP
PUBLISHERS: Brooke Alexander, Inc., and Marlborough Graphics, New York
PRINTER: Jennifer Melby, New York
COMMENTS: The 10 Nineteenth-Century Artists included in the port-folio were: Whistler, Guys, Courbet, Degas, Rodin, Bazille, Baudelaire, Cézanne, Delacroix, and Nadar.

63. **Nadar** 1976

Etching, aquatint and drypoint in one color on Rives BFK paper from *Nineteenth-Century Artists* portfolio of 10 prints
SHEET: 15 × 11″ (38.1 × 27.9 cm)
PLATE: 6⅞ × 4⅞″ (17.5 × 12.4 cm)
INSCRIPTIONS: Signed and dated in pencil, lower right: *Red Grooms '76*, numbered in pencil, lower left; inscribed in

pencil, lower center: "NADAR," printer's chop, lower right.
EDITION: 40
PROOFS: 10 AP, 1 BAT, 2 PP
PUBLISHERS: Brooke Alexander, Inc., and Marlborough Graphics,
 New York
PRINTER: Jennifer Melby, New York
COMMENTS: The 10 Nineteenth-Century Artists included in the port-
 folio were: Whistler, Guys, Courbet, Degas, Rodin, Bazille,
 Baudelaire, Cézanne, Delacroix, and Nadar.

64. *Rudy Burckhardt as a Nineteenth-Century Artist* 1976

Etching in one color on Arches Cover paper
SHEET: 15 × 10½" (38.1 × 26.7 cm)
PLATE: 4⅞ × 3⅞" (12.4 × 9.8 cm)
INSCRIPTIONS: Signed and dated in pencil, lower right: *Red
 Grooms '76*, numbered in pencil, lower left, printer's chop,
 lower right.
EDITION: 20
PROOFS: 1 AP, 2 PP
PUBLISHER: The Artist
PRINTER: Jennifer Melby, New York
COMMENTS: This was the Artist's way of poking fun at his good
 friend Rudy. It was produced while the Artist was printing the
 Nineteenth-Century Artists portfolio.

65. *Picasso Goes to Heaven I* 1976

Etching in one color on Arches Cover paper
SHEET: 29½ × 30½" (74.9 × 77.5 cm)
PLATE: 23⅜ × 23⅞" (60.0 × 60.6 cm)
INSCRIPTIONS: Signed and dated in pencil, lower right: *Red Grooms
 1976*, numbered in pencil, lower right.
EDITION: 20
PROOFS: 8 AP, 2 SP
PUBLISHERS: Brooke Alexander, Inc., and Marlborough Graphics,
 New York
PRINTER: Jennifer Melby, New York
COMMENTS: A large painting on paper started immediately after the
 death of Picasso in 1973, sometime later the Artist made the etch-
 ing from this painting. "Picasso sitting on the swing while at the
 top left, an African period woman from *Les Demoiselles
 d'Avignon* is letting down a rope. On the other side, a fat, classi-
 cal woman is doing the same thing. They're trying to pull him up
 into heaven. Apollinaire sits at a café table, blood from his
 wartime head wound seeping through his bandages. The
 Douanier Rousseau sits at a table stamping documents—
 Diaghilev appears on the far left, Stravinsky is shown above
 Picasso waving a baton." (Ratcliff, Carter, *Red Grooms*, 1984
 Abbeville Press, N.Y., p.147)

66. *Picasso Goes to Heaven II* 1976

Etching in one color and pochoir (hand colored with watercolor) on
Arches Cover paper
SHEET: 29½ × 30½" (74.9 × 77.5 cm)
PLATE: 23⅜ × 23⅞" (60.0 × 60.6 cm)
INSCRIPTIONS: Signed and dated in pencil, lower right: *Red Grooms
 1976*, numbered in pencil, lower right.
EDITION: 53
PROOFS: 12 AP, 2 PP, 1 SP
PUBLISHERS: Brooke Alexander, Inc., and Marlborough Graphics,
 New York
PRINTER: Jennifer Melby, New York
POCHOIRIST: Chip Elwell

67. *Self-Portrait with Mickey Mouse* 1976

Etching in one color on Somerset paper
SHEET: 22¼ × 15⅜" (56.5 × 39.1 cm)
PLATE: 10 × 8" (25.4 × 20.3 cm)
INSCRIPTIONS: Signed in pencil, lower right: *Red Grooms*, numbered
 in pencil, lower left.
EDITION: 10
PROOFS: 2 PP, 1 SP
PUBLISHER: The Artist
PRINTER: Jennifer Melby, New York

68. *Taxi* 1976

Etching in one color on Rives BFK paper
SHEET: 7¾ × 6½" (19.7 × 16.5 cm)
PLATE: 2⅞ × 2" (7.3 × 5.1 cm)
INSCRIPTIONS: Signed and dated in pencil, lower right: RED GROOMS
 '76; numbered in pencil, lower left; printer's chop, lower right.
EDITION: 36
PROOFS: 10 AP, 2 PP
PUBLISHERS: Brooke Alexander, Inc., and Marlborough Graphics,
 New York
PRINTER: Jennifer Melby, New York

69. *Coney Island* 1978

Aquatint in four colors on Arches Cover paper
SHEET: 22 × 25¾" (55.9 × 65.4 cm)
PLATE: 15¾ × 19¾" (40.0 × 50.2 cm)
INSCRIPTIONS: Signed in pencil, lower right: RED GROOMS; num-
 bered in pencil, lower left.
EDITION: 34
PROOFS: 10 AP, 1 BAT, 3 PP
PUBLISHERS: Brooke Alexander, Inc., and Marlborough Graphics,
 New York
PRINTER: Jennifer Melby, New York
COMMENTS: First color aquatint.

70. *You Can Have a Body Like Mine* 1978

Silkscreen in nine colors on Arches Cover paper
SHEET: 24 × 18" (61.0 × 45.7 cm)
IMAGE: 24 × 18" (61.0 × 45.7 cm)
INSCRIPTIONS: Signed in pencil, lower right: *Red Grooms*; numbered
 in pencil, lower left.
EDITION: 150
PROOFS: 25 AP
PUBLISHER: G. H. J. Graphics, New York
PRINTER: Chromacomp, Inc., New York

71. *Chuck Berry* 1978

Silkscreen in nine colors with die-cut on Arches Cover paper
SHEET: 31½ × 25" (80.0 × 63.5 cm)
IMAGE: 24½ × 18½" (62.2 × 47.0 cm)
INSCRIPTIONS: Signed in pencil, lower right: *Red Grooms*; numbered
 in pencil, lower left.
EDITION: 150
PROOFS: 25 AP
PUBLISHER: G. H. J. Graphics, New York
PRINTER: Chromacomp, Inc., New York

72. *Red Grooms, Martin Wiley Gallery* 1978

Offset lithograph in four colors on Arches Cover paper
SHEET: 28 × 20¾" (71.1 × 52.7 cm)

IMAGE: 28 × 20¾″ (71.1 × 52.7 cm)

INSCRIPTIONS: Signed and dated in pencil, lower right: *Red Grooms '78*; numbered in pencil, lower left.

EDITION: 150

PUBLISHER: Martin Wiley Gallery, Inc., Nashville, Tennessee

PRINTER: Joe Petrocelli, Siena Studios, New York

COMMENTS: The subject is the Artist looking out of the Parthenon, in Nashville, Tennessee. For poster edition, see Section III.

73. *Museum* 1978

Offset lithograph in seven colors on F. J. Head handmade paper

SHEET: 10¼ × 23¾″ (26.0 × 60.3 cm)

IMAGE: 8⅝ × 22¼″ (21.9 × 56.5 cm)

INSCRIPTIONS: Signed in pencil, lower right: *Red Grooms*; numbered in pencil, lower left.

EDITION: 150

PROOFS: 15 AP, 15 HC, 5 PP

PUBLISHER: Brooke Alexander, Inc., New York

PRINTER: Joe Petrocelli, Siena Studios, New York

COMMENTS: Reproduced for the cover of the catalogue: *Brooke Alexander, A Decade of Print Publishing*, published for the Boston University Art Gallery, Boston, MA. February 1978.

74. *Sex in the Midwest* 1979 (published in 1998)

Lithograph in two colors and silkscreen on Hatome Japan paper

SHEET: 20½ × 15¾″ (52.1 × 40.06 cm)

IMAGE: 20½ × 15¾″ (52.1 × 40.06 cm)

INSCRIPTIONS: Signed in red pencil, lower right: *Red Grooms*; numbed in red pencil lower left, printer's chop, lower left.

EDITION: 37

PROOFS: 7 AP, 1 BAT, 2 PP, 1 SP, 1 SP with Collage

PUBLISHER: Akasha Studio, Minneapolis, Minnesota

PRINTER: Steven M. Andersen, Vermillion Editions, Ltd., Minneapolis, Minnesota, assisted by Melinda Knell

75. *Rosie's Closet* 1979 (published in 1997)

Lithograph with collage and hand-coloring on pink-dyed Japan paper

SHEET: 34¼ × 25¼″ (87.0 × 64.1 cm)

IMAGE: 34¼ × 25¼″ (87.0 × 64.1 cm)

INSCRIPTIONS: Signed in purple pencil lower right: *Red Grooms*; numbered in purple pencil, lower left, printer's chop, lower left.

EDITION: 30

PROOFS: 6 AP, 1 BAT , 3 CTP on Arches Cover, 1 PP, 2 TP (signed "for Brooke" and "for Avis")

PUBLISHER: Akasha Studio, Minneapolis, Minnesota

PRINTER: Steven M. Andersen, Vermillion Editions, Ltd., Minneapolis, Minnesota, assisted by Melinda Knell

76. *Peking Delight* 1979

A three-dimensional wall multiple sculpture both hand-painted and printed in twenty-one colors utilizing two pochoir stencils, eight silkscreens, and two rubber stamps on wood, cut out and glued.

CASE: 18¼ × 20½ × 8¼″ (46.4 × 52.1 × 21.0 cm)

IMAGE: 16¼ × 18½ × 6″ (40.0 × 47.0 × 12.7 cm)

INSCRIPTIONS: Signed in red tempera paint, upper right: *Red Grooms*; numbered on brass plate on back.

EDITION: 50

PROOFS: 10 AP, 6 PP

PUBLISHERS: Brooke Alexander, Inc., and Marlborough Graphics, New York

PRINTER: Steven M. Andersen, Vermillion Editions, Ltd., Minneapolis, Minnesota, assisted by William Lagattuta, Agnes Story, Leigh

Roger, Philip Barber, Rolla Herman, Tim McClellen, and Andersen family

COMMENTS: In some publications it is titled *Chinaman* and *Peking Duck*. The Artist, after consideration, felt the former title to be improper and re-titled the piece. The original print was not mounted in a Plexiglas case, some were mounted in a Plexiglas case at a later date.

77. *Truck* 1979

Lithograph in one color on Japanese Oka paper

SHEET: 24½ × 61¾″ (62.2 × 156.9 cm)

IMAGE: 24½ × 61¾″ (62.2 × 156.9 cm)

INSCRIPTIONS: Signed in white colored pencil, lower right center: *Red Grooms*; numbered in white colored pencil, lower right center; printer's chop, lower left.

EDITION: 36

PROOFS: 11 AP, 1 BAT, 3 PP

PUBLISHERS: Brooke Alexander, Inc., and Marlborough Graphics, New York

PRINTER: Steven M. Andersen, Vermillion Editions, Ltd., Minneapolis, Minnesota, assisted by Philip Barber

78. *Truck II* 1979

Lithograph, 2 rubber stamps and 2 silkscreens in thirteen colors on Arches Cover paper

SHEET: 24½ × 61¾″ (62.2 × 156.9 cm)

IMAGE: 24½ × 61¾″ (62.2 × 156.9 cm)

INSCRIPTIONS: Signed in black colored pencil, lower right: *Red Grooms*; numbered in black colored pencil, lower left, printer's chop, lower right.

EDITION: 75

PROOFS: 10 AP, 2 SP, 6 TP, 1 WP

PUBLISHERS: Brooke Alexander, Inc., and Marlborough Graphics, New York

PRINTER: Steven M. Andersen, Vermillion Editions, Ltd., Minneapolis, Minnesota, assisted by William Lagattuta and Philip Barber

79. *Benefit for Creative Time* 1980

Offset lithograph in five colors on 100% rag paper

SHEET: 27 × 22″ (68.6 × 55.9 cm)

IMAGE: 24½ × 20″ (62.2 × 50.8 cm)

INSCRIPTIONS: Signed in pencil, lower right: *Red Grooms*; numbered in pencil, lower left.

EDITION: 100

PROOFS: 10 AP

PUBLISHER: Creative Time, Inc., New York

PRINTER: Joe Petrocelli, Siena Studios, New York

CHROMIST: Jean-Pierre Remond

80. *Lorna Doone* 1980

Lithograph in eleven colors with collage and rubber stamp impressions on Gyoko paper

SHEET: 49 × 32″ (124.5 × 81.3 cm) two sheets each 24½ × 32″ (62.2 × 81.3 cm)

IMAGE: 43½ × 29″ (110.5 × 73.7 cm)

INSCRIPTIONS: Signed in pencil, lower right: *Red Grooms*; numbered in pencil, lower left, printer's chop, lower right.

EDITION: 48 A/C two sheets of custom-made Gyoko paper

PROOFS: 6 AP, 5 PP

EDITION: 19 B/C two sheets of Gyoko paper

PROOFS: 4 AP

EDITION: 5 C/C on one sheet of Arches Cover paper

PUBLISHERS: Brooke Alexander, Inc., and Marlborough Graphics, New York

PRINTER: Steven M. Andersen, Vermillion Editions, Ltd., Minneapolis, Minnesota, assisted by William Lagattuta and Philip Barber

81. *Jack Beal Watching Super Bowl XIV* 1980

Etching and aquatint in one color on Somerset paper

SHEET: 18 × 14¾" (45.7 × 37.5 cm)

PLATE: 7⅞ × 7⅞" (20.0 × 20.0 cm)

INSCRIPTIONS: Signed in pencil, lower right: *Red Grooms;* signed lower right, numbered in pencil, lower left; inscribed in pencil, lower center: "JACK BEAL WATCHING THE SUPER BOWL," printer's chop, lower right.

EDITION: 15

PROOFS: 2 PP

PUBLISHER: Brooke Alexander, Inc., New York

PRINTER: Jennifer Melby, New York

COMMENTS: The subject is the American artist Jack Beal. This print and *Dallas 14, Jack 6* were drawn on a copper plate in Jack Beal's loft in New York, while watching the Super Bowl XIV. Often referred to as *Jack Beal Watching Super Bowl.*

82. *Dallas 14, Jack 6* 1980

Etching and aquatint in one color on Somerset paper

SHEET: 13⅞ × 14⅛" (35.2 × 35.9 cm)

PLATE: 5¾ × 8" (14.6 × 20.3 cm)

INSCRIPTIONS: Signed in pencil, lower center: *Red Grooms*; numbered in pencil, lower left; inscribed in pencil, lower center: "DALLAS 14 JACK 6," printer's chop lower right.

EDITION: 25

PROOFS: 2 PP

PUBLISHER: Brooke Alexander, Inc., New York

PRINTER: Jennifer Melby, New York

COMMENTS: The subject is the American artist, Jack Beal. This print and *Jack Beal Watching the Super Bowl XIV* were drawn on a copper plate in Jack Beal's loft in New York, while watching Super Bowl XIV.

83. *Rrose Selavy* 1980

Etching in one color on Rives BFK paper

SHEET: 10½ × 7½" (26.7 × 19.1 cm)

PLATE: 3 × 2¼" (7.6 × 5.7 cm)

INSCRIPTIONS: Signed in pencil, lower right: *Red Grooms*; numbered in pencil, lower left; inscribed in pencil, lower center: "RROSE SELAVY," printer's chop, lower right.

EDITION: 30

PROOFS: Various unsigned CTP, 2 PP

PUBLISHER: The Artist

PRINTER: Jennifer Melby, New York

84. *Dali Salad I* 1980

Three-dimensional lithograph in ten colors and silkscreen in nine colors on Arches Cover paper, Japanese paper and vinyl, cut out, glued, and mounted on blue painted board backing; framed and covered with a Plexiglas dome

DOME: 26½ × 27½ × 12½" (67.3 × 69.9 × 31.8 cm)

IMAGE: 23 × 23 × 10" (58.4 × 58.4 × 25.4 cm)

INSCRIPTIONS: Signed and dated in pink tempera, upper left, *Red Grooms*; inscribed on 1½" × 4½" brass plaque, upper center front.
"DALI SALAD"
Copyright: *Red Grooms, 1980*
Published by: Brooke Alexander, Inc.
Marlborough Gallery, Inc.
Produced by: Vermillion Editions, Ltd.
This is copy: 1/X

EDITION: Roman numeral edition of X

PROOFS: 2 CTPs

PUBLISHERS: Brooke Alexander, Inc., and Marlborough Gallery, New York

PRINTER: Steven M. Andersen, Vermillion Editions Ltd., Minneapolis, Minnesota, assisted by William Lagattuta, Jon Swenson, Albert Clouse, Mary Roska, Agee Story, Helen Slade, Leigh Royer, Philip Barber, assembled by Philip Barber with assistance from Daniel Rounds

COMMENTS: This edition was designed with a plastic support which allowed the print to be hung on the wall at an angle or reversed and set on a table at yet another angle.

85. *Dali Salad II* 1980

Three-dimensional lithograph in ten colors and silkscreen in nine colors on Arches Cover paper, Japanese paper and vinyl, cut out, glued, and mounted on white painted museum board backing; framed and covered with a Plexiglas dome

DOME: 26½ × 27½ × 12½" (68.9 × 69.9 × 31.8 cm)

IMAGE: 23 × 24 × 10" (58.4 × 61.0 × 25.4 cm)

INSCRIPTIONS: Signed and dated in pencil, upper right: *Red Grooms '80*; inscribed on 2 × 4½" brass plate on lower right, back.
"DALI SALAD"
Copyright: *Red Grooms, 1980*
Co-published by Brooke Alexander, Inc. and Marlborough Gallery, Inc. New York
Produced by Vermillion Editions, Ltd., Minneapolis, Minnesota
This is copy 33/55

EDITION: 55

PROOFS: 12 AP

PUBLISHERS: Brooke Alexander, Inc., and Marlborough Graphics, New York

PRINTER: Steven M. Andersen, Vermillion Editions, Ltd., Minneapolis, Minnesota

86. *Pancake Eater* 1981

Three-dimensional color lithograph silkscreen with gold radiance powder on Arches Cover paper, Mylar and window shade paper; cut out, glued and framed and covered with Plexiglas

CASE: 42½ × 30½ × 3" (108.0 × 77.5 × 7.6 cm)

IMAGE: 41½ × 29⅞ × 2" (105.4 × 75.9 × 5.1 cm)

INSCRIPTIONS: Signed and dated in red colored pencil, lower right: *Red Grooms 81*; inscribed on brass plaque, lower center on back.
"THE PANCAKE EATER"
Copyright: *Red Grooms, 1981*
Co-published by Brooke Alexander, Inc. and Marlborough Gallery, Inc. New York
Produced by Vermillion Editions, Ltd., Minneapolis, Minnesota
This is copy: AP 7/9

EDITION: 31

PROOFS: 9 AP, 1 BAT, 5 PP, 2 TP

PUBLISHERS: Brooke Alexander, Inc., and Marlborough Graphics, New York

PRINTER: Steven M. Andersen, Vermillion Editions, Ltd., Minneapolis, Minnesota, assisted by Michael Reid, Agnes Story, William Lagattuta, Albert Clouse, and Philip Barber. Assembly by Michael Reid and Steven M. Andersen.

COMMENTS: The subject on the left is Philip Barber, Steve Andersen's studio manager, and the one on the right is Gregory Page, an assistant printer. The Pancake Eater was a character made up by the Artist. Produced from sixteen plates, six silkscreens, and twenty-five colors.

87. *The Tattoo Artist* 1981

Lithograph in ten colors on Japanese Chauke heavyweight paper
SHEET: 36 × 25″ (91.4 × 63.5 cm)
IMAGE: 28 × 25″ (71.1 × 63.5 cm)
INSCRIPTIONS: Signed in red colored pencil, lower right: *Red Grooms*; numbered in red colored pencil, lower left, printer's chop, lower left.
EDITION: 38
PROOFS: Roman numeral edition of XI, numbered as CTP on Arches Cover paper. 10 AP, 1 BAT, 7 HC, 3 PP, 2 TP on Japanese Chauke lightweight paper
PUBLISHER: Brooke Alexander, Inc., New York
PRINTER: Steven M. Andersen, Vermillion Editions, Ltd., Minneapolis, Minnesota, assisted by Albert Clouse

88. *Mid-Rats* 1981

Lithograph in twelve colors on Rives BFK paper
SHEET: 22⅜ × 30″ (56.8 × 76.2 cm)
IMAGE: 22⅜ × 30″ (56.8 × 76.2 cm)
INSCRIPTIONS: Signed and dated in red felt pen, lower right: *Red Grooms '81*; numbered in red felt pen, lower right.
EDITION: 88
PROOFS: 12 AP, 1 BAT, 7 CTP, 7 PC, 5 PP, 2 SP
PUBLISHER: Vermillion Press, Ltd., Minneapolis, Minnesota
PRINTER: Steven M. Andersen, Vermillion Press, Ltd., Minneapolis, Minnesota, assisted by Albert Clouse and Brian Leo
COMMENTS: The title *Mid-Rats* is derived from a slang term used in the armed forces to describe the middle meal for those who work the evening hours (i.e., midnight rations).

89. *Mountaintime* 1981

Color lithograph with collage on Arches Cover paper
SHEET: 30 × 22″ (76.2 × 56.5 cm)
IMAGE: 30 × 22″ (76.2 × 56.5 cm)
INSCRIPTIONS: Signed and dated in white colored pencil, lower right: *Red Grooms '81*; numbered in white colored pencil, lower left.
EDITION: 65
PROOFS: 8 AP, 1 BAT, 3 PP, 3 TP, 3 TP Sheet one without collage, 3 TP Sheet two uncut, 3 WSP
PUBLISHER: Signet Arts, St. Louis, Missouri
PRINTER: Bud Shark, Shark's Lithography, Ltd., Boulder, Colorado, assisted by Matthew Christie; elements hand cut and attached to sheet by Barbara Shark
COMMENTS: First lithograph printed by Bud Shark. Proofed at Anderson Ranch, Snowmass, Colorado. Printed in Boulder, Colorado. Print has elements that are cut out and inserted into slits and the ski lift cables are real strings used for a collage effect. Produced from nine plates, seventeen colors on two sheets.

90. *Ruckus Taxi* 1982

Three-dimensional color lithograph on Arches Cover paper, cut out, glued, and mounted in Plexiglas case
CASE: 16 × 28½ × 14″ (40.6 × 72.4 × 35.6 cm)
IMAGE: 13½ × 20½ × 5⅝″ (34.3 × 52.1 × 14.3 cm)
INSCRIPTIONS: Signed and dated in red colored pencil, lower center on rear view: *Red Grooms '82*; numbered in red colored pencil, lower left on rear view.
EDITION: 75
PROOFS: 5 AP, 4 CSP (black), 2 PP, 8 TP, 4 TP (flat, uncut), 3 WSP
PUBLISHERS: Red Grooms and Shark's Lithography, Ltd., assisted by Matthew Christie; Boulder, Colorado
PRINTER: Bud Shark, Shark's Lithography, Ltd., Boulder, Colorado, cut and assembled by Barbara Shark

COMMENTS: First three-dimensional lithograph with Shark's, marking the beginning of the "Pop-Up" series. Done on the Artist's first visit to Boulder when *Self-Portrait with Lizzie,* 1982 was also produced. Produced from five plates, five colors on one sheet.

91. *Self-Portrait with Liz* 1982

Lithograph in nine colors on Twinrocker handmade paper
SHEET: 20 × 16″ (50.8 × 40.6 cm)
IMAGE: 16¼ × 12½″ (41.3 × 31.8 cm)
INSCRIPTIONS: Signed and dated in pencil, lower right: *Red Grooms '82*; numbered in pencil, lower left.
EDITION: 44
PROOFS: 7 AP, 2 SP (unsigned), 2 PC, 3 PP, 3 TP, 3 WSP
PUBLISHER: Signet Arts, St. Louis, Missouri
PRINTER: Bud Shark, Shark's Lithography, Ltd., Boulder, Colorado
COMMENTS: Image same as watercolor, *Self-Portrait with Lizzy*, 1982, 16 × 12″ (40.6 × 30.5 cm). The Artist was forty-four at the time of this self-portrait, hence the number of the edition.

92. *Fred and Ginger* 1982

Silkscreen in eight colors on Rives BFK paper
SHEET: 40 × 26″ (101.6 × 66.0 cm)
IMAGE: 40 × 26″ (101.6 × 66.0 cm)
INSCRIPTIONS: Signed and dated in pencil, lower right: *Red Grooms '82*; numbered in pencil, lower left.
EDITION: 100
PUBLISHER: Senator Howard Metzenbaum's re-election committee, Washington, D.C.
PRINTER: Alexander Heinrici, Studio Heinrici, New York
COMMENTS: Produced for Howard Metzenbaum's re-election campaign for the Senate. The Artist did all of the color separations himself, using Mylar sheets which were then photographically reproduced onto silkscreen.

93. *Franklin's Reception at the Court of France* 1982

Silkscreen in twelve colors on Rives BFK paper
SHEET: 45 × 31½″ (114.3 × 80.0 cm)
IMAGE: 42 × 29″ (106.7 × 73.7 cm)
INSCRIPTIONS: Signed and dated in pencil, lower right: *Red Grooms '82*; numbered in pencil, lower left.
EDITION: 125
PROOFS: 5 PP
PUBLISHER: Institute of Contemporary Art, Philadelphia, Pennsylvania
PRINTER: Alexander Heinrici, Studio Heinrici, New York
COMMENTS: Edition donated by the Artist for the benefit of the Institute of Contemporary Art in support of Philadelphia Cornucopia, Institute of Contemporary Art, University of Pennsylvania, Philadelphia. This print was executed for "Rally Round the Flag," a fund-raising benefit. The benefit is an annual event, with a new theme each year. Other artists who created prints for the ICA benefits include Claes Oldenburg, James Rosenquist, and Andy Warhol.

94. *Pierpont Morgan Library* 1982

Offset lithograph in four colors on Arches Cover paper
SHEET: 15 × 37¹¹⁄₁₆″ (38.1 × 95.7 cm)
IMAGE: 9 × 22¼″ (22.9 × 56.5 cm)
INSCRIPTIONS: Signed in pencil, lower right: *Red Grooms*; numbered in pencil, lower left.
EDITION: 300
PROOFS: 40 AP, 7 SP
PUBLISHER: Jackie Fine Arts, New York
PRINTER: Joe Petrocelli, Siena Studios, New York

95. _Mayor Byrne's Mile of Sculpture_ 1982

Lithograph in twelve colors on Arches Cover paper
SHEET: 36 × 23¼″ (91.4 × 59.1 cm)
IMAGE: 35¾ × 22¾″ (90.8 × 57.8 cm)
INSCRIPTIONS: Signed in red colored pencil, lower right: _Red Grooms_; numbered in red colored pencil, lower left, printer's chop, lower center.
EDITION: 100
PROOFS: 20 AP, 1 BAT, 8 PP, 15 Other impressions
PUBLISHER: Chicago Sculpture Society, Chicago, Illinois
PRINTER: Steven M. Andersen, Vermillion Editions, Ltd., Minneapolis, Minnesota, assisted by Philip Barber, Michael Reid, Stephanie Nowak, John Harris, Richard Jones, Denis van Horn, John Petroski
CHROMIST: Steven M. Andersen
COMMENTS: Produced for a sculpture exhibition on the Navy Pier commissioned by the City of Chicago, Mayor Jane M. Byrne, May 1982. Fifty-four artists were included. For poster edition, see Section III.

96. _Tonto—Condo_ 1983

Three-dimensional color lithograph on Arches Cover paper with moving parts, cut out, glued, and mounted in Plexiglas case
CASE: 23¼ × 30⅝ × 6¾″ (59.1 × 77.9 × 17.2 cm)
IMAGE: 22¾ × 30 × 5″ (57.8 × 76.2 × 12.7 cm)
INSCRIPTIONS: Signed in pencil, upper left: _Red Grooms_; numbered in pencil, upper right.
EDITION: 75
PROOFS: 5 AP, 1 BAT, 1 Set (6) CSP, 2 PP, 5 TP, 3 WSP
PUBLISHERS: Red Grooms and Shark's Lithography, Ltd., Boulder, Colorado
PRINTER: Bud Shark, Shark's Lithography, Ltd., Boulder, Colorado, assisted by Matthew Christie, Ron Trujillo, and Margaretta Gilboy, cut and assembled by Barbara Shark and Margaretta Gilboy
COMMENTS: First three-dimensional print with moving parts. A before and after view of the West with "Indians" or "Condominiums" appearing on the top of the Mesa. Produced from nine plates, six colors on two sheets.

97. _Saskia Down the Metro_ 1983

Silkscreen, two separate prints, one die-cut and laminated to the other on 250# Rives tan paper, from _New York, New York,_ a portfolio of original graphic works by eight contemporary artists
SHEET: 29½ × 36¼″ (75.0 × 92.1 cm)
IMAGE: 23 × 30″ (55.9 × 76.2 cm)
INSCRIPTIONS: Signed and dated in pencil, lower right: _Red Grooms '83_; numbered in pencil, lower left.
EDITION: 250
PROOFS: 25 AP, 6 SP (on white paper)
PUBLISHER: New York Graphic Society, Ltd., Greenwich, Connecticut
PRINTER: Alexander Heinrici, Studio Heinrici, New York
COMMENTS: A special edition of XXXV was also produced with X AP's. The title sheet of the portfolio refers to _Subway Riders;_ the artist prefers _Saskia Down the Metro._ The center subject is Saskia, the Artist's daughter at age 13. The contributing artists were: Robert Indiana, Larry Rivers, Robert Rauschenberg, R. B. Kitaj, James Rosenquist, Alex Katz, Robert Motherwell, and Red Grooms.

98. _Red Grooms Drawing David Saunders Drawing Red Grooms_ 1983

Lithograph in one color on Arches 88 paper
SHEET: 22 × 30″ (55.9 × 76.2 cm)
IMAGE: 22 × 30″ (55.9 × 76.2 cm)
INSCRIPTIONS: Signed in pencil, lower right: _David Saunders_; signed in pencil, lower left: _Red Grooms_; numbered in pencil, lower center; printer's chop, lower right.
EDITION: 15
PUBLISHERS: Red Grooms, David Saunders, and Shark's Lithography, Ltd., Boulder Colorado
PRINTER: Bud Shark, Shark's Lithography, Ltd., Boulder, Colorado
COMMENTS: David Saunders and the Artist had gone to Boulder to produce prints with Bud Shark when they decided to do one of each other. David Saunders was an important collaborator with the Artist. He was a crew member on _Ruckus Manhattan,_ as well as _Ruckus Rodeo._

99. _Downhiller_ 1983

Lithograph in six colors on Arches Cover paper
SHEET: 41½ × 29″ (105.4 × 73.7 cm)
IMAGE: 41½ × 29″ (105.4 × 73.7 cm)
INSCRIPTIONS: Signed and dated in pencil, lower right: _Red Grooms '83_; numbered in pencil, lower right; publisher's chop, lower left.
EDITION: 75
PROOFS: 10 AP, 1 BAT, 2 PP, 3 TP, 3 WSP
PUBLISHERS: Unicorn Gallery and Andersen Ranch Art Center, Snowmass, Colorado
PRINTER: Bud Shark, Shark's Lithography, Ltd., Boulder, Colorado, assisted by Matthew Christie
COMMENTS: Print was done as a proposed poster for the "Winternational" ski competitions in Aspen, Colorado.

100. _London Bus_ 1983

Three-dimensional color lithograph on Rives BFK paper, cut out, glued, and mounted in Plexiglas case
CASE: 20 × 22 × 14″ (50.8 × 55.9 × 35.6 cm)
IMAGE: 17½ × 21½ × 13½″ (44.5 × 54.6 × 34.3 cm)
INSCRIPTIONS: Signed in gray colored pencil, lower left of side view: _Red Grooms_; numbered in gray colored pencil, lower left.
EDITION: 63
PROOFS: 5 AP, 1 BAT, 2 PP, 4 TP (black plates only), 3 WSP
PUBLISHERS: Red Grooms and Shark's Lithography, Ltd., Boulder, Colorado
PRINTER: Bud Shark, Shark's Lithography, Ltd., Boulder, Colorado, assisted by Matthew Christie, assembled by Barbara Shark, cut out by Margaretta Gilboy and Jean Pless
COMMENTS: Produced from twelve plates, six colors on two sheets.

101. _Wheeler Opera House_ 1984

Three-dimensional color lithograph on Arches 88 paper, cut out, glued, and mounted in a Plexiglas case
CASE: 17½ × 20 × 4¾″ (44.5 × 50.8 × 12.1 cm)
IMAGE: 17 × 19½ × 4″ (43.2 × 49.5 × 10.2 cm)
INSCRIPTIONS: Signed in pencil, lower right: _Red Grooms;_ numbered in pencil, lower left.
EDITION: 30
PROOFS: 5 AP, 6 CSP (black), 2 PP, 3 TP (2 flat uncut on Rives BFK), 3 WSP
PUBLISHERS: Red Grooms and Shark's Lithography, Ltd., Boulder, Colorado
PRINTER: Bud Shark, Shark's Lithography, Ltd., Boulder, Colorado, assisted by Matthew Christie, assembled by Barbara Shark, Jean Pless, and Marilyn Duke
COMMENTS: Commissioned by Bob Murray of Wheeler Opera House in Aspen to celebrate reopening of the Opera House, which was refurbished and restored for its 95th anniversary in 1984. Produced from six plates, six colors on one sheet.

102. **Fats Domino** 1984

Three-dimensional color lithograph on Rives BFK paper and Arches 88 paper, cut out, glued, and mounted in Plexiglas case
CASE: 17¼ × 20⅜ × 17⅜″ (43.8 × 51.8 × 44.1 cm)
IMAGE: 13 × 18½ × 15½″ (33.0 × 47.0 × 39.4 cm)
INSCRIPTIONS: Signed in red colored pencil, upper right on top view: *Red Grooms*; numbered in red colored pencil, upper right on top view.
EDITION: 54
PROOFS: 5 AP, 2 PP, 4 TP (1 black plate only), 3 WSP
PUBLISHERS: Red Grooms and Shark's Lithography, Ltd., Boulder, Colorado
PRINTER: Bud Shark, Shark's Lithography, Ltd., Boulder, Colorado, assisted by Ron Trujillo
COMMENTS: Produced from 8 plates, six colors on two sheets.

103. **The Existentialist** 1984

Woodcut in five colors on Toyoshi handmade paper
SHEET: 77 × 42″ (195.6 × 106.7 cm)
IMAGE: 72¼ × 42″ (183.5 × 106.7 cm)
INSCRIPTIONS: Signed in pencil, lower right: *Red Grooms*; numbered in pencil, lower left.
EDITION: 15
PUBLISHER: Experimental Workshop, San Francisco, California, in collaboration with Garner Tullis
PRINTERS: John Stemmer and Will Foo, San Francisco, California
COMMENTS: Sometimes referred to as "Portrait of Giacometti. "

104. **Red's Roxy** 1985

Three-dimensional color lithograph on Rives BFK paper, cut out, folded, and mounted in Plexiglas case; assembled lithograph is a crank operated Mylar film. Film consists of thirty-five frames printed on Mylar from the Artist's original drawings
CASE: 8¼ × 6½ × 11⅝″ (21.0 × 16.5 × 29.5 cm)
IMAGE: 7 × 6 × 11″ (17.8 × 15.2 × 27.9 cm)
INSCRIPTIONS: Signed in pencil, lower center on front view: *Red Grooms*; numbered in pencil, lower center on front view.
EDITION: 200
PROOFS: 15 AP, 1 BAT, 3 PP, 3 TP, 4 WSP
PUBLISHERS: Red Grooms and Shark's Lithography, Ltd., Boulder, Colorado
PRINTER: Bud Shark, Shark's Lithography, Ltd., Boulder, Colorado, assisted by Ron Trujillo, Roseane Colachis, and Meg Ingraham, assembled by Roseanne Colachis and Barbara Shark
COMMENTS: Produced from five plates, five colors on one sheet.

105. **American Geisha** 1985

Lithograph, woodcut, and linoleum cut in ten colors on calendared Suzuki paper
SHEET: 18½ × 22½″ (47.0 × 57.2 cm)
IMAGE: 11¾ × 16″ (29.9 × 40.6 cm)
INSCRIPTIONS: Signed in pencil, lower right: *Red Grooms*; numbered in pencil, lower left.
EDITION: 25
PUBLISHERS: Red Grooms and Shark's Lithography, Ltd., Boulder, Colorado
PRINTERS: Bud Shark, Barbara Shark, and Jean Pless, Shark's Lithography, Ltd., Boulder, Colorado, assisted by Ron Trujillo and Roseanne Colachis

106. **Café Tabou** 1985 (published in 1986)

Etching and aquatint in one color on Hahnemuhle paper
SHEET: 14 × 15⅝″ (35.6 × 39.7 cm)
PLATE: 7 × 9⅜″ (17.8 × 23.8 cm)
INSCRIPTIONS: Signed in pencil, lower right: *Red Grooms*; numbered in pencil, lower left.
EDITION: 50
PROOFS: 10 AP
PUBLISHER: Marlborough Graphics, New York
PRINTER: Aldo Crommelynck, Paris, France
COMMENTS: Café Tabou is a famous nightclub in Paris where the existentialists and later, the beatniks, liked to hang out.

107. **Les Deux Magots** 1985 (published 1987)

Etching in one color and aquatint on Hahnemuhle paper
SHEET: 26¼ × 31⅜″ (66.7 × 79.7 cm)
PLATE: 19½ × 25½″ (50 × 65 cm)
INSCRIPTIONS: Signed in pencil, lower right: *Red Grooms*; numbered in pencil, lower left.
EDITION: 50
PROOFS: 10 AP
PUBLISHER: Marlborough Graphics, New York
PRINTER: Aldo Crommelynck, Paris, France

108. **2 A.M., Paris 1943** 1985 (published in 1996)

Aquatint in eleven colors on Hahnemuhle paper
SHEET: 14⅜ × 16″ (36.5 × 40.6 cm)
PLATE: 7 × 9⅜″ (17.8 × 23.8 cm)
INSCRIPTIONS: Signed and dated in pencil, lower right: *Red Grooms '96*; numbered in pencil, lower left; inscribed in pencil, lower center: 2 A. M., PARIS 1943.
EDITION: 50
PROOFS: 6 AP, 1 BAT, 3 PP, 1 TP
PUBLISHER: Marlborough Graphics, New York
PRINTERS: Aldo Crommelynck, Julia D'Armario, Bill Hall, New York
COMMENTS: The subject is Pablo Picasso working in his studio during the German occupation.

109. **Sunday Funnies** 1985

Lithograph and photo lithograph in seven colors on Rives BFK paper
SHEET: 30¼ × 44½″ (76.8 × 113.0 cm)
IMAGE: 30¼ × 44½″ (76.8 × 113.0 cm)
INSCRIPTIONS: Signed in red colored pencil, lower right center: *Red Grooms*; numbered in red colored pencil, lower center.
EDITION: 125
PROOFS: 25 AP, 1 BAT, 1 C, 5 PP, 5 WSP
PUBLISHER: The Greater Miami Women's Auxiliary of M. J. H. H. A. (Miami Jewish Hospital, Hadasa Association, Miami, Florida)
PRINTER: Bud Shark, Shark's Lithography, Ltd., Boulder, Colorado, assisted by Roseanne Colachis and Ron Trujillo
COMMENTS: The print was produced as a donation from the Artist to M.J.H.H.A.

110. **Charlie Chaplin** 1986

Three-dimensional color lithograph on Rives BFK paper, cut out, glued, and mounted in Plexiglas case
CASE: 23 × 18½ × 11¼″ (58.4 × 47.0 × 28.6 cm)
IMAGE: 19½ × 18 × 10⅞″ (49.5 × 45.7 × 27.6 cm)
INSCRIPTIONS: Signed in blue colored pencil, upper right on bottom view: *Red Grooms*; numbered in blue colored pencil, upper left on bottom view.
EDITION: 75
PROOFS: 5 AP, 1 BAT, 1 C, 2 PP, 5 TP (1 black and white), 3 WSP, 1 Set (7) Separation proofs
PUBLISHERS: Red Grooms and Shark's Incorporated, Boulder, Colorado

PRINTER: Bud Shark, Shark's Incorporated, Boulder, Colorado, assisted by Roseanne Colachis and Ron Trujillo

COMMENTS: Produced from eleven plates, seven colors on two sheets.

111. *Subway* 1986

Three-dimensional color lithograph on Rives BFK paper, cut out, glued, and mounted in Plexiglas case

CASE: 14½ × 40⅜ × 7″ (36.8 × 102.6 × 17.8 cm)

IMAGE: 14 × 40 × 4½″ (35.6 × 101.6 × 11.4 cm)

INSCRIPTIONS: Signed in red colored pencil, lower left: *Red Grooms*; numbered in red colored pencil, lower left.

EDITION: 75

PROOFS: 10 AP, 1 BAT, 2 CP (1 of each "Key" plate), 1 set-13 CSP, 5 PP, 5 WSP

PUBLISHERS: Red Grooms and Shark's Incorporated, Boulder, Colorado

PRINTER: Bud Shark, Shark's Incorporated, Boulder, Colorado, assisted by Roseanne Colachis and Ron Trujillo, assembled by Roseanne Colachis, Jean Pless, Jim Robb, and Barbara Shark

COMMENTS: Produced from thirteen plates, seven colors on two sheets.

112. *De Kooning Breaks Through* 1987

Three-dimensional color lithograph on Rives BFK paper, cut out, glued, and mounted in Plexiglas case

CASE: 47 × 33 × 8¾″ (119.4 × 83.8 × 22.2 cm)

IMAGE: 44 × 29 × 7¾″ (111.8 × 73.7 × 19.7 cm)

INSCRIPTIONS: Signed in red colored pencil, lower right: *Red Grooms*; numbered in red colored pencil, lower left.

EDITION: 75

PROOFS: 10 AP, 1 BAT, 11 CSP (unsigned) one of each plate sheets 2 and 3, 4 PP, 7 TP (4 assembled, 3, one each sheet, uncut), 4 WSP

PUBLISHERS: Red Grooms and Shark's Incorporated, Boulder, Colorado

PRINTER: Bud Shark, Shark's Incorporated, Boulder, Colorado, assisted by Roseanne Colachis and Ron Trujillo, assembled by Roseanne Colachis, Jean Pless, Barbara Shark, and Jim Robb

COMMENTS: Same image as *Willem de Kooning*, 1987, collage with colored pencil, acrylic and oil pastel, 85¾ × 60½″ (217.8 × 153.7 cm). Produced from sixteen plates, six colors on three sheets.

113. *The Cedar Bar* 1987

Offset lithograph in four colors on film and Mylar on Arches Cover paper

SHEET: 24½ × 32″ (62.2 × 81.3 cm)

IMAGE: 22 × 30″ (55.9 × 76.2 cm)

INSCRIPTIONS: Signed in pencil, lower right: *Red Grooms*; numbered in pencil, lower left; inscribed in pencil, lower center: CEDAR BAR.

EDITION: 200

PROOFS: 20 AP, 1 BAT, 6 PP, 2 WSP

PUBLISHER: Marlborough Graphics, New York

PRINTERS: Maurice Sanchez, J. Petrocelli; Derriere L'Etoile Studios, New York

114. *Lysiane and Red's Wedding Invitation* 1987

Three-dimensional lithograph in five colors on Rives BFK paper, cut out, glued, and mounted in Plexiglas case

CASE: 9¼ × 12¼ × 2¼″ (23.5 × 31.1 × 5.7 cm)

IMAGE: 8⅜ × 11⅞ × 1¼″ (21.3 × 30.2 × 3.2 cm)

INSCRIPTIONS: Signed and dated in blue colored pencil, top center on back: *Red Grooms, JULY '87*; numbered in blue colored pencil, top center on back.

EDITION: 80

PROOFS: 10 AP, 2 PP, 3 WSP

PUBLISHERS: Red Grooms and Shark's Incorporated, Boulder, Colorado

PRINTER: Bud Shark, Shark's Incorporated, Boulder, Colorado, assisted by Ron Trujillo

COMMENTS: The image is Lysiane Luong and the Artist shown during their wedding ceremony at St. John The Divine Cathedral in the Chapel of St. James, New York. Sent to friends invited to the wedding.

115. *Elvis* 1987

Lithograph in eleven colors on Rives BFK paper

SHEET: 44½ × 30″ (113.0 × 76.2 cm)

IMAGE: 44½ × 30″ (113.0 × 76.2 cm)

INSCRIPTIONS: Signed in black colored pencil, lower right: *Red Grooms*; numbered in black colored pencil, lower left.

EDITION: 75

PROOFS: 10 AP, 1 BAT, 4 Black and White Impressions, 5 PP, 3 TP, 5 WSP

PUBLISHERS: Red Grooms and Shark's Incorporated, Boulder, Colorado

PRINTER: Bud Shark, Shark's Incorporated, Boulder, Colorado, assisted by Ron Trujillo

116. *Van Gogh with Sunflowers* 1988

Lithograph in five colors on feather deckle Twinrocker paper

SHEET: 18½ × 24½″ (47.0 × 62.2 cm) irregular

IMAGE: 16 × 22″ (40.6 × 55.9 cm)

INSCRIPTIONS: Signed in pencil, lower right: *Red Grooms*; numbered in pencil, lower left.

EDITION: 75

PROOFS: 10 AP, 1 BAT, 4 PP, 1 TP, 6 WSP

PUBLISHERS: Red Grooms and Shark's Incorporated, Boulder, Colorado

PRINTER: Bud Shark, Shark's Incorporated, Boulder, Colorado, assisted by Ron Trijillo

117. *Little Italy* 1989

Three-dimensional color lithograph with die-cut on Rives BFK paper, cut out, glued, and mounted in Plexiglas case

CASE: 27 × 38½ × 16½″ (68.6 × 97.8 × 41.9 cm)

IMAGE: 25½ × 35½ × 15″ (64.8 × 90.2 × 38.1 cm)

INSCRIPTIONS: Signed in red colored pencil, lower right on bottom view: *Red Grooms;* numbered in red colored pencil, lower right on bottom view.

EDITION: 90

PROOFS: 10 AP, 1 BAT, 5 PP, 2 TP, 5 WSP

PUBLISHERS: Red Grooms and Shark's Incorporated, Boulder, Colorado

PRINTER: Bud Shark, Shark's Incorporated, Boulder, Colorado, assisted by Ron Trujillo, assembled by Roseanne Colachis, Barbara Shark, Ron Trujillo, and Lisa Merrin

COMMENTS: Produced from eighteen plates, five colors on five sheets.

118. *Henry Moore in a Sheep Meadow* 1989

Color lithograph in three colors on Rives BFK paper, a marginalia

SHEET: 5⅝ × 17″ (14.3 × 43.2 cm)

IMAGE: 5½ × 15½″ (14.0 × 39.4 cm)

INSCRIPTIONS: Signed in brown colored pencil, lower right: *Red Grooms*; numbered in brown colored pencil, lower left.

EDITION: 75

PUBLISHERS: Red Grooms and Shark's Incorporated, Boulder, Colorado

PRINTER: Bud Shark, Shark's Incorporated, Boulder, Colorado

COMMENTS: Produced in the margin of *Little Italy*, 1989. Sent to friends for Christmas, 1989. The subject is the sculptor Henry Moore, whose sphinx-like head has been grafted onto one of his own creations. The Artist made a monumental epoxy sculpture of the same subject.

119. *Los Aficionados* 1990

Three-dimensional color lithograph on Rives BFK paper, cut out, glued, and mounted in Plexiglas case

CASE: 26½ × 37¼ × 25″ (67.3 × 94.6 × 63.5 cm)

IMAGE: 24½ × 36⅜ × 23¾″ (62.2 × 92.4 × 60.3 cm)

INSCRIPTIONS: Signed and dated in brown colored pencil, lower right on bottom view: *Red Grooms '90,* numbered in brown colored pencil, lower left.

EDITION: 90

PROOFS: 10 AP, 1 BAT, 5 PP, 2 TP, 5 WSP

PUBLISHERS: Red Grooms and Shark's Incorporated, Boulder, Colorado

PRINTER: Bud Shark, Shark's Incorporated, Boulder, Colorado, assisted by Matthew Christie and Ron Trujillo, assembled by Roseanne Colachis, Barbara Shark, and Lisa Merrin

COMMENTS: Produced from twenty-three plates, five colors on five sheets.

120. *Grooms's Mother, On Her 81st Birthday* 1990

Color lithograph on Arches Cover paper

SHEET: 21½ × 25½″ (54.6 × 63.5 cm)

IMAGE: 19 × 23½″ (48.3 × 59.7 cm)

INSCRIPTIONS: Signed in black colored pencil, lower right: *Red Grooms*; numbered in black colored pencil, lower left; printer's chop, lower left.

EDITION: 81

PROOFS: 4 PP

PUBLISHER: The Artist

PRINTER: Mauro Giuffrida, American Atelier, New York

COMMENTS: The Artist gave the prints to friends to celebrate his mother's 81st birthday, thus an edition of 81.

121. *Sno-Show I* 1991

Color lithograph on Rives BFK paper

SHEET: 41½ × 29½″ (105.4 × 74.9 cm)

IMAGE: 41½ × 29½″ (105.4 × 74.9 cm)

INSCRIPTIONS: Signed in blue pencil, lower right: *Red Grooms*; numbered in blue pencil, lower center, printer's chop, lower left.

EDITION: 8

PROOFS: 2 AP, 1 BAT, 2 PP, 4 TP

PUBLISHER: Vermillion Editions, Ltd., Minneapolis, Minnesota

PRINTER: Steven M. Andersen, Vermillion Editions, Ltd., Minneapolis, Minnesota, assisted by Cole Rogers

COMMENTS: Produced to celebrate Vermillion Editions fifteenth anniversary. When Vermillion Editions closed, Sno-show II was produced in edition of 13, with 4 AP, 1 BAT, 2PP proofs. Same image as Sno-Show I except the inscription changed *from Vermillion Ed.15th Birthday Show* to *Museum Print Show Today.* For poster edition, see Section III.

122. *Holy Hula* 1991

Color lithograph on Rives BFK paper, with cut-out moving parts

FRAME: 28½ × 36½ × 1½″ (72.4 × 92.7 × 3.8 cm)

IMAGE: 22 × 30″ (55.9 × 76.2 cm)

INSCRIPTIONS: Signed in red colored pencil, lower right: RED GROOMS; numbered in red colored pencil, lower left.

EDITION: 90

PROOFS: 10 AP, 1 BAT, 5 PP, 4 TP, 5 WSP, 1 A (Rutgers)

PUBLISHERS: Red Grooms and Shark's Incorporated, Boulder, Colorado

PRINTER: Bud Shark, Shark's Incorporated, Boulder, Colorado, assisted by Matthew Christie

COMMENTS: Produced from sixteen plates, ten colors on two sheets. The frame with plastic pulls designed by Bud Shark for this print.

123. *Noa-Noa* 1991

Woodcut in eight colors on Suzuki paper

SHEET: 20 × 30″ (50.8 × 76.2 cm)

IMAGE: 18¼ × 28¼″ (46.4 × 71.8 cm)

INSCRIPTIONS: Signed and dated in pencil, lower right: *Red Grooms, '91*; numbered in pencil, lower left; inscribed in pencil, lower center: NOA NOA.

EDITION: 40

PROOFS: 1 A, 5 AP, 2 PP, 3 TP, 3 WSP

PUBLISHERS: Red Grooms and Shark's Incorporated, Boulder, Colorado

PRINTER: Bud Shark, Shark's Incorporated, Boulder, Colorado, assisted by Matthew Christie

124. *Stenciled Elvis* 1991

Stencil in five colors, Krylon spray paint on Japanese Mulberry paper

SHEET: 48¾ × 27½″ (123.8 × 69.9 cm)

IMAGE: 48¼ × 26¼″ (122.6 × 66.7 cm)

INSCRIPTIONS: Signed and dated in black colored pencil, lower right: *Red Grooms '91*; numbered in black colored pencil, lower left.

EDITION: 12

PUBLISHER: The Artist

PRINTER: Tom Burckhardt, New York

125. *Bull Rider* 1991

Lithograph in seven colors on Rives BFK paper

SHEET: 30 × 22¼″ (76.2 × 56.5 cm)

IMAGE: 25⅝ × 18″ (65.1 × 45.7 cm)

INSCRIPTIONS: Signed and dated in black colored pencil, lower right: *Red Grooms '91,* numbered in black colored pencil, lower left.

EDITION: 100

PROOFS: 1 A,15 AP, 1 BAT, 3 PP, 3 TP, 10 WSP

PUBLISHER: Modern Art Museum of Fort Worth, Fort Worth, Texas

PRINTER: Bud Shark, Shark's Incorporated, Boulder, Colorado, assisted by Mark Villarreal

COMMENTS: Commissioned by the Modern Art Museum of Fort Worth in honor of the 15th anniversary of Red's *Ruckus Rodeo,* 1991.

126. *Coolsan* 1991

Stencil in six colors, Krylon spray paint on rice paper, from *Sprayed Haiku* portfolio of 6 images

SHEET: 8 × 8″ (20.3 × 20.3 cm)

IMAGE: 2¼ × 1¾″ (5.7 × 4.5 cm)

INSCRIPTIONS: Signed and dated in pencil, lower right: *Red Grooms '91*; numbered in pencil, lower left.

EDITION: 10

PUBLISHER: The Artist

PRINTER: Michael Staats, New York

COMMENTS: Series includes *Coolsan, Fat Man Down, Fuji Friendly, Gracious Geisha, Into the Wind,* and *Sake Souls* in paper folder designed by the Artist.

127. Fat Man Down 1991

Stencil in four colors, Krylon spray paint on rice paper, from *Sprayed Haiku* portfolio of 6 images
SHEET: 8 × 8″ (20.3 × 20.3 cm)
IMAGE: 1½ × 1⅝″ (3.8 × 4.1 cm)
INSCRIPTIONS: Signed and dated in pencil, lower right: *Red Grooms '91*; numbered in pencil, lower left.
EDITION: 10
PUBLISHER: The Artist
PRINTER: Michael Staats, New York
COMMENTS: Series includes *Coolsan, Fat Man Down, Fuji Friendly, Gracious Geisha, Into the Wind,* and *Sake Souls* in paper folder designed by the Artist.

128. Fuji Friendly 1991

Stencil in five colors, Krylon spray paint on rice paper, from *Sprayed Haiku* portfolio of 6 images
SHEET: 8 × 8″ (20.3 × 20.3 cm)
IMAGE: 1½ × 1⅝″ (3.8 × 4.1 cm)
INSCRIPTIONS: Signed and dated in pencil, lower right: *Red Grooms '91*; numbered in pencil, lower left.
EDITION: 10
PUBLISHER: The Artist
PRINTER: Michael Staats, New York
COMMENTS: Series includes *Coolsan, Fat Man Down, Fuji Friendly, Gracious Geisha, Into the Wind,* and *Sake Souls* in paper folder designed by the Artist.

129. Gracious Geisha 1991

Stencil in three colors, Krylon spray paint on rice paper, from *Sprayed Haiku* portfolio of 6 images
SHEET: 8 × 8″ (20.3 × 20.3 cm)
IMAGE: 1⅛ × 1″ (2.9 × 2.5 cm)
INSCRIPTIONS: Signed and dated in pencil, lower right: *Red Grooms '91*; numbered in pencil, lower left.
EDITION: 10
PUBLISHER: The Artist
PRINTER: Michael Staats, New York
COMMENTS: Series includes *Coolsan, Fat Man Down, Fuji Friendly, Gracious Geisha, Into the Wind,* and *Sake Souls* in paper folder designed by the Artist.

130. Into the Wind 1991

Stencil in eight colors, Krylon spray paint on rice paper, from *Sprayed Haiku* portfolio of 6 images
SHEET: 8 × 8″ (20.3 × 20.3 cm)
IMAGE: 1⅞ × 1⅝″ (4.8 × 4.1 cm)
INSCRIPTIONS: Signed and dated in pencil, lower right: *Red Grooms '91*; numbered in pencil, lower left.
EDITION: 10
PUBLISHER: The Artist
PRINTER: Michael Staats, New York
COMMENTS: Series includes *Coolsan, Fat Man Down, Fuji Friendly, Gracious Geisha, Into the Wind,* and *Sake Souls* in paper folder designed by the Artist.

131. Sake Souls 1991

Stencil in six colors, Krylon spray paint on rice paper, from *Sprayed Haiku* portfolio of 6 images
SHEET: 8 × 8″ (20.3 × 20.3 cm)
IMAGE: 2 × 2⅛″ (5.1 × 5.4 cm)
INSCRIPTIONS: Signed and dated in pencil, lower right: *Red Grooms '91*; numbered in pencil, lower left.

EDITION: 10
PUBLISHER: The Artist
PRINTER: Michael Staats, New York
COMMENTS: Series includes *Coolsan, Fat Man Down, Fuji Friendly, Gracious Geisha, Into the Wind,* and *Sake Souls* in paper folder designed by the Artist.

132. Elaine de Kooning at the Cedar Bar 1991

Stratograph in one color on Washi paper on Gasenchi Echizen mounted onto Rives BFK gray paper, a portfolio of seven artists
SHEET: 30 × 22″ (76.2 × 55.9 cm)
IMAGE: 19⅞ × 15⅞″ (50.5 × 40.3 cm)
INSCRIPTIONS: Signed and dated in pencil, lower right: *Red Grooms '91*; numbered in pencil, lower left.
EDITION: 50
PROOFS: 5 AP (on Somerset Sand paper), 1 BAT, 5 PP (on Somerset Sand paper), 1 HC, 1 WSP
PUBLISHER: Bard College, New York
PRINTER: Joe Wilfer, Spring Street Workshop, New York
COMMENTS: The 1–27 editions went to Bard College and 28–50 to the Pace Gallery. Produced as part of a fund-raising portfolio for Bard College in memory of Elaine de Kooning. Organized by Barbara Schwartz, the portfolio includes prints by Barbara Schwartz, Michael Goldberg, Michael David, Rudy Burckhardt, Yvonne Jacquette, Alfred Leslie, and Red Grooms, and a poem by David Schapiro.

133. South Sea Sonata 1992

Three-dimensional color lithograph on Rives BFK paper, cut out, glued, and mounted in Plexiglas case
CASE: 20⅜ × 21¾ × 11⅜″ (51.8 × 55.3 × 28.9 cm)
IMAGE: 18 × 21¼ × 10″ (45.7 × 54.0 × 25.4 cm)
INSCRIPTIONS: Signed and dated in brown colored pencil, lower right on bottom view: *Red Grooms '92*; numbered in brown colored pencil, lower left on bottom view.
EDITION: 60
PROOFS: 1 A, 10 AP, 3 PP, 2 TP, 3 WSP, 3 Patron Impressions
PUBLISHERS: Red Grooms and Shark's Incorporated, Boulder, Colorado
PRINTER: Bud Shark, Shark's Incorporated, Boulder, Colorado, assisted by Matthew Christie and Mark Villarreal, assembled by Roseanne Colachis
COMMENTS: Produced on sixteen plates, nine colors on two sheets.

134. Matisse in Nice 1992

Lithograph in eight colors on Rives BFK paper
SHEET: 22¼ × 30″ (56.5 × 76.2 cm)
IMAGE: 22¼ × 30″ (56.5 × 76.2 cm)
INSCRIPTIONS: Signed and dated in black colored pencil, lower right: *Red Grooms '92*; numbered in black colored pencil, lower left.
EDITION: 45
PROOFS: 1 A (Rutgers), 7 AP, 1 BAT, 2 PP, 2 TP, 3 WSP
PUBLISHERS: Red Grooms and Shark's Incorporated, Boulder, Colorado
PRINTER: Bud Shark, Shark's Incorporated, Boulder, Colorado, assisted by Matthew Christie
COMMENTS: Matisse at work in his studio, painting from the model. Also, an imagined letter from the Cone sisters of Baltimore, who request that Matisse set aside some special paintings for their next visit. Same image as *Matisse in Nice,* 1992, collage with watercolor 22¼ × 30″ (56.5 × 76.2 cm).

135. Bronco Buster 1992

Lithograph in seven colors on Rives BFK paper, a marginalia
SHEET: 8⅜ × 8⅜″ (21.9 × 21.3 cm)

IMAGE: 8 × 7½″ (20.3 × 19.1 cm)
INSCRIPTIONS: Signed in brown colored pencil, lower right: *Red Grooms*; numbered in brown colored pencil, lower left.
EDITION: 75
PROOFS: 1 A (Rutgers), 10 AP, 1 BAT, 3 PP, 3, WSP
PUBLISHERS: Red Grooms and Shark's Incorporated, Boulder, Colorado
PRINTER: Bud Shark, Bud Shark's Incorporated, Boulder, Colorado, assisted by Matthew Christie and Mark Villarreal
COMMENTS: Produced in the margin of *South Sea Sonata*, 1992.

136. *Slam Dunk* 1992

Three-dimensional lithograph in seven colors on Rives BFK paper, cut out, glued, and mounted in Plexiglas case
CASE: 21⅜ × 18⅛ × 12½″ (54.3 × 46.0 × 31.8 cm)
IMAGE: 20¼ × 17¾ × 12⅛″ (51.4 × 45.1 × 30.8 cm)
INSCRIPTIONS: Signed and dated in red colored pencil, lower left on bottom view: *Red Grooms '92*; numbered in red colored pencil, upper left on bottom view.
EDITION: 60
PROOFS: 1 A (Rutgers), 10 AP, 1 BAT, 4 PP, 2 TP, 4 WSP
PUBLISHERS: Red Grooms and Shark's Incorporated, Boulder, Colorado
PRINTER: Bud Shark, Shark's Incorporated, Boulder, Colorado, assisted by Matthew Christie, assembled by Roseanne Colachis
COMMENTS: The player is a composite of several current pro stars, an "MVP" who plays for the fictitious pro team the "Stars." The artist's tribute to the stars of the NBA.

137. *A Light Madam* 1992

Stratograph in one color on rice paper
SHEET: 25¾ × 18½″ (65.4 × 47.0 cm)
IMAGE: 17 × 15⅞″ (43.2 × 40.3 cm)
INSCRIPTIONS: Signed and dated in red colored pencil, lower right: *Red Grooms '92*; numbered in red colored pencil, lower left.
EDITION: 75
PUBLISHER: The Artist
PRINTER: Joe Wilfer, Spring Street Studio, New York
COMMENTS: Same image as *A Light Madam*, 1962, oil on cardboard and wood, 19 × 25 × 4″ (49.2 × 63.5 × 10.2 cm).

138. *Corner of Canal* 1993

Lithograph in six colors on Rives BFK paper
SHEET: 22¼ × 30″ (56.5 × 76.2 cm)
IMAGE: 22¼ × 30″ (56.5 × 76.2 cm)
INSCRIPTIONS: Signed in black colored pencil, lower right: *Red Grooms*; numbered in black colored pencil, lower left.
EDITION: 115
PROOFS: 1 A (Rutgers), 25 AP, 1 BAT, 4 PP, 2 TP, 5 WSP
PUBLISHER: Brooklyn Museum, Community Committee, Brooklyn, New York
PRINTER: Bud Shark, Shark's Incorporated, Boulder, Colorado, assisted by Matthew Christie
COMMENTS: Same image as *Study for Corner of Canal Street*, 1993, gouache and litho crayon, 22½ × 30″ (55.9 × 76.2 cm). The Artist donated this edition to the Brooklyn Museum.

139. *Bud on the Lanai* 1993

Lithograph in eleven colors on handmade Japanese Gampi paper chine collé on Rives BFK paper
SHEET: 18½ × 15¾″ (47.0 × 40.0 cm)
IMAGE: 13½ × 10⅝″ (34.3 × 27.0 cm)
INSCRIPTIONS: Signed in brown colored pencil, lower right: *Red Grooms*; numbered in brown colored pencil, lower left.
EDITION: 12

PROOFS: 4 AP, 2 PP, 1 TP, 2 WSP
PUBLISHERS: Red Grooms and Shark's Incorporated, Boulder, Colorado
PRINTER: Bud Shark, Shark's Incorporated, Boulder, Colorado, assisted by Matthew Christie

140. *Taxi to the Terminal* 1993

Lithograph in six colors on Rives BFK paper
SHEET: 22¼ × 30″ (56.5 × 76.2 cm)
IMAGE: 22¼ × 30″ (56.5 × 76.2 cm)
INSCRIPTIONS: Signed and dated in black colored pencil, lower right: *Red Grooms '94*; numbered in black colored pencil, lower left.
EDITION: 75
PROOFS: 1 A, 18 AP, 1 BAT, 2 PP, 1 TP, 3 WSP
PUBLISHER: Marlborough Graphics, New York
PRINTER: Bud Shark, Shark's Incorporated, Boulder, Colorado, assisted by Matthew Christie
COMMENTS: Same image as *Study for Grand Central*, 1993, watercolor 22½ × 30″ (57.2 × 76.2 cm).

141. *Looking Up Broadway, Again* 1993

Lithograph in six colors on Rives BFK paper
SHEET: 30 × 22¼″ (76.2 × 56.5 cm)
IMAGE: 30 × 22¼″ (76.2 × 56.5 cm)
INSCRIPTIONS: Signed and dated in black colored pencil, lower center: *Red Grooms '94*; numbered in black colored pencil, lower center.
EDITION: 75
PROOFS: 1 A, 18 AP, 1 BAT, 2 PP, 1 TP, 3 WSP
PUBLISHER: Marlborough Graphics, New York
PRINTER: Bud Shark, Shark's Incorporated, Boulder, Colorado, assisted by Matthew Christie

142. *Hot Dog Vendor* 1994

Three-dimensional color lithograph with linocut on Rives BFK paper (one sheet with aluminum foil chine collé paper), cut out, glued, and mounted in Plexiglas case
CASE: 33¼ × 26¼ × 10″ (84.5 × 66.7 × 25.4 cm)
IMAGE: 31⅜ × 24 × 7″ (79.7 × 61.0 × 17.8 cm)
INSCRIPTIONS: Signed and dated in black colored pencil, lower right on front view: *Red Grooms '94*; numbered in black colored pencil, lower left on front view.
EDITION: 75
PROOFS: 1 A, 10 AP, 1 BAT, 5 PP, 4 TP, WSP
PUBLISHERS: Red Grooms and Shark's Incorporated, Boulder, Colorado
PRINTER: Bud Shark, Shark's Incorporated, Boulder, Colorado, assisted by Matthew Christie, assembled by Roseanne Colachis, Lisa Merrin, and Barbara Shark
COMMENTS: Produced from thirteen plates, six colors on three sheets.

143. *Red Bud Diner* 1994

Lithograph in eight colors on calendared Rives BFK waterleaf paper
SHEET: 24¼ × 62½″ (61.6 × 158.8 cm)
IMAGE: 24¼ × 62½″ (61.6 × 158.8 cm)
INSCRIPTIONS: Signed and dated in gray colored pencil, lower right: *Red Grooms '94*; numbered in gray colored pencil, lower left.
EDITION: 75
PROOFS: 1 A, 10 AP, 1 BAT, 5 PP, 3 TP, 5 WSP
PUBLISHERS: Red Grooms and Shark's Incorporated, Boulder, Colorado
PRINTER: Bud Shark, Shark's Incorporated, Boulder, Colorado, assisted by Matthew Christie
COMMENTS: Lysiane Luong, Bud and Barbara Shark, Matt Christie, Mike Byanski (Postman in Boulder), Roseanne Colachis, and the Artist appear in this print.

144. *Dixie's* 1994

Lithograph in seven colors on Rives BFK paper, a marginalia
SHEET: 11¼ × 9½" (28.6 × 24.1 cm)
IMAGE: 8½ × 6½" (21.6 × 16.5 cm)
INSCRIPTIONS: Signed and dated in black colored pencil, lower right:
Red Grooms '94; numbered in black colored pencil, lower left.
EDITION: 75
PROOFS: 1 A, 10 A, 1 BAT, 5 PP, 2 TP, 5 WSP
PUBLISHERS: Red Grooms and Shark's Incorporated, Boulder, Colorado
PRINTER: Bud Shark, Shark's Incorporated, Boulder, Colorado
COMMENTS: Produced in the margin of *Hot Dog Vendor*, 1994.

145. *Main Concourse, Grand Central Terminal I* 1994

Etching, aquatint, and soft ground in six colors on Hahnemuhle
paper
SHEET: 31½ × 33¾" (80.0 × 85.7 cm)
PLATE: 24¼ × 28½" (61.6 × 72.4 cm)
INSCRIPTIONS: Signed and dated in pencil, lower right: *Red Grooms*
'94; numbered in pencil, lower left; printer's chop, lower left corner.
EDITION: 75
PROOFS: 10 AP, 1 BAT, 1 HC, 10 PP, 4 SP, 3 TP
PUBLISHER: Pace Editions, Inc., New York
PRINTER: Aldo Crommelynck, New York

146. *Main Concourse, Grand Central Terminal II* 1994

Etching, aquatint, and soft ground in one color on Hahnemuhle
paper
SHEET: 31½ × 33¾" (80.0 × 85.7 cm)
PLATE: 24¼ × 28½" (61.6 × 72.4 cm)
INSCRIPTIONS: Signed and dated in pencil, lower right: *Red Grooms*
'94; numbered in pencil, lower left; printer's chop, lower left.
EDITION: 75
PROOFS: 10 AP, 1 BAT, 1 HC, 10 PP, 4 SP, 3, TP, 4 other proofs
(unsigned)
PUBLISHER: Pace Editions, Inc., New York
PRINTER: Aldo Crommelynck, New York
COMMENTS: Same image as *Main Concourse Terminal, Grand Central
Station*, 1994, but the plate was considerably re-worked by the
Artist.

147. *Underground Platforms* 1994

Etching and aquatint in one color on Hahnemuhle paper, from *The
Main Concourse, Grand Central Terminal and Other Thoughts on
Trains and Engravings* series of 6 etchings
SHEET: 13¾ × 16¼" (34.9 × 41.3 cm)
PLATE: 9 × 11¾" (22.9 × 29.9 cm)
INSCRIPTIONS: Signed and dated in pencil, lower right: Red Grooms
'94; numbered in pencil, lower left; printer's chop, lower right.
EDITION: 30
PROOFS: 8 AP, 1 BAT, 1 HC, 4 PP
PUBLISHER: Pace Editions, Inc., New York
PRINTER: Aldo Crommelynck, New York
COMMENTS: Series includes *Underground Platforms, Commodore
Vanderbilt, Self-Portrait, Grand Central, Portrait of A. C.,* and *Train
2007*. Anecdotal reflections on the Artist's experience in realizing
the print *Main Concourse, Grand Central Terminal*, 1994.

148. *Commodore Vanderbilt* 1994

Etching and aquatint in one color on Hahnemuhle paper, from *The
Main Concourse, Grand Central Terminal and Other Thoughts on
Trains and Engravings* series of 6 etchings
SHEET: 13¾ × 16¼" (34.9 × 41.3 cm)

PLATE: 9 × 11¾" (22.9 × 29.9 cm)
INSCRIPTIONS: Signed and dated in pencil, lower right: *Red Grooms*
'94; numbered in pencil, lower left; printer's chop, lower right.
EDITION: 30
PROOFS: 8 AP, 1 BAT, 1 HC, 4 PP
PUBLISHER: Pace Editions, Inc., New York
PRINTER: Aldo Crommelynck, New York
COMMENTS: Series includes *Underground Platforms, Commodore
Vanderbilt, Self Portrait, Grand Central, Portrait of A. C.,* and *Train
2007*. Anecdotal reflections on the Artist's experience in realizing
the print, *Main Concourse, Grand Central Terminal*, 1994.

149. *Self-Portrait* 1994

Etching and aquatint in one color on Hahnemuhle paper, from *The
Main Concourse, Grand Central Terminal and Other Thoughts on
Trains and Engravings* series of 6 etchings
SHEET: 13¾ × 16¼" (34.9 × 41.3 cm)
PLATE: 9 × 11¾" (22.9 × 29.9 cm)
INSCRIPTIONS: Signed and dated in pencil, lower right: *Red Grooms*
'94; numbered in pencil, lower left; printer's chop, lower right.
EDITION: 30
PROOFS: 8 AP, 1 BAT, 1 HC, 4 PP
PUBLISHER: Pace Editions, Inc., New York
PRINTER: Aldo Crommelynck, New York
COMMENTS: Series includes *Underground Platforms, Commodore
Vanderbilt, Self Portrait, Grand Central, Portrait of A. C.,* and *Train
2007*. Anecdotal reflections on the Artist's experience in realizing
the print, *Main Concourse, Grand Central Terminal*, 1994.

150. *Grand Central* 1994

Etching and aquatint in one color on Hahnemuhle paper, from *The
Main Concourse, Grand Central Terminal and Other Thoughts on
Trains and Engravings* series of 6 etchings
SHEET: 13¾ × 16¼" (34.9 × 41.3 cm)
PLATE: 9 × 11¾" (22.9 × 29.9 cm)
INSCRIPTIONS: Signed and dated in pencil, lower right: *Red Grooms*
'94; numbered in pencil, lower left; printer's chop, lower right.
EDITION: 30
PROOFS: 8 AP, 1 BAT, 1 HC, 4 PP
PUBLISHER: Pace Editions, Inc., New York
PRINTER: Aldo Crommelynck, New York
COMMENTS: Series includes *Underground Platforms, Commodore
Vanderbilt, Self Portrait, Grand Central, Portrait of A. C.,* and *Train
2007*. Anecdotal reflections on the Artist's experience in realizing
the print, *Main Concourse, Grand Central Terminal*, 1994.

151. *Portrait of A.C.* 1994

Etching and aquatint in one color on Hahnemuhle paper, from *The
Main Concourse, Grand Central Terminal and Other Thoughts on
Trains and Engravings* series of 6 etchings
SHEET: 13¾ × 16¼" (34.9 × 41.3 cm)
PLATE: 9 × 11¾" (22.9 × 29.9 cm)
INSCRIPTIONS: Signed and dated in pencil, lower right: *Red Grooms*
'94; numbered in pencil, lower left; printer's chop, lower right.
EDITION: 30
PROOFS: 8 AP, 1 BAT, 1 HC, 4 PP
PUBLISHER: Pace Editions, Inc., New York
PRINTER: Aldo Crommelynck, New York
COMMENTS: The subject is Aldo Crommelynck. Series includes
*Underground Platforms, Commodore Vanderbilt, Self Portrait,
Grand Central, Portrait of A. C.,* and *Train 2007*. Anecdotal reflec-
tions on the Artist's experience in realizing the print, *Main
Concourse, Grand Central Terminal*, 1994.

152. *Train 2007* 1994

Etching and aquatint in one color on Hahnemuhle paper, from *The Main Concourse, Grand Central Terminal and Other Thoughts on Trains and Engravings* series of 6 etchings

SHEET: 16¼ × 13¾″ (41.3 × 34.9 cm)

PLATE: 11¾ × 9″ (29.9 × 22.9 cm)

INSCRIPTIONS: Signed and dated in pencil, lower right: *Red Grooms '94*; numbered in pencil, lower left; printer's chop, lower right.

EDITION: 30

PROOFS: 8 AP, 1 BAT, 1 HC, 4 PP

PUBLISHER: Pace Editions, Inc., New York

PRINTER: Aldo Crommelynck, New York

COMMENTS: Series includes *Underground Platforms, Commodore Vanderbilt, Self Portrait, Grand Central, Portrait of A. C.,* and *Train 2007.* Anecdotal reflections on the Artist's experience in realizing the print, *Main Concourse, Grand Central Terminal,* 1994. The subject in lower left is Don Nelson, President of Metro North, New York. He was one of the people responsible for the exhibition at Grand Central Terminal, March–May 1993.

153. *Rockefeller Center* 1995

Offset lithograph in thirteen colors on Somerset soft 300 gm paper

SHEET: 41¼ × 27½″ (104.8 × 69.9 cm)

IMAGE: 36½ × 23½″ (92.7 × 59.7 cm)

INSCRIPTIONS: Signed and dated in pencil, lower right: *Red Grooms '95*; numbered in pencil, lower left.

EDITION: 75

PROOFS: 15 AP, 5 HC, 5 PP, 2 WSP

PUBLISHER: Marlborough Graphics, New York

PRINTERS: J. Miller, Maurice Sanchez; Derriere L'etoile Studios, New York

COMMENTS: Same image as *Rockefeller Center,* 1995, a mixed media 60¼ × 56¼ × 28¼″ (153 × 143 × 71.8 cm).

154. *Train to Potsdam* 1995

Woodcut in four colors on rice paper

SHEET: 28 × 22″ (71.1 × 55.9 cm)

IMAGE: 25¾ × 19¾″ (65.4 × 50.2 cm)

INSCRIPTIONS: Signed and dated in black colored pencil, lower right: *Red Grooms '95*; numbered in black colored pencil, lower left.

EDITION: 15

PUBLISHERS: The Artist & Lysiane Luong, New York

PRINTER: The Artist & Lysiane Luong, New York

COMMENTS: Print was produced to promote the exhibition of the *Ruckus Subway Car,* at the Film Museum, Potsdam, Germany. For poster edition, see Section III.

155. *Times Square* 1995

Three-dimensional color lithograph on Rives BFK paper, cut out, glued, and mounted in Plexiglas case

CASE: 27⅛ × 21⅜ × 8 ³⁄₁₆″ (68.9 × 54.3 × 20.8 cm)

IMAGE: 24 × 17⅜ × 5½″ (61.0 × 44.1 × 14.0 cm)

INSCRIPTIONS: Signed and dated in black colored pencil, lower center: *Red Grooms '95*; numbered in black colored pencil, lower center.

EDITION: 75

PROOFS: 1 A, 10 AP, 1 BAT, 5 PP, 5 TP, 5 WSP

PUBLISHERS: Red Grooms and Shark's Incorporated, Boulder, Colorado

PRINTER: Bud Shark, Shark's Incorporated, Boulder, Colorado, assisted by Matthew Christie, assembled by Roseanne Colachis

COMMENTS: Produced on eleven plates, six colors on two sheets.

156. *Flatiron Building* 1996

Etching, soft ground and aquatint in five colors on Somerset textured paper with hand-torn deckle edges

SHEET: 45 × 26″ (114.3 × 66.0 cm)

PLATE: 36 × 18″ (91.4 × 45.7 cm)

INSCRIPTIONS: Signed and dated in pencil, lower right: *Red Grooms '95*; numbered in pencil, lower left.

EDITION: 75

PROOFS: 12 AP, 1 BAT, 2 HC, 6 PP

PUBLISHER: Marlborough Graphics, New York

PRINTERS: Carol Weaver and Felix Harlan; Harlan & Weaver Inc., New York

COMMENTS: Same image as *Flatiron Building,* 1995, mixed media 81 × 45 × 24½″ (205.7 × 114.3 × 62.2 cm).

157. *Macy's Thanksgiving Day Parade* 1995 (published in 1996)

Etching and aquatint in four colors on Somerset textured paper with hand-torn deckle edges

SHEET: 20¾ × 26″ (52.7 × 66.0 cm)

PLATE: 12 × 18″ (30.5 × 45.7 cm)

INSCRIPTIONS: Signed and dated in pencil, lower right: *Red Grooms '95*; numbered in pencil, lower left.

EDITION: 35

PROOFS: 10 AP, 5 PP, 1 WP

PUBLISHER: Marlborough Graphics, New York

PRINTERS: Carol Weaver and Felix Harlan; Harlan & Weaver Inc., New York

COMMENTS: All plates wiped with ball tarlatan and palm. Sometimes referred to as *Macy's Day Parade,* the Artist prefers *Macy's Thanksgiving Day Parade.*

158. *Hallelujah Hall* 1995 (published in 1996)

Etching, aquatint, and sugarlift, spit-bite in one color on Somerset textured 300 gm paper, from *New York Sweet* portfolio of 5 prints

SHEET: 17½ × 20½″ (44.5 × 52.1 cm)

PLATE: 9 × 12½″ (22.9 × 31.8 cm)

INSCRIPTIONS: Signed and dated in pencil, lower right: *Red Grooms '95*; numbered in pencil, lower left.

EDITION: 30

PROOFS: 10 AP, 2 HC, 5 PP, 2 WP

PUBLISHER: Marlborough Graphics, New York

PRINTERS: Carol Weaver and Felix Harlan; Harlan & Weaver Inc., New York, assisted by Todd Elkin

COMMENTS: The title page and colophon page were designed by the Artist and Leslie Miller, and printed at the Grenfell Press, New York. The edition consists of 30 suites: 1–12 are presented in a handmade red fabric-covered portfolio box, 13–30 are loose. Series includes *Hallelujah Hall, Piebald Blue, Tootin' Tug, Down Under,* and *Graveyard Ruckus.*

159. *Piebald Blue* 1995 (published in 1996)

Etching, roulette, aquatint, and drypoint in two colors on Somerset textured 300 gm paper, from *New York Sweet* portfolio of 5 prints

SHEET: 20½ × 17½″ (52.1 × 44.5 cm)

PLATE: 12½ × 9″ (31.8 × 22.9 cm)

INSCRIPTIONS: Signed and dated in pencil, lower right: *Red Grooms '95*; numbered in pencil, lower left.

EDITION: 30

PROOFS: 10 AP, 2 HC, 5 PP, 2 WP

PUBLISHER: Marlborough Graphics, New York

PRINTERS: Carol Weaver and Felix Harlan; Harlan & Weaver Inc., New York, assisted by Todd Elkin

COMMENTS: The title page and colophon page were designed by the Artist and Leslie Miller, and printed at the Grenfell Press, New York. The edition consists of 30 suites: 1–12 are presented in a handmade red fabric-covered portfolio box, 13–30 are loose. Series includes *Hallelujah Hall, Piebald Blue, Tootin' Tug, Down Under,* and *Graveyard Ruckus.*

160. *Tootin' Tug* 1995 (published in 1996)

Etching, roulette, and aquatint in two colors on Somerset textured 300 gm paper, from *New York Sweet* portfolio of 5 prints
SHEET: 17½ × 20½″ (44.5 × 52.1 cm)
PLATE: 9 × 12½″ (22.9 × 31.8 cm)
INSCRIPTIONS: Signed and dated in pencil, lower right: *Red Grooms '95*; numbered in pencil, lower left.
EDITION: 30
PROOFS: 10 AP, 2 HC, 5 PP, 2 WP
PUBLISHER: Marlborough Graphics, New York
PRINTERS: Carol Weaver and Felix Harlan; Harlan & Weaver Inc., New York, assisted by Todd Elkin
COMMENTS: The title page and colophon page were designed by the Artist and Leslie Miller, and printed at the Grenfell Press, New York. The edition consists of 30 suites: 1–12 are presented in a hand made red fabric covered portfolio box, 13–30 are loose. Series includes *Hallelujah Hall, Piebald Blue, Tootin' Tug, Down Under,* and *Graveyard Ruckus*

161. *Down Under* 1995 (published in 1996)

Aquatint and sugarlift in two colors on Somerset textured 300 gm paper, from *New York Sweet* portfolio of 5 prints
SHEET: 20½ × 17½″ (52.1 × 44.5 cm)
PLATE: 12 × 9″ (30.5 × 22.9 cm)
INSCRIPTIONS: Signed and dated in pencil, lower right: *Red Grooms '95*; numbered in pencil, lower left.
EDITION: 30
PROOFS: 10 AP, 2 HC, 5 PP, 2 WP
PUBLISHER: Marlborough Graphics, New York
PRINTERS: Carol Weaver and Felix Harlan; Harlan & Weaver Inc., New York, assisted by Todd Elkin
COMMENTS: The title page and colophon page were designed by the Artist and Leslie Miller, and printed at the Grenfell Press, New York. The edition consists of 30 suites: 1–12 are presented in a handmade red fabric-covered portfolio box, 13–30 are loose. Series includes *Hallelujah Hall, Piebald Blue, Tootin' Tug, Down Under,* and *Graveyard Ruckus.*

162. *Graveyard Ruckus* 1995 (published in 1996)

Drypoint, etching, sugarlift, and aquatint in one color on Somerset textured 300 gm paper, from *New York Sweet* portfolio of 5 prints
SHEET: 17½ × 20½″ (44.5 × 52.1 cm)
PLATE: 9 × 12½″ (22.9 × 31.8 cm)
INSCRIPTIONS: Signed and dated in pencil, lower right: *Red Grooms '95*; numbered in pencil, lower left.
EDITION: 30
PROOFS: 10 AP, 2 HC, 5 PP, 2 WP
PUBLISHER: Marlborough Graphics, New York
PRINTERS: Carol Weaver and Felix Harlan; Harlan & Weaver Inc., New York, assisted by Todd Elkin
COMMENTS: The title page and colophon page were designed by the Artist and Leslie Miller, and printed at the Grenfell Press, New York. The edition consists of 30 suites: 1–12 are presented in a hand made red fabric covered portfolio box, 13–30 are loose. Series includes *Hallelujah Hall, Piebald Blue, Tootin' Tug, Down Under,* and *Graveyard Ruckus.*

163. *Les Baigneuses after Picasso* 1996

Stencil in nine colors, Krylon spray paint on Japanese Mulberry paper
SHEET: 29½ × 23½″ (74.9 × 59.7 cm)
IMAGE: 24 × 18¾″ (61.0 × 47.6 cm)
INSCRIPTIONS: Signed and dated in black colored pencil, lower right: *Red Grooms '96*; numbered in black colored pencil, lower left.
EDITION: 12
PROOFS: 1 PP, 2 TP
PUBLISHER: The Artist
PRINTER: Tom Burckhardt, New York
COMMENTS: Same image as *Ladies Sunbathing*, Biarritz, France, 1996, watercolor 28½ × 22⅜″ (72.4 × 56.8 cm).

164. *Balcony* 1996

Lithograph in five colors on Rives BFK paper, from a series of 4 miniature prints, a marginalia
SHEET: 3½ × 2½″ (8.9 × 6.4 cm) irregular
IMAGE: 2 × 1½″ (5.1 × 3.8 cm)
INSCRIPTIONS: Signed in red pencil, lower right: *Red Grooms*; numbered in red pencil, lower left.
EDITION: 75
PUBLISHER: TWO ONE TWO Inc., New York
PRINTER: Bud Shark, Shark's Incorporated, Boulder, Colorado, assisted by Matthew Christie
COMMENTS: Series includes *Balcony, Dappled Gray, Olympia,* and *Rover*, each framed by Lysiane Luong. Produced in the margin of *Times Square,* 1996.

165. *Dappled Gray* 1996

Lithograph in five colors on Rives BFK paper, from a series of 4 miniature prints, a marginalia
SHEET: 3½ × 2½″ (8.9 × 6.4 cm) irregular
IMAGE: 2¼ × 2⅞″ (5.7 × 7.3 cm) oblong
INSCRIPTIONS: Signed in red pencil, lower center: *Red Grooms*, numbered in red pencil, lower left.
EDITION: 75
PUBLISHER: TWO ONE TWO Inc., New York
PRINTER: Bud Shark, Shark's Incorporated, Boulder, Colorado, assisted by Matthew Christie
COMMENTS: Series includes *Balcony, Dappled Gray, Olympia,* and *Rover*, each framed by Lysiane Luong. Produced in the margin of *Times Square,* 1996.

166. *Olympia* 1996

Lithograph in five colors on Rives BFK paper, from a series of 4 miniature prints, a marginalia
SHEET: 2 × 3″ (5.1 × 7.6 cm)
IMAGE: 1⅝ × 2⅜″ (4.1 × 6.1 cm)
INSCRIPTIONS: Signed in red pencil, lower right: *Red Grooms*; numbered in red pencil, lower left.
EDITION: 75
PUBLISHER: TWO ONE TWO Inc., New York
PRINTER: Bud Shark, Shark's Incorporated, Boulder, Colorado, assisted by Matthew Christie
COMMENTS: Series includes *Balcony, Dappled Gray, Olympia,* and *Rover*, each framed by Lysiane Luong. Produced in the margin of *Times Square,* 1996.

167. *Rover* 1996

Lithograph in five colors on Rives BFK paper, from a series of 4 miniature prints, a marginalia
SHEET: 2½ × 2¾″ (6.4 × 7.0 cm)

IMAGE: 2 × 1⅝″ (4.1 × 4.1 cm)
INSCRIPTIONS: Signed in red pencil, lower center: *Red Grooms*; numbered in red pencil, lower left.
EDITION: 75
PUBLISHER: TWO ONE TWO Inc., New York
PRINTER: Bud Shark, Shark's Incorporated, Boulder, Colorado, assisted by Matthew Christie
COMMENTS: Series includes *Balcony, Dappled Gray, Olympia,* and *Rover,* each framed by Lysiane Luong. Produced in the margin of *Times Square,* 1996.

168. *Picasso* 1997

Three-dimensional color lithograph on Rives BFK paper, cut out, glued, and mounted in Plexiglas case
CASE: 22⁷⁄₁₆ × 23⅜ × 13⅜″ (57.0 × 59.4 × 34.0 cm)
IMAGE: 20¾ × 21¾ × 12¼″ (52.7 × 55.3 × 31.1 cm)
INSCRIPTIONS: Signed and dated in black colored pencil, bottom left front: *Red Grooms '97*; numbered in black colored pencil, bottom left front.
EDITION: 75
PROOFS: 1 A, 10 AP, 1 BAT, 5 PP, 4 TP, 5 WSP
PUBLISHER: Red Grooms and Shark's Incorporated, Boulder, Colorado
PRINTER: Bud Shark, Shark's Incorporated, Boulder, Colorado, assisted by Matthew Christie, assembled by Roseanne Colachis, and assisted by Lisa Merrin and Barbara Shark
COMMENTS: Produced from ten plates, six colors on two sheets.

169. *Tennessee Fox Trot Carousel* 1997

Three-dimensional color lithograph on Rives BFK paper, cut out, glued, and mounted in Plexiglas case
CASE: 17 × 18⅜ × 18⅜″ (43.2 × 46.7 × 46.7cm)
IMAGE: 16⅜ × 14¼ × 14½″ (41.6 × 36.2 × 36.8 cm)
INSCRIPTIONS: Signed and dated in red colored pencil, on base: *Red Grooms*; numbered in red colored pencil, on base.
EDITION: 25
PROOFS: 1 A, 6 AP, 1 BAT, 1 Patron Impression, 3 PP, 4 TP, 3 WSP
PUBLISHER: The Tennessee Fox Trot Carousel Committee, Nashville, Tennessee
PRINTER: Bud Shark, Shark's Incorporated, Boulder, Colorado, assisted by Matthew Christie, assembled by Roseanne Colachis
COMMENTS: A certain number were produced for the donors of the *Tennessee Fox Trot Carousel,* Nashville, Tennessee. Produced from fourteen plates, eight colors on two sheets.

170. *Tennessee Fox Trot Carousel Portfolio Cover* 1997

Lithograph in eight colors on Rives BFK paper, a marginalia
SHEET: 12 × 10″ (30.5 × 25.4 cm)
IMAGE: 10¼ × 8⅜″ (26.0 × 21.3 cm)
EDITION: 40
PROOFS: 1 A, 8 AP, 1 BAT, 3 PP, 2 TP, 3 WSP
PUBLISHER: The Tennessee Fox Trot Carousel Committee, Nashville, Tennessee
PRINTER: Bud Shark's Incorporated Boulder, Colorado. Cut and folded by Roseanne Colachis
COMMENTS: A certain number were produced for the benefit of the *Tennessee Fox Trot Carousel,* Nashville, Tennessee. The cover of the portfolio *Tennessee Fox Trot Carousel.* This marginalia was done in the margin of sheet 2 of the three-dimensional, *Tennessee Fox Trot Carousel,* 1997.

171. *William Strickland* 1997

Lithograph in six colors on Rives BFK paper, from *Tennessee Fox Trot Carousel,* a portfolio of 9 prints

SHEET: 11⅞ × 9⅞″ (30.2 × 25.1 cm)
IMAGE: 11⅞ × 9⅞″ (30.2 × 25.1 cm)
INSCRIPTIONS: Signed and dated in red colored pencil, lower right: *Red Grooms '97*; numbered in red colored pencil, lower left.
EDITION: 40
PROOFS: 1 A, 8 AP, 1 BAT, 3 PP, 2 TP, 3 WSP
PUBLISHER: The Tennessee Fox Trot Carousel Committee, Nashville, Tennessee
PRINTER: Bud Shark, Shark's Incorporated, Boulder, Colorado, assisted by Matthew Christie
COMMENTS: A certain number were produced for the benefit of the *Tennessee Fox Trot Carousel,* Nashville, Tennessee. Portfolio includes *William Strickland, Cornelia Clark-Fort, Charlie Soong, Lula Naff, Leroy Carr, Hot-Dog Horse, Eugene Lewis, Andrew Jackson,* and *Davy Crockett.* All nine prints were done on the same sheet.

172. *Cornelia Clark-Fort* 1997

Lithograph in six colors on Rives BFK paper, from *Tennessee Fox Trot Carousel,* a portfolio of 9 prints
SHEET: 11⅞ × 9⅞″ (30.2 × 25.1 cm)
IMAGE: 11⅞ × 9⅞″ (30.2 × 25.1 cm)
INSCRIPTIONS: Signed and dated in red colored pencil, lower right: *Red Grooms '97*; numbered in red colored pencil, lower left.
EDITION: 40
PROOFS: 1 A, 8 AP, 1 BAT, 3 PP, 2 TP, 3 WSP
PUBLISHER: The Tennessee Fox Trot Carousel Committee, Nashville, Tennessee
PRINTER: Bud Shark, Shark's Incorporated, Boulder, Colorado, assisted by Matthew Christie
COMMENTS: A certain number were produced for the benefit of the *Tennessee Fox Trot Carousel,* Nashville, Tennessee. Portfolio includes *William Strickland, Cornelia Clark-Fort, Charlie Soong, Lula Naff, Leroy Carr, Hot-Dog Horse, Eugene Lewis, Andrew Jackson,* and *Davy Crockett.* All nine prints were done on the same sheet.

173. *Charlie Soong* 1997

Lithograph in six colors on Rives BFK paper, from *Tennessee Fox Trot Carousel,* a portfolio of 9 prints
SHEET: 11⅞ × 9⅞″ (30.2 × 25.1 cm)
IMAGE: 11⅞ × 9⅞″ (30.2 × 25.1 cm)
INSCRIPTIONS: Signed and dated in red colored pencil, lower right: *Red Grooms '97*; numbered in red colored pencil, lower left.
EDITION: 40
PROOFS: 1 A, 8 AP, 1 BAT, 3 PP, 2 TP, 3 WSP
PUBLISHER: The Tennessee Fox Trot Carousel Committee, Nashville, Tennessee
PRINTER: Bud Shark, Shark's Incorporated, Boulder, Colorado, assisted by Matthew Christie
COMMENTS: A certain number were produced for the benefit of the *Tennessee Fox Trot Carousel,* Nashville, Tennessee. Portfolio includes *William Strickland, Cornelia Clark-Fort, Charlie Soong, Lula Naff, Leroy Carr, Hot-Dog Horse, Eugene Lewis, Andrew Jackson,* and *Davy Crockett.* All nine prints were done on the same sheet.

174. *Lula Naff* 1997

Lithograph in six colors on Rives BFK paper, from *Tennessee Fox Trot Carousel,* a portfolio of 9 prints
SHEET: 11⅞ × 9⅞″ (30.2 × 25.1 cm)
IMAGE: 11⅞ × 9⅞″ (30.2 × 25.1 cm)
INSCRIPTIONS: Signed and dated in red colored pencil, lower right: *Red Grooms '97*; numbered in red colored pencil, lower left.

EDITION: 40
PROOFS: 1 A, 8 AP, 1 BAT, 3 PP, 2 TP, 3 WSP
PUBLISHER: The Tennessee Fox Trot Carousel Committee, Nashville, Tennessee
PRINTER: Bud Shark, Shark's Incorporated, Boulder, Colorado, assisted by Matthew Christie
COMMENTS: A certain number were produced for the benefit of the *Tennessee Fox Trot Carousel*, Nashville, Tennessee. Portfolio includes *William Strickland, Cornelia Clark-Fort, Charlie Soong, Lula Naff, Leroy Carr, Hot-Dog Horse, Eugene Lewis, Andrew Jackson*, and *Davy Crockett*. All nine prints were done on the same sheet.

175. *Leroy Carr* 1997

Lithograph in six colors on Rives BFK paper, from *Tennessee Fox Trot Carousel*, a portfolio of 9 prints
SHEET: 11⅞ × 9⅞" (30.2 × 25.1 cm)
IMAGE: 11⅞ × 9⅞" (30.2 × 25.1 cm)
INSCRIPTIONS: Signed and dated in red colored pencil, lower right: *Red Grooms '97*; numbered in red colored pencil, lower left.
EDITION: 40
PROOFS: 1 A, 8 AP, 1 BAT, 3 PP, 2 TP, 3 WSP
PUBLISHER: The Tennessee Fox Trot Carousel Committee, Nashville, Tennessee
PRINTER: Bud Shark, Shark's Incorporated, Boulder, Colorado, assisted by Matthew Christie
COMMENTS: A certain number were produced for the benefit of the *Tennessee Fox Trot Carousel*, Nashville, Tennessee. Portfolio includes *William Strickland, Cornelia Clark-Fort, Charlie Soong, Lula Naff, Leroy Carr, Hot-Dog Horse, Eugene Lewis, Andrew Jackson*, and *Davy Crockett*. All nine prints were done on the same sheet.

176. *Hot Dog Horse* 1997

Lithograph in six colors on Rives BFK paper, from *Tennessee Fox Trot Carousel*, a portfolio of 9 prints
SHEET: 11⅞ × 9⅞" (30.2 × 25.1 cm)
IMAGE: 11⅞ × 9⅞" (30.2 × 25.1 cm)
INSCRIPTIONS: Signed and dated in red colored pencil, lower left center: *Red Grooms '97*; numbered in red colored pencil, lower left.
EDITION: 40
PROOFS: 1 A, 8 AP, 1 BAT, 3 PP, 2 TP, 3 WSP
PUBLISHER: The Tennessee Fox Trot Carousel Committee, Nashville, Tennessee
PRINTER: Bud Shark, Shark's Incorporated, Boulder, Colorado, assisted by Matthew Christie
COMMENTS: A certain number were produced for the benefit of the *Tennessee Fox Trot Carousel*, Nashville, Tennessee. Portfolio includes *William Strickland, Cornelia Clark-Fort, Charlie Soong, Lula Naff, Leroy Carr, Hot-Dog Horse, Eugene Lewis, Andrew Jackson*, and *Davy Crockett*. All nine prints were done on the same sheet.

177. *Eugene Lewis* 1997

Lithograph in six colors on Rives BFK paper, from *Tennessee Fox Trot Carousel*, a portfolio of 9 prints
SHEET: 11⅞ × 9⅞" (30.2 × 25.1 cm)
IMAGE: 11⅞ × 9⅞" (30.2 × 25.1 cm)
INSCRIPTIONS: Signed and dated in red colored pencil, lower right: *Red Grooms '97*; numbered in red colored pencil, lower left.
EDITION: 40
PROOFS: 1 A, 8 AP, 1 BAT, 3 PP 2 TP, 3 WSP
PUBLISHER: The Tennessee Fox Trot Carousel Committee, Nashville, Tennessee

PRINTER: Bud Shark, Shark's Incorporated, Boulder, Colorado, assisted by Matthew Christie
COMMENTS: A certain number were produced for the benefit of the *Tennessee Fox Trot Carousel*, Nashville, Tennessee. Portfolio includes *William Strickland, Cornelia Clark-Fort, Charlie Soong, Lula Naff, Leroy Carr, Hot-Dog Horse, Eugene Lewis, Andrew Jackson*, and *Davy Crockett*. All nine prints were done on the same sheet.

178. *Andrew Jackson* 1997

Lithograph in six colors on Rives BFK paper, from *Tennessee Fox Trot Carousel*, a portfolio of 9 prints
SHEET: 11⅞ × 9⅞" (30.2 × 25.1 cm)
IMAGE: 11⅞ × 9⅞" (30.2 × 25.1 cm)
INSCRIPTIONS: Signed and dated in red colored pencil, lower right: *Red Grooms '97*; numbered in red colored pencil, lower left.
EDITION: 40
PROOFS: 1 A, 8 AP, 1 BAT, 3 PP 2 TP, 3 WSP
PUBLISHER: The Tennessee Fox Trot Carousel Committee, Nashville, Tennessee
PRINTER: Bud Shark, Shark's Incorporated, Boulder, Colorado, assisted by Matthew Christie
COMMENTS: A certain number were produced for the benefit of the *Tennessee Fox Trot Carousel*, Nashville, Tennessee. Portfolio includes *William Strickland, Cornelia Clark-Fort, Charlie Soong, Lula Naff, Leroy Carr, Hot-Dog Horse, Eugene Lewis, Andrew Jackson*, and *Davy Crockett*. All nine prints were done on the same sheet.

179. *Davy Crockett* 1997

Lithograph in six colors on Rives BFK paper, from *Tennessee Fox Trot Carousel*, a portfolio of 9 prints
SHEET: 11⅞ × 9⅞" (30.2 × 25.1 cm)
IMAGE: 11⅞ × 9⅞" (30.2 × 25.1 cm)
INSCRIPTIONS: Signed and dated in red colored pencil, lower right: *Red Grooms '97*; numbered in red colored pencil, lower left.
EDITION: 40
PROOFS: 1 A, 8 AP, 1 BAT, 3 PP 2 TP, 3 WSP
PUBLISHER: The Tennessee Fox Trot Carousel Committee, Nashville, Tennessee
PRINTER: Bud Shark, Shark's Incorporated, Boulder, Colorado, assisted by Matthew Christie
COMMENTS: A certain number were produced for the benefit of the *Tennessee Fox Trot Carousel*, Nashville, Tennessee. Portfolio includes *William Strickland, Cornelia Clark-Fort, Charlie Soong, Lula Naff, Leroy Carr, Hot-Dog Horse, Eugene Lewis, Andrew Jackson*, and *Davy Crockett*. All nine prints were done on the same sheet.

180. *Western Pals* 1997

Lithograph in six colors on Rives BFK paper, a marginalia
SHEET: 8½ × 12½" (21.6 × 31.8 cm)
IMAGE: 4½ × 9" (11.4 × 22.9 cm)
INSCRIPTIONS: Signed and dated in red colored pencil, lower right: *Red Grooms '97*; numbered in red colored pencil, lower left.
EDITION: 40
PROOFS: 1 A, 8 AP, 1 BAT, 3 PP 2 TP, 3 WSP
PUBLISHERS: Red Grooms and Shark's Incorporated, Boulder, Colorado
PRINTER: Bud Shark, Shark's Incorporated, Boulder, Colorado, assisted by Matthew Christie
COMMENTS: Same image as *Western Pals*, 1966, acrylic on plywood, two parts, 17 × 22½" (43.2 × 57.2 cm) and 13½ × 13½" (34.3 × 34.3 cm) irregular. Produced in the margin of *Tennessee Fox Trot Carousel*.

181. **Toad Hall** 1997

Lithograph in six colors on Rives BFK paper, a marginalia
SHEET: 8½ × 9¼″ (21.6 × 23.5 cm)
IMAGE: 5 × 5¾″ (12.7 × 14.6 cm)
INSCRIPTIONS: Signed in red pencil, lower right: *Red Grooms '97*,
 numbered in red pencil, lower left.
EDITION: 40
PROOFS: 1 A, 6 AP, 1 BAT, 3 PP 2 TP, 3 WSP
PUBLISHER: The Artist
PRINTER: Bud Shark, Shark's Incorporated, Boulder, Colorado, assist-
 ed by Matthew Christie
COMMENTS: Produced in the margin of *Tennessee Fox Trot Carousel*
 portfolio, 1997.

182. **Samurai** 1997

Lithograph in six colors on Rives BFK paper, a marginalia
SHEET: 8½ × 8⅜″ (21.6 × 22.0 cm)
IMAGE: 4 × 4″ (10.2 × 10.2 cm)
INSCRIPTIONS: Signed and dated in red colored pencil, lower right:
 Red Grooms '97, numbered in red colored pencil, lower left.
EDITION: 40
PROOFS: 1 A, 8 AP, 1 BAT, 3 PP, 2 TP, 3 WSP
PUBLISHERS: Red Grooms and Shark's Incorporated, Boulder,
 Colorado
PRINTER: Bud Shark, Shark's Incorporated, Boulder, Colorado
COMMENTS: Produced in the margin of *Tennessee Fox Trot Carousel*
 portfolio, 1997.

183. **To The Lighthouse** 1997

Etching, soft ground and aquatint in five colors on Hahnemuhle paper
SHEET: 22 × 20″ (55.9 × 50.8 cm)
PLATE: 14⅞ × 14⅞″ (37.8 × 37.8 cm)
INSCRIPTIONS: Signed and dated in pencil, lower right: *Red Grooms
 '97*; numbered in pencil, lower left; inscribed in pencil, lower center:
 "TO THE LIGHTHOUSE," printer's chop, lower left.
EDITION: 50
PROOFS: 10 AP (Roman Numerals), 1 BAT, 8 HC, 3 PP, 4 SP
PUBLISHER: Pace Editions, Inc., New York
PRINTERS: Aldo Crommelynck, Bill Hall, Clemens Buntig, New York

184. **Nijinsky** 1997

Stencil in six colors, Krylon spray paint on Japanese Mulberry paper
SHEET: 18¼ × 31¾″ (46.4 × 80.7 cm)
IMAGE: 15½ × 29½″ (39.4 × 74.9 cm)
INSCRIPTIONS: Signed in blue colored pencil lower right: *Red
 Grooms '97*; numbered in blue colored pencil, lower left.
EDITION: 12
PROOFS: 2 AP, 2 PP
PUBLISHER: TWO ONE TWO, Inc., New York
PRINTER: Tom Burckhardt, New York
COMMENTS: Printed in the Artist's studio in New York.

185. **Empire State Building** 1997

Three-dimensional silkscreen in forty-two colors, on wood, mounted
on one sheet of scored and crease folded aluminum contained in
custom modular framework
FRAME: 13 × 14¼ × 2¾″ (33 × 36.2 × 7.0 cm)
IMAGE: 13 × 14¼ × 2¾″ (33 × 36.2 × 7.0 cm)
INSCRIPTIONS: Brass plaque on back
 "The Empire State Building" by Red Grooms, 1997
 Produced and Published by AKASHA: Minneapolis, MN-1997
 All rights reserved: AKASHA-1997
 Copyright: Red Grooms-1997 This is copy: 4/75

EDITION: 75
PROOFS: 12 AP, 1 BAT, 5 PC, 4 PP, 3 TP
PUBLISHER: AKASHA Studio, Minneapolis, Minnesota
PRINTER: Steven M. Andersen, AKASHA Studio, Minneapolis,
 Minnesota; assisted by Matthew Bergen, Jeffery J. Andersen,
 Timothy McClellan, and Melinda Knell

186. **Jackson in Action** 1997

Three-dimensional color lithograph on Rives BFK paper, cut out,
glued, and mounted in Plexiglas case
CASE: 26 × 33 × 7¼″ (66.0 × 83.8 × 18.4 cm)
IMAGE: 24½ × 30 × 6″ (62.2 × 76.2 × 15.2 cm)
INSCRIPTIONS: Signed and dated in blue colored pencil, lower right:
 Red Grooms '97; numbered in blue colored pencil, lower left.
EDITION: 75
PROOFS: 1 A, 10 AP, 1 BAT, 1 Patron Impression, 5 PP, 1 TP, 5 WSP
PUBLISHERS: Red Grooms and Shark's Incorporated, Lyons,
 Colorado
PRINTER: Bud Shark, Shark's Incorporated, Lyons, Colorado, assisted
 by Matthew Christie; assembled by Roseanne Colachis
COMMENTS: Produced from fourteen plates, fourteen colors on two
 sheets.

187. **Katherine, Marcel and the Bride** 1998

A multiple of 130 colors, three-dimensional silkscreens on plywood,
Lexan, cast polyester resin, steel, and copper
SHEET: 44 × 35½ × 5¼″ (111.8 × 90.2 × 13.3 cm)
IMAGE: 44 × 35½ × 5¼″ (111.8 × 90.2 × 13.3 cm)
INSCRIPTIONS: Signed in silver enamel paint, lower right under floor,
 numbered in brass plate on back.
EDITION: 48
PROOFS: 1 A, 8 AP, 1 BAT, 2 PC, 4 PP, 8 RTP
PUBLISHER: AKASHA Studio, Minneapolis, Minnesota
PRINTER: Steven M. Andersen, AKASHA Studio, Minneapolis,
 Minnesota; assisted by Matthew Bergen, Cole Rogers, Timothy
 McClellan and Melinda Knell.

188. **Pollock's Model A** 1998

Lithograph in eight colors on Rives BFK paper, a marginalia
SHEET: 13½ × 19¾″ (34.3 × 50.2 cm)
IMAGE: 12½ × 18½″ (31.8 × 47.0 cm)
INSCRIPTIONS: Signed in blue pencil, lower right: *Red Grooms '98*,
 numbered in blue pencil, lower left.
EDITION: 75
PROOFS: 1 A, 10 AP, 1 BAT, 1 Patron Impression, 5 PP, 1 TP, 5 WSP
PUBLISHERS: Red Grooms and Shark's Incorporated, Lyons, Colorado
PRINTER: Bud Shark, Shark's Incorporated, Lyons, Colorado
COMMENTS: Produced in the margin of *Jackson in Action,* 1997.

189. **Nymphs in a Bottle** 1998

Color lithograph on Rives BFK paper, a marginalia, a series of 3
small prints
SHEET: 7 × 5″ (17.8 × 12.7 cm)
IMAGE: 4⅞ × 3⅝″ (12.3 × 9.2 cm)
INSCRIPTIONS: Signed in purple pencil, lower right Center: *Red
 Grooms '98*, numbered in purple pencil, lower left center.
EDITION: 75
PROOFS: 9 AP
PUBLISHERS: Lysiane Luong and the Artist, New York
PRINTER: Bud Shark, Shark's Incorporated, Lyons, Colorado
COMMENTS: Series includes *Nymphs in a Bottle, Rover's Treasure,*
 and *Lunch on the Grass,* each framed by Lysiane Luong.
 Produced in the margin of *Tennessee Fox Trot Carousel,* 1997.

190. **Rover's Treasure** 1998

Color lithograph on Rives BFK paper, a marginalia, a series of 3
small prints
SHEET: 7⅜ × 5⅛" (18.7 × 12.9 cm)
IMAGE: 3¼ × 3" (8.3 × 7.6 cm)
INSCRIPTIONS: Signed in red pencil, lower right Center: *Red Grooms
 '98*, numbered in red pencil, lower left center.
EDITION: 75
PROOFS: 10 AP
PUBLISHERS: Lysiane Luong and the Artist, New York
PRINTER: Bud Shark, Shark's Incorporated, Lyons, Colorado
COMMENTS: Series includes *Nymphs in a Bottle*, *Rover's Treasure*,
 and *Lunch on the Grass*, each framed by Lysiane Luong.
 Produced in the margin of *Tennessee Fox Trot Carousel*, 1997.

191. **Lunch On The Grass** 1998

Color lithograph on Rives BFK paper, a marginalia, a series of 3
small prints
SHEET: 6¼ × 5⅛" (15.9 × 13.0 cm)
IMAGE: 3¾ × 4" (9.5 × 10.2 cm)
INSCRIPTIONS: Signed in green pencil, lower right: *Red Grooms '98*,
 numbered in green pencil, lower left.
EDITION: 75
PROOFS: 9 AP
PUBLISHERS: Lysiane Luong and the Artist, New York
PRINTER: Bud Shark, Shark's Incorporated, Lyons, Colorado
COMMENTS: Series includes *Nymphs in a Bottle*, *Rover's Treasure*,
 and *Lunch on the Grass*, each framed by Lysiane Luong.
 Produced in the margin of *Tennessee Fox Trot Carousel*, 1997.

192. **Liberty Front and Back** 1998

Color woodcut on rice paper
SHEET: 3⅜ × 5¾" (8.6 × 14.6 cm)
IMAGE: 1⅛ × 1⅜" (2.8x 3.5 cm)
INSCRIPTIONS: Signed in green pencil lower right Center: *Red
 Grooms '98*, numbered in green pencil, lower left center.
EDITION: 25
PROOFS: 5 AP, 2 PP, 2 WP
PUBLISHER: TWO, ONE, TWO, Inc., New York

PRINTER: Lysiane Luong and the Artist, New York

193. **Self-Portrait with Litho Pencil** 1999

Woodcut on Japanese paper.
SHEET: 30¼ × 20¼" (76.8 × 51.4 cm)
IMAGE: 23¾ × 18" (60.3 × 45.7 cm)
INSCRIPTIONS: Signed in pencil, lower right: *Red Grooms '99*, num-
 bered in pencil, lower left.
EDITION: 10
PROOFS: 3 AP, 1 PP, 3 TP
PUBLISHER: The Artist
PRINTER: Tom Burckhardt, New York

194. **The Collector** 1999

Woodcut on Japanese paper.
SHEET: 30¼ × 20¼" (76.8 × 51.4 cm)
IMAGE: 23¾ × 18" (60.3 × 45.7 cm)
INSCRIPTIONS: Signed in pencil, lower right: *Red Grooms '99*, num-
 bered in pencil, lower left.
EDITION: 10
PROOFS: 3 AP, 1 PP, 2 TP
PUBLISHER: The Artist
PRINTER: Tom Burckhardt, New York

195. **Traffic!** 1999

Three-dimensional color lithograph on Rives BFK paper, cut out,
glued and mounted in Plexiglas case.
SHEET: 23⅜ × 28⅜ × 10" (59.4 × 72.1 × 25.4 cm)
IMAGE: 21 × 24 × 8" (53.3 × 61.0 × 20.3 cm)
INSCRIPTIONS: Singed and dated, lower right: *Red Grooms '99*; num-
 bered in red colored pencil, lower left
EDITION: 75
PROOFS: 1 A, 10 AP, 1 BAT, 4 Patron's Impressions, 2 TP
PUBLISHERS: Red Grooms and Shark's Incorporated, Lyons, Colorado
PRINTER: Bud Shark, assisted by Matthew Christie, Lyons, CO.
 Assembled by Roseanne Colachis
COMMENTS: Produced in 9 colors from 10 aluminum plates on two
 sheets. The scene is the corner of Broadway and Canal, one of
 the busiest intersections in New York City.

Section III

196. *A Two Man Show* 1955

Offset lithograph in one color on light brown stationary paper
SHEET: 9½ × 5″ (24.1 × 12.7 cm)
IMAGE: 8 × 4″ (20.3 × 10.2 cm)
EDITION: Approximately 50
PUBLISHER: Myron King, Lyzon Art Gallery, Nashville, Tennessee
PRINTER: Unknown
RUNS: black
COMMENTS: First exhibition of the Artist's original work, a two
 man exhibition with Walter Knestrick. Announcing the opening
 of their two man show, February 13–28, Lyzon's Gallery,
 Nashville, TN.

197. *Drawings* 1958

Offset lithograph in one color on bond paper
SHEET: 9 × 5″ (22.9 × 12.7 cm)
IMAGE: 8¼ × 5″ (21.0 × 12.7 cm)
EDITION: Unknown
PUBLISHER: City Gallery, New York
PRINTER: Unknown
RUNS: black
COMMENTS: Produced for the exhibition "Drawings" in the fall of
 1958. The Artist along with Jay Milder opened the City Gallery
 where they and their friends, Claes Oldenburg, Jim Dine, Robert
 Whitman, and others exhibited their work.

198. *Happenings* 1960

Offset lithograph in one color on light weight poster paper
SHEET: 17 × 12″ (43.2 × 30.5 cm) unfolded; 8½ × 12″ (21.6 × 30.5 cm)
 folded
IMAGE: 17 × 12″ (43.2 × 30.5 cm) unfolded; 8½ × 12″ (21.6 × 30.5 cm)
 folded
EDITION: Unknown
PUBLISHERS: Anita Reuben and Max Baker, Reuben Gallery, New
 York
PRINTER: Unknown
COMMENTS: Drawing on back is a cannon by Allan Kaprow. Drawing
 on front is a fireman by Red Grooms. On the opposite side is a
 partial script for *Burning Building* on the Artist's copy. Produced
 for "Happenings at the Reuben Gallery," January 8, 9, 10, 11, 1960.
 The evening's program consisted of three Heppenings: Groom's
 The Magic Train Ride, Allan Kaprow's *The Big Laugh*, and Robert
 Whitman's *Small Cannon*. These were prototype "Happenings"
 which have been described as art in a new medium produced
 before an audience that often stood or moved around.

**199. *The Nashville Artist Guild Presents Charles "Red"
Grooms*** 1961

Offset lithograph in one color on light weight poster paper
SHEET: 11 × 8½″ (27.9 × 21.6 cm)
IMAGE: 10½ × 7⅝ ″(26.7 × 19.4 cm)
EDITION: Unknown
PUBLISHER: The Nashville Artist Guild, Nashville, Tennessee
PRINTER: Unknown
RUNS: black
COMMENTS: Produced as an announcement for the exhibition, "The
 Nashville Artist Guild presents Charles 'Red' Grooms with
 Paintings, Drawings and Theatre Designs."

200. *Shoot the Moon* 1963

Offset lithograph in one color on bond paper
SHEET: 11 × 7½″ (27.9 × 19.1 cm)
IMAGE: 10 × 6½″ (25.4 × 16.5 cm)
EDITION: Unknown
PUBLISHERS: The Artist and Rudy Burckhardt, New York
PRINTER: Unknown
COMMENTS: Produced for the showing of two films entitled, *Shoot
 the Moon* by the Artist and Rudy Burckhardt and *How Wide Is
 6th Avenue* by Rudy Burckhardt at The New Bowery Theater,
 New York on May 30th.

201. *Tibor de Nagy Presents Red Grooms* 1963

Glitter and offset lithograph in one color on heavy bond paper
SHEET: 12 × 9″ (30.5 × 22.9 cm)
IMAGE: 12 × 9″ (30.5 × 22.9 cm)
EDITION: Unknown
PUBLISHER: Tibor de Nagy Gallery, New York
PRINTER: Unknown
COMMENTS: Produced as a mailer for the exhibition "Tibor de Nagy
 Presents Red Grooms," at the Tibor de Nagy Gallery, New York,
 October 15–November 2.

202. *Lurk* 1965

Offset lithograph in one color on bond paper
SHEET: 11 × 8½″ (28.0 × 21.6 cm)
IMAGE: 11 × 8½″ (28.0 × 21.6 cm)
EDITION: Unknown
PUBLISHER: Tibor de Nagy Gallery, New York
PRINTER: Unknown
COMMENTS: Produced for a showing of a film entitled, *Lurk* by Rudy
 Burckhardt at the Tibor de Nagy Gallery on April 14th. The Artist
 plays Frankenstein, also starring Edwin Denby and Mimi Gross.

203. *Intolerance* 1965

Offset lithograph in one copy on pink bond paper
SHEET: 18 × 23″ (45.7 × 58.4 cm)
IMAGE: 18 × 23″ (45.7 × 58.4 cm)
PUBLISHER: Tibor de Nagy Gallery, New York
PRINTER: Unknown
COMMENTS: Produced for an exhibition of new work at the Tibor de
 Nagy Gallery, New York, on March 30th.

204. *Paper Bag Players* 1966

Color offset lithograph on light weight poster paper
SHEET: 23 × 18″ (58.4 × 45.7 cm)
IMAGE: 22 × 17½″ (55.9 × 44.5 cm)
EDITION: Unknown
PROOFS: 10 AP
PUBLISHER: List Art Poster Program of the American Federation of
 Arts, New York
PRINTER: Unknown
COMMENTS: Produced for "Paper Bag Players," The Children's
 Theater Group who performed at the Settlement Play House,
 October 8–January 31, March and April. A smaller poster of the
 same subject, an offset lithograph in one color on yellow bond
 paper, 11 × 8½″ (27.9 × 21.6 cm) was also produced.

205. City of Chicago 1968 (begun 1967)

Offset lithograph in one color on light weight off-white poster paper

SHEET: 28¾ × 21⅞" (73.0 × 55.6 cm)

IMAGE: 26¾ × 20" (68.0 × 50.8 cm)

EDITION: Unknown

PUBLISHER: Allan Frumkin Gallery, Chicago, Illinois

PRINTER: Unknown

COMMENTS: Produced for the exhibition, "City of Chicago," Allan Frumkin Gallery, Chicago, IL, opened January 19, 1968.

206. This Way to the Marvel 1967

Offset lithograph in one color on 40 lb. rag paper

SHEET: 19 × 13" (48.3 × 33.0 cm)

IMAGE: 16½ × 12¼" (41.9 × 31.1 cm)

EDITION: Unknown

PUBLISHER: Vanderlip Gallery, Philadelphia, Pennsylvania

PRINTER: Unknown

COMMENTS: Produced for the exhibition at the Vanderlip Gallery, Philadelphia, Pennsylvania, November 24–December 31. A group showing of prints and drawings by Baker, Barrell, Bhasvar, Biddle, D'Arcangelo, De Mayo, Fahler, Grooms, Gross, Harvard, Jacobs, Kahn, Kruss, Marcus, Milder, Ranieri, Roth, Schwedler, Stasik, Thek, and Zox.

207. Animation from Tappy Toes 1968

Offset lithograph in two colors on heavy poster paper

SHEET: 11¼ × 5½" (28.6 × 14.0 cm)

IMAGE: 10 × 4⅝" (25.4 × 11.8 cm)

PUBLISHER: Tibor de Nagy Gallery, New York

PRINTER: Unknown

COMMENTS: Produced for the exhibition "Red Grooms–Animation from Tappy Toes," Tibor de Nagy Gallery, New York, May 26th.

208. Doughnut Girl 1970

Color offset silkscreen in four colors on medium weight poster paper

SHEET: 28¾ × 21¾" (73.0 × 55.3 cm)

IMAGE: 28½ × 21¾" (69.9 × 55.3 cm)

EDITION: Unknown—Possibly produced as a limited edition, some AP's exist.

PUBLISHER: Walker Art Center, Minneapolis, Minnesota

PRINTER: Unknown

COMMENTS: Poster designed by James E. and Sandra K. Johnson. Produced for the exhibition "Figures & Environments" organized by the Walker Art Center at the Dayton Hudson Department Store, Minneapolis.

209. Saskia 1971

Offset lithograph, in one color, light weight poster paper

SHEET: 8 × 9½" (20.3 × 24.1 cm)

IMAGE: 7¼ × 8¾" (18.4 × 22.2 cm)

EDITION: Unknown

PUBLISHER: John Bernard Myers Gallery, New York

PRINTER: Unknown

RUNS: black

COMMENTS: Portrait of Saskia, the Artist's daughter. Produced as an announcement for an exhibition, "Red Grooms" at the John Bernard Myers Gallery, 50 West 57th Street, New York, December 4, 1971–January 6, 1972.

210. Discount Store 1971

Offset silkscreen in three colors on cartridge paper

SHEET: 11¾ × 29" (29.9 × 73.7 cm)

IMAGE: 10½ × 26½" (26.7 × 67.3 cm)

EDITION: Approximately 1,000

PUBLISHER: John Bernard Myers Gallery, New York

PRINTER: Chromacomp, Inc., New York

EXHIBITIONS: *Red Grooms: Prints of the Seventies*, p. 19, pl 91981; *Red Grooms: The Graphic Work from 1957–1985*, p. 13, pl. 9, 1986

COMMENTS: Produced for the exhibition "Discount Store" shown in a temporary John Bernard Myers Gallery at 924 Madison Avenue across from the Whitney Museum of American Art, New York, February 3–28, 1971 for the benefit of the Spanish Refugee Aid. For a signed and numbered edition see Section II.

211. Inside Dope 1971

Mimeograph in one color on off-white light weight poster paper

SHEET: 23½ × 18" (58.8 × 45.7 cm)

IMAGE: 20¾ × 16½" (52.7 × 41.9 cm)

EDITION: Unknown

PUBLISHER: Rudy Burckhardt, New York

PRINTER: Unknown

COMMENTS: Produced for the film showing of *Inside Dope or Too Great For The Grave* by Rudy Burckhardt, New York.

212. Guggenheim 1971

Color lithograph on cartridge paper

SHEET: 38⅛ × 26⅛" (96.8 × 66.4 cm)

IMAGE: 38⅛ × 26⅛" (96.8 × 66.4 cm)

EDITION: 250

PUBLISHER: George Goodstadt, New York

PRINTER: Mauro Giuffrida, Bank Street Atelier, New York

CHROMIST: Jean-Pierre Remond

COMMENTS: Commissioned by the Solomon Guggenheim Museum, New York for the exhibition "Ten Independent Artists," January 14–February 27, 1972. The ten artists were H. C. Westermann, Robert Beauchamp, Red Grooms, Romaire Bearden, Lester Johnson, Peter Schumann, Joseph Kurhajec, Mary Frank, Maryan and Irving Kriesburg. For signed and numbered edition, see Section II.

213. The Ruckus World of Red Grooms 1973

Offset silkscreen in three colors on medium weight poster paper

SHEET: 28 × 22" (71.1 × 55.9 cm)

IMAGE: 26¾ × 21¼" (68.0 × 54.0 cm)

EDITION: Unknown

PUBLISHER: New York Cultural Center in Association with Fairleigh Dickinson University, New York

PRINTER: Unknown

COMMENTS: Produced for the exhibition "The Ruckus World of Red Grooms," Voorhees Hall, Rutgers University Art Gallery, New Brunswick, NJ, September 30–November 21. Traveled to New York Cultural Center, New York, NY, December 5, 1973–January 20th, 1974, and Museo de Arte Contemporaneo Venezuela, April 1974.

214. Red Grooms—Caracas 1974

Offset lithograph in two colors on medium weight poster paper

SHEET: 25⅛ × 18¼" (63.8 × 46.4 cm)

IMAGE: 25⅛ × 18¼" (63.8 × 46.4 cm)

EDITION: Unknown

PUBLISHER: Museo De Arte Contemporaneo, Parque Central–Caracas, Venezuela

PRINTER: Unknown

COMMENTS: Produced for the exhibition "Red Grooms," Museum of Contemporary Art, Parque Central, Caracas, Venezuela, April 1974.

215. **The Great American Rodeo** 1975

Color offset lithograph on light weight glossy poster paper
SHEET: 29 × 17½″ (73.7 × 44.5 cm)
IMAGE: 27½ × 16½″ (69.9 × 41.9 cm)
EDITION: Unknown
PUBLISHER: Texas Commission on the Arts and Humanities, Fort
 Worth, Texas
PRINTER: Unknown
COMMENTS: Produced for the exhibition "The Great American
 Rodeo," Fort Worth Art Museum, Fort Worth, Texas, January
 25–April 11, 1975. Poster designed by James E. and Sandra K.
 Johnson.

216. **Red Grooms à Paris** 1977

Lithograph in two colors on gray paper
SHEET: 29 × 19⅝″ (73.7 × 49.9 cm)
IMAGE: 29 × 19⅝″ (73.7 × 49.9 cm)
EDITION: Unknown
PUBLISHER: Roger d'Amécourt, Paris, France
PRINTER: Mourlot print shop, Paris, France
COMMENTS: Produced for the exhibition "Red Grooms à Paris,"
 Roger d'Amécourt Galerie, Paris, France, May–July 1977.

217. **Red Grooms, Martin Wiley Gallery** 1978

Offset lithograph in one color on light weight poster paper
SHEET: 28 × 20½″ (71.1 × 52.1 cm)
IMAGE: 28 × 20½″ (71.1 × 52.1 cm)
EDITION: Unknown
PUBLISHER: Martin Wiley Gallery, Nashville, Tennessee
PRINTER: Joe Petrocelli, Siena Studios, New York
COMMENTS: Produced for the exhibition: "Red Grooms," Martin
 Wiley Gallery, Nashville, TN, November 19–December 31, 1978.
 The subject is the Artist looking out of the Parthenon, Nashville,
 TN. For numbered and signed edition, see Section II.

218. **Play Ball!** 1978

Color offset lithograph on heavy weight poster paper
SHEET: 23⅝ × 19″ (60.1 × 48.3 cm)
IMAGE: 21⅝ × 17⅛″ (55.1 × 43.5 cm)
EDITION: Unknown
PUBLISHER: The Queens Museum, Flushing, New York
PRINTER: Unknown
COMMENTS: Produced for the exhibition "Play Ball! A Century of
 Sports in Art," The Queens Museum, New York City Building,
 Flushing Meadow-Corona Park, Flushing, New York, June
 24–September 10, 1978.

219. **Ruckus Manhattan** 1981

Color offset lithograph on light weight poster paper
SHEET: 11 × 28″ (27.9 × 71.1 cm)
IMAGE: 10 × 28″ (25.4 × 71.1 cm)
EDITION: Unknown
PUBLISHER: Creative Time, Inc., New York
PRINTER: Unknown
COMMENTS: Produced for the exhibition "Ruckus Manhattan," at the
 Burlington House, New York, December 18, 1981.

220. **Mayor Byrne's Mile of Sculpture** 1982

Lithograph on 70# vellum paper
SHEET: 35 × 22¼″ (88.9 × 56.5 cm)
IMAGE: 35¼ × 22¼″ (89.5 × 56.5 cm)
EDITION: 10,000
PUBLISHER: Chicago Sculpture Society, Chicago, Illinois

PRINTER: Steven M. Andersen, Vermillion Editions, Ltd., Minneapolis,
 Minnesota
COMMENTS: Produced for a sculpture exhibition on the Navy Pier
 commissioned by the City of Chicago, Mayor Jane M. Byrne, May
 1982, fifty-four artists were included. The poster was printed from
 the original plates, all pulled by Steve Andersen. For signed and
 numbered editions, see Section II.

221. **Museum Opening** 1983

Color offset lithography on heavy weight grained paper
SHEET: 13 × 8″ (33.0 × 20.3 cm)
IMAGE: 11½ × 7″ (29.2 × 17.8 cm)
EDITION: Unknown
PUBLISHER: Jane Voorhees Zimmerli Art Museum, New Brunswick,
 New Jersey
PRINTER: Unknown
COMMENTS: Produced for the cover of the invitation to the opening
 of the Jane Voorhees Zimmerli Museum.

222. **"Fat Free" Surrealism** 1990

Offset lithograph in two colors on light weight off-white poster
paper
SHEET: 22 × 17″ (55.4 × 43.2 cm)
IMAGE: 21 × 16″ (53.3 × 40.6 cm)
EDITION: Unknown
PUBLISHER: Michael Leonard, New York
PRINTER: Unknown
COMMENTS: Produced for a four-man exhibition at the Michael
 Leonard & Associates Gallery, New York, December 6,
 1990–January 5, 1991, curated by the artist. The four artists were
 Jeff Starr, John R. Fudge, Tom Burckhardt, and Michael (Art)
 Staats.

223. **Sno-Show II** 1991

Color lithograph on medium weight glossy poster paper
SHEET: 37 × 24″ (94.0 × 61.0 cm)
IMAGE: 36 × 22½″ (91.4 × 57.2 cm)
EDITION: Unknown
PUBLISHER: Minneapolis Institute of Arts, Minneapolis, Minnesota
PRINTER: Litho Colorplate, Inc., Minneapolis, Minnesota
COMMENTS: Produced for the exhibition "Vermillion Editions 15th
 Anniversary Exhibition," Minneapolis Institute of Arts,
 Minneapolis, Minnesota, March–May 1992. For signed and num-
 bered edition, see Section II.

224. **Art in the Park** 1992

Color offset lithograph on medium weight, textured off-white wove
paper
SHEET: 22 × 14″ (55.9 × 35.6 cm)
IMAGE: 19¼ × 10¼″ (49.0 × 26.0 cm)
EDITION: Unknown
PUBLISHER: Des Moines Art Center, Des Moines, Iowa
PRINTER: Unknown
COMMENTS: Produced for the exhibition "Art in the Park," Des
 Moines Art Center, Des Moines, Iowa, 1992.

225. **Grand Central Terminal** 1993

Color offset lithograph on medium weight glossy poster paper
SHEET: 33⅝ × 24⅛″ (85.4 × 61.3 cm)
IMAGE: 30⅝ × 22¾″ (77.8 × 57.8 cm)
EDITION: Unknown
PUBLISHER: TWO ONE TWO, Inc., New York
PRINTER: Kenner Printing, New York

COMMENTS: Produced for the exhibition "Grand Central Terminal," 1993, New York.

226. *Train to Potsdam* 1995

Color offset lithograph on poster paper
SHEET: Unknown
IMAGE: Unknown
EDITION: Unknown
PUBLISHER: The Artist and Lysiane Luong, New York
PRINTER: Unknown
COMMENTS: Produced for the exhibition of *Subway*, at the Film Museum, Potsdam, Germany. Image is the same as edition. Poster

has never been found. For signed and numbered edition, see Section II.

227. *Tennessee Fox Trot Carousel* 1998

Color offset lithograph on glossy light weight paper
SHEET: 27¼ × 19″ (69.2 × 48.3 cm)
IMAGE: 25¼ × 14¼″ (64.1 × 36.2 cm)
EDITION: Unknown
PUBLISHER: TWO ONE TWO, Inc., New York
PRINTER: Eveready Printing Co., Nashville, Tennessee
COMMENTS: Produced to promote the *Tennessee Fox Trot Carousel* installation, Nashville, Tennessee.

Section IV

228. *Art Cash* 1971

Photo-offset lithographs in two colors on Crane's Bond paper, set of 3
SHEET: 27 × 22″ (68.6 × 55.9 cm)
IMAGE: 24½ × 19¾″ (61.6 × 50.2 cm)
INSCRIPTION: One single sided and double sided print is numbered and dated in pencil lower right; signed in pencil RED GROOMS in block provided for the signatures; the other one sided print is the same except numbered and dated in lower left.
EDITION: 75
PROOFS: 10 AP, 1 TP
PUBLISHER: Experiments in Art & Technology, Inc., New York
PRINTER: U. S. Banknote Co., Brooklyn, New York, assisted by Tom Gormley
COMMENTS: A set of bills were produced: $1.00 by Andy Warhol, $3.00 by Robert Whitman, $12.00 by Robert Rauschenberg, $24.00 by Tom Gormley, $51.00 by Red Grooms, and $88.00 by Marisol.

229. *Menu* 1973

Silkscreen in one color on cartridge paper
SHEET: 12 × 9″ (30.5 × 22.9 cm), folded, 12 × 18″ (30.5 × 45.8 cm), open
IMAGE: 12 × 9″ (30.5 × 22.9 cm), folded, 12 × 18″ (30.5 × 45.8 cm), open
INSCRIPTION: Signed in red felt pen: *Red Grooms* (possibly signed at a later date).
EDITION: Unknown
PUBLISHER: Experiments in Art & Technology, Inc., New York
PRINTER: Adolph Rischner, Styria Studio Inc., New York

230. *Millet* 1976

Etching on Rives BFK paper
SHEET: 14¾ × 11″ (37.5 × 27.9 cm)
IMAGE: 4⅞ × 3⅞″ (12.4 × 9.8 cm)
EDITION: None
PROOFS: 2 TP
INSCRIPTION: Signed in pencil lower right: *Red Grooms*, numbered in pencil, lower left, inscribed in pencil, lower left center: "MILLET."

PUBLISHER: The Artist
PRINTER: Jennifer Melby, New York

231. *Sunday Afternoon in the Park with Monet* 1976

Drypoint in one color on Arches Cover paper
SHEET: 30 × 22¼″ (76.2 × 56.5 cm)
PLATE: 19½ × 15¾″ (49.5 × 40.0 cm)
INSCRIPTIONS: Signed in pencil, lower right: *Red Grooms*, numbered in pencil, lower left.
EDITION: None
PROOFS: Approximately 6 TP
PUBLISHER: The Artist
PRINTER: Jennifer Melby, New York

232. *Roger, Wayne, and Nephew* 1980

Drypoint in one color on Chrisbrook paper
SHEET: 11⅝ × 15⅛″ (29.5 × 38.4 cm)
PLATE: 3½ × 7⅛″ (8.9 × 18.1 cm)
INSCRIPTIONS: Signed in pencil, lower right: *Red Grooms*; numbered in pencil, lower left; printer's chop, lower right.
EDITION: 10
PROOFS: 1 PP
PUBLISHER: The Artist
PRINTER: Jennifer Melby, New York
COMMENTS: The subjects are Roger d'Amecourt, Wayne Brown, and Wayne's nephew.

233. *Shark's Ink* 1981

Offset lithograph in three colors on Beckett Cover paper
SHEET: 11 × 22½″ (27.9 × 57.2 cm)
IMAGE: 9¾ × 17½″ (24.8 × 44.5 cm)
EDITION: 2,000
PUBLISHER: Brooke Alexander, Inc., New York
PRINTER: Joe Petrocelli, Siena Studios, New York
COMMENTS: Cover for the catalogue: *A Catalogue Raisonné of His Graphic Work, 1957–1981*. Published for the Fine Arts Center at

Cheekwood, Nashville, TN. The subject on the right is Bud Shark, master printer; the subject on the left is Matt Christie, Assistant Printer, at Shark's studio in Boulder, Colorado.

234. *Croissant Crusher* 1979 (published in 1999)

Lithograph in eleven colors on Twinrocker special paper
SHEET: 29 × 21½" (73.7 × 54.6 cm)
IMAGE: 27 × 20½" (68.6 × 52.1 cm)
INSCRIPTION: Signed in red felt pen, lower right: *Red Grooms 1979–99*; numbered in red felt pen, lower left, printer's chop, lower left.
EDITION: 11
PROOFS: 4 AP, 1 BAT, 5 CTP, 2 PP, 5 TP
PUBLISHER: AKASHA Studio, Minneapolis, Minnesota
PRINTER: Steven M. Andersen, AKASHA Studio, Minneapolis, Minnesota
COMMENTS: Portrait of master print maker, Steven M. Andersen, 1979. Proofs: 4 AP, 29 × 21½" (73.7 × 54.6 cm) on shaped Twinrocker paper; 1 BAT, 27½ × 21½" (69.9 × 54.6 cm) on Arches Cover paper; 5 CTP, 30 × 21½" (76.2 × 54.6 cm) on buff Japan paper; 2 PP, 25½ × 22½" (64.89 × 57.2 cm) on Arches cover paper; 5 TP, 30 × 32" (76.2 × 55.9 cm) on various Japan paper.

235. *A Charlie for Saskia* 1986

Lithograph in one color on Rives BFK paper, a marginalia
SHEET: 15 × 4" (38.1 × 10.2 cm)
IMAGE: 9½ × 3¾" (24.1 × 9.5 cm)
EDITION: None
PROOFS: Possibly 3 TP
PUBLISHERS: Red Grooms and Shark's Inc., Boulder, Colorado
PRINTER: Bud Shark, Shark's Inc., Boulder, Colorado
COMMENTS: Produced in the margin of *Subway*, 1986.

236. *Self-Portrait with Bow Tie* 1987

Lithograph in three colors, hand colored with pencil on Rives BFK paper, a marginalia

SHEET: 16¼ × 11½" (41.3 × 29.2 cm)
IMAGE: 16¼ × 10⅝" (41.3 × 27.0 cm)
INSCRIPTIONS: Signed in red colored pencil, lower right: *Red Grooms*; numbered in red colored pencil, lower left.
EDITION: 6
PUBLISHER: The Artist
PRINTER: Bud Shark, Shark's Incorporated, Boulder, Colorado
COMMENTS: Produced in the margin of *De Kooning Breaks Through*, 1987.

237. *Lysiane in Blue* 1987

Lithograph in one color on Rives BFK paper, a marginalia
SHEET: 16¼ × 11½" (41.3 × 29.2 cm)
IMAGE: 15¼ × 11½" (38.7 × 29.2 cm)
INSCRIPTIONS: Signed in black colored pencil, lower right: *Red Grooms*; numbered in black colored pencil, lower left.
EDITION: 4
PUBLISHERS: Red Grooms and Shark's Incorporated, Boulder, Colorado
PRINTER: Bud Shark, Shark's Incorporated, Boulder, Colorado
COMMENTS: Produced in the margin of *De Kooning Breaks Through*, 1987.

238. *Chinese Poet* 1990

Drypoint on Rives BFK paper
SHEET: 13 × 9⅞" (33.0 × 25.1 cm)
PLATE: 6¾ × 4⅝" (17.1 × 11.8 cm)
INSCRIPTIONS: Unknown
EDITION: None
PROOFS: Several TP
PUBLISHER: The Artist
PRINTER: Unknown
COMMENTS: This etching was intended as an illustration for a book of Chinese poems by an ancient writer translated by Iris Hao (Lysiane's sister).

Chronology

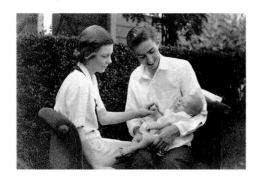

Billy and Jerry Grooms with baby Charles, Nashville, Tennessee, 1937. Photo by Calvert Studios.

1937

June: Charles Rogers Grooms is born in Nashville, Tennessee, to Wilhelmina Haggard Rogers and Roger Gerald Grooms.

1943

Grooms attends Clements School, Nashville.

1944

Transfers to Burton Grammar School and meets Walter Knestrick in the fifth grade.

1947

Attends art classes at the Children's Museum, Nashville.

1950

Visits New York with a 4-H group.

1952

Freshman at Hillsboro High School, Nashville. Takes art classes in the evening with Joseph van Sickle. Walter Knestrick is a fellow student.

1954–55

While a senior at Hillsboro High School, Grooms is hired by Myron King, proprietor of Lyzon Art Gallery and Frame Shop in Nashville, he works on watercolors in an attic room for a weekly salary. An avid reader of *Artnews*, Grooms's influences ranged from Alberto Giacometti and Georges Rouault, to the Action Painters of the New York School.

1955

Two-man show with Walter Knestrick at Lyzon Art Gallery, Nashville.
September: Enters the School of the Art Institute of Chicago; drops out after part of one semester.

1956

Enrolls at the New School for Social Research in New York; lives at the McBurney YMCA on Twenty-third Street.
September: Returns to Nashville to enroll at George Peabody College for Teachers. Produces his first print, *Minstrel*.

1957

Completes Spring semester at Peabody College.
June: With his mother's encouragement, enrolls in Hans Hofmann's art classes Provincetown, Massachusetts. Lives and works in an attic apartment on Commercial Street. Meets the proprietors of Provincetown's Sun Gallery, painter Yvonne Andersen and poet Dominic Falcone. Collaborates with Andersen on an "event" called *Friends*. Employed as a dishwasher at The Moors, a Provincetown restaurant. Falcone, a co-worker, nick-names the artist "Red", and he begins signing works "Red Grooms". Meets Allan Kaprow.
Mid-September: Goes to New York City. Lives with Andersen and Falcone in a loft close by the northeast corner of Twenty-fourth Street and Sixth Avenue, until the following May. Contributes linocuts to *The City*, a portfolio of prints and poems printed by Andersen. Works as an usher at the Roxy movie theater.

1958

Spring: Falcone arranges for Grooms, Andersen, and Lester Johnson to paint billboards in Salisbury, Massachusetts, at the edge of a parking lot owned by his father.
June: Grooms returns to Provincetown. He lives and works in a small rented cottage and paints outside. Gives his first happening *A Play Called Fire* at the Sun Gallery. Meets Lucas Samaras and Robert Whitman.
October: Lives in a loft on the northwest corner of Sixth Avenue and Twenty-fourth Street. He and Jay Milder turn a portion of this space into the City Gallery, where they show work by Lester Johnson, Jim Dine, Alex Katz, Claes Oldenburg, Bob Thompson, and others.
December: Two-man show with Milder, held at the City Gallery.

1959

Grooms and Thompson move to a loft occupied by the painter Christopher Lane and Milder, on Monroe Street on the Lower East Side.
May–June: Travels to Omaha, Nebraska, with Thompson and Milder.
June: Returns to Provincetown. Works in the basement of the Sun Gallery.

Red Grooms in The Walking Man, a performance at the Sun Gallery, 1959. Photo by Yvonne Andersen.

August: Solo exhibition held at the Sun Gallery, including paintings, and a Happening, *The Walking Man*, performed by Grooms, Falcone, Andersen, Sylvia Small, and the painter Bill Barrell.
October: Rents an ex-boxing gym on Delancey Street. Turns a portion of this loft into the Delancey Street Museum.
December: Does woodcut poster and stages the Happening *The Burning Building* at the Delancey Street Museum. Draws *Comic* for Claes Oldenburg's *Ray Gun* show.

1960

January: Shows collages and cutout sculptures at the Reuben Gallery, New York. During this exhibition stages *The Magic Train Ride* along with Happenings by Robert Whitman and Allan Kaprow.

June: Travels to Europe. Tours extensively and lives in Florence for a year.

1961

Spring: Produces the early prints *Ruckus* and *Man with a Bowler.* Makes his first movie, *The Unwelcome Guest* in 8MM.

September: Grooms returns to New York, moves into a loft on Twenty-sixth Street between Seventh and Eighth Avenues.

1962

Makes Ruckus paper movies. Produces first etching, *Self-Portrait in a Crowd* , showing the artist and others walking the streets of New York, which was included in the portfolio *International Anthology of Contemporary Engravings. The International Avant-Garde: America Discovered, Volume 5, 1964.* With Rudy Burckhardt, makes the film *Shoot the Moon.*

1963

Has his first uptown exhibition at the Tibor de Nagy Gallery, New York.

1964

Work included in the *67th Annual American Exhibition*, Art Institute of Chicago. Designs sets and masks for *Guinevere,* a play by Kenneth Koch.

Summer: Encouraged by Alex Katz, Grooms spends the summer in Lincolnville, Maine, where he shares a house with Burckhardt, Yvonne Jacquette, and Mimi Gross. He stars in Burckhardt's film *Lurk.* Marries Mimi Gross in Belfast, Maine.

1965

His work is included in *Eleven from the Reuben Gallery,* a group exhibition at the Guggenheim Museum.

1966

July–August: Lives with Falcone and Andersen in Lexington, Massachusetts, while making the film *Fat Feet.* Has exhibition at Tibor de Nagy Gallery.

December: First full-length article on Grooms, "Red Power" by Ted Berrigan, appears in *Artnews.*

1967

Summer: Visits Montreal Expo. Exhibits work at the Tibor de Nagy Gallery. This exhibition includes *Loft on 26th Street,* props from *Fat Feet,* as well as *Somewhere in Beverly Hills* and *Other Hollywood Pieces.*

October: Lives in Chicago for seven months and builds "The City Of Chicago," for the Frumkin Gallery, "Rusty" Morgan is brought in to help with the piece, becoming the first of Grooms's hired assistants.

1968

January 19: "The City of Chicago" opens at the Frumkin Gallery.

January: Begins filming *Tappy Toes* with *City of Chicago* as the set while the show is still running at the Allan Frumkin Gallery; finishes filming the live action segment in the industrial loft which he rented to build "The City Of Chicago."

February: Commissioned by the Museum of Contemporary Art, Chicago, to design and execute a billboard, *Chicago—Magic City of the West*; works on the billboard with Rusty Morgan. The billboard is up during the Democratic Convention held in Chicago that summer.

April: Is a visiting artist at Swarthmore College.

June: Awarded a grant by the Ingram Merrill Foundation. "The City of Chicago" exhibited at the XXXIV Venice Biennale; travels to Venice for the installation.

1969

Appears in the *Encyclopedia of the Blessed*, a film by George Kuchar.

November: Takes a ground-floor studio in Tribeca.

1970

Works on first color lithograph, *Nervous City.* Finishes the animated sections of *Tappy Toes.*

Summer: Begins work on the *Discount Store* for the *Figure Environments* exhibition organized by the Walker Art Center in Minneapolis. Receives a CAPS grant for film. Work included in *Happenings and Fluxus*, a group exhibition in Stuttgart, Amsterdam, and Berlin.

November: Daughter, Saskia Leah Grooms, is born. Produces linoleum cut of Saskia sent to friends announcing her birth.

1971

Exhibits at John Bernard Myers Gallery. Spends the summer in Maine.

Fall: Receives commission from Vera List for *Fall of Jericho.* Myers arranges to have *The Discount Store* shown in a temporary gallery on Madison Avenue. The *Discount Store* poster is produced. Makes *No Gas*, a portfolio of six lithographs at Bank Street Atelier. Exhibits them at Harry N. Abrams Gallery, New York, in November.

1972

Constructs *Astronauts on the Moon* for the "Ten Independent Artists" exhibition at the Guggenheim Museum, New York. Designs poster for the exhibition. Stages *Hippodrome Hardware* at his studio as part of a program of performances organized by Grooms and Robert Whitman. Spends the summer in Maine.

1973

Working with cameraman Rudy Burckhardt, completes film version of *Hippodrome Hardware.*

September: "The Ruckus World of Red Grooms," a retrospective of large works, curated by Dennis Cate, opens at the Rutgers University Art Gallery, New Brunswick, New Jersey; then traveled to the New York Cultural Center in Manhattan. Designs posters for exhibition. Produces a silkscreen titled *Menu* to be used as the real menu for the SAS flight to Stockholm chartered by a group of artists and collectors who attended the opening of The New York Collection for Stockholm exhibition, organized by Billy Klüver. First print published by Brooke Alexander, *45 Characters.*

1974

Holds his last exhibition at the John Bernard Myers Gallery. *The Ruckus World of Red Grooms* is exhibited at the Museo de Arte Contemporaneo, Caracas, Venezuela.

1975

Joins the Marlborough Gallery, New York.

May–October: Begins work on *Ruckus Manhattan* with an expanding crew which will be around 25 people at its zenith. A film of *Ruckus Manhattan* is shot as the project proceeds, the footage is edited by David Saunders.

November–December: Ruckus Manhattan opens at 88 Pine Street.

During the two-month break from *Ruckus Manhattan*, Grooms works on *Ruckus Rodeo* for *The Great American Rodeo*, an exhibition at the Fort Worth Art Museum. Produces poster for the exhibition.

1976
Fred Kline, Kent Hines, Andrew Ginzel, and other members of the Ruckus Construction Co. spend six weeks installing *Ruckus Manhattan* on the Marlborough Gallery sculpture court.

1977
Brooke Alexander Gallery publishes *Nineteenth-Century Artists*, a portfolio of ten etchings and aquatints. Separates from Mimi Gross.

November–Spring: Lives and works in Paris for a one-man exhibition at the Galerie Roger d'Amécourt, Paris. Works at the Mourlot print shop and produces the exhibition poster.

1978
Makes maquette for *Way Down East,* an outdoor sculpture commissioned by The National Endowment for the Arts, to be located on the campus of Northern Kentucky University in Highland Heights, Kentucky.

March: Visits St. Thomas. Spends summer in Maine. Makes film *Little Red Riding Hood*, starring Saskia Grooms. Designs sets for *Red Robins*, a play by Kenneth Koch.

Fall: Builds *The Bookstore* at the Hudson River Museum, Yonkers, New York (opens March 10, 1979).

1979
Spring: Makes his first series of bronzes, *Cowboys and Indians*, cast at the University of New Mexico. Produces first multiple with Steve Andersen, *Peking Delight*.

1980
April: Visits St. Bartholemy, West Indies.

Summer: Visits Brittany with his daughter, Saskia. Casts *Football Series* at the University of Southern Illinois under the guidance of Tom Walsh.

1981
Spends summer in Martha's Vineyard. Does a series of watercolors in a "pointillist" style. Completes first print with Bud Shark, *Mountaintime,* at Anderson Ranch, CO.

1982
January–March: Ruckus Manhattan shown, with addition of a giant taxi, at Burlington House, New York.

Winter: Begins work on *Philadelphia Cornucopia*. Commissioned by The Institute of Contemporary Art, University of Pennsylvania, Philadelphia.

March: Constructs *Welcome to Cleveland* during a four-day period at the New Gallery of Contemporary Art, Cleveland.

April: Visits Tortola, British Virgin Islands. Continues his Tourist Watercolor Series.

May: City of Chicago included in *Mayor Byrne's Mile of Sculpture*, Chicago International Art Exposition; produces poster for exhibition.

June 14: Philadelphia Cornucopia opens at the Institute of Contemporary Art.

September–October: Accompanies *The Subway* and other smaller parts of *Ruckus Manhattan* to Tokyo, where it is exhibited at the Seibu Museum. Bud Shark and David Saunders make the trip and help with the installation. Works with Bud Shark in Boulder, CO. They produce their first 3-D lithograph, *Ruckus Taxi*.

1983
March: Philadelphia Cornucopia installed at the city's Visitors Center, an agency of the National Parks Department, Philadelphia, Pennsylvania. Its three-year run there, sets a record for a Sculpto-pictorama installation.

April: Visits Eleuthra, the Bahamas. *Brooklyn Bridge* from *Ruckus Manhattan* shown at the Brooklyn Museum as part of the Brooklyn Bridge centennial celebration. It is subsequently sold to the Museum for Outdoor Sculpture, Denver, CO.

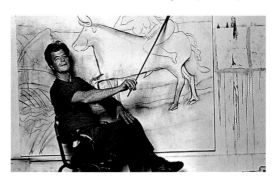

Red Grooms painting Europa, 1983, size unknown. Photo by Harvey Stein.

August–September: Shoot-out installed in The Denver Art Museum, Denver, CO.

1984
February: Inspired by his trip to Japan completes *Night Raid on Nijo Castle*.

April: Exhibition of new works opens at the Marlborough Gallery.

June: Rents a house in Gordes, France. Meets Lysiane Luong.

December: Returns to New York, begins to build a large sculpto-picturama, *The Alley* for an upcoming show at the Marlborough Gallery in London. Also completes a large oil painting, *A Room in Connecticut*, depicting Marcel Duchamp and Katherine Dreier, now in the collection of the Pennsylvania Academy of Art, Philadelphia; this is the subject for the three-dimensional "woodie" multiple, *Katherine, Marcel and the Bride*, 1998.

1985
January: Shows *The Alley* at the Marlborough Gallery, London, an environmental work depicting Cortlandt Alley in New York, and other works. With Lysiane Luong takes a grand tour of Egypt. Upon their return to New York, with a small crew, works on a model for *Tut's Fever Movie Palace*; the maquette will be acquired by the Tennessee State Museum, Nashville.

Spring: Travels to Philadelphia to install "Red Grooms: A Retrospective" at the Pennsylvania Academy of Art, curated by Judith Stein.

Wilhelmina, Jerry, Red, Lysiane and Paul Luong, (left to right). The opening of "Red Grooms: A Retrospective," Pennsylvania Academy, 1985. Photo by Rosemary Ranck.

Summer: Apt, France, uses local stone for his first carving, *The Palanquin* later cast in epoxy resin and painted with acrylic.

Autumn: Flies to Madrid accompanied by Daniel Berlin to install *The Alley* at the Circulo de Bellas Artes. Attends "Red Grooms: A Retrospective" at the Denver Fine Arts Museum. Works in Boulder, Colorado, with Bud Shark on *Charlie Chaplin,* a three-dimensional lithograph.

1986

January: In his New York studio with Lysiane Luong and a large crew, starts to work on the full-scale project, *Tut's Fever Movie Palace,* a portable movie theater in the grand Hollywood Egyptian style.

February–March: Goes to Los Angeles. With a crew from New York and numerous volunteers from Los Angeles, completes *Tut's Fever* for its premiere at MOCA's *Temporary Contemporary* along with *Red Grooms: A Retrospective.*

Lysiane and Red, 1986. Photo by Rudolph Burchkhardt.

Summer: Works on the installation of *Red Grooms: A Retrospective* at the Tennessee State Museum, Nashville, Tennessee. Receives 1986 Tennessee Governors Award for Outstanding Artist presented by Governor Lamar Alexander. Using the image from the etching paints a mural along the museum's escalator wall, *Nashville 2001.*

Late summer, fall, winter: Works on large-scale colored pencil drawings of the Cedar Bar. Is approached by the Whitney Museum to create an environmental work for the street level gallery at the museum. With several assistants, makes a three-dimensional maquette of the Cedar Bar. The print titled *The Cedar Bar* was produced with Maurice Sanchez. Receives the Gold Medal Honor from The National Arts Club.

Saskia, Jerry, Wilhelmina, Honey Alexander, Governor Lamar Alexander, Red and Lysiane (left to right). The Governor's Award, Nashville, Tennessee, 1986. Photo by Tennessee Arts Commission-State of Tennessee Photo Services.

1987

July: Marries Lysiane Luong at St. John the Divine Cathedral, New York. Produces three-dimensional lithograph sent to friends to announce the event. The Whitney Museum decides to do their own version of *Red Grooms: A Retrospective.* The show opens in mid-July and is curated by Barbara Haskell.

Autumn: Philadelphia Cornucopia, a work from 1982, reinstalled at the Thirtieth Street train station, Philadelphia, Pennsylvania. Travels to Hollywood to work on *Moby Dick,* an installation at Barnsdale Art Center.

1988

January–February: Installation of *Tut's Fever Movie Palace* in its permanent home, The Museum of the Moving Image, in Astoria, Queens. Attends the Gold Medal Award dinner for Armand Hammer at The National Arts Club.

Lysiane and Red with Armand Hammer, 1988. Photo by C. Zumwalt.

March: Leaves for Mexico, visits Mexico City, Cuerna Vaca, Las Hadas in Manzanillo, sketches and watercolors on famous sites. Flies to Jackson Hole. Discovers the Grand Tetons, Jenny Lake, and Yellowstone Park. Receives The Mayors Awards of Honor for art and culture, New York City, from Mayor Ed Koch.

July: In Gordes, south of France with family and friends. Watercolors all summer; the works will be later shown at the Marlborough Gallery under the title *Traveling With Red Grooms,* introduction by David March.

August: Takes a trip to south of Spain, visits Marbella. Drives to Granada, sees the Alhambra, the Generalife Gardens, and Barcelona.

Winter: Returns to Mexico, discovers the world of Carreyes, polo grounds in the jungle, fishing and whale-watching, and the Mariachi Bands.

1989

Works on next show for the Marlborough Gallery, *Tourist Traps and Other Places* (1990), a full show on traveling memories from Egypt to Spain, Russia to Mexico. Designs backdrop for *Meilleurs Amis* by Jacques d'Amboise presented by The National Dance Institute.

Red Grooms and Mayor Ed Koch, 1988. Photo by Joan Vitale Strong.

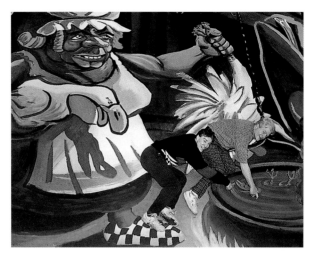

Red Grooms and Jacques d'Amboise, 1989. Photo by Carolyn George.

Red Grooms and Texas Governor Ann Richards (in the background are Grooms's Astronauts on the Moon), 1993. Photo by Frank English.

June: First trip to Russia, accompanying the Minneapolis Children's Theater, who will present in Moscow a play after Mark Strand's children's book, Rembrandt Takes a Walk with sets and costumes after the artist's illustrations. Completes miniature notebook of drawings, and publishes them as a limited edition, Travels to Moscow and Leningrad, May 29th–June 4th.

1990

Returns to Jackson Hole, this time Lysiane and Red travel through Yellowstone Park to Cody, Wyoming on the tracks of "Buffalo Bill." Then they take a short break together in Venice. Starts work for the FIAC show in Paris (annual art fair at the Grand Palais). Takes his first trip to Hawaii, and works with Bud Shark, who opened a workshop in Holualoa, on the Big Island. Completes Holy Hula lithograph and numerous monotypes.

1991

Collaborates with David Gordon and Philip Glass on The Mysteries or What's So Funny, a play by David Gordon, sponsored by the Spoleto Festival in Charleston. The play tours the United States, returning to New York for The Serious Fun Festival in 1991.

Summer: Takes his second trip to Hawaii. Works on a three-dimensional lithograph, South Sea Sonata, inspired by the Polynesian islands and Gauguin. Leaves Hawaii for Nagoya, Japan, visits Kyoto, Hiroshima, Kurashiki, Fukuoka, and Yokohama.

1992

April: Shows at the Marlborough Gallery. Completes commissioned large-scale sculpture The Agricultural Building Iowa State Fair for the Des Moines Art Center.

Summer: Third trip to the Big Island of Hawaii. He and Lysiane rent a house on Kealakekua Bay. Works on watercolors, collages, and on a lithograph Matisse in Nice with Bud Shark.

1993

March: Red Grooms at Grand Central opens in the newly renovated waiting room of the terminal.

April: Works on a new piece, Moby Dick Meets the New York Public Library, also shown at the terminal.

July: Visits Japan for the installation of his show at Nagoya City Art Museum, curated by Yasuo Yamawaki and sponsored by Asahi

Shimbum. The exhibition will tour to Ashiya City Museum of Art & History, Mitsukoshi Museum in Tokyo and the Museum of Art, in Kochi.

Summer: In Hawaii, working with Bud Shark, initiates Taxi to the Terminal, Hot Dog Vendor, and Looking Up Broadway Again, which Shark proofs on his jungle press.

December: Red Grooms' Have Brush Will Travel Watercolor Show—Marlborough Gallery, New York.

1994

April: Is commissioned by the New York State Council of the Arts to do a wall relief for the College of Staten Island's new gymnasium.

June: Nashville. First of a series of showings of the Tennessee Fox Trot Carousel model to initiate interest and financial support in the project.

November: Nagoya city officials and the Imaike Neighborhood Association commission two large outdoor sculptures to be permanently installed in the Imaike Entertainment district.

1995

February: Travels to Potsdam, Germany for the showing of Subway from Ruckus Manhattan, at the film museum; exhibition is organized by the Brandenburgischer Kunstverein. Produces Train to Potsdam a linocut limited edition and a poster.

April: Chicago. Première by the Remains Theater Company of Moon Under Miami a play by John Guare with set designs by Red Grooms.

May: Travels to Greece and Turkey, will work on numerous watercolors including a self-portrait with Lysiane commissioned by the Cheekwood Museum in Nashville.

June 11: Opening of Red Grooms' Watercolor Show—What's All the Ruckus About? at Cheekwood Museum. Starts work on The Bus. Mr. Rogers and a film crew visit the artist's studio and record progress on The Bus.

Summer: Works in New York with Felix Harlan and Carol Weaver on new etchings and with Maurice Sanchez on the lithograph Rockefeller Center.

October: Opening of New York Stories at Marlborough Gallery, New York.

1996

February: Works on Paper show, Marlborough, New York.

July: Nashville. Presentation of the first 3 Tennessee Fox Trot Carousel figures (Wilma Rudolph, Davy Crockett, and Mr. Fox

Red Grooms and Fred Rogers (Mr. Rogers), 1994. Photo by Susan Gray.

Trot) at the Rotary club. The presentation will kick off the fund-raising campaign headed by Trudy Byrd and Christie Hauck.

October: Red Grooms, A Personal Art History, curated by Laureen Buckley, opens at the New Britain Museum in Connecticut. The show will travel to the Newport Museum, Rhode Island, and the Cape Museum, Massachusetts.

Fall: Starts to work on the remaining 33 *Tennessee Fox Trot Carousel* figures. Prints, at his studio, *Les Baigneuses after Picasso.*

1997

March: Inauguration of "Showtime" and "Some Like It Hot" in the Imaike district in Nagoya, Japan.

April: Travels to China and visits Shanghai, Hangzhou, Huangshan, Guilin, Yangshuo, Xian, and Beijing; produces watercolors extensively through the journey. *Works on Paper* show at Marlborough, New York.

May: Survey show, curated by Steven Wicks, opens at the Knoxville

Museum of Art. Works on the *Tennessee Fox Trot Carousel* all through the year.

1998

September: A show of selected works is presented at the Palmer Museum, Penn State University, curated by Joyce Robinson.

November: Moby Dick meets the New York Public Library and other literary-inspired works, curated by Neil Watson are shown at the Norton Museum, West Palm Beach, Florida. Production of the *Tennessee Fox Trot Carousel* occupies most of this year, when it is inaugurated at the end of November, it will have taken two and a half years to complete. During this time, Grooms and his team (Tom Burckhardt, Lysiane Luong, and Anu Schwartz) will produce 34 figures, 2 chariots, 14 outside rounding boards, 14 inside rounding boards, and 12 panels to cover the central column which holds the mechanism, all depicting a piece of Nashville's history. The *Tennessee Fox Trot Carousel* is permanently installed at Riverfront Park in downtown Nashville.

1999

January: Shows new sculptures at Marlborough Gallery in Boca Raton, Florida.

April: Opening of new works at Marlborough, New York. This show includes *Hot Dog Vendor*, a monumental sculpture, and many New York tableaux.

August: Works with Bud Shark in Holualoa, Hawaii, on a 3-D lithograph, *Traffic!*, and produces a number of monotypes.

September: Travels to Paris, France, for the installation of *Hot Dog Vendor,* which is included in Les Champs de la Sculpture 2000 (September 15th–November 14th).

2000

May: Sculpture retrospective, *Grounds for Sculpture*, Hamilton, New Jersey.

June: Red Grooms: In Search of Serious Fun, Contemporary Art Center of Virginia. Virginia Beach. *Hot Dog Vendor* exhibited at the *International Sculpture Festival of Monte Carlo*, Monte Carlo, organized by the Marlborough Gallery.

December: New works, Galarie Patrice Trigano, Paris.

Red Grooms and Lysiane, 1997. Photo by Sanjiro Minamikawa.

Glossary

Aquatint: An etching technique in which acid-resistant particle material (powdered resin or asphaltum or spray lacquer) is applied to the surface of a metal plate. When the plate is immersed in acid, only the interstices around the particles are bitten. When the particles are removed by a solvent the surface of the plate exhibits a granular pattern of pits and bumps. Depending on the size of the particles, the nature of their distribution, and the action of the acid, aquatint can produce an effect of soft smoothness or a rough stubble.

Archive Impressions (A): A proof pulled at the same time as the edition set aside by the publisher for documentation or exhibition purposes.

Artist's Proof (AP): A proof pulled at the same time as the regular numbered edition, set aside for the artist's use.

BAT: The proof designated by the artist as the impression that the entire edition must match. Literally, *bon á tirer*—"good to print." Also called "right to print" (RTP).

Blind Intaglio: Deep etching used only for its embossing effect. The plate is passed through the press uninked with a sheet of very thick damp paper. For very deep embossing the paper is left to dry on the plate.

Cancellation Proof (C): When the printing of an edition has been completed, the key image is defaced and a proof is pulled to document the cancellation.

Catalogue Raisonné: Classified and numbered list of all known works made by an artist in a particular medium.

Chine Collé: A technique used in both intaglio and lithography. A thin sheet of paper, often Oriental, is adhered to a larger, heavier sheet and printed at the same time. The subtle tone and texture of the Oriental paper provide a unifying background for the image.

Chop: A symbol or logo of the publisher, artist, or printer, embossed or blind stamped in the margin of a print.

Color Trial Proof (CTP): A trial proof printed before the colors to be used in the edition have been established.

Drypoint: An intaglio technique in which a sharp needle scratches into a bare metal plate, creating rough burrs of metal on either side of the line. Both the incised line and burr retain ink when the plate is wiped giving the printed line a soft and velvety quality.

Edition: Set of identical prints. Editions may be limited or unlimited in number. The size of the edition may be pre-determined by the artist or publisher, usually numbered and signed. The prints are either pulled by or under the supervision of the artist.

Etching: An intaglio technique where a metal plate is covered with a thin layer of acid-resistant materia; the artist using an etching needle or other sharp object, draws on the plate exposing the base metal. When the plate is submerged in the acid bath, the acid dissolves the metal in the exposed areas, creating recessed lines that hold ink. Ink is then applied and the plate is wiped so the ink remains in the recessed areas that have been attacked by the acid. Under printing pressure, dampened paper is forced into the ink recesses of the plate and ink is deposited on the paper.

Hard Ground: A compound of asphaltum, beeswax, and rosin used to coat etching plates. This is easily drawn through with an etching needle and protects areas of the plate from the action of the acid.

HC: A form of proof, stands for *hors de commerce* or "not for sale." The proofs may differ from the edition in some way; they are often used by publishers as exhibition copies.

Intaglio: A printing process in which a sharp tool and techniques are used to incise or etch an image into a metal plate so the printing area is recessed below the surface. Ink is applied to the recessed area of the plate and the excess is wiped away. Dampened paper is laid on the plate followed by a felt blanket, which helps to absorb the pressure exerted as the plate and paper are run through the press. The action of the press forces the paper into the recessed area of the plate so it can receive the ink. Intaglio prints are characterized by beveled plate marks where the edges of the plate have embossed the paper and by the distinctive way in which the ink sits up on the surface of the paper rather than soaking into it.

Line cut: A type of relief print block in which the areas that are not to be printed are removed by chemical or mechanical means. For many years it was the common form of newsprint illustrations.

Linocut: A relief print in which the design is carved into a sheet of linoleum. Unlike wood, linoleum has no grain, so it lends itself to more fluid carving and will print flat tonal areas.

Lithographic crayon: Greasy drawing substance used for drawing images on a lithographic stone or plate. The substance attracts ink, so the image drawn is the image printed in reverse.

Lithography: A planographic process. A method of printing based on the chemical resistance of oil and water, invented by Aléis Senefelder in 1798. The image is applied to a grained aluminum plate or to a Bavarian limestone using greasy ink ("Tusche") or litho-crayon. The plate or stone is then etched by a wash of acid and gum arabic, which fixes the image and makes blank surfaces receptive to water. During printing, the stone or plate is placed on the press bed and water is sponged onto it. Then a rubber roller charged with ink is rolled over the stone or plate. The grease-drawn areas accept ink, while the water-receptive blank areas reject it. A sheet of paper is laid on the stone or aluminum and both are passed under the scraper bar of the lithography press.

Marginalia: A small print produced in the open space of a plate used for a larger print.

Offset lithograph: The process of almost all commercial printing. On an offset press the image is transferred from the lithographic

plate to a cylindrical blanket, and then onto paper. Because of this double action, images do not appear reversed. The modern mechanical equivalent of traditional lithography.

Photo-offset lithograph: A process of printing in which an image is photographed and the image then transferred to a specially sensitized lithographic plate and printed by offset.

Portfolio: A selection of prints by a single artist or group of artists. Portfolios often have a title and title sheet and the prints most often share a common theme. They are usually presented in a protective folder or clothbound box.

Print: An image produced on paper or other materials (such as wood or cardboard) by placing it in contact with an inked block, plate, or stone and applying pressure or by pressing ink onto a sheet of paper through a stencil. Sometimes referred to as an impression.

Pochoir: French word for "stencil." Stencils are usually made from paper, film or plastic and the color can be applied with brushes, spray guns and other means. It is a common way of "hand-coloring" an edition of prints with consistency (see *Picasso Goes to Heaven II*).

Printer's Proof (PP): Proofs pulled at the same time as the edition and set aside for the master printer.

Proof: Any print that is not part of the regular edition. A print pulled prior to the edition, documenting the stages of a print in process. Other proofs may be the same as the edition but are not part of the regular numbering sequence, such as artist's proofs or printer's proofs.

Publisher: Generally the publisher pays for the development and printing of the edition and in exchange shares in the profits or receives a certain number of prints. Some publishers are creatively involved in the development of the print, overseeing it on a daily basis, others simply fund the project.

Relief: A printmaking technique, such as woodcut or linocut, in which raised areas are inked and printed while the recessed areas are not.

Screenprint: A print made by creating a stencil on a fine mesh screen (traditionally of silk, but commonly of synthetic material). Ink is forced through the stretched mesh fabric, parts of which have been blocked out. It differs from other techniques in that the image is passed through the surface rather than being transferred from a surface. The block-out can be painted by hand with glue or lacquer; an adhesive film may be used which can be cut with a knife, then applied to the screen; or a light-sensitive resist may be painted on the screen and developed photographically. This process allows large editions and multicolored prints to be produced without the use of a stratograph press.

Serigraph: Another name for screenprint. To produce "serigraphs" the artist paints directly on the screen. The use of serigraph is an attempt to distinguish artistic forms of printing from commercial ones.

Series: Sometimes referred to as "suite." A series of related prints on a central theme.

Soft Ground: An etching ground containing a greasy element that renders it soft and nondrying, used to produce soft lines and complex textures. Cloth and other objects can be pressed into the ground, leaving an impression that is transferred to the plate when it is bitten by acid. A piece of cloth or paper could also be laid on the soft ground and drawn on; when the cloth or paper is lifted from the surface, it pulls up some of the sticky ground to give a broader, more granular line than that of an etching needle.

Sugarlift aquatint: An etching technique in which an image is painted on a plate with a solution of ink and granulated sugar. The plate is then covered with a ground and submerged in water, which dissolves the sugar solutions, lifting the ground and exposing the image areas so the plate can be etched; often referred to as "lift-ground."

Trial Proof (TP): A print pulled during the early stages of proofing to check the appearance of the image; usually printed in a single color, most often black.

Tusche: German for "ink" it is the name given to the greasy liquid used to make images on a stone, acetate or Mylar. Tusche can be diluted with water to produce a liquid medium for painting delicate washes and tones. It is also used for drawing screenprint screens.

Woodcut: The most ancient form of printing (AD 618–906). A block of wood is carved in relief, rolled with ink, and pressed against paper so the raised portions print and the depressed portions do not.

Working Proofs (WP): A proof on which the artist has drawn or painted to make changes in preparation of the final edition.

Selected Exhibitions and Literature

1962

Motive, May, *Ruckus* (shown as *Horseman*), p. 11.

1970

Dallas Time Herald. December 13. *Doughnut Girl*.

1971

Harry N. Abrams Gallery, New York, NY. "Abrams Original Editions—'No Gas' Lithos": *Aarrrrrrhh, Local, No Gas Café, Rat, Slushing, Taxi Pretzel*. December–January 1971.

1972

Fine Arts Center, Cheekwood, Nashville, TN. Slushing, Taxi Pretzel, No Gas Cafe, Rat, Local, Aarrrrrrhh.
Graphics One and Two, Boston, MA. (group exhibition).

1973

Moderna Museet, Stockholm, Sweden. "New York Collection for Stockholm." (group exhibition). October–December. Catalogue: essay by Pontus Hultēn and Emile de Antonio.
Moore College of Art, Philadelphia, PA. "Artists Books." March 23–April 20. Catalogue: text by Lynn Lester Hershman and John Perreault; *Organize the Sea*, from *Stamped Indelibly*, 1967.
Brooke Alexander Gallery, New York, NY. "Hand-Colored Prints" (traveling group exhibition). November. Catalogue: commentary by Carter Ratcliff.
Rutgers University Art Gallery, Voorhees Hall, New Brunswick, NJ. September 30–November 21. *The New York Cultural Center, New York, NY*. December 5, 1973–January 20, 1974."The Ruckus World of Red Grooms." Catalogue: essay by Phillip Dennis Cate; *Aarrrrrrhh*-index no.9, *Local*-index no.9, *No Gas Cafe*-index no.9, Illustrated-pl. 6, *Rat*-index no.9, *Slushing*-index no.9, *Taxi Pretzel*-index no.9.

1975

Brooke Alexander Gallery, New York, NY, January 1975–January 1976, *University of Redlands, CA; San Jose Museum of Art, CA; Tacoma Art Museum, WA; Simon Fraser University, BC; University of Saskatchewan, Saskatoon, Saskatchewan, Canada; Fine Arts Brooke Alexander Gallery of San Diego, CA; Philbrook Art Center, OK*. "Traveling Group Exhibition of Prints."

1976

Brooklyn Museum, Brooklyn, NY. "Thirty Years of American Printmaking." November 20, 1975–January 30, 1976 (group exhibition). Catalogue: essay by Gene Baro; *Nervous City*-1972, p.51, Illustrated-pl. 104: *Gertrude*-p.51. Illustrated-pl. 105.
Brooke Alexander Gallery, New York, NY. "Traveling Group Exhibition of Prints." January–December, Brooke Alexander, sponsor, and E.D.O. Comprehensive Exhibitions Services of Los Angeles, organizer, traveled to *University of Oklahoma, Norman, OK. Tyler Museum of Art, Tyler, TX. Wichita Falls Museum and Art Center, Wichita Falls, TX. Arkansas Arts Center, Little Rock, AR., Hunter Museum of Art, Chattanooga, TN.*
Corcoran Gallery of Art, Washington, DC. "Kent Bicentennial Portfolio Exhibition." October 16. Catalogue: *Bicentennial Bandwagon*. Illustrated p. 13.
Kramer Hilton. "Art: 30 Years of American Prints." *New York Times* November 19. p. C18.

1977

Contemporary Graphics Center, Santa Barbara Museum of Art, Santa Barbara, CA. "Red Grooms, Drawings and Prints." July 14–August 14.
Brooke Alexander Gallery, New York, NY. "Selected Prints 1960–1977." Part I: September 13–October 8, Part II October 15–November. Catalogue: *Manet/Romance*-pl. no.61; *Matisse*-pl. no.62; *Café Manet*-pl. no.63; *Gertrude*-pl. no.64. All illustrated.
Marlborough Gallery, New York, NY, "Marlborough Graphics." November.
New Gallery of Contemporary Art, Cleveland, OH. "Red Grooms." November 18–December 24. Checklist: *Manet/Romanc*-no.15, *Cézanne*-no.16; *Nadar*-no.17, *Degas*-no.18, *Bazille*-no.19, *Delacroix*-no.20, *Whistler*-no.21, *Guys*-no.22, *Baudelaire*-no.23, *Matisse* (shown as *Matisse in His Studio*)-no.24, *Picasso Goes to Heaven*-no. 25, and *Taxi* (not numbered).
Washington Post Magazine. "Folding Their Tent." December 11.p.87: *Gertrude*. Illustrated.

1978

Boston University Art Gallery, Boston, MA. "A Decade of Print Publishing." Brooke Alexander, Inc. February 3–26. Traveled to *Tennessee Botanical Gardens and Fine Arts Center, Nashville, TN.* April 8–May 22, 1979. Catalogue: essay by Judith Goldman; *Museum* is on the cover of Catalogue: *45 Characters*-index no.17, *Manet/Romance*-index no.18, *Matisse*-index no.19. Illustrated. *Picasso Goes to Heaven II*-index no.20.
Brooke Alexander, Inc. New York, NY. "Selected Prints II." Catalogue: *Baudelaire*-pl. no.36a, *Bazille*-pl. no.36b, *Cézanne*-pl. no.36c, *Courbet*-pl. no.36d, *Degas*-pl. no.36e, *Delacroix*-pl. no.36f, *Guys*-pl. no.36g, *Nadar*-pl. no.36h, *Rodin*-pl. no.36i, *Whistler*-pl. no.36j, *Self-Portrait in a Crowd* 1962 (shown as *Untitled*)-pl. no.37, *Nashville, 2001 A.D.*-pl. no.38, (print incorrectly titled *2002 A.D.*). All illustrated.
Martin Wiley Gallery, Nashville, TN. "Red Grooms." November 19–December 31. *Museum*.

1979

Benjamin Mangel Gallery, Philadelphia, PA. "Red Grooms." May 6–27.

1980

Glueck, Grace. "How Picasso's Vision Affects American Artists." *New York Times*. June 22, section 2, p. 25, *Gertrude*. Illustrated.
Brook Alexander Gallery, New York, NY. "New Publications Acquisitions." Catalogue: *Truck*-pl. no.32, *Peking Delight*-pl. no.33.
Camp Gallery, Signet Fine Prints, St. Louis, MO. "Red Grooms."
The Print Collector's Newsletter, Minneapolis, MN. "Multiples & Objects & Artists' Books. Red Grooms, *Peking Delight*, a wood multiple." January/February. p. 203; *Peking Delight*.
The Print Collector's Newsletter, Minneapolis, MN. "Prints and Photographs Published, Red Grooms *Lorna Doone*, ...a color lithograph." March/April. p. 16; *Lorna Doone*.
Clark Hatton Gallery, Colorado State University, Boulder, CO. "Red Grooms: Works from the 60's." September 1–26. Traveled to *Signet Fine Prints, St. Louis, MO.*
Walker Art Center, Minneapolis, MN. "Artists and Printer: Six American Print Studios." December 7, 1980–January 18, 1981. Catalogue: *Dali Salad*-index no. 109; *Pancake Eater*- index no. 110; *Peking Delight*-index no. 111-Illustrated pl. 24, Traveled to *Sarah*

Campbell Blaffer Gallery, University of Texas, Houston, TX.
February 22–April 5.

1981

Goodyear, Frank H. Jr. *Contemporary American Realism Since 1960.*
Little Brown and Co., Boston, New York Graphic Society. p. 216.

Ratcliff, Carter. *Red Grooms' Human Comedy Portfolio.* March/April.
Picasso Goes to Heaven II-p.59. Illustrated.

University of Wisconsin and Madison Art Center, Madison, WI. "New
Graphics 2, Contemporary American Prints." March 13–April 25
(group exhibition).

Marlborough Gallery, New York, NY. "Red Grooms—Recent Works."
April 3–May 5. Catalogue: *A Body Like Mine*-index no. 61, *Chuck
Berry*-index no. 62, *Peking Delight* (shown as *The Chinaman*)-p.39,
pl. 63, *Truck*-index no. 65, *Truck II*-p.37, pl. 66, *Dali Salad*-p.37, pl.
67, *Pancake Eater*-p.39, pl. 68.

Alexander, Brooke and Cowles, Virginia. "Red Grooms: A Catalogue
Raisonné of His Graphic Work, 1957- 1981."

Newport Harbor Art Museum, Newport Beach, CA. "Inside Out: Self
Beyond Likeness." May 22-July 12 (traveling group exhibition).
Organized by Lynn Gamwell and Victoria Kogan. Catalogue:
Checklist: *Gertrude, Dali Salad.*

Tennessee Fine Arts Center at Cheekwood, Nashville, TN. "Red Grooms:
Prints of the Seventies." August 7–September 16. Traveled to
University Museum, University of Mississippi, University, MS.
October 1981. *West Georgia College, Carrollton, GA.* January 1981–
February 1982. *University of South Carolina, Columbia, SC.* April
1982. *Pensacola Museum of Art, Pensacola, FL.* May–June 1982.
Hickory Museum, NC. August–September 1982. *Virginia Polytechnic
Institute, Blacksburg, VA.* September–October 1982. *Contemporary
Arts Center, New Orleans, LA.* January–February 1983. *Louisville
Art Gallery, Louisville, KY.* March–April 1983. *Rowan Art Guild
Gallery, Salisbury, NC.* April–May 1983. *Davidson College Art
Gallery, Davidson, NC.* August–October 1983. Catalogue.

1982

Brooke Alexander, Inc. New York, NY. "Selected Prints III."
Catalogue: *Dali Salad*-pl. no. 66, *Ruckus Taxi*-pl. no. 67, *Pancake
Eater*-pl. no. 68, *The Tattoo Artist*-pl. no. 69, *Self-Portrait with Liz*-
pl. no. 70, *Mid-Rats*-pl. no. 71, *Lorna Doone*-pl. no. 72. All illustrated.

Madison Art Center, Madison, MI. "New American Graphics 2."
March 13–April 25. Catalogue: *Pancake Eater.* Illustrated p. 18.

Benjamin Mangel Gallery, Philadelphia, PA. "Red Grooms." June 12–
July 2.

1983

Anderson Ranch, Snowmass, CO. "Maquettes, Monotypes, and
Graphics." March.

Vermillion Editions, Ltd. Inc. Minneapolis, MN. "Vermillion Publications
1978-1983." Catalogue: *Mid-Rats*-pl. no. 8, *Mayor Brynes Mile of
Sculpture*-pl. no. 9, *Pancake Eater*-pl. no. 10. All illustrated.

Unicorn Gallery, Aspen, CO. "Graphics from the 80's." May.
Downhiller-no.155. Illustrated.

The Tampa Museum, Tampa, FL "Public Works—Private Patrons:
Images of Modern Times by Red Grooms." May–August. Traveled
to *Hunter Museum, Chattanooga, TN.* September–October.
Catalogue: Essay by Bradley J. Nickels; *Five Futurists*-index no. 7;
Aarrrrrrhh-index no. 18a, *Local*-index no. 18b, *No Gas Café*-index
no. 18c, *Rat*-index no. 18d, *Shushing*-index no. 18e, *Taxi Pretzel*-
index no. 18f, *Nashville, 2001 A.D.*-index no. 21, *Baudelaire*-index
no. 25a, *Bazille*-index no. 25b, *Cézanne*-index no. 25c, *Courbet*-
index no. 25d, *Degas*-index no. 25e, *Delacroix*-index no. 25f, *Guys*-
index no. 25g, *Nadar*-index no. 25h, *Rodin*-index no. 25i
Illustrated. *Whistler*-index no. 25j, *Taxi*-index no. 27. Illustrated.
Martin Wiley Gallery-index no. 38, *Chuck Berry*-index no. 39,

Museum-index no. 40, *Peking Delight*-index no. 43. Illustrated.
Ruckus Taxi (shown as *Ruckus*)-index no. 49.

Pratt Graphics Center, New York, NY. "From the Beginning: A
Graphics Exhibit of 24 Major American Artists." (group exhibition).

Preview. North Carolina Museum of Art, Raleigh, NC. Autumn.
Gertrude. Illustrated. *Museum.* Illustrated.

1984

Doss, Erika. "Uncommon Prints." *Arts, Minneapolis Society of Fine
Arts.* January, pp. 13–16. *Dali Salad.* Illustrated-p. 16.

Minneapolis Institute of Arts, Minneapolis, MN. "The Vermillion
Touch: Master Prints from a Minneapolis Studio's Archives,"
January 21–March 18. Catalogue exists in the form of a videotape
includes an interview with the Artist. *Dali Salad, Lorna Doone,
The Tatoo Artist, Pancake Eater, Truck, Peking Delight.*

Howell, Camile. "Troubled Times for a Premier Printmaker."
Minneapolis Tribune. April 1. *Dali Salad*-and *Lorna Doone.*
Illustrated p. 18.

Marlborough Gallery, New York, NY. "Red Grooms: Recent Works."
April 6–May 1. Catalogue.

Tully, Judd. "Red Grooms Has an Artful Fun with High Culture-and
Low." *Smithsonian Magazine.* June. *Dali Salad* and *Fats Domino*-p.
109. Illustrated. *Local*-pp. 114-115.

Ratcliff, Carter. "Red Grooms." Published by *Abbeville Press, New
York, NY.* Giacometti-pl. no. 18 p. 19; *The Burning Building*-pl. no.
52 p. 44, *Parade in Top Hat City*-pl. no. 89 p. 79, *Crucifixion* (shown
as *Crucifixation*)-pl. no. 90 p. 80, *Angel*-pl. no. 91 p. 80, *Fall of
Jericho*-pl. no. 135 p.117, *Local*-pl. no. 136 Illustrated p.118, *Taxi
Pretzel*-pl. no. 137 p. 119, *Slushing*-pl. no. 138 p. 120, *Aarrrrrhh*
(shown as *Aarrrrghh*) -pl. no. 139 p. 120, *Rat*-pl. no. 140 p. 121, *No
Gas Café*-pl. no. 141 p. 121, *Mango Mango*-pl. no. 164 p. 144, *45
Characters*-pl. no. 165 p.145, *Picasso Goes to Heaven II*-pl. no. 167
p. 147, *Bicentennial Bandwagon*-pl. no. 173 p. 155, *Delacroix*-pl.
no. 191 p. 171, *Whistler*-pl. no. 192 p.171, *Guys*-pl. no. 193 p. 172,
Baudelaire-pl. no. 194 p. 172, *Rudy Burckhardt as a Nineteenth-
Century Artist*-pl. no. 195 p. 173, *Self Portrait with Mickey Mouse*
(shown as *Self Portrait*)-pl. no. 196 p. 173, *Chuck Berry*-pl. no. 213
p. 182, *Museum*-pl. no. 215 p. 183, *The Tattoo Artist*-pl. no. 237 p.
199, *Pancake Eater*-pl. no. 238 p. 199, *Lorna Doone*-pl. no. 240 p.
200, *You Can Have A Body Like Mine* (shown as *A Body Like
Mine*)-pl. no. 241 p. 201, *Heads Up D.H.*-pl. no. 243 p. 202, *Rrose
Selavy* -pl. no. 244 p. 243, *Dali Salad*-pl. no. 245 p. 203, *Peking
Delight*-pl. no. 249 p. 206, *Truck* -pl. no. 250, p. 207, *Minstrel*-pl.
no. 296 p. 239. All illustrated.

Whitney Museum of American Art, New York, NY "Print
Acquisitions, 1974–1984." August 29–November 25. Catalogue:
essay by Judith Goldman; *Guggenheim.*

1985

University Art Museum, University of New Mexico, Albuquerque, NM.
"Fifty Artists/Fifty Printers." February 2–March 24. *Ruckus Taxi,
London Bus.*

Marlborough Gallery, New York, NY. "Red Grooms—Recent Works."
April 5–May 1.

Castleman, Riva. "American Impressions Prints Since Pollock."
Published by Alfred A. Knopf, Inc., NY. *Gertrude*-pl. 133.
Illustrated.

Benjamin Mangel Gallery, Philadelphia, PA. "World Span of Red
Grooms." Checklist: *Charlie Chaplin, Fats Domino, Red's Roxy.*

Pennsylvania Academy of the Fine Arts, Philadelphia, PA "Red
Grooms, A Retrospective." June 21–September 29. Traveled to
Denver Art Museum, Denver, CO. November 2, 1985–January 5,
1986. *Museum of Contemporary Art, Los Angeles, CA.* March
12–June 29, 1986, *Tennessee State Museum-Nashville, TN.* August
17–October 26, 1986. Catalogue: *Double Portrait with Butterfly*-pl.

no. 44, *Aarrrrrrhh*-pl. no. 56, *Local*-pl. no. 57, *Cézanne*-pl. no. 79, *Rodin*-pl. no. 80, *Matisse*-pl. no. 82; *Picasso Goes to Heaven II*-pl. no. 85, *Dali Salad*-pl. no. 89, *Gertrude*-pl. no. 93, *Fats Domino*-pl. no. 95, *Museum*-pl. no. 99, *Guggenheim* -pl. no. 100, *Wheeler Opera House*-pl. no. 123, *Patriot's Parade*-pl. no. 135, *London Bus*-pl. no. 146, *Nashville 2001 A.D.*-pl. no. 148, *45 Characters*-pl. no. 149, *Bicentennial Bandwagon*-pl. no. 152, *Lorna Doone*-pl. no. 155, *Heads Up D.H.*-pl. no. 156, *The Tattoo Artist*-pl. no. 157, *Jack Beal Watching the Super Bowl*-pl. no. 159, *Self-Portrait with Mickey Mouse* (shown as *Self Portrait*)-pl. no. 165. All illustrated.

1986

Gainsley, Bonnie. "Printmaking at Vermillion Editions, The Delicate Balance of Collaboration." *Art Gallery International Magazine.* September/October. *Dali Salad*-p. 55. Illustrated.

Rocke, Nancy McGuire. "Seeing Red." *Nashville Magazine,* August. pp. 20-25, *Museum*-p. 22, Illustrated. *Picasso Goes to Heaven II*-p. 24. Illustrated.

Wilson Art Center, Rochester, NY. "Print Making, Four Approaches: An Exhibition of Original Prints 1969-1985."

Smithsonian Magazine. July. *Charlie Chaplin.* Illustrated on front cover.

Cumberland Gallery, Nashville, TN. "Homage to Red Grooms." August 17–September 15. *Fats Domino, Heads Up D.H., Picasso Goes to Heaven I, Truck, Mountaintime, Coney Island, Nashville 2001 AD* (shown as *Nashville 2020 AD*), *Dali Salad, Museum, Peking Delight* (shown as *The Chinaman*) *Gertrude, American Geisha, Rodin, Café Tabou, Subway, Charlie Chaplin, London Bus, Ruckus Taxi, Red's Roxy, Martin Wiley Gallery.*

Alexander, Brooke and Cowles, Virginia. "Red Grooms: A Catalogue Raisonné of His Graphic Work 1957-1985," New York, NY.

Trust for Museum Exhibitions, Washington, DC. "Red Grooms: The Graphic Work from 1957-1985." Catalogue: Traveled to *Muscarelle Museum of Art, Williamsburg, VA.* August–October 1986. *Ruth Eckerd Hall, Clearwater, FL.* October–December 1986. *Erie Art Museum, Erie, PA.* December 1986–January 1987. *William Benton Museum of Art, University of Connecticut, Storrs, CT.* January-March 1987. *South Dakota Memorial Art Gallery, Brookings, SD.* April–May 1987. *The Nelson-Atkins Museum of Art, Kansas City, MO.* June–July 1987; *Arvada Center for the Arts and Humanities, Arvada, CO.* August–September 1987. *University of Arizona Museum of Art, Tucson, AZ.* September–October 1987. *Louisiana Arts and Science Center, Baton Rouge, LA.* November 1987–January 1988. *Amarillo Arts Center, Amarillo,TX.* January–March 1988. *Blanden Memorial Art Museum, S. Fort Dodge, IA,* March–May 1988. *Community Gallery of Lancaster, Lancaster, PA.* May–June 1988. *Roanoke Museum of Fine Arts, Roanoke, VA.* July–September 1988. *Canton Art Institute, Canton, OH,* September–October 1988. *Kalamazoo Institute of Arts, Kalamazoo, MI.* November 1988–January 1989. *Oklahoma City Art Museum, Oklahoma City, OK.* January 1989–March 1989. *Dahl Fine Arts Center, Rapid City, SD.* March–April 1989. *Bronx Museum of the Arts, Bronx, NY.* June–September 1989. *Anchorage Museum of History and Art, Anchorage, AK.* October–December 1989. *Hudson River Museum, Yonkers, NY.* January–April 1990. *Sawhill Gallery, James Madison University, Harrisburg, VA.* September–October 1990. *Museum of Arts and Sciences, Macon, GA.* January–March 1991. *Sunrise Museum, Charleston, WV.* April–June 1991. *Johnson Memorial Gallery, Middlebury College, VT.* October 1991–January 1992. *Knoxville Museum of Art, Knoxville, TN.* March–May 1992. *Asheville Art Museum, Asheville NC.* June–July 1992.

Carpenter Center for the Visual Arts, Harvard University, Cambridge, MA. "Red Grooms, Recent Prints." December 11, 1986–February 8, 1987. Checklist: *Bicentennial Bandwagon, Gertrude, A Body Like Mine, Chuck Berry, Sunday Afternoon in the Park with Monet,*

Aarrrrrrhh, Local, No Gas Café, Rat, Slushing, Taxi Pretzel, Lorna Doone, Blewy II, Picasso Goes to Heaven I, Museum, Saskia Down the Metro, Café Tabou, Sunday Funnies, Pierpont Morgan Library, Truck. Illustrated.

Taylor, Robert. "Works on Paper: Grooms A, Salle D-." *The Boston Globe.* December 21, 1986. *You Can Have a Body Like Mine* (shown as *A Body Like Mine*) and *Truck.* Illustrated.

1987

American Embassy Residence, Madrid, Spain. "North American Art." February. Catalogue: essay by James Tottis; *Ruckus Taxi*-index no. 1. Illustrated on front cover.

The Picker Art Gallery, Colgate University, Hamilton, NY. "Printmaking—The Third Dimension." September–October. Catalogue: *Red's Roxy.* Checklist 11-p. 18.

Simms Fine Art Museum, New Orleans, LA. "Graphics."

1988

Greenville County Museum of Art, Greenville, SC "Imprimatur." January 26–March 6. Traveled to *North Carolina Museum of Art, Raleigh, NC,* April 9–May 29. Folder. *Fats Domino.*

Boulder Center for the Visual Arts, Boulder, CO. "Selected Prints." November 4–December 4. Catalogue: *De Kooning Breaks Through*-no. 11. Illustrated on Front Cover. *Tonto—Condo*-no. 10. Illustrated. *Fats Domino*-no. 12, *Elvis*-no. 1. Illustrated.

1990

Downtown Arts Gallery, Church Street Centre, Nashville, TN. "The Best of Nashville—Nashville Collects Red." March–May. *Aarrrrrrhh, Local, No Gas Café, Rat, Slushing, Taxi Pretzel, Peking Delight, Coney Island, Elvis State II, No Gas Portfolio Cover, Lysianne and Red's Wedding Invitation* (shown as *Wedding Invitation*), *Mango Mango, London Bus, Ruckus Taxi, Van Gogh with Sunflowers, Elvis, Baudelaire, Bazille, Cézanne, Courbet, Degas, Delacroix, Guys, Nadar, Rodin, Whistler, American Geisha, Truck, Charlie Chaplin, and Subway.* Illustrated.

Marlborough Gallery, New York, NY. "Red Grooms, Tourist Traps and Other Places." April. Catalogue: *Los Aficionados*-no. 10. Illustrated p.40.

Federal Reserve Board Gallery, Washington, DC. "Red Grooms: A Survey of His Graphic Work 1957–1985." June 12–August 3. Catalogue: introduction by Mary Anne Goley, Director. *Untitled*-no. 1, *Blewy II*-no. 2, *Red Grooms Discount Store*-no. 3, *Aarrrrrrhh*-no. 4, *Local*-no. 5, *No Gas Café*-no. 6. Illustrated. *Rat*-no. 7, *Slushing*-no. 8, *Guggenheim*-no. 9, *Mango Mango*-no. 10, *Nashville, 2001 A.D.*-no. 11, *The Daily Arf*-no. 12, *Gertrude*-no. 13, *Becentennial Bandwagon*-no. 14, *Café Manet*-no. 15. Illustrated. *Coney Island*-no. 16, *Monet/Romance*-no. 17, *Cézanne*-no. 18, *Courbet*-no. 19, *Nadar*-no. 20, *Rodin*-no. 21, *Whistler*-no. 22, *Picasso Goes to Heaven II*-no. 23, *Taxi*-no. 24, *You Can Have a Body Like Mine*-no. 25, *Chuck Berry*- no. 26, *Martin Wiley Gallery*-index no. 27, *Museum*-index no. 28. Illustrated. *Lorna Doone A/C*-index no. 29, *Peking Delight*-index no. 30, *Truck (C)*-index no. 31, *Dallas 14, Jack 6*-no. 32, *Dali Salad*-no. 33, *Heads Up D.H.*-no. 34, *Self-Portrait with Liz*-no. 35 Illustrated. *Mayor Bryne's Mile of Sculpture*-no. 36, *London Bus*-no. 37, *Wheeler Opera House*-no. 38, *Fats Domino*-no. 39.

1991

Brooke Alexander Editions, New York, NY. "Poets—Painters—Collaborators."

1992

Minneapolis Institute of Arts, Minneapolis, MN. "Vermillion 15th Birthday Show." March–May. Checklist: *Dali Salad, Peking Delight, Truck.*

Cumberland Gallery, Nashville, TN. "Red Grooms." October 17–
November 14. Checklist: *Ruckus Taxi*-no. 1, *Lorna Doone*-no. 2
(shown as *Lorna Dune*), *Martin Wiley Gallery*-no. 3, *Elvis*-no. 4,
South Sea Sonata-no. 6, *Holy Hula*-no. 8, *Little Italy*-no. 9,
Subway-no. 10, *Wheeler Opera House*-no. 11, *Fats Domino*-no. 14,
Tonto—Condo-no. 15, *The Cedar Bar*-no. 16, *Café Tabou*-no. 17,
Heads Up D. H. -no. 18, *Café Deux Magots*-no. 19,
Manet/Romance-no. 20, *Charlie Chaplin*-no. 21, *Truck*-no. 22,
Truck II-no. 23, *London Bus*-no. 26, *Dali Salad*- no.30, *Los
Aficionados*-no. 31.

1993

Art Museum of Southeast Texas, Beaumont, TX. "Red Grooms."
February 6–May 23. Catalogue: essay by Charles Dee Mitchell;
*Gertrude, Matisse, Ruckus Taxi, Fats Domino, Cedar Bar,
De Kooning Breaks Through*, and *Van Gogh with Sunflowers*.
All illustrated.

Grand Central Station, New York, NY. "Red Grooms, Grand Central
Terminal." March–May. *Ruckus Taxi, London Bus, Fats Domino,
Slam Dunk.*

Grolier Club, New York, NY. "The American Livre de Peintre." March
17–May 15. Catalogue: text by Elizabeth Phillips, Tony Zwicker,
and Robert Rainwater. *Organize the Sea*, from *Stamped Indelibly.*

Quartet Editions, New York, NY. "Red Grooms, Selected Prints
1982–1993." May 1–June 11.

Nagoya City Art Museum, Nagoya, Japan. "Red Grooms." Traveled to
Ashiya City Museum of Art and History, Ashiya, Tokyo, Japan.
November 20, 1993–January 9, 1994; *Mitsukoshi Museum of Art,
Tokyo, Japan.* January 22–February 27, 1994, Catalogue: essay
"Red Grooms' American Art Power." by Kuzuo Yamawaki; *Dali
Salad.* Illustrated. pl. no. 35-p. 79.

Marlborough Gallery, New York, NY. "Red Grooms." December 8,
1993–January 8, 1994. Catalogue: Interview with the Artist by
Judd Tully. *Looking up Broadway*-no. 33; *Taxi to the Terminal*-no. 41.

1994

Irving Galleries, Palm Beach, FL. "Red Grooms." March 4–March 31.

Vanderbilt University Medical Library, Nashville, TN. "Red Grooms."
October 2, 1994–April 30, 1995. Catalogue: *Gertrude, Gertrude 2D,
Peking Delight, Dali Salad, Self Portrait with Liz, Fats Domino,
De Kooning Breaks Through, South Sea Sonata, Bronco Buster,
Slam Dunk.*

Pace Gallery, New York, NY. "Red Grooms New York/New York."
September 16–October 15. *Main Terminal Grand Central Station,
Main Concourse, Grand Central Terminal, Underground Platforms,
Commodore Vanderbilt, Self Portrait, Grand Central, Portrait of
A.C.,* and *Train 2007.*

1995

Lequire, Louise. "Red Grooms, Are His Works Headed for the Mil-
lion-Dollar Mark?" *Nashville Life Magazine, Nashville, TN.*
June–July. Illustrated. *Mango Mango, You Can Have a Body Like
Mine, No Gas Café, Bud on the Lanai, Dixie's*-p.63.

Hansen, Trudy: Mickenberg, David: Moser, Joann: and Walker,
Barry: "Printmaking in America," *Harry N. Abrams, Inc., New
York, NY.* in association with *Mary and Leigh Block Gallery,
Northwestern University, Evanston, IL. Ruckus Taxi*-p. 54,
Aarrrrrhh-pl. 24, p. 146; *No Gas Café*-pl. 25, p. 147.

Mary and Leigh Block Gallery, Northwestern University, Evanston, IL.
"Printmaking in America." September 22–December 3, 1995.
Traveled to *The Jane Voorhees Zimmerli Art Museum, Rutgers,
New Brunswick, NJ.* April 23–June 18, 1995. *The Museum of Fine
Arts, Houston, TX.* January 23–April 2, 1996. *National Museum of
American Art; Smithsonian Institution, Washington, DC.* May
10–August 4, 1996.

1996

Milwaukee Art Museum, Milwaukee, WI and *Quad/Graphics Gallery,
Sussex, WI.* "Ink on Paper: The Quad / Collection, 1971-1996."
August 23–November 3. Catalogue: *Holy Hula* Illustrated p. 63.

New Britain Museum of American Art, New Britain, CT. "Red
Grooms, A Personal Art History." October 12, 1996–January 5,
1997. Catalogue: Foreword and Interview with the Artist by
Laurene Buckley. *De Kooning Breaks Through* and *Dali Salad.*
Illustrated.

1997

Cumberland Gallery, Nashville, TN. "Red Grooms—Stephen
Hannock." May 17–June 14. *Tennessee Fox Trot Carousel.*

North Shore Gallery, Chattanooga, TN. "Red Grooms." May 1–June 7.
Checklist: *Guggenheim, Mango Mango, Bicentennial Bandwagon,
Elvis, Sno-Show II, Matisse in Nice, Picasso.*

Boardman Arts Center, Martinsburg, WV. "On the Road with Rusty
and Red: Rusty Morgan and Red Grooms." September 21–October.
Checklist: *Elaine de Kooning*-no. 2, *Bull Rider*-no. 3, *Holy Hula*-no.
4, *Mayor Byrne's Mile of Sculpture*-no. 5, *Downhiller* (shown as
Downhill Skier)-no. 6, *45 Characters*-no. 7, *A Light Madam*-no. 8,
Franklin's Reception at the Court of France -no. 9, *Sunday
Funnies*-no. 10, *Tonto—Condo*-no. 11, *Elvis*-no. 12, *Taxi*-no. 13, *No
Gas Café*-no. 14, *Dallas 14, Jack 6*-no. 15, *Guggenheim* (shown as
10 Independents at the Guggenheim)-no. 16, *Lorna Doone*-no. 17,
Macy's Thanksgiving Day Parade (shown as *Macy's Parade)*-no.
18, *Main Concourse, Grand Central Terminal*-no. 19, *Dixie's*-no. 20.

1998

Watkins Gallery, American University, Washington DC. "Red Grooms."
January 20–February 7. *Elvis, Downhiller* (shown as *Downhiller
Skier), Sunday Funnies, Ben Franklin's Reception at the Court of
France, Mayor Byrne's Mile of Sculpture, Holy Hula, Elaine de
Kooning, A Light Madam, Guggenheim, Dallas 14-Jack 6, 45
Characters, Tonto—Condo, No Gas Café, Taxi, Macy's Thanksgiving
Day Parade* (shown as *Macy's Parade), Jack Beal Watching the
Super Bowl, Dixie.*

Palmer Museum of Art, the Pennsylvania State University, University
Park, PA. "Red Grooms and the Heroism of Modern Life."
September 12–December 23. Catalogue: essay by Joyce Henri
Robinson; *Museum, Dali Salad, Fats Domino, Charlie Chaplin,
Subway, De Kooning Breaks Through, Slam Dunk, Looking up
Broadway, Again, Taxi to the Terminal, The Flatiron Building,
Down Under, Graveyard Ruckus, Hallelujah Hall, Piebald Blue,
Tootin' Tug, Rockefeller Center, Picasso.*

1999

Fletcher Priest Gallery, Worcester, MA. "Red Grooms." April 21–May
13. *Bull Rider, Dixie's, Elvis, Fats Domino, Jackson in Action, Little
Italy, Los Aficiondos, Picasso, Pollock's Model A, South Sea Sonata,
Sunday Funnies, Times Square, Western Pals.*

2000

Contemporary Art Center of Virginia, Virginia Beach, VA. "Red
Grooms: In Pursuit of Serious Fun." June 9–September 3. *Charlie
Chaplin, Hot Dog Vendor, Traffic!, American Geisha, Bronco
Buster, Bud on the Lanai, Bull Rider, Dixie's, Picasso, Pollock's
Model A, Red's Roxy, Samurai, Tonto—Condo, Western Pals.*

William Havu Gallery, Denver, CO. "Select Prints Shark's Inc."
August 25–October 7. *Fats Domino, Jackson in Action, Little Italy,
Tonto—Condo, Red Bud Diner, Traffic!*

2001

Mary Brogan Museum of Arts & Science, Tallahassee, FL. "Red
Grooms." March 9–June 10. *Hot Dog Vendor, Traffic!*

Index